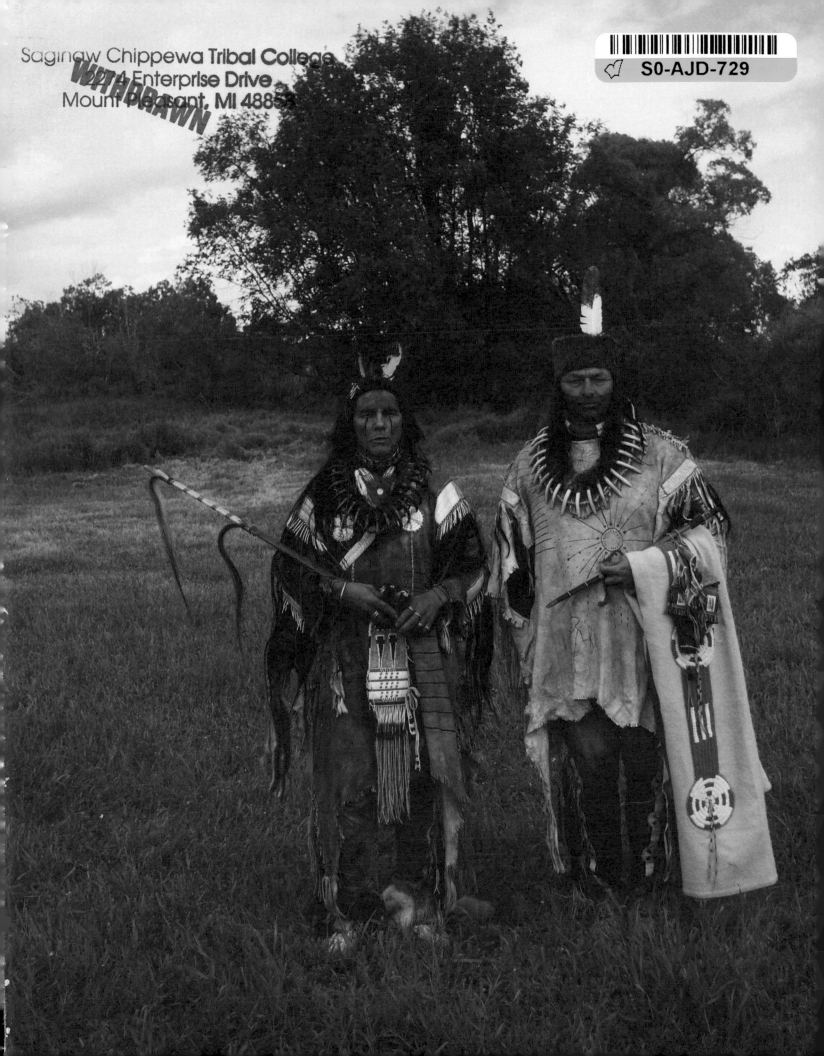

# Plains Indians
## Regalia & Customs

# Plains Indians

## Regalia & Customs

### Bad Hand

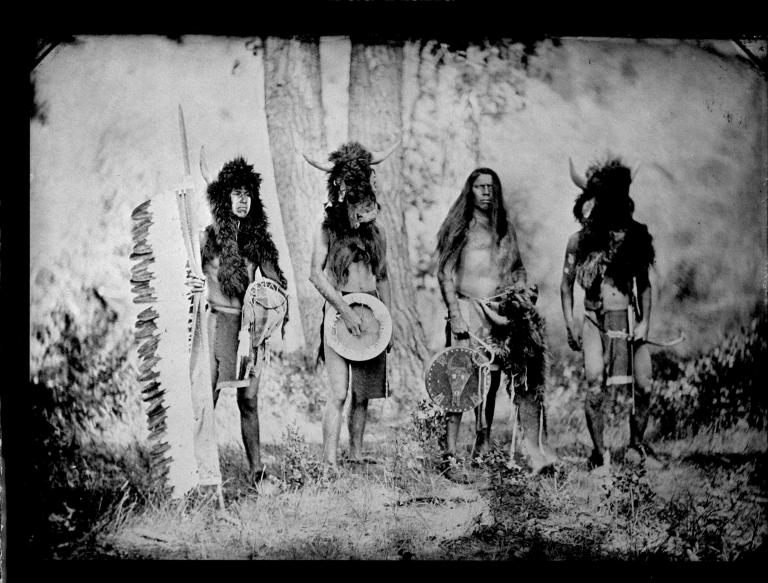

*Schiffer Publishing Ltd* ®

4880 Lower Valley Road Atglen, PA 19310

Dedicated to
The Land and The Plains People,
Past, Present and Future

*"There is some justification for regarding the Plains people as the most Indian of Indians. They were an amalgam of people from the eastern forests and the western mountains who created a new culture with the help of the only two useful things the white man brought, the horse and the gun. The Plains Indian was a late flowering of cultures already vanished or in ruins throughout most of the hemisphere. The Indian of the Plains, riding the European's horse and wearing the European's beads, was less sheer Indian, in the purest terms, than his predecessors, if one reckons such things in tiers of cultural trappings. But this merely proves that the Indians were dynamic people with a viable way of life. They were eminently able to survive by adaptation as long as there was hope of preserving their essential nature…"*
— **Cliff Soubier,** *Little Bighorn Battle: Context & Significance*

HALF TITLE PAGE
"BUFFALO DANCER," PAINTING BY JAMES BAMA

TITLE PAGE
BUFFALO DANCERS PREPARE FOR A DANCE ON THE BANKS OF THE GREASY GRASS RIVER, CONTEMPORARY TINTYPE PHOTO-GRAPH

Copyright © 2010 by Bad Hand
Photography © by Bad Hand, Myron Beck, Howard Buffet, Will Dunniway, and Sean Watson

Library of Congress Control Number: 2010928652

Cover designed by: Bruce Waters
Type set in Adobe Jenson

ISBN: 978-0-7643-3536-5

Printed in China

Schiffer Books are available at special discounts for bulk purchases for sales promotions or premiums. Special editions, including personalized covers, corporate imprints, and excerpts can be created in large quantities for special needs. For more information contact the publisher:

Published by Schiffer Publishing Ltd.
4880 Lower Valley Road, Atglen, PA 19310
Phone: (610) 593-1777; Fax: (610) 593-2002
E-mail: Info@schifferbooks.com

For the largest selection of fine reference books on this and related subjects, please visit our web site at www.schifferbooks.com
We are always looking for people to write books on new and related subjects. If you have an idea for a book please contact us at the above address.

This book may be purchased from the publisher.
Include $5.00 for shipping.
Please try your bookstore first.
You may write for a free catalog.

In Europe, Schiffer books are distributed by
Bushwood Books
6 Marksbury Ave., Kew Gardens
Surrey TW9 4JF England
Phone: 44 (0) 20 8392 8585; Fax: 44 (0) 20 8392 9876
E-mail: info@bushwoodbooks.co.uk
Website: www.bushwoodbooks.co.uk

# Contents

# Preface

This book is by no means intended to be a complete or comprehensive study of Plains Indian clothing or culture. Notes and observations would be a more accurate description of this effort.

It is, instead, a compilation of various facts and original primary source quotes and references recorded by the 18th and 19th century Plains Indian people themselves, and the peoples that knew them best and thought it important enough to record their observations.

Many people, such as soldiers, settlers, traders, trappers, explorers, missionaries, buffalo hunters, amateur and professional ethnologists, all left extensive notes and records to examine today. Many of these personal journals have only recently been put into print, allowing us to cross-reference them looking for similarities in their observations of styles and mannerisms of the Plains Indian people. So many of these recollections and observations are in complete agreement with what the Plains Indian people said of themselves, and so much of all of that is often quite contrary to what many people believe today. Some contemporary students and enthusiast of Plains Indian culture may see the lifestyle as idealistic, peaceful, and in harmony with all of nature and mankind, while other interpretations would say it was anything but.

The Plains Indians of the 18th and 19th century were a people in constant flux and transition, while adapting to the many new, interesting, exciting and sometimes frightening and deadly bits of Euro-American culture they were constantly bombarded with. If these introduced items and cultural ways were useful and adaptable to their own indigenous culture, then the People readily and eagerly adapted them to their own ways. If not, they rejected them.

I do not consider myself a professional writer or scholar, but I hope the reader can enjoy the many new illustrations in color and black and white, and read the text with an open mind. I am excited and grateful to have had the opportunity to work on this book, as I have been fascinated by the culture and have spent a good portion of my personal and professional life studying history and gathering information, simply because I love it.

Part of what I am attempting to do with this study is show readers how much mystique and incredible aura the old-time tintype, ambrotype, and other early photographic image-capturing methods preserved. They have added significantly to our understanding of the people and subjects shown. If you have a modern person and the same setting, and take a modern color photograph for comparison, it may be clear and colorful but will never have the same emotional impact as the old style photographs. On the other hand, if you are used to looking at old images in black and white photographs, perhaps the new, colorful images may help you see the reality of how the 19th century may have looked in living color.

It was a great experience to be a part of the transformation from being the modern Native person to getting in touch with the historical past as we created these color images together. Of course, many Native people already have a strong sense of tribal and family pride, but by putting them in the old-style clothing, and focusing our effort, the journey to earlier days was made easier. You could see it in each person as they came in touch with their heritage and culture. It is a personally rewarding experience to be able to help them make that journey. At some point in the process, you see the change come over them, as they feel the pride, power and majesty that existed in this very brief time in history. Today, we all learn from each other as we go, and we hope to continue to keep our minds open and active as we try to keep the history alive.

Putting together the various modeling sessions in order to stage some of the color photos for this book was generally challenging; it took a considerable amount of work in coordination. As with the text of the book, one will never be fully satisfied with the final results and must go forward with what you have. Hiring the photographers and models, and sometimes renting the locations for the shoots, adds up quickly. Like a movie, you have limited time to acquire the shots you want, so you must keep moving along at a rapid pace, dealing with the sun—too much or not enough—wind, rain, and hours of daylight in a day. Then you have the models and photography crews: are they all happy, fed and watered, ready to go?

Getting clothes that would fit the models was a challenge, especially when it came to moccasins. We had to use the same pair in a couple of shots. We would like to have been able to spend an hour or more on each model's hair, as was done originally, but we did not have that luxury. In the old days, especially, the young men spent a lot of time prepping their hair.

That lifestyle is now past and gone forever. None of us will ever feel the emotions and thought processes that made the moments. The best we can do is to try, accurately and without bias, to record and interpret how they looked, lived, and felt about the many cultural changes around them.

In reality, the American Indians of the nineteenth century were, like all cultures throughout the history of the world, ever-changing and always adapting to new problems and conditions.

The reenactments of the old-time photo images were taken at four locations: Medicine Tail Coulee, Little Bighorn Battlefield; Wakinyan Pass (Union Pass), Wyoming; Wild Horse Sanctuary, Cheyenne River, Black Hills of Dakota; and Fort Phil Kearney State Park, Wyoming. All these awesome and powerful places are where I have shared a great many good times with many friends.

Anyone could easily go into much more detail on any one of the images or the chapters within these pages, but, as with any project like this, there are limitations due to publication issues, deadlines, rights to photographs, etc. in many degrees, all resulting in leaving little choice but to make brief and incomplete descriptions of subjects or items that deserve more detailed studies. However, finally, there comes a time when you must dot the last period and submit the book.

A work like this can never truly be finished, nor will you ever be a hundred percent satisfied with the finished product. There is much more to be said, more photos and quotes to add, and perhaps in the future I can do follow-up book to this one. For now, please accept my effort with its limitations. I hope you enjoy this book.

# Acknowledgments

Many thanks go to my wife, Carol, and my family, and good friends Steady Hand, Big Weapon, Travels Far (Norbert Kohlruss), and Walking Water. The staffs at Fort Phil Kearney State Historic Site, Little Bighorn Battlefield National Monument, Bird In Ground Family, Laila Williamson American Museum of Natural History, National Museum of the American Indian, Chicago Field Museum, and Montana Historical Society were very helpful. James Bama, Mike Cowdrey, Charles Childs, Bill Holm, Janet Wragge, Howard Buffet, Don Troiani, Graham Arader, the many artists and photographic artists helped make it all happen. All the people who took the time to record their observations of Plains Indian culture significantly contributed to this work.

## List of Models

Ernie LaPointe - Blackfeet Chief
Paul Hill  - Otter head dress
Albert Gros Ventre -  Crow
Casey Bird in Ground -  Crow
Amy Pretty on Top -  Cheyenne, girl with cradle
Cash Smith - Lakota Chiefs coat
Elauna Nelson - Girl with white dress
Painted Soldier - Bear Man
Harold Rides Horse - Crow Scout
Iron Bull - Lakota Chief
Jade Nelson - Girl with baby
John Bird in Ground -  Winter Hunter
Allie Bird in Ground -  Winter Hunter
Marie Bird in Ground - Girl with flag
Olivia Real Bird - Cheyenne mother and daughter
Beth Real Bird - Cheyenne mother and daughter
Prudence Pretty on Top - Woman with travois
Ramiko - Upper Missouri Woman
Richard Old Coyote -  Miwatani
Jaxin Enemy Hunter - Four Bears
Thomas Rides Horse - Lakota cloth jacket
Tim Bird in Ground -  Dog Man
Tyrell Old Coyote -  Boy
Wolfy Read Bird -  Double trailer
Willis Not Afraid - Comanche
Christy Not Afraid - Warrior Woman
Many Hats -  Warrior buffalo
Bad Hand - Hidatsa
Ken Woody - Lakota
Ivan Hankla- Southern Cheyenne
Alexander Bird in Ground - Elder
Ruben Fast Horse - Miwatani
Wayne Not Afraid and Two Bears (Roy Martin) - Cheyenne Visor head dress
Painted Soldier ( James Nemeth) - Grizzly Bear Medicine Man

## Artists and Photographers

Bad Hand
James Bama
Myron Beck
Howard Buffett
Todd Conner
Will Dunniway
John Fawcett
Jim Hatzell
Glen Hopkinson
Ed Kucera
Chris McFarlene
Krystii Melaine
Larry Moniot
Jim Norton
Bill and Kathy Brewer
Steven Lang
Z. S. Liang
Ted Roberts
Brian Scadden
David Yorke
Sean Watson
Janet Wragge

# Introduction

## by Big Weapon

In this book on Plains Indian regalia, one focus is to show that the early style of photographic imagery created an "aura" of the earlier Indian people. The "aura" is plainly seen in those old tintype images and other styles of early photographs that came and went through that historic Plains Indian period after European/White contact. This aura also extended to anyone who was photographed during that time period. The Old West was certainly a very hard environment to live in, and as the romanticism of the Old West is carried on in stories, books and movies, these haunting images of the past only help to deepen that imagination.

Even further is the fact that this visual phenomena extends with early sketches by explorers and artists as well. One good example of this observation includes a sketch of a Metis man in Canada wearing a porcupine quilled Metis man's coat. What really caught our attention is the fact that the man was sketched, both front and back. These early sketches deepen the mystique of the Old West, just as early photographs do. "A time gone by." Notice the slight use of shadows sketched by the artist and the fine drawn lines as well. The "aura" is evident in this line drawing. Yet when compared with the original Metis coat of similar quality and age, the realism brings home the fact the color was a reality those early people also saw. The same reality we have today.

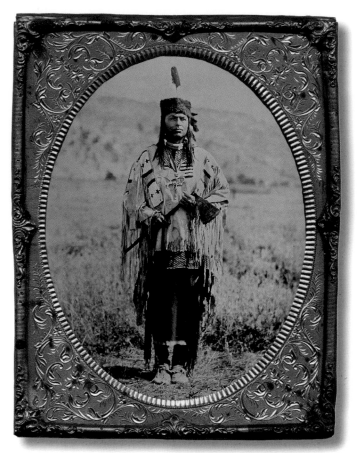

Big Weapon in Paha sapa on the Cheyenne River, contemporary tintype photograph

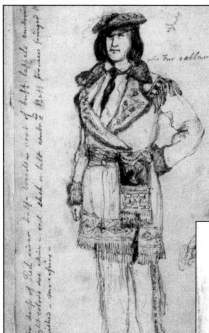

Winter dress, Red River Metis half-breed coat, 1851. A Red River Metis (front view), F. B. Mayer

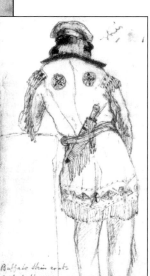

Buffalo skin coat, 1851, A Red River Metis (rear view), F. B. Mayer

The same photographic processes of yesteryear were applied to modern Indian people of today. Using modern color photographs, the Indian people who modeled for this book can be compared side by side with the old images. By doing so, no attempt was made to remove any of the mysticism that the early style of imagery unknowingly created with the historic figures, but rather the new color humanizes those individuals from the past and shows that many attractive people with expressions of personality were photographed by the gifted photographers.

Even when creating images of ourselves, in our Indian regalia, with early developing techniques, we provide evidence that really anyone from the Old West, Indian or White, were made larger than life due in part to these images.

The point needs to be made that making this book was not a matter of simply going to a tourist town or a state fair where vendors provide an "Old West" backdrop and, using modern equipment with grainy film, placing Velcro-taped prop clothing for an Old West portrait. This is simply not the case. The clothing appearing on these pages is correct to the time period being discussed, and has taken a lifetime to collect and produce. As an old saying goes, "A photo speaks a thousand words" and these most certainly do.

Just as in all cultures and peoples around the globe, clothing styles and trends came and went for the Native Americans of North America. For instance, the clothing of a Cheyenne person in 1760 would not be the same for a Cheyenne of 1860, nor for any other tribe. Tribal trends and

styles flowed, as in any culture, and was influenced by many factors. Study the images that appear here, both old and new, to compare and contrast their color and darkness along with the shadows.

As old time photographs expert, Bill Holm, says in his *American Indian Art Magazine* article, "Old Photos Might Not Lie, But They Fib A Lot About Color!," "there is something wonderful about old photographs. They often tell us more about the past, its people and their culture than many thousands of carefully crafted words. Collectors and scholars revel in the richness of information available from images of Indians left to us by photographers of the past. Their photography allows us to slip back into the last century and draw conclusions about the times and places of artifact types, about tribal styles of beadwork or painting, and about design forms."

The following paraphrased excerpt of questions and answers by Bill Holm explains in more detail the difficulty in identifying color of Plains Indian garments from old photographs and images.

*"Identifying a color from an "old time" photo cannot be done 100%. Light and some medium blues look just like white. Dark purplish blue may look black, almost like red. The many shades of gray may be just about anything else. However, sometimes you can tell what a color is not and I emphasize, sometimes. If a design is very light or white it isn't yellow. If it's gray, it likely isn't red, which will ordinarily look black. For example, the quill-wrapped horsehair coat worn by Ouray, now in NMAI [the National Museum of the American Indian, in Washington, D.C.] is dark navy blue with red cloth details. The red looks black against a gray background in the old photo of Ouray, the reverse of what we would expect. In addition the same colors do not always show the same shade of gray. Emulsions were variable in the 19th century. Many photographers prepared their own. Different lighting affects the colors. Late or early sunlight will shift the colors toward red. Shade under a clear sky may shift the colors to blue. Light reflecting from various colored surfaces may affect the colors. Yet, there a simple rule. Blues go light, reds and yellows go dark!*

Photography had its beginnings in the early 1820s. The earliest photographic methods were very slow, and the emulsions only sensitive to the blue, blue-violet, and ultra violet end of the spectrum. It wasn't until 1873 that some improvements extended the sensitivity range, but still far from including the yellow and red end. In 1884 there were improvements that led to emulsions called "iso-chromatic" (equal color) or "ortho-chromatic" (true color).

These films were still not sensitive to red light, and not much to yellow. There were more improvements in the 1920s. Ortho-chromatic films were still in common use into the 1940s, although modern "panchromatic" (all colors) films were developed in the early 1930s. If anyone out there is as old as I am, they may remember developing roll film under a red safelight, as I did in the late 1930s and early '40s. That was possible because the common roll films then in use were not sensitive to red light. So, what does all this mean? It means that any photograph made before 1900 will clearly follow the simple rule, "Reds and Yellow go dark, Blues go light." Photographs made before 1930 may still follow that rule, but possibly not so drastically.

Now to the question about blue verses white back-

grounds. Medium to light blue will render white or nearly so in the old photos. The advice that certain object types have typical color choices is the only way to make an educated guess. To refine that, we have to look at existing, documented pieces to see if there is any chronological sequence to the use of blue or white backgrounds on specific object types. The objects mentioned before (Trans-montaine shirt strips, Lakota dress tops) are examples. Don't forget, we have to look at the actual objects, not to old photos, to tell if the background was blue or white; or to a painting done from life. Mrs.. Weldon's well-known painting of Sitting Bull, based on the Nottman photograph, is an example. She painted the shirt strips with a white background, whereas they are blue, the shirt being extant in the NMAI collection."

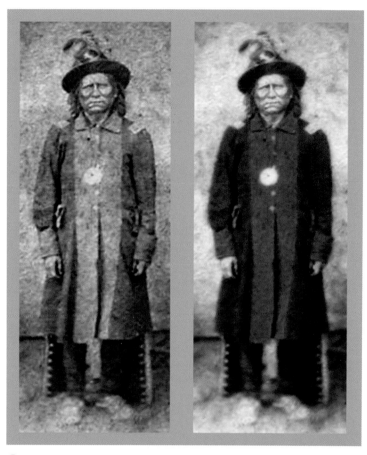

COLORIZED VERSION SHOWS THAT LIGHT COLOR GOES TO DARK BLUE.

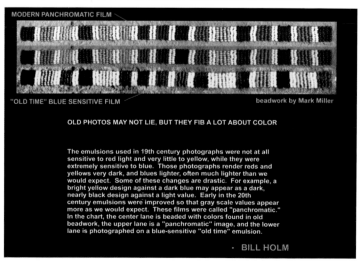

BILL HOLM'S COLOR CHART COMPARING THREE BEADED ROWS, DEMONSTRATING HOW THE VARIOUS FILMS AND TECHNIQUES PRODUCED DIFFERENT COLORS IN THE FINISHED IMAGE

RED RIVER METIS COAT, 1851, OTTAWA. THE MUSEUM OF CIVILIZATION, OTTAWA, CANADA

# Old-time Photographic Processes

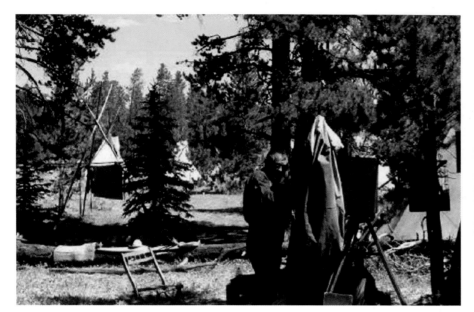

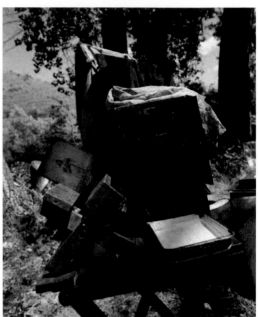

A PHOTOGRAPHER'S DRYING RACK FOR WET PLATES

### Daguerreotypes

The Daguerreotype may be considered to be the best form of photography ever developed. For example, very fine details can be captured that rival even today's standards. Discovered in France in 1839, it was popular until 1860. The way in which the daguerreotype worked was that a highly buffed copper plate coated with silver was sensitized by exposure to fumes of iodine. After the plate was exposed to light and the image, it was developed by exposing the plate to fumes of heated mercury.

Glass was placed on top of the plate after processing, and usually a decorative mat was placed over the surface of the plate. The mat was usually made of brass and doubled as a spacer, for esthetic reasons, and usually came in different designs and shapes. All of this layering of plates was held together by a preserver. The type of preserver changed over the years, including the designs which made the dating of the daguerreotype easier. A malleable brass frame was the most popular preserver and locked all the parts together The finished daguerreotype was then placed into a case that protected it.

The exposures for the daguerreotype were very long, making it impractical for portrait photography. Not only that, but exposure time was dependant upon the weather as well, and it varied according to the time of day and the season of the year. However, over time the exposure time was advanced with new techniques that shortened this dilemma so that portraits could be made.

### Ambrotypes

Old ambrotype photographs produced wonderful images of the past. The ambrotype was an inexpensive alternative to the Daguerreotype. One can see that the photograph skills flourished and developed during the period 1851-1890. The ambrotype was produced on glass with a thin negative image. The image appears as a positive view when black is made as the background. There were two ways in which this is done. One was when the back of the glass plate was either painted black or a black material was placed behind. Ambrotypes were usually kept in cases made of wood or leather. Ambrotypes' exposure time was much longer than Daguerreotypes, and ambrotypes were often colored.

### Tintypes

Tintypes were also called ferrotypes and melainotypes. The tintype was a photograph made on a sheet of iron, not tin. After the image was completed, it was varnished to protect the surface. The tintype spanned a longer time-frame than other photographic techniques, and were popular from 1856 until the early 1900s. The common size of a tintype is about 2 ½ " X 3 ½." Many tintypes were put in cases, making it more difficult to differentiate them from Daguerreotypes. Tintypes were often placed in paper or cardboard frames, as well as in jewelry or photo albums. Often their corners were clipped. Gem tintypes were less than an inch by an inch in size. Tintypes are probably the most common photos from the 1800s found today. Tintypes may have been an imaging process used by early photographers on the Great Plains, but most images were made on paper or pasteboard as a Carte de Viste (CDV), stereograph, cabinet card, and larger formats.

*Below are the most popular sizes of tintypes and Daguerreotypes, although other sizes were produced.*

|  | Full plate | 6 1/2" x 8 1/2" |
|--|------------|-----------------|
|  | Half plate | 4 1/2" x 51/2" |
|  | ¼ plate | 3 1/8" x 4 1/8" |
|  | 1/6 plate | 2 1/2" x 3 1/2" |
|  | 1/9 plate | 2" x 2 ½" |

# Plains Indian Clothing

There is a point to be made about clothing styles. By the historic period under discussion, Euro-Americans had a big influence on the styles of fashions of the Plains Indians, due to the availability of goods from all over the world at the trading posts. Here are some generalities about Plains Indian clothing.

During the period **1840 to 1850,** we see, in general, major changes that took place concerning most Plains Indians' clothing:

#1 Most Plains tribes abandoned the use of soft-sole, side-seam moccasins for hard-sole moccasins.

#2 Most Plains tribes' men abandoned a very long shirt for a shorter, cut shirt.

#3 Most Plains tribes abandon using pound beads (also known as pony beads), which were limited in color and obtained at trading posts (they were imported form Italy), and changed to using seed beads.

#4 Most Plains tribes chose their preferred tribal colors, probably due to the wide range of colors available in seed beads.

#5 Some Plains tribes abandoned the early style of women's cut dresses, called "Fur Trade dresses" (two hide dresses), for the three-hide dress with a beaded yoke (especially among the Sioux).

Men's clothing almost always was of the lightest type hides available, such as big horn sheep, antelope, and deer (usually in that order). Men's shirts and leggings were usually not made from buffalo or elk.

Women's clothing was generally made from heavier animal skins, such as elk or very heavy deer hides.

As you look, study and read through this book, remember that the Indian people of long ago were people just like today, and the photographs will prove this.

Ken "Big Weapon" Woody
May 2010

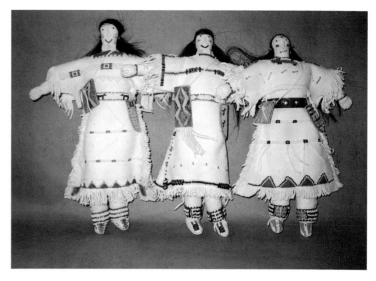

DOLLS DRESSED AS CHEYENNE AND LAKOTA GIRLS OF THE MID-19TH CENTURY

CHEYENNE GIRL'S CLOTHING, 1850S TO 1870S

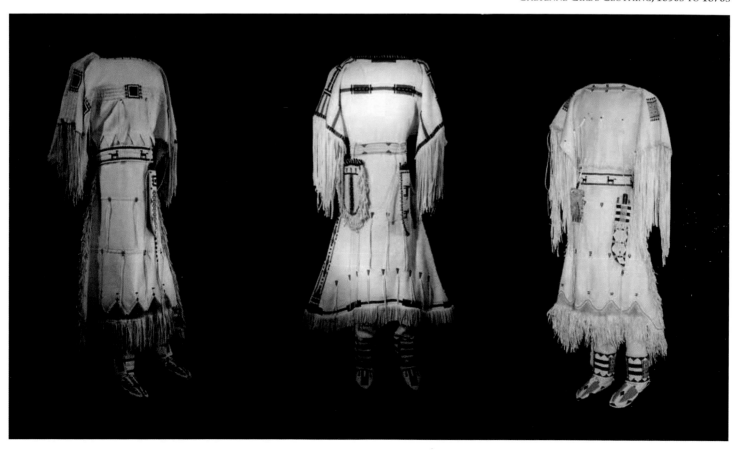

# Chapter 1
# Some Clothing Details

Contemporary, eye witness descriptions of Plains Indian clothing and regalia are available today for us to learn from. As with everything else concerning the subject, so much depended on the tribe, the season of the year, how prosperous the tribe was at the time the observations were recorded, who recorded them, and in what decade of the 19th century it was written. There will always be social and racial bias in many of the accounts, but it is usually easy enough to read through them and still get a good idea of how the people looked and how they acted.

Europeans and people visiting from the eastern United States usually had a somewhat more analytical view and less judgmental attitude toward the Indian people they met. Missionaries, others there for religious salvation, people who lived near Indians, and those just passing through their territories often had a harsh or at least less tolerant view of Plains people.

Speaking about what the trader Edwin Thompson Denig told him of Plains Indian dress, Prince Maximilian wrote in his journals:

*Mr. Denig declares that the Indians dress themselves much better now than in earlier days. When he became acquainted with them first (speaking, of Indians here) they were either nude or else clothed in soiled, shabby, ragged skins. Only very seldom, upon special occasions, were they rigged out in their finery. Nowadays they are more cleanly, bedeck themselves with beads and blankets, own horses, and, according to their own fancy or their needs, they make saddles that are beautiful as well as practical. In short, along with much that might be spared, Indians have received from the fur traders a very great deal that is beneficial to them.*

*"Many of them are particularly cleaned in their persons, and bathe daily, both in winter and summer; their hands, however, are often smeared with colors and fat, nay, sometimes the whole body is bedaubed. The women are, in general, less cleanly, particularly their hands, which arises from their continual and severe labour. They generally let their nails grow long. These rude inhabitants of the prairies are extremely agile and hardy; they bathe, in the depth of winter, in the half-frozen rivers, and wear no covering on the upper part of their body under the buffalo robe; they are very expert swimmers, even when quite young. They often practice riding on horseback without a saddle, and very swift horse-racing. They are capital marksmen with the bow; all their senses are remarkable acute.*

### Beads
Previous to the introduction of glass trade beads from Italy (1840s), Plains Indians never made embroidery beads. They did make bone, stone, horn and wood beads, but they were all generally utilized as necklaces or strung-type beads.

Some of the river tribes, like the Arikara, Mandan and Hidatsa, did learn a process of re-making beads, as described by Meriwether Lewis, in March of 1805, when he watched the French trader, Joseph Gravelines, demonstrate how the Arikara made beads. They had learned the technique either from Shoshone prisoners, who had picked it up from the south, or perhaps, as Tabeau said, that the art was taught to them from a captured Spaniard, who had possibly been traded up the Grand River and the Pawnee.

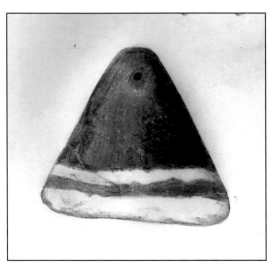

An original Hidatsa cloud stone, American Museum of Natural History

Meriwether Lewis recorded in detail the process, and noted of the Arikara:

*The Indians are extremely fond of the large beads formed by this process. They use them as pendants to their years [ears], or hair and sometimes wear them about their necks. [Author's note: The Hidatsa and Mandan called these pendants 'Cloud Stones.']*

These beads were the origin, on the Arikara-Hidatsa-Mandan hairstyle, of a separate forelock hanging down the center of the forehead. To this the blue bead was tied, and this could only be done by a wealthy person for whom a ceremony had been performed during which the entire tribe was fed and elaborate gifts were given away, in order to validate the privilege. This fashion lasted from the late-18th century until the 1860s. Carl Wimar sketched a portrait of the Arikara Head Chief, Star, wearing such beads as earrings, in 1858.

Rudolf Kurz, the Swiss artist, described men's dress in his journal:

*The manner of dress among Indians varies quite as much and sets them as distinctly apart from us as their copper-colored skin. As a rule, the men wear only breechcloths, moccasins, and woolen blankets; otherwise, they are nude. Sometimes they wear leggings, i.e., trousers of deerskin, that are cut differently according to the tribe to which the wearer belongs; that denote tribal differences also in the way they are made and ornamented.*

*As I have said already, men use belts but rarely. In the vicinity or their villages the braves adopt a manner of wearing their blankets that is peculiar to themselves. For instance, in order to have free use of the right hand and to reveal the tattoo marks, usually on the right breast, they take hold of their blanket or robe on the right side, draw it from under the right arm across the body to the left hip; the other half of the robe is brought forward with the left hand which remains covered and holds that part, brought under from the right, in its proper place.*

Often these braves carry a fan in the right hand as they strut about the village dressed in this way. That style is followed, however, only in warm weather. As these coverings are ornamented with one or more colored stripes along the border of their narrower sides that fall straight down in front, those stripes always attract one's attention. The buffalo robe is worn in the same way as the blanket, i.e., lengthwise around the body, the head end brought over from the right, the tail end carried forward from the left. But, as buffalo robes, are sometimes painted, but they are not as artistic, because the woolen surface does not allow detailed drawing. One sees, usually only on the back, red or yellow hands; these denote "coups"; and red or yellow hoof prints, which denote horses stolen. If the hoof prints are blue or black they indicate that the horses were presented as gifts. The blanket is, as a rule, is the Indians' only bed covering. Their pouch is made use of as a pillow. Having taken off their moccasins and loosened their girdles or belts, they are ready for bed.

The blankets, however, Indians are beginning to use as material for coats, similar to the blanket coat worn by Americans. They give to these garments the shape of a palette with hood but without buttons. They are held in place only by means of the belt. The garment is cut in such a way that the colored stripes forms the lower part of the coat; nay, even the strokes denoting the quality (1, 2, 3 point blanket) are left in view; and stripes outline shoulder seams and extend along the base of the hood. This kind of coat I saw among the Herantsa, the Crows, Assiniboin, Cree, Sauteurs, both for children and young and old men; women and girls, on the contrary, do not wear them. The hood is pulled up in bad weather and here and there one sees on the peak of one of these a feather for decoration. Indians wear white, red, green, sky blue, and indigo blue blankets. Special sizes are woven for children. ( Journal of Rudolph Frederick Kurz)

Kurz continued later on, describing the wearing of robes and blankets by the warriors:

Soldiers are recognized, first of all, by their tattoo mark; also by their bearings, their dignified demeanor and their especial manner of wearing the buffalo robe or blanket. The latter they throw about the body in such a way that the right shoulder, breast, and arm remain free, and that part of the robe which is supposed to cover the right shoulder they draw under the right arm and hold in place with the left hand. Thus they form a drapery that falls in a natural but at the same time majestic and graceful folds, the most beautiful drapery for the human body that I know. Indians, in addition to their passion for ornamentation, are adepts with their small hands in giving the blankets a graceful swing.

They wear only their ornamented buffalo robes to make a show. The Indians' blankets are never clumsy or unwieldy; whether they hang freely over the shoulders, are drawn up over the head so as to wrap the body closely, or are allowed to drag on the ground, they are always soft and pliable.

A traveler on the Oregon Trail described a group of Indian women and children along the trial:

June 19, 1862- on the Oregon Trail 3 days west of Kearney.
Jogged along to day after the same fashion over the smooth level road with nothing to be seen but an occasional Doby house and the frequent emigrant trains which now fail to attract hardly a passing glance as they all bear the same monotonous appearance. About noon we came to a camp of Sioux (pronounced Sooz). The women and children came out of their tents to wonder and admire our omnibus

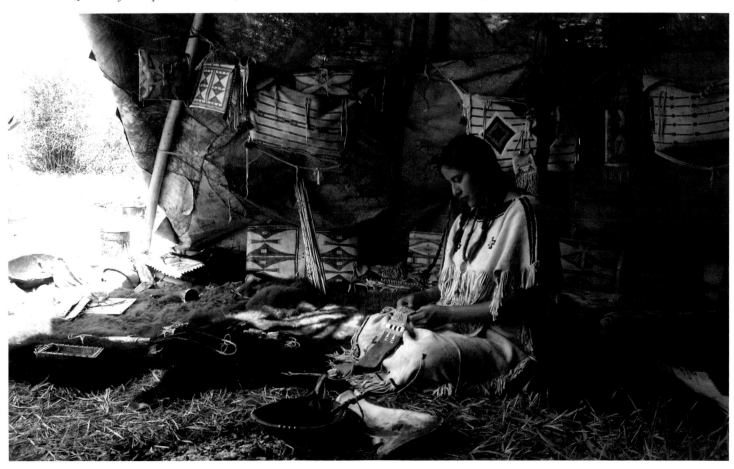

A WOMAN WORKS IN HER TIPI MAKING ITEMS FOR A GIVEAWAY CEREMONY. TIPIS, LIKE ANY MODERN-DAY HOUSE, VARIED FROM WIFE TO WIFE IN NEATNESS AND CLEANLINESS.

*the first of the kind probably they have ever seen. We looked in one of their tents a dirty smoky filthy place filled with dried Buffalo skins and various other articles. The women wore a blanket fastened round the neck and waist, their arms and legs bare, beads round their necks and hanging from their ears, brass rings round their wrists and fingers, their faces and at the parting of their hair painted with sort of red paint. Some of the children were in a perfectly nude state. Others had a short cloth tied round their waist and two to three of the boys had a pair of old pants. Drove 31 miles and camped near some bluffs.*

The bands and tribes that camped along the wagon trails were generally peaceful and were usually looking for food and goods that could be obtained through trade with the people heading west along the trails. Of course there were people going east as well, but the majority was heading west.

Mariett Foster Cummings, a pioneer woman traveling west on the Oregon Trail, wrote in her diary, on June 12, 1852, while nearing Fort Laramie, in Wyoming Territory:

*12th, Saturday- Took an early start and after traveling a few miles struck the river which was bordered with trees, the first we have seen on this side for over 200 miles. In a group of trees near the road was a trader's tent pitched, and several skin wigwams near for the manufacture of moccasins. Saw an Indian village on the opposite side of the river."*

A little over a month later, and a bit further west, on July 30, 1852, Cecelia Adams and Parthenia Blank (twin sisters) wrote just a little past Devil's Gate on the Sweetwater River:

*30 Fri ......... We passed a Station to day here we saw plenty of Indians they seem very friendly they were engaged in dressing some prairie dogs They had several little Papoose's they look very cunning Some were making moccasins for sale they trim them very nicely with beads…*

In late May of 1854, Sarah Sutton, a pioneer woman on the Oregon Trail, was traveling east of Ft.. Laramie when they came upon a group of Indians:

*May 31. Past three trading post today, and the Indians more than A few stopped half way to the river and get water out of a spring. The half starved Indians gathered around us, and wanted to swap moccasins and beads for bread and we got some met to day 6 large covered wagons loaded with fur. 45 May 31, 1854.*

Evidently this practice of trading moccasins had been going on for some time, because in 1820, an Omaha woman wanted to trade moccasins for a couple of military stocks to ornament the cruppers for her horse, from S.H. Long. (Military stocks were broad thick leather collars commonly worn in the first quarter of the 19th century by infantry men to protect and support their necks and be a pain to wear!) The early United States Marine Corps wore these, hence their nick name, 'Leathernecks.'

Although moccasins were a popular native-made item that many non-Indians wore, complete Indian outfits worn by whites was relatively unknown, except perhaps for portraits or show. Whites dressing in Indian clothing and regalia gained no special respect among the Indians; and, in fact, lowered himself in their view. Furthermore, if he is a white man in the Indian garb of a different tribe, he ran far more risk of being killed, because he may not be recognized as a white until it was too late.

However, Charles McKenzie wore Indian clothes when living among them, so dogs would not bother him and to fit in better while among them. He said he found them comfortable.

## Notes on Clothing Details

These notes are so important that we include them, as they represent years of exhaustive research and touch on many details of dress never before gathered together.

### Breckenridge's Journal:
- "Women-children filthy & disgusting"

### Townsend's Journal, 1839:
- Nez Perce wore short checked shirt with bow and arrow, knife, tomahawk
- Arrows smeared with blood stains to the feathers
- Most dresses made of deer and antelope, occasionally the bodice of linen
- Very neat and clean compared to "greasy, filthy, disgusting Snake Indians"

### George Bent:
- Buffalo tail used to make knife sheaths

### Lieutenant Abert:
- Kiowa and Comanche had rawhide soles on moccasins. His watercolors clearly show that Southern Cheyenne women were still wearing side-seam soft sole moccasins in 1846.
- Indians braid fringe on moccasins and leggings when weather is muddy
- Indians said reason for fringe to prevent snake bites
- Indian women stuff their leggings with wool or cottonwood floss when cold

### Mrs. Carrington:
- Eight Cheyenne with one Cheyenne woman came by fort, very poor and shabby
- Every article of use of the United States Army that was discarded was put to use by Indians
- Women painted vermillion in the part of their hair, cheeks and chin
- Cheyenne Warriors with fancy breechcloth and large umbrella
- Men's hair brought before their ear and braided and wrapped

### Beldon:
- Wearing robes called "body robe"
- "Squaw cloth" - $4 per yard
- Blankets white, blue, red, black, green
- Worsted ribbons
- Cotton and flax thread, needles all used
- Squaws used cotton ticking for summer dresses
- Double sole sometimes sewn on worn out moccasins

### Jonathan Carter:
- Saw some mixed blood Sioux early on with very fair hair, light skin and freckles
- 1787 English pass out coats and flags to Dakota Chiefs (at last one was Teton Sioux)

## Coronado:
-Also saw many mixed bloods even in the 1500s and one Indian girl as white as a Castilian lady, with a chin pointed like the Moors.
-Woman, eyes decorated too
-Saw painted hides

## Crazy Horse:
-Filled their breechcloths with white mans goods
-He had no basket to put them in, so he drew off his leggings, tied the bottoms shut with his moccasin strings, and, when he had filled the leggings with berries, he slung them over his horse's back like a pair of saddle bags."

Another similar quote tells of a man who went to a shore of a large lake to collect seagull feathers with which to do bird quillwork. There were so many and he had no way to carry them so he tied and filled his leggings in this same manner.

## Le Verendrter:
-Cree got floral bead design idea from imported figures and ornaments of the Francis I period

## Effects of white culture:
-Flathead tradition says they traded rabbit skin robes to Blackfoot in pre-horse days

## -LaSalle:
-Hennepin among the Sioux 1680, 1681
-Shirts of quill embroidered deerskin
-Had buffalo robes, bull boats, painted hair fringed shirt
-Cenis (Pawnee) Indians mounted, red or black face paint on leaders, headdresses,
-Painted robe (1687) Near or on Arkansas River (and Trinity River)
-Strung necklace beads on red silk thread or thread colored with vermillion
-Animals of hunt sometimes painted on robe
-Saw a Pawnee chief with double trailer bonnet, lance plaited with blue and red cloth

## The Plateau:
-Bighorn sheep tail equals chocolate colored tip with white upper section
-Mountain sheep for shirts and clothing scarce by 1900
-Twisted fringes sometimes lightly coated with clay (moistened first) to help them hold shape
-Small holes at bottom of antelope hide shirts come from scent glands
-Crow influence equals Nez Perce, Umatilla
-Blackfoot influence equals Flathead, Kalispell, Spokane

## Charles McKenzie Narrative:
-They had many articles of foreign dress- Russia sheeting trousers, swans downs vest, corduroy jackets, calico shirts like Canadian Voyageurs, they got them from some Blackfeet they killed
-Bloods in 1810 – carried off fine cotton shirts, beaver traps, hats, knives, handkerchiefs, Russian sheeting tents, bank notes, some signed NY and Trenton banking Co.

## Miles Gilbert in 1877:
-Saw an Indian with a linen duster on

## J.C. Ewer's Plains Indian Painting:
-Earliest dated box & border existing 1851 and 1860 on feathered design, (Bodmer painted a Sioux woman wearing one in 1833)
-Teton Lakota box and border robe given double meaning equals wearer had taken part in Hunka ceremony and also that her relatives had been successful in war. Only a woman whose husband had been a successful warrior could make such a robe.
-Lost symbolism by 1902-(Wissler)
-Used in girls puberty ceremony
-Feathered sun among Lakota equals black war bonnet design, Catlin said was representation of the sun
Maximilian said to the Mandan it represented the feather cap under the image of the sun
-Medicine herbs kept in small pouch on quill of Eagle feather
-Long breechcloths called tails
Warpath (White Bull) by S. Vestal Minneconjou

## Prince Maximilian made these notes and observations of various Upper Missouri tribes dress:
-Saw a warrior with his hair in a que with hussar sabre
-Colored calico shirts were popular
-Many black and white striped breechcloths
-Skunk skin and white swan-skin garters
-Many brass bracelets and neck rings
-Omaha and Oto commonly wore buffalo robes with the hair side out
-Ponca dyed leggings black with white walnut juice
-Sioux- preferred yellow, red, sky blue quills
-Favorite wife was best dressed and clean
-Dress with border of blue and white beads, metal buttons and fringe wrapped with lead. This "lead" actually meant "tinned iron" and is an early reference to the used of tin cones on clothing fringe.
-Hide soaked in tub of water, and then stretched with teeth, and then the hide pulled across rope
-Sioux with brass hair plates
-Strings of blue or white beads in ear
-Women parted their hair in the middle painted the part red wore red & blue painted robes
-Old women were dirty, made to do hard work
-Children all wear bit of tobacco in amulet on neck
-Whole crowd of Mandan/Hidatsa appeared reddish brown, robes painted reddish brown
-Broad white metal bracelets
-Finest skin shirts from the Crows
-Blackfoot with Spanish blanket and silver crosses
-Most warriors dirty and slovenly
-Most had guns, all had bows and quivers
-Tuft of feathers on end of bow case, wound about head so feathers stuck upright
-12 moccasins equals $1, sometimes with elk hides or rawhide
-12 pairs moccasins made from 1 elk
-Weasel 500 – 600 skins traded annually
-Assiniboine chief with black leather shirt, red blanket and medal
-Chiefs in red and blue uniforms trimmed with lace round hats with plumes, carried sabers
-Felt hats with brass rim
-Tweezers with twisted wire or piece of bent tin
-Brass and iron wire wrapped around hair
-Glass beads costs 3-4 dollars a pound
-Many wore 6-8 brass rings on each finger
-Sometimes only 1-2 rings on hand

- Finger nails grown long especially the thumb nail, it was often crooked like a claw
- Among Blackfeet background moccasin colors usually different if one white other yellow
- Gloves were rare
- Cree wore leather hats or piece of skin over head most had wolf skins, lances, guns, quivers
- Carolina Parrot or parquet still around in numbers
- Saw Lakota with parquets in their hair
- Mirrors came in pasteboard case, changed for wooden frame, hung on wrist with red ribbon of different colored stripes and bear or buffalo carved into frame
- During rainy weather buffalo robes were worn hair side out
- Quilled strips on robes considered old fashioned
- Robes frequently fringed at bottom and green and yellow horse hair locks and beads
- Crow rubbed body with beaver castoreum because of "pleasant" scent
- Ponca Chief- beautiful otter skin shirt with red cloth collar, cap of otter and tobacco pouch of otter
- Other chief robe with red painted figures
- Most dresses of deer and antelope with occasional bodice of linen very neat and clean compared to greasy, filthy, disgusting Snake Indians

## Bureau of American Ethnology, Mandan/Assiniboine:
- Some chiefs' coat uniforms half red-half green, worth $150.00, with red and green facings, silver lace, red felt hat
- Mehkskehme – Sukahs – the iron shirt – had shirt with slips of otter and ermine
- Blackfeet arrived for battle in finest clothes quivers on their backs, guns in hand in groups of three to twenty arrived at a time.
- Some had war bonnets with trailers
- Many rich men shirts with ermine strips
- Sleeves embroidered with blue flowers, right arm, had rolled ermine with red feathers, and left arm with long black hair locks
- Across shoulders palatine of otter skin with tassels of ermine (a tippet) These tippets were illustrated by Bodmer and Catlin and were signs of status. With the Piegan, they had a civil and military Chief, the first was called Sakatow or orator, the office was hereditary and the insignia of the office was the backs of two fine otter skins covered with mother of pearl which from behind his neck hung down his breast to below the belt. Chiefs could loan this badge of office to his son when acting for him. Meriwether Lewis had his portrait painted wearing a Nez Perce tippet.

- Chiefs coat red with blue facings and yellow lace from English, red and black plumes and colored hand kerchief
- Breechcloth white wool with blue stripes popular with Mandan/ Hidatsa

## Paul Wilhelm, Duke of Württemberg, *Travels In North America:*
- Old lady with dragoon uniform and round hat
- Both sexes smear braids with a resin
- Oto dirtier than neighbor the Omaha & Ponco
- Head Oto Chief wore red uniform and tri-corn hat with feathers with bare body
- Had many trophies from conquistadores
- Lakota hair usually long sometimes with braids pasted together
- Did not usually shear heads like Oto & Omaha

## Tabeau's Narrative of Loisel's Expedition to the Upper Missouri:
- Rees were medium height, best runners, good swimmers
- Apapaho and Commanche fair skin and reddish hair
- Sioux women brass wire in ears, all dresses with blue beads
- Sioux men- buffalo fur pasted into hair to resemble head of buffalo
- Skunk skin trailers on moccasins
- Balls of swans down on head
- Brass wires in ears
- Clothes trimmed with bells
- Face white, blue, black and vermillion
- Red leather hair wraps
- Rees loin cloth of blades of curled grass

## Colonel Dodge:
- Breechcloths were usually dirty
- Heaped every article of dress on themselves to dress
- Saw chief with green veil, tall stove pipe hat and very scant calico shirt
- Pawnee scouts cut out trouser seat and front and left waistband intact, they could then thread a belt through the cut fabric which formed crude loops, since belt loops were not used on white man trousers at this point.
- Indian men loves soldier insignia
- Shirts never washed became very dirty
- Pawnee naked except for yards of red, white and blue narrow ribbons in his and ponies hair
- Black and White spotted beads called Skunk beads or hail beads

# Chapter 2
# The Blackfeet

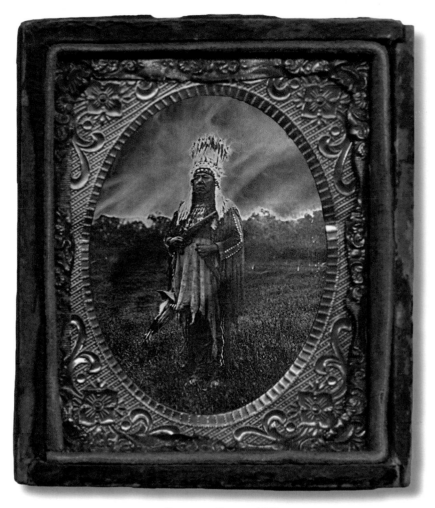

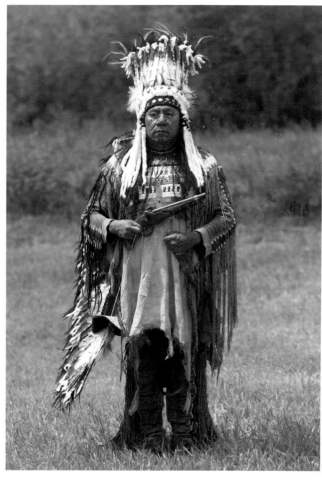

BLACKFEET CHIEF IN 1840S CLOTHING, CONTEMPORARY TINTYPE PHOTOGRAPH AND COLOR PHOTOGRAPH

The Blackfeet tribe is from the Algonquin linguistic group, one of six such groups from which the Plains tribes originated. The tribes that originated from the largest group, the Algonquian, were the Arapaho, Blackfoot, Cheyenne, and Gros Ventre. Athabaskan speakers were the Sarsi and Apache. These were the last to arrive in North America, and the only one directly related to the Old World (Sino-Tibetan.)

Caddoans were the Arikara Pawnee, Wichita and Winnebago. Kiowan was spoken by the Kiowa only. Shoshonean tribes were the Comanche, Shoshone, Ute. Siouan dialects were spoken by the Hidatsa, Iowa, Mandan, Missouri, Omaha, Oto, Ponca, Sioux, Winnebago.

The Blackfeet call themselves Siksikawa, or persons having black feet. The origin of the name is disputed, but it is commonly believed to have reference to the discoloring of their moccasins by the ashes of the prairie fires; it may possibly have reference to black-painted or dyed moccasins. From personal experience of wearing moccasins in the area inhabited by the Blackfeet, I can add that the earth there discolors your moccasins black, and I have never believed in the 'stomping out fires with their moccasins' theory. Generally, this is not a good thing to do if you want your moccasins to last any length of time.

These Sihasapa Sioux or Blackfeet Sioux, are not to be confused with the Algonquin-speaking Blackfeet tribe.

The Blackfeet were an important confederacy of the northern plains, consisting of three sub-tribes, the Siksika proper or Blackfeet, the Kainah or Bloods, and the Piegan (spelled Peigan in Canada). This whole body being popularly known as the Blackfeet. Today they are officially known as the Blackfeet in the United States, and Blackfoot in Canada.

According to Hugh Dempsey in the *Handbook of North American Indians:*

> *The Blackfoot territory in the early historic period has been reconstructed as extending southward from the North Saskatchewan River (in Canada) to the Milk River (in Montana), a tributary of the Missouri. This territory, bounded by the Rocky Mountains to the west and by the mouth of the Vermillion River on the east, consisted primarily of short grass plains interspersed by deep coulees and streams running from west to east.*

The Blackfeet origin story has them living along a large lake to the north and east, possibly Lake Winnepeg.

The Blackfeet are well known for the saying "the dog days," referring to a pre-contact time when dogs were used as a beast of burden, until the arrival of the horse, which took over that role. Their first direct contact

<small>ORIGINAL SKETCH OF A DOG TRAVOIS OR SLED, FOR PULLING LOADS</small>

with whites was with Anthony Henday, in 1754, and later by Henry Pessick, 1760–61, who met the Blood and Blackfoot.

The Blackfeet had seen horses by 1732, but still did not own any and the first ones they acquired they used as beasts of burden before moving on to riding them. Like other tribes, they began acquiring horses in large numbers by the 1740s. They named the new animal Puhnokamita "big dogs," yet later also "elk dogs" and, literally, 'Elk that does the work of a dog.'

The population of this Blackfoot confederacy varied over the years and was loosely estimated, based on the number of tipis observed by explorers, traders, military officers and missionaries, etc. The earliest total population estimate was in 1780 with about 15,000 people, yet in 1855-59 a dip in population to about 7,000 could be attributed to diseases, such as smallpox, that devastated whole populations of people during this time period. James Doty, in 1855, gave their numbers as Bloods 250 lodges, Blackfoot 290, Piegans 290, or 830 lodges total averaging ten people per lodge, so around 8300. Over the next few decades their numbers slowly grew.

In 1870 there were reported to be nine bands each, among the Blood and Northern Blackfoot, and 15 bands among the Piegan (Ewers 1958:97). Some examples of bands among the Blood are: Fish Eaters, All Short People, Many Fat Horses, and Black Elks. Some Southern Piegan examples are Don't Laughs, Fat Roasters, Skunks, Short Necks, and Small Robes. Some Blackfoot examples include: Bad Guns, Liars, Strong Ropes, All Medicine Men and Big Provision Bags. Some examples of the Northern Piegan are the Big Buffalo Chips, Gopher Eaters, Lonesome Mourning, Hairy Noses and Lone Fighters.

The leadership or government of each Blackfeet tribe centered upon the band. Each band had a leader, or several depending on the size of the band. Therefore, large bands could have sub-chiefs. The leaders of these bands were recognized solely for their ability as a leader and provider, and allegiance by the people of the band could shift if that leader did not perform. Usually a band leader or chief of one of the larger bands was considered chief of the entire tribe. Although, in times of war, complete leadership could be handed over to a war chief.

The Blackfeet had frequent battles and skirmishes with other tribes, such as the Crow, Assiniboine and others. Early on they were allies with another Algonquian speaking peoples, the Atsina or Gros Ventre (Big Bellies) of the Prairie, and the Sarci an Athabascan speaking people and Cree. But the peace with the Cree ended by 1806, when the Blackfeet broke alliance with the them, because of Cree hostility to Gros Ventre and the Blackfeet's new direct access to guns. Once they had the trade connections for firearms, they did what many tribes and peoples throughout the world have done: they broke their ties with these people they felt they no longer needed for their own survival.

In the mid-1860s, they also ended their ties with the Atsina, but continued their relations with the Sarci, because the Sarci were such a small tribe (less than 1000 total) and therefore were not considered any sort of threat to the Blackfeet's power in the northern plains.

They were generally hostile to most all tribes they came in contact with and were more known for sneak raids than open warfare. According to Hugh Dempsey: "The Blackfeet murder indiscriminately all that come within their reach." They were well known among trappers and mountain men for their hatred for them and what they felt was an encroachment on their lands and taking of their animals therein. Like most tribes though they usually welcomed the traders and trading posts because of the many goods they supplied and soon became addicted to. When not fighting other tribes or whites, the Bloods and Piegan were known to fire live rounds at each other from time to time. One would imagine that this was usually done more in antagonistic threat than with a real intent to kill

The Blackfeet had only one military engagement with the United States, in January of 1870, when Major Eugene Baker and his combined cavalry and infantry force attacked the Piegan Camp of Heavy Runner. 173 men, women and children were killed during this battle. White Montanans, during this period between 1866 to 1870, called this the "Blackfoot War."

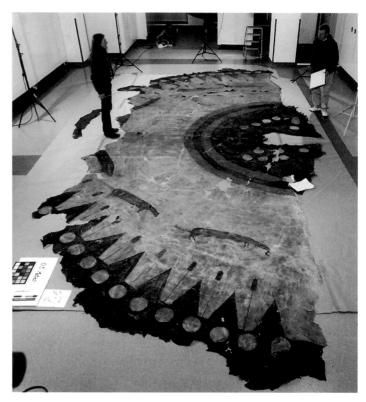

<small>PAINTED BLACKFEET TIPI IN THE NATIONAL MUSEUM OF THE AMERICAN INDIAN COLLECTION THAT WAS EXAMINED BY THE AUTHOR AND KEN WOODY</small>

*The Blackfeet religion was based upon the belief that the sun was the major deity, his wife was the Moon, and Morning Star was their son. Thunder was also a major spirit. The Sun gave success in war and hunting, health, long life and happiness."*
—Grinnell 1892, p. 258

Medicine bundles were a basis for all religious activity among the Blackfeet, and the composition of its contents and container of each bundle varied. These bundles and the powers associated with them brought great social prestige to the owners, or keepers. Each bundle generally had its own home or tipi that it resided in. These special tipis were usually painted with sacred designs which represented the power of the bundle that 'lived'

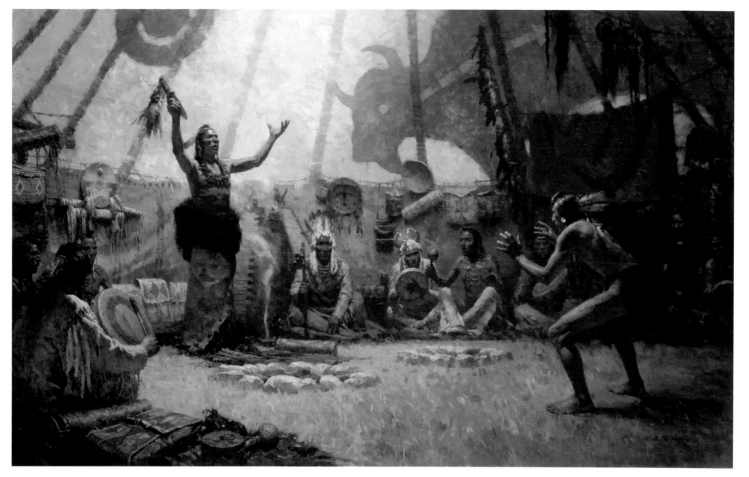

"Transferring the Bear Knife" showing a sacred bear knife transfer ceremony of the Blackfeet taking place within a holy painted tipi, painting by Z. S. Liang

within. The painted cover reminded all people to be reverent around them, not to lean or sit against their covers or for children to play around.

An elaborate system of bundle ownership, purchases and transfers still exists among the traditional Blackfeet today. Common among the Blackfeet was the belief of "Napi" or "Old Man" who created the world and all within.

Among the Blackfeet, division of labor was the same as all northern plains tribes. The women did most of the labor in and around camp, while the men smoked, gambled, made and repaired weapons, and told stories; however, always were on the ready to protect the people when needed.

Hunting was not a mere pastime to them, but was actual work that was an on-going process. Regulated, tribal-mounted buffalo hunts where large numbers of animals were killed at once allowed them more spare time than in the past, but they still hunted large and small game on a regular basis.

Physically, the Blackfeet are generally tall and thin, with angular strong faces and, again like most tribes, they felt they were "the cream of creation." Red Crow (Hugh A. Dempsey)

In the color photo of the Blackfeet chief, we were honored to have Ernie LaPointe model for us. Ernie is recognized by the Lakota Nation and the United States government as the great-grandson of Hunkpapa Lakota Chief Sitting Bull. His given Indian name is Crowfoot, which honors the Blackfeet connection with Sitting Bull and his son Crowfoot, who was killed with him in 1890.

Sitting in my lodge on the Little Piney Creek, where the Lakota and Cheyenne camped while raiding against and visiting Fort Phil Kearney in 1866-68, Ernie related this story to us:

> My Indian given name is Crowfoot, the same name as the Blackfoot Nation's chief. When my great-grandfather, Sitting Bull, was in exile in Canada, he and the Blackfoot chief, Crowfoot, became very good friends. Crowfoot took in the Lakota and gave them food and shelter and was an advocate for them, by trying to help them get a reserve. Sitting Bull honored this great man by giving the Blackfoot chief's name to his son, Crowfoot. Sitting Bull's son died with him on December 15th, 1890. My mother gave this name to me when I was just a-few months old, she said later, when I was old enough to understand, to walk with this name in honor of my great-grandfather and his son, and also the Blackfoot chief who was the first to have this name."

So Ernie chose to have his image done as a Blackfeet Kainah, or a chief.

The Blackfeet headdress was very distinctive among the Plains tribes, in that it was made with upright-standing feathers, which represents a more ancient style than the more common flare bonnets, made popular by the Crow early on, then by the Lakota and Cheyenne.

The Blackfeet style headdresses are made by taking a folded piece of rawhide with the feathers inserted through cuts in the top of the fold or laced directly to the rawhide base. This is then usually covered with red wool. A pair of leather ties in the back hold it together when used.

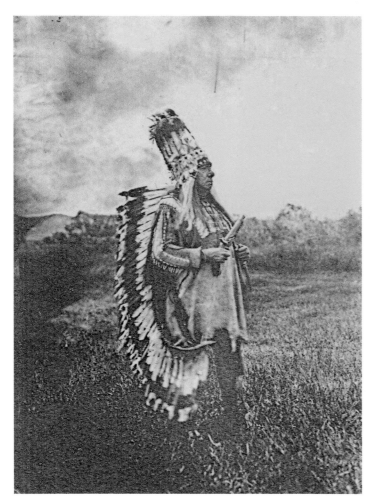 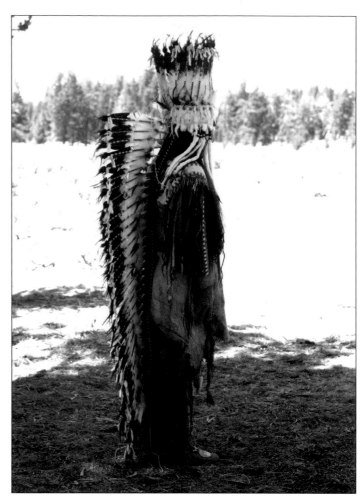

BLACKFEET CHIEF, CONTEMPORARY TINTYPE PHOTOGRAPH AND COLOR PHOTOGRAPH

Flat brass coin buttons obtained through trade were called moon discs, or just moons, and were a common decoration, which had both strong symbolic meaning as well as adding to its overall aesthetic beauty. The buttons were a common 18th and 19th century (and much earlier) style, used in Europe and North America.

The buttons were traded to and used by Plains Indians as early as 1800, as demonstrated by a dress brought back east by the explorers Lewis and Clark. This dress was recently examined and shown to have been sewn with thread and colored with commercial trade dyes as well. Quite unexpected of such an early piece. This dress is also decorated with porcupine quills as well as bird quills.

The use of bird quills is attributed to an early style of fashion among the Mandan, Hidatsa, Arikara and Assiniboine and Eastern Sioux. The practice of using Gull bird quills for decoration soon vanished among these northern people, because the gulls that would migrate to the northern plains soon disappeared in numbers, probably after 1850, just as migrating Carolina Parakeets and passenger pigeons declined as well.

Another feature important about this dress was the use of hide glue to create a decorative affect. In the creation of the dress, a common technique, used in hide painting, was to take clear hide glue and apply it in straight lines upon the hide itself. Later, as the dress was worn and somewhat soiled from dust, the clear white color of the natural un-smoked hide lines would appear as the surrounding hide became a little darker from age and use.

This technique, of using glue as a sizing or waterproofing agent, incorporating its characteristic of keeping the hide white, and using this white outline as part of the design element, was also used on most painted buffalo robes for both men and women.

The smaller brass "ball," or "bullet," shoe buttons were popular by the late 1850s and used extensively in the 1860s by many tribes. This same style button is shown on the shirt of our Lakota War Chief (**page 83**) with a double-trailer bonnet. When used by the Blackfeet, the buttons may have represented stars, when used on headdresses. Many tribes used them to represent hailstones and bullets, and for protection against those projectiles.

## Headdresses

When the upright headdress was worn, it was tied in the back and a small, bent willow hoop was set down into the top, enabling the feathers to flare out. Some examples examined show that sometimes each feather was slightly bent outwards, away from the base of the headdress. This is made easier by steaming the shaft of the feather to soften it and allowing it to bend easier.

Like all Plains headdresses, these were imbued with power and constructed with symbolism associated with the heavens, the moon, stars, and sun (by way of the eagle feathers and their relation to the sun).

Strips of ermine fur are sewn directly to the red wool covering the rawhide along with ermine skin tube drops. These tubes are made from an entire ermine skin that has had an approximately one-inch-wide strip cut from the tip of the nose to the end of the tail. A long leather cord runs the whole length of the body and extends 5cm or so beyond the nose end. This cord is for attaching the ermine to various garments, including headdresses. It also gives body and strength to the fragile and thin ermine skin.

Rooster hackles, available in a variety of pre-dyed and natural colors, were a common item carried by the trading companies and were more

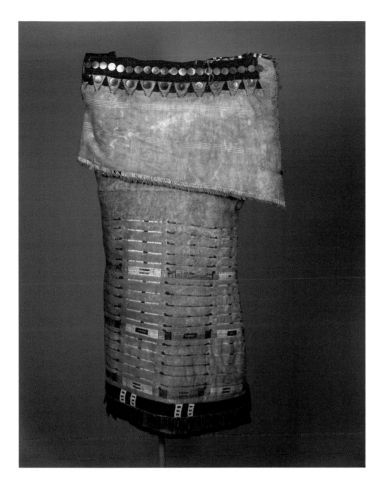

For packing the headdress away and moving it, the trailer would be removed, the headdress would be untied in the back, and both of them would be rolled up tightly and packed away. Typically, they would be wrapped with a piece of protective cloth or thin summer-killed leather, and then put into the rawhide container.

popular with some tribes than others. It is more common to see them on Northern Plains and Plateau styles of feather work.

Each feather quill has a porcupine quill-wrapped, rawhide strip attached below the ermine fur with rooster hackles on the top of each feather. These quill-wrapped rawhide slats are held in place with a small stitch of sinew directly onto the feather shaft. The designs made from the quills could have personal meaning to their owners, as well.

On the trailer that goes down the back, each feather is quilled this same way on both sides. Like most headdresses, this one could be worn without the trailer. Just as in pre-reservation days, today this style of headdress is considered sacred among many Blackfeet.

The one I made and show here I do not consider to be a sacred item, just because I made it. The purpose of this book is not to define political or social correctness. We support the Blackfeet Nation and their views on such headdresses, but feel anyone has the right to make one, as long as it is kept in context. We have no illusion of it being an actual holy item in the Indian way; it is a mere representation, or illustration, of one.

Many of these projects are fairly easy to make, just very, very time consuming. You may spend as much time doing research into a piece as you do making it. Obviously, items with lots of quillwork or beadwork require many hours of labor, but it too is fairly repetitive work. Quillwork demands a much higher level of skill and concentration. The worker must keep their eyes on their work at all times, and it must be fairly precise for it to look well. Like all craft items and crafts people, you will see a wide range of talents and skill levels on original 18th and 19th century Plains Indian material items.

## Shirts

Along with other northern plains tribes from this time period, the Blackfeet shared distinctive shirt characteristics, and one unique unto themselves.

Some of the shared traits with other earlier style Northern Plains tribes are: very long shirts, asymmetrical designs where quilled or beaded strips and background colors of the leather do not necessarily always match up left to right. The use of the entire deer hide with legs and tail attached and sometimes a fringe of hair along the animals hind end, which makes up the bottom edge of the mans shirt. You will also see, as shown on Crowfoot's shirt, that one sleeve may have long fringes while the other sleeve has human hair locks.

The large rectangular or square quilled ornament on both the front and back of the shirt is the strongest Blackfeet characteristic about the shirt and is only used by the Plains Cree on a limited level.

These shirts were considered very powerful and could be infused with the power of the sun and creator. So besides displaying your war honors, they had a protective quality about them as well.

Shirts could be bought and sold, and the power associated with them transferred from one owner to the next. When this was done, the shirt would be rubbed or painted with red ochre, a common practice with some tribes. Red ochre could be put on medicine bundles and cases too, when they were transferred from one owner to the next or when used in a sacred ceremony. In ceremonies today, Holy People may sometimes take the sacred red paint used in a ceremony and wipe the excess off onto a bundle or other holy object instead of wiping it off of their hands casually or disrespectfully.

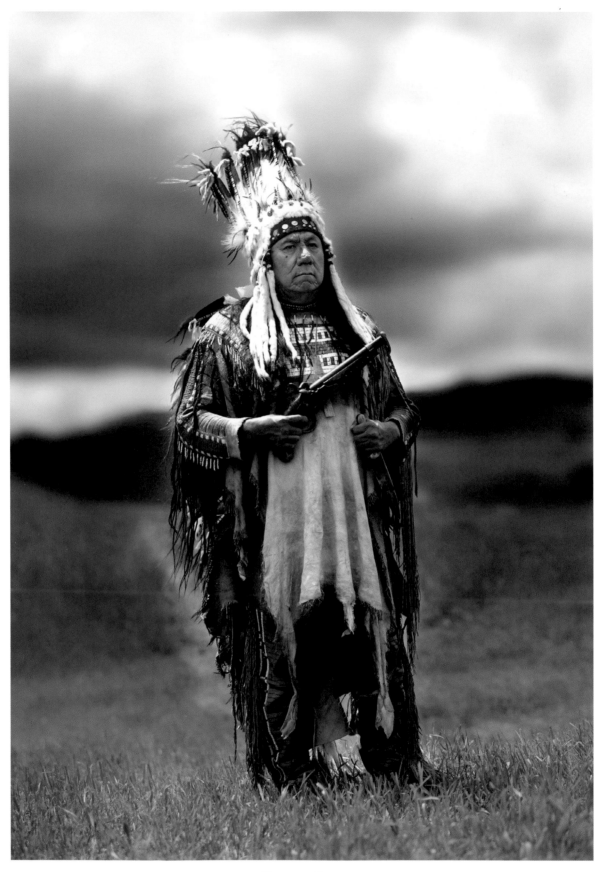

BLACKFEET CHIEF

## Grey Hair

The quill-wrapped hair locks denote a successful war party leader among the Blackfeet and many other tribes. Wearing grey hair scalps and scalp locks was considered a higher honor on the part of the wearer, because it indicates that this warrior had made it past the first-line of any Indian defense, which would be the young men who were in the prime of life, eager for a fight and to prove their bravery and manhood. They would be dangerous due to their youth and physical agility, but not always so wise in a fight. Next in a line of defense would be getting past the middle-aged men, who were more or less retired from fighting. These men would generally not go on active war parties, but instead would readily and very effectively defend the village or the people when attacked. Ernie's great-grandfather, Sitting Bull, was at the Battle of the Little Bighorn in 1876. Sitting Bull was about 42 years old and considered at that age an old man warrior and not expected to fight, unless the enemy making it past the young men forced the older men to fight. The older, gray-haired men were the hardest to reach. Therefore, it was a greater honor to kill one. Grey haired scalps and locks proved a man had penetrated to the heart of the defense; grey haired warriors often guarded the interiors of the tipis.

This class of aged warriors often times had their own society. The Lakota had such a society, called the Silent Eaters, or the Big Bellies. They were called this because they were old men who ate in silence, and they were usually fat men. They had a right to a seat in every council. If they wanted to speak, they had a right to do so at any time. They listened to all the talk of a camp. If they gathered together and considered a matter in silence, and after they had eaten they counseled about it. Their decoration was a sash of white skin worn over the left shoulder and hanging down below the waist. They did not go on war parties unless there was a general war. They were warriors who had been on war parties but had grown old. They would fight if the camp was attacked. But they would go with the camp and defend the women and children. Their name in Lakota is Anihila (silently) Wota(to eat), which means the "Silent Eaters," or those that have matured. (*Lakota Ritual and Belief*, p. 101)

## Leggings

The leggings display the asymmetrical look, in that both have the same pattern and color quillwork, but the coup stripes and honor marks on the left leg have been done in brown lignite, a poor quality of coal that makes a good and permanent brownish black paint, and on the right leg the marks are done in vermillion red mixed with hide glue.

Vermillion, or cinnabar, was highly sought after and traded at all trading posts, as an import from China. The bright red vermillion made all or most indigenous natural red earth colors pale by comparison. Unknowingly by all involved in the creation of vermillion, exporting and importing middle men, and the Indian consumer, vermillion was Mercuric sulfide or Mercury based, so had the potential to poison all who handled it, especially the Indians who applied it directly to their skin.

According to Prince Maximilian, the Blackfeet commonly painted the back ground color of each moccasin with different colors. One may be yellow while the other white, or one red ochre and one black, and so on. They figured …'hey, I've got two feet, why should they be the same.'

## Horse pistols

He also carries in his belt a 75 caliber horse pistol. This piece has been converted by a blacksmith from a flintlock into a percussion pistol by removing the hammer and pan, plugging that hole then drilling a new hole on the top and inserting a nipple needed to use it as a percussion weapon. This was a common technique in the mid-19[Th] century, when people were switching over to percussion weapons. They were more reliable and allowed you to use the weapon in inclement weather, something you cannot do with a flintlock, since the pan and powder can not be exposed to rain or snow.

Early horse pistols were used by Dragoons and others on horseback. It has a 75 caliber smooth bore barrel opening that narrows down to 69 caliber or less. This allows for easier loading while on horseback, by the funneling effect created by the narrowing barrel which enabled the rider to easily fit a smaller powder horn spout into the tapering barrel. When loaded with heavy shot at close range, it can be quite effective. We call it the "Tipi Door Clearer!"

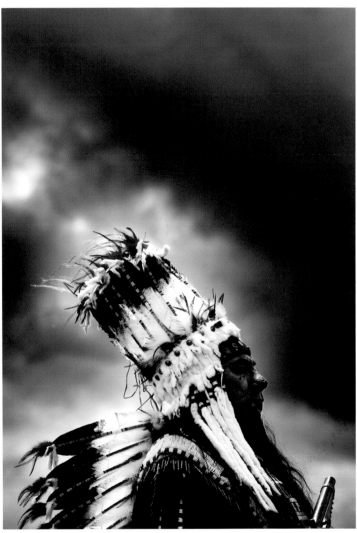

BLACKFEET "SKY"

RED AND YELLOW OCHRES, WHOLE
AND GROUND, TO BE USED FOR PAINT

# Chapter 3
# The Cheyenne

Wobenako, or White Bear, of the Southern Cheyenne is a shirt wearer of his people. Among the Cheyenne this brought grave responsibilities, as the shirt wearer always had to have the good of the People as a whole in mind at all times. To show just such an attitude, men that owned these shirts were expected to turn a blind eye to any men that made advances towards the shirt wearer's wife or wives. They could even have their wives stolen and not protest it. This is to show how magnanimous he was and not concerned with the everyday affairs of the people. This is one of the main reasons very few men wore these shirts, even if they were qualified to do so.

Similar to this showing of an apparent non-caring attitude by the Cheyenne shirt wearers, an interesting sidelight was in the relationship and competitions between the Crow tribe Lumpwoods and Foxes. After the election of officers in the spring of the year, a Lumpwood or Fox member was entitled to kidnap a woman of the opposite society, provided he had been intimate with her prior to her marriage. When the time came to capture the woman, the husband had to let her go, showing no emotion. If he resisted the theft, he lost status, was ridiculed, had songs made up about him designed to humiliate, and his property was destroyed. If he tried to reclaim his wife or remarry her later, he was tied up and dog excrement was rubbed on him. (*White Man Runs Him*, p. 58)

White Bear's hair shirt is stained with verdigris and yellow ochre and has typical Cheyenne-style block beaded designs.

He wears a mottled, adolescent-stage, eagle tail-feather headdress that was gifted to him in a great ceremony on the Cheyenne River. The immature golden eagle has white feathers with solid black distinct tips. As the bird ages and reaches maturity, at three years of age, the birds' feathers go through a color change. The adolescent, or teen-age, markings are barred white and black, as White Bear's feathers are. Once the bird is mature, the entire feather will be barred brown with darker brown lines.

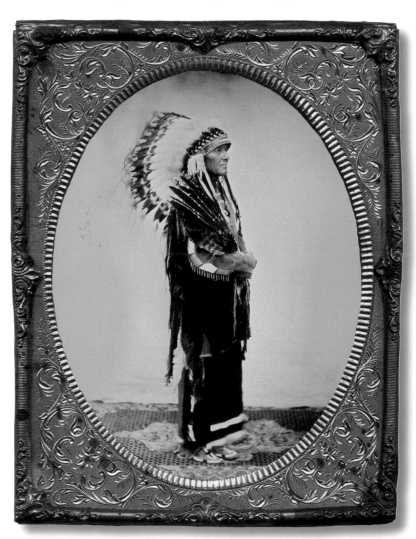

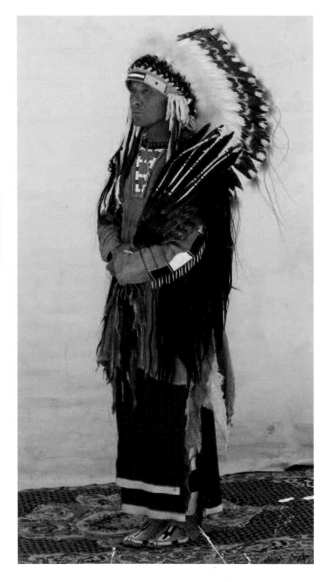

SOUTHERN CHEYENNE WOBENAKO, THE WHITE BEAR, CONTEMPORARY TINTYPE
PHOTOGRAPH AND COLOR PHOTOGRAPH

Catching eagles to obtain their feathers was a sacred right with most tribes and not all men had the right to do so.

Elaborate ceremonies, fasts, abstinence and purifications took place before the pits were dug to catch and kill the eagles in. A book that goes into great detail on eagle catching is *Hidatsa Eagle Trapping*, by Gilbert Livingstone Wilson.

TEMPORARY LODGE MADE BY EAGLE CATCHERS AND WAR PARTIES

SINEW BOW STRING SNARE INSIDE THE PIT, READY TO TIE EAGLE'S LEGS TOGETHER OR TO USE AS A GAROTTE

THE CAMOUFLAGED PIT FOR CATCHING EAGLES, WITH RABBIT BAIT SECURED

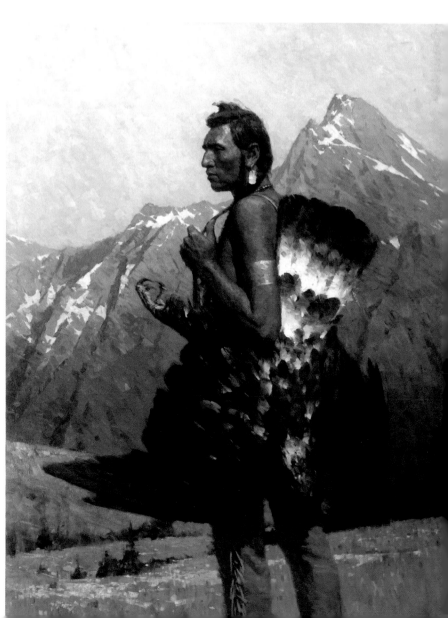

"OLD SUN, THE EAGLE CATCHER"
PAINTING BY Z. S. LIANG

The colors used in the headdress represent the four sacred colors of the Cheyenne: red, black, yellow and white. This motif is represented in the feathers and their ornamentation, the porcupine quilled brow band and the silk ribbons hanging at the sides.

In his arm he cradles a large, mature-golden-eagle-wing feather fan. It has porcupine-quill, wrapped-rawhide slats attached to the primary wing pointers, and otter-fur fringe hangs from the bottom of the handle.

These two images of White Bear are great examples of how the colors can change with the different photographic techniques used. Notice the color change on the red breechcloth and how it has turned from a lighter color red to a much darker hue in the tintype. Also, see how the beadwork on his shirt has changed from dark blue blocks to a much lighter shade in the tintype. Someone unfamiliar with this phenomenon might think these were two different shirts.

The Cheyenne belong to the Algonquian family and language. The name Cheyenne comes from the Sioux word "Sha-h'yena." The Cheyenne call themselves "itsistau," or Tsistsistas, meaning "people alike."

In the Indian sign language, the Cheyenne are indicated by the gesture which is interpreted to mean 'cut fingers', or 'cut arms.' This motion is made by drawing the right index finger several times rapidly across the left index finger. Rather than this "cut finger" meaning, though, is the probability that it has more of a meaning that indicates "cut arms," or some say it denotes striped arrows because of the habit the Cheyenne had of using the striped feather of the turkey for fletching the arrows.

The earliest territory of the Cheyenne, before the 1700s, was the part of Minnesota bordered by the Mississippi, Minnesota, and upper Red rivers. The Cheyenne are first mentioned in 1680, by the French, under the name of "Chaa," when a party of that tribe, then living on the headwaters of the Mississippi River, visited La Salle's fort on the Illinois river.

The Cheyenne probably preceded the Sioux in the upper Mississippi River region, and were found already established in Minnesota by the Sioux. At a later time the Cheyenne moved westward to the Shienne branch of the Red river, in North Dakota. At this time period, the Cheyenne were farmers living in earth lodges along that river, which still holds the name today.

According to their own story, the Cheyenne, while living in Minnesota and on the Missouri river, occupied fixed villages, practiced agriculture, and made pottery. But they lost these arts on being driven out into the plains, to become roving buffalo hunters. Therefore, although originally an agrarian people who lived in hardwoods and river bottom country, the Cheyenne existed for a century or more as a typical prairie/plains tribe, living in skin tipis, following the buffalo over great areas, and traveling and fighting on horseback.

This westward movement of the Cheyenne was due, in part, from pressure from the Sioux, who were themselves being pushed west by the Chippewa, who were in possession of firearms. The Cheyenne moved west toward the Missouri river, where they came into contact with the Suhtai. After what may have been a vague period of semi-hostility, the two tribes made an alliance. The Suhtai people spoke a closely related dialect of the Cheyenne language and had preceded them to the west. They would eventually evolve to become the Northern Cheyenne, while the Tsistsitas moved further south and became the Southern Cheyenne.

The Cheyenne obtained two sacred aspects of their evolving religion from the Sutaio: the Sun Dance and the Sacred Buffalo Hat medicine. However, the Cheyenne claim the Medicine Arrow ceremony as their own from the beginning. Early on, the Sutaio retained their distinctive dialect, dress, and ceremonies, and they camped apart from the Cheyenne. According to the half-Cheyenne George Bent, after the split in the year he gives as 1826, and by the 1860s-1870s, it was often hard to understand the speech of the Northern Cheyenne and they appeared wilder, wearing more

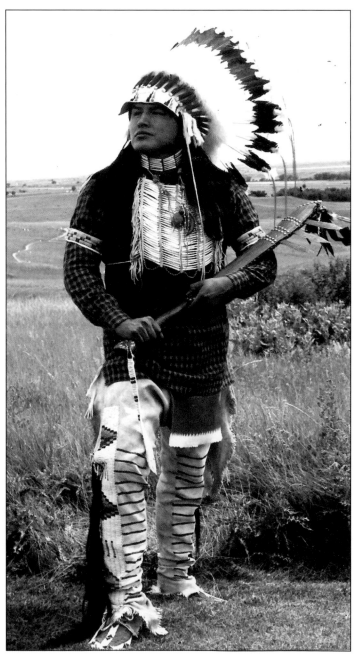

NORTHERN CHEYENNE AT THE TOP OF CUSTER HILL, LITTLE BIGHORN BATTLEFIELD

DAILY LIFE IN A TIPI, CONTEMPORARY TINTYPE PHOTOGRAPH

leather clothes and feathers, and were more like the Sioux. By this time, the Southern tribes were wearing a mixture of Native and white man's clothing, with cotton shirts and wool vests being the height of fashion (and comfort). Bent also mentioned other minor and major variations between the Northern and Southern Cheyenne, such as that the Northern bands would eat bear, but the Southern would not.

A CONTRARY WARRIOR RUNS OVER AN ENEMY WITH HIS HORSE

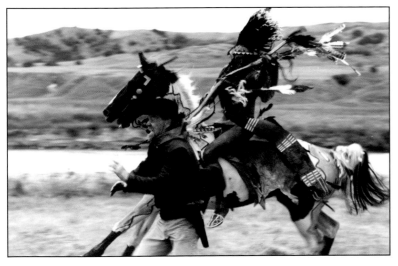

HE SHOULD HAVE STAYED IN ST. LOUIS

## Dentalia

Standing on the crest of Custer Hill, at the Little Bighorn Battlefield, is a Northern Cheyenne in semi-dress attire. The Eagle tail feather headdress (Tsai-mit-an in Cheyenne) is a typical Cheyenne pattern. It has a detachable full-length trailer down the back, (not shown). The feathers are tipped with red horse hair, yellow fluffs, and white ermine and with the black of the feather represent the four sacred colors of the Cheyenne.

The breastplate is of smooth dentalia (Dentalium is one of those trick words which has an irregular plural form: one dentalium; two dentalia.) shells, not bone or conch shell, hair pipes. Dentalia were imported from West coast tribes, where they have been gathered for centuries and used in inter-tribal trade. They are a type of tube worm and filter feeder, and the shell is the exoskeleton of the creature. Multi-pronged long spears or stabbing sticks were thrust down into patches of dentalia, along the seashores and tide pools, and

then brought to the surface, cleaned and dried. With their typical 19th century value of 80 to 100 dentalia worth a good saddle horse in trade, this breastplate represents a wealthy man. Mrs. Carrington, the wife of Colonel Carrington at Fort Phil Kearney, Wyoming Territory, 1866-1868, said that 75 dentalia shells equal 1 horse. In fact, they were in such great demand over time that the dentalia shell beds off the Northwest coast of America were cleaned out, and fur companies began importing dentalia from Russia.

A saddle-sizing plate off an army McClellan saddle adorns the center of the breastplate and a quilled grizzly bear claw amulet is worn over it. Quilled arm bands are worn with a hand-woven, cotton shirt and a military-style, wool vest.

Manufactured shell and bone hair pipes were also popular trade items used in making breastplates and chokers. These shell hair pipes were originally made for trade by Will Campbell, from Pascack (now Park Ridge) Bergen County, New Jersey. He began making them from conch shells in 1776-1798.

The shells, which averaged five pounds each, were brought in as ship's ballast to New York. Will Campbell invented a lathe that could turn several individual hairpipes out of the lip of each shell. Once drilled lengthwise, so they could be strung or threaded together, these tubes were easily traded to eastern tribes, and by 1800 the Plains Indians had access to them as well.

The French Canadian trader and explorer, in 1741, mentions the use and trade of hair pipes, and that two complete eagle tails equals one good horse or gun.

By the early 1820s the shells were becoming more common, though used sparingly and not constructed into breast plates yet. Paul Wilhelm, the Duke of Würtemberg, saw among the Lakota many hair pipes worn in ears and on necks and wrists. (*Travels in North America*, Paul Wilhelm, Duke of Württemberg)

Bone hair pipes were already being made and traded, and the American Fur Company was already carrying them, in 1834. By 1880, most all were made of bone, as these could be made much cheaper and easier than the shell ones.

A popular Kiowa hairstyle for men was to cut the hair level with the ear on their right side to show hair pipe, or sometimes on both sides.

## Three-bladed Knife Club

The three-bladed knife club, more commonly known as a gun stock war club, is more typically associated with the Lakota and other tribes, but were used by the Cheyenne as well. It may have been gifted to him by a Lakota relative or friend. Called a gun stock club today, these weapons were possibly originally made from broken gunstocks. The theory is that rather than throw the gun away, a weapon was made from it. Later, Indian men began making these weapons straight from a carved piece of wood, rather than wait for a weapon to break.

Crow feathers and orange shafted flicker feathers are attached on the end with a beaded pendant off of the grip. The brain-tanned, sinew-sewn leggings are fringed with quill-wrapped human hair locks and are beaded in a classic 1860–1870s, Northern Cheyenne design, as are the moccasins.

## History

Sometime after the Cheyenne crossed the Missouri River below the mouth of the Cannonball River, they took refuge in the Black Hills in South Dakota, driving the Kiowa in turn farther to the south. The Cheyenne are often thought of as one of the quintessential Plains Indian tribes, even though they were one of the very last tribes to become a fully nomadic, horse-back culture, living in hide tipis and obtaining almost all of their food through hunting and gathering alone.

The Mandan and Hidatsa probably had a hand in driving the Cheyenne from the Missouri river valley, as did pressure from the Sioux, even if that pressure was not hostile. Yet, the Cheyenne kept

on good terms with the Arikara, another earth-lodge people along the Missouri river in South Dakota, and were generally on good terms with the Sioux.

The Cheyenne tribe was usually split into ten bands throughout the year, with each band wintering in specific areas. These bands were known as: Shriveled Buffalo Aorta, Arrow-Men, Eating Band, Scabby, Ridge Men, Sutai, Prominent Jaws, Poor People, Dog Band, and Eaters.

The political makeup of the Cheyenne was that each of the ten bands elected four chiefs for about a ten year span. Thus, the Cheyenne had a council of forty-four men (four held over from previous term) or leaders, who were distinct from the war chiefs. The war chiefs were usually leaders of the six men's societies: Dog Men, Kit Fox (also known as Flint Men), Elkhorn Scrapers (also known as Coyote Warriors,) Bowstrings, Crazy Dogs (also known as Contrary Ones), and Red Shields (also known as Buffalo Bull Warriors). The Wolf Warriors and the War Dancers would be developed later among the men's societies.

The Cheyenne have a good reputation among other Plains tribes for their high morals, virtuous women and organized society. However, polygamy was also acceptable among the Cheyenne and, as with other people from time to time, their morals dropped, so the chiefs would have to take action and stop it.

The Cheyenne believed the universe consisted of the world above and the world below. The Creator of all things inhabited the sky and beyond, while the earth was associated with the female and life-giving. The Cheyenne had four principal ceremonies: The Sacred Arrow Renewal, The Sun Dance (also known as Medicine Lodge), The Massaum or Animal Dance, and the Sacred Hat ceremony.

Many of the sacred items were given and taught to the Cheyenne by their cultural hero, Sweet Medicine, who gave the Sacred Arrow tradition to the Cheyenne when he visited them, when they were on the Coteau of eastern North Dakota. Sweet Medicine was given the Sacred Arrows when he was visited by spiritual beings in a cave in Bear Butte. The arrows included two "Man Arrows" for warfare against men and two "Buffalo Arrows" for hunting animals.

The Cheyenne Sun Dance was required for Cheyenne world renewing, while the Massaum ceremony told the story how "Yellow-Haired Girl" taught the Cheyenne how to hunt animals. The Sacred Hat was a Northern Cheyenne tradition and acted as a talisman to be carried into battle.

The search for more horses had led the Tsistsistas further south. The Hevantaneo, or the Hair Rope band, named for their horse catching lariats, were known to be south of the Arkansas River by 1817. They were soon followed by other bands that continued a slow southern-western migration. Bents Fort, built in 1832-1833, served these peoples along with other more southern tribes.

As with other tribes, war parties usually preceded the migration and arrival of the main tribe. An Arapaho-Cheyenne camp met by Long in 1820 had just returned from three years "in Mexico," which probably meant the Mexican-colonial area of south Texas.

The rest of the Cheyenne continued to roam around the headwaters of North Platte and in what is now northern Wyoming and southeastern Montana. Thus began the sepa-

ration of the Northern and Southern Cheyenne, which was more or less made permanent by the treaty of Ft. Laramie in 1851. The two sections were then known respectively as Southern and Northern Cheyenne. The Southern Cheyenne are known in the tribe as Sówoní, "southerners," while the Northern Cheyenne are commonly designated as O'mi'sis, "eaters."

White Bear is shown prepared to walk about his village. He has taken up his tobacco bag, which is also typical of Cheyenne style work, with alternating bands of color and four long tabs that hang down from the mouth of the bag. This bag rests upon his summer elk skin robe that has been de-haired and scraped thin, then beaded with horizontal lines. These lines are interrupted with red tufts of wool, that some say represent meat drying on racks, and the lines travois trails. Above these lines pictographic paintings of him and his fellow warriors are painted as they ride into battle together.

The Southern Cheyenne's southern journeys and forays brought them into the Arkansas River area and constant collision with the Kiowa. With the Comanche, the Kiowa claimed this territory. By 1840, these tribes had made peace with the allied Cheyenne-Arapaho, whose relationship went back to the mid 18th century.

The Arapaho first followed their "Blackfeet" (probably A'aninin) relatives south of the Arkansas river to steal Comanche horses, and the Hevataneo Cheyenne soon followed the Arapaho.

About 1840, the Cheyenne made peace with the Kiowa in the south, with the help of their mutual allies, the Arapaho. They were already on peaceful terms to their north and north east with the Lakota. All these tribes, together with the Kiowa Apache and Comanche, have usually acted as allies in wars with other tribes and with the whites.

Their peace with the Kiowa enabled them to continue their incursions farther to the south and into Mexico, but sometimes with disastrous results. In 1853 they lost all but three men in a fight with Mexican lancers.

From 1860 to 1878 they were prominent in border warfare, acting with the Sioux in the north and with the Kiowa and Comanche in the south. Cheyenne have probably lost more people in conflict with the whites than any other tribe of the plains, in proportion to their number. Although skilled and honorable as warriors, victors in battle they usually were not. In most of the conflicts with whites or Indians, they came out for the worst. This does not include the battles when they were allied with the more numerous and powerful Lakota, such as Little Bighorn, Fetterman Massacre, etc.

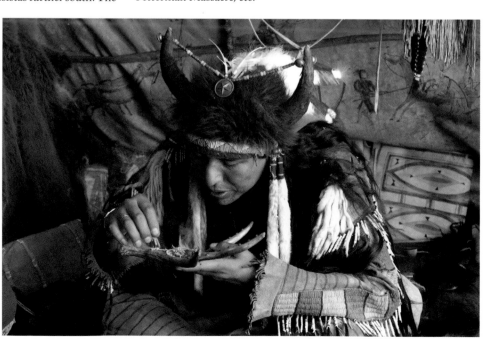

DIFFERENT TRIBES USED VARIOUS ITEMS AS PURIFYING INCENSES OR SMUDGES, SUCH AS FLAT CEDAR, SAGE, SWEET GRASS ETC. NORTHERN CHEYENNE SMUDGE WITHIN THEIR TIPI TO PURIFY

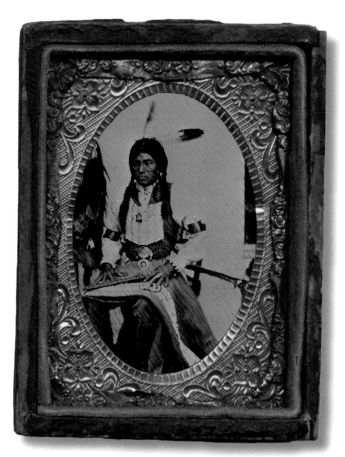

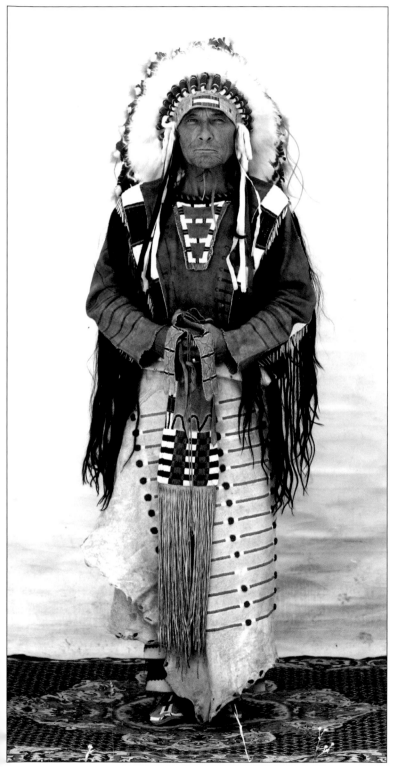

WHITE BEAR WITH SUMMER ROBE, FRONT AND BACK

Repeated defeats and villages being captured and destroyed by soldiers caused the Cheyenne to rely on their Lakota allies to refit them. The steady decline in their power and wealth occurred as they spent extra materials and time replacing lost and destroyed items. An early Northern Cheyenne camp near Platte Bridge was attacked and their 171 lodges abandoned and then burned, in 1856.

In 1864, Lieutenant Eayre attacked the camp of Crow Chief (a Cheyenne) and burned seventy of their tipis and equipment. Three days later they burned the camp of Chief Coons as well. The Kiowa then abandoned all their lodges near Fort Larned after that incident.

A powerful example of just how devastating such raids could be is the list of items captured and destroyed in 1864. It was Southern Cheyenne leader Black Kettles' village that suffered a severe blow by the Colorado State Militia, under Colonel Chivington. Black Kettle, with forty seven lodges of Southern Cheyenne, two Arapaho lodges, and two Sioux lodges, lost the following items:

| | | | |
|---|---|---|---|
| 53 women and children captured | | 210 axes | |
| 875 horses and mules (800 horses killed) | | 140 hatchets | |
| 241 saddles | | 35 revolvers | |
| 700 pounds of tobacco | | 47 rifles | |
| 775 lariats | | 535 lbs of powder | |
| 940 saddlebags | | 1050 lbs of lead | |
| 93 coats | | 75 spears | |
| 573 buffalo robes | | 35 bows and quivers | |
| 390 buffalo skins for lodges | | 4000 arrows | |
| 160 buff robes | | 12 shields | |
| 470 blankets | | 90 bullet molds | |
| | | 300 lbs of bullets | |
| | | and a large supply of meat (George Bent) | |

Again, on April 18th 1867, General W. Hancock burned a combined Sioux-Cheyenne Village on the Pawnee Fork river in Kansas. Lt. Col. George Custer was ordered to surround the abandoned village, but it was Hancock's decision to burn the village. Hancock determined to destroy the village, except for 40 lodges that were retained and to be given to the newly recruited Indian Scouts. Scouts Ed Guerrier, Bill Comstock and Delaware Indian scouts assisted. Everything else was inventoried, piled together, and burned.

Lieutenant Colonel J.W. Davidson, 10th Cavalry under Hancock's command, made a list of the items abandoned on the Pawnee Fork and in turn burned, on April 19, 1867.

This incredible list shows the wide variety of civilian and military goods that were being used by these Plains tribes during this period. In the Lakota, camp Hancock captured 140 tipis and 420 buffalo robes, which you might expect to see. However, the 28 coffee-mills and 8 pitch forks found in the combined villages might come as a surprise to most.

### Inventory of articles abandoned in the villages on Pawnee Fork, burned April 19, 1867:

| Item | No. | Item | No. |
|---|---|---|---|
| Lodges | 111 | Coffee-mills | 13 |
| Bridles | 11 | Rubbing hones | 9 |
| Buffalo Robes | 522 | Rawhide ropes | 48 |
| Curry-combs | 11 | Water kegs | 35 |
| Traventers (travois?) | 238 | Sacks paint | 142 |
| Blacksmith Tongs | 1 | Saddles | 197 |
| Parfleches | 144 | Oven | 1 |
| Lariats | 164 | Hoes | 22 |
| Whet-stones | 8 | Hammers | 6 |
| Head-mats | 142 | Tin cups | 134 |
| Stew-pans | 4 | Meat-stones | 22 |
| Axes | 49 | Fry-pans | 34 |
| Spades | 5 | Files | 8 |
| Crow-bars | 12 | Skillets | 1 |
| Pitchforks | 5 | Scythes | 4 |
| Fleshing-irons | 39 | Horn spoons | 55 |
| Knives | 9 | Meat-skewers | 7 |
| Brass kettles | 19 | Chairs | 78 |
| Pick-axe | 6 | Kettles | 49 |
| Coffee-pots | 8 | Drawing-knives | 4 |
| Wooden spoons | 14 | Tea-kettles | 12 |

### Inventory of Articles in the Sioux Camp:

| Item | No. | Item | No. |
|---|---|---|---|
| Lodges | 140 | Horn spoons | 94 |
| Hoes | 34 | Pick-axes | 6 |
| Buffalo robes | 420 | Chairs | 51 |
| Head-mats | 145 | Wooden spoons | 4 |
| Traventers (travois?) | 197 | Drawing-knives | 9 |
| Axes | 142 | Door-mats | 140 |
| Parfleches | 159 | Bridles | 9 |
| Crowbars | 15 | Stone mallets | 61 |
| Whet-stones | 2 | Curry-combs | 4 |
| Fleshing-irons | 42 | Swords | 1 |
| Rubbing-hones | 2 | Lariats | 280 |
| Brass kettles | 54 | Bayonets | 1 |
| Water-kegs | 63 | Coffee-mill | 15 |
| Coffee-pots | 59 | U.S. mail-bags | 1 |
| Saddles | 239 | Sacks paint | 70 |
| Tin pans | 179 | Lances | 1 |
| Iron spoons | 25 | Ovens | 5 |
| Spades | 2 | Kettles | 141 |
| Tin cups | 216 | Hammers | 11 |
| Pitch-forks | 3 | Tea-kettles | 3 |
| Fry-pans | 43 | Stew-pans | 4 |
| Knives | 3 | | |

Remarks- Six (6) ponies were also found running loose near the villages.

(signed)

J.W. DAVIDSON

Lieutenant Colonel, 10th Cavalry

Brevet Major General, Acting Inspector General

A true copy:

W.G. MITCHELL, Captain and A.A.A.G.

Another list of goods came from a Cheyenne village captured July 11th, 1869, at Susanna Springs (Summit Springs). This was the last big fight of the Cheyenne Dog Men society, and the last time a Dog Rope wearer deployed or used his Dog Rope in battle.

When the 5th United States Cavalry, commanded by General Eugene A. Carr, left the village site, there were 160 separate fires burning an estimated ten tons of items. Some items were carried off as souvenirs by some of the soldiers, but the itemized list contained the following:

| | |
|---|---|
| 56 Rifles | 40 Sets of bows and arrows |
| 22 Revolvers | 20 Tomahawks |

| | |
|---|---|
| 47 Axes | 200 Raw hide lariats |
| 150 Knives | 16 Bottles strychnine |
| 50 Pounds powder | 84 Lodges, complete |
| 20 Pounds bullets | 125 Travois |
| 14 Bullet moulds | 9300 Pounds meat, dried |
| 8 Bars lead | 160 Tin cups |
| 25 Boxes percussion caps | 180 Tin plates |
| 17 Sabres | 200 Dressing knives |
| 17 War Shields | 8 Shovels |
| 9 Lances | 75 Lodge skins (new) |
| 13 War Bonnets | 40 Saddle bags |
| 690 Buffalo robes | 75 Bridles |
| 552 Panniers (baskets carried on horses) | 28 Woman dresses |
| 50 Hammers | |
| 152 Moccasins | 9 Coats |
| 319 Raw hides | 100 Pounds tobacco |
| 361 Saddles | 200 Coffee pots (tin) |
| 31 Mess pans | 1500 Dollars (in gold & national bank notes) |
| 52 Water kegs | |
| 67 Brass & iron camp kettles | 25 Horses and mules killed |

Then came another severe blow. In 1868, the U. S. 7th Cavalry, at the Battle of the Washita, destroyed more tipis and material goods needed to survive.

General Custer destroyed a large village with aid of scouts Ed Guerrier, Bill Comstock and Delaware Indian scouts. 110 Cheyenne and 140 Sioux lodges were all burned.

Spotted Tails Brule, Red Clouds Oglala, and ninety tipis of Northern Arapaho (Sage People) were all camped on Horse Creek when their collective villages were attacked. Most of these tipis were abandoned when the soldiers attacked. The people had been able to pack and flee with most of their camp goods.

The Kiowa Village under Tohasan was burned by Kit Carson and seventy five Ute and Jicarilla Apache Scouts. They destroyed all 150 lodges with their meat and robes.

Slim Buttes, South Dakota, was yet another example where the lodges were captured and destroyed. On September 10, 1876, thirty seven tipis and all of their furnishings met their end.

The collective loss of all of these villages and the items in them would have represented many millions of dollars worth of goods and raw materials.

Though the Lakota nation was very large, and therefore could absorb some losses and still maintain their power and defend their lands, the Cheyenne and the Arapaho numbered nowhere near as many individuals. The best count of Southern Cheyenne and Arapaho tipis during the Indian Wars period averaged around 480 Southern Cheyenne tipis and 390 Southern Arapaho tipis. This puts into perspective the severe loss and drain on their economic and material items. Many of the Cheyenne were helped by their Lakota allies, so it would not be unusual at all for any Cheyenne during this period to have numerous items of Lakota manufacture, including clothing, horse tack, and tipis as well. As time went on, the Cheyenne re-made their own items, but this took time, and they retained the items they were gifted.

The Northern Cheyenne joined with the Sioux in the Great Sioux War of 1876, and were active participants in the famous Battle of the Little Bighorn. Later in the year, they received such a severe defeat from Mackenzie as to compel their surrender. In the winter of 1878-79, a band of Northern Cheyenne under Dull Knife, Wild Hog, and Little Wolf, who had been brought down as prisoners to Fort Reno to be united with the southern portion of the tribe, in Oklahoma. They made a desperate attempt to escape. Of an estimated 89 men and 146 women and children who broke away on the night of Sept. 9, about 75 people, including most of the warriors, were killed in the pursuit, which continued to the Dakota border. In the course of the pursuit, about 50 whites lost their lives. Thirty-two of the slain Cheyenne were killed in a second break for liberty from Ft. Robinson, Nebraska, where the captured fugitives had been confined. Little Wolf, with about 35 warriors, got through to safety to Montana. At a later period, the Northern Cheyenne were assigned to the present reservation in Montana. By 1904 they numbered 1,903 Southern Cheyenne and 1,409 Northern Cheyenne, for a total of 3,312.

## Dog Men

In 1837, while raiding the Kiowa horse herds along the North Fork of the Red River, a party of 48 Cheyenne Bowstring Men were discovered and killed by the Kiowa and Comanche. Porcupine Bear, chief of the Dog Men (or Dog Soldiers), took up the war pipe of the Cheyenne and proceeded to carry it to the various Cheyenne and Arapaho camps in order to gain support for a revenge raid against the Kiowa.

Due to a drunken fight between Porcupine Bear's cousins, Little Creek and Around, in which Porcupine Bear helped kill Little Creek, Porcupine Bear was banned from tribal societies and camping within the tribal circle. Porcupine Bear also killed a Northern Cheyenne when the Omissin (Northern Cheyenne) all were drunk in camp.

By the rules governing Cheyenne military societies, a man who had murdered or even accidentally killed another tribe member was expelled and outlawed. Therefore, Porcupine Bear was expelled from the Dog Men for his act of murder and, along with all his relatives, was made to camp apart from the rest of the tribe. The Dog Men were also disgraced by Porcupine Bear's actions. This deprived them of their leadership in bringing war against the Kiowa. Instead, Yellow Wolf reformed the Bowstring Society and the task of leading the effort against the Kiowa was given to them.

Though Porcupine Bear was outlawed by the main body of the Cheyenne tribe, Dog Men still followed him as their leader, contrary to Cheyenne law. Porcupine Bear led the Dog Men into battle against the Kiowa and Comanche at Wolf Creek; they were reportedly the first to strike the enemy. However, due to their outlaw status, they were not accorded the traditional honors. The outlawing of Porcupine Bear, his relatives, and his followers led to the transformation of the Dog Men from a military society into a separate division or band of the tribe. Over time, as the Dog Men took a prominent leadership role in the wars against the whites, the rest of the tribe began to regard them no longer as outlaws but with great respect.

It is ironic that these events of the Dog Men contributed to the transformation of the traditional clan system of the Cheyenne. An example would be that usually a man would move to his wife's family's camp circle. But due to these new circumstances, the Dog Men dropped this custom and brought their wives to their own camp, beginning a new tradition.

The Dog Men considered their territory the headwaters country of the Republican and Smokey Hill rivers in southern Nebraska, northern Kansas, and the northeast of Colorado Territory. They were friends with the Lakota, who also frequented that area, and often intermarried with the Lakota. Many Dog Men were half-Lakota, including the Dog Man chief, Tall Bull. However, due to extreme tensions between the Dog Men and the council chiefs, the Dog Men were never really considered a band of the Southern Cheyenne. They actually could be considered a third division of the Cheyenne tribe, between the Northern Cheyenne who ranged north of the Platte River and the Southern Cheyenne who occupied the land along the Arkansas River. The Dog Men had about 100 lodges (i.e. approximately

1000 people). George Bent said their range was the Solomans Fork, Smokey Hill, Republican River areas.

In the spring of 1867, the Dog Men band returned north with the intention of joining Red Cloud in the Powder River country. However, they were attacked by General Eugene Carr, and instead of continuing north to Red Cloud, they began raiding settlements on Smokey Hill for revenge. Eventually, the Dog Men fled west into Colorado, but were attacked when they relaxed their guard and became careless by a force composed of a Pawnee attachment with General Eugene Carr's eight companies of cavalry. Although today some may find the idea of a village of Indians being surprised usual, Captain Luther North hinted at such when he wrote that when an Indian "knows that an enemy is after him it is impossible to take him unawares but let him think himself safe and he is the most careless being on earth…

Almost everyone, including Tall Bull, died in the attack near Summit Springs, Colorado. Captain L. Walker, in his report of the fight, wrote that the village "was charged with the most frantic enthusiasm. The Indians, Sioux, Cheyenne and Arapahoe, numbering about 500 warriors, were taken with panic, and almost paralyzed with fear, they ran, offering but little resistance, leaving over 50 killed…"

The actual fight inside the village lasted only about twenty minutes. When the fight was over, fifty-two dead warriors were officially counted. Only one soldier had a wound, "slightly scratched by an arrow." It is amazing that such a conflict could produce such staggering differences in casualties.

Carr reported that one horse was killed during the fight, but another twelve were ridden to death in the ensuing chase of several miles. One Indian caught in the village, seeing he could not escape, tried to pass as a woman covered with a blanket and, when discovered, replied, "Me good Indian, talk heap." Such a plea had no efficacy and he was quickly killed. Carr reported soldiers chasing Indians for about four miles. Volkmar wrote that the pursuit lasted six or eight miles.

According to Bent, Cheyenne accounts gave more credit to the Pawnee Indians at Susanna Springs than the soldiers, the Pawnee doing most of the killing, and capturing most of the pony herd. Bent said: "The reason this command did so much damage, the Indians say, was because of the presence of the Pawnee scouts. They always showed up first and the Cheyennes mistook them for friendly warriors."

Wolf with Plenty of Hair was the last Dog Rope Owner to wear one in battle for the Cheyenne, and he was killed in 1869 at this battle where almost all the horses and mules were lost, as well as 52 Sioux and Cheyenne were reported killed. (The 52 "killed in action" list does not separate by sex.) Seventeen women and children were captured.

Carr added further details regarding the Dog Soldier dead on the battlefield, and non-warrior dead. The day after the fight, wrote Carr:

> The surgeon {Louis Tesson} and I walked over the field to look at the dead. He wanted a skull to send to the Smithsonian, but all had been broken by the Pawnees. Only a few women and no small children had been killed. We saw the body of what looked like a tall warrior lying on its back with a smaller one on each side. The doctor found it was a woman with a very light complexion. On one side lay a girl about 13, who was very dark, on the other a boy of 10. The Pawnees told me she was trying to escape, and when she found that she could not, stopped and knifed the children, and they {the Pawnees} killed her.

If Carr is correct, non-warrior deaths did occur, but were minimal. And, as both Carr and Bent note, the Pawnees were responsible for nearly all of them. The Cheyenne, Two Crows, was one Dog Soldier who escaped and did much to help protect the fleeing women and children, but he regretted "leaving so many Cheyenne and Sioux women and children to be killed by the Pawnees." Grinnell gives accounts of seven Indian women and four children killed. The Pawnees killed all of them during the frantic retreat from the village. Given the long festering animosity that existed between the Pawnees and the Sioux and Cheyenne, it should not be surprising that the Pawnees did most of the non-warrior killing at Susanna Springs. Another Dog Soldier account says the Pawnees early in the fight killed two Indian women and a young girl.

It is hard to condemn the Pawnees for their killing of women or children, because as far back as anyone could remember the Cheyenne and Sioux slaughtered every male, female and child they could run across of the Pawnee tribe. Each tribe hated the other with a deadly passion that resulted in total war.

Besides 10 tons of Indian goods destroyed, there were 690 buffalo robes, 361 saddles, 84 lodges—complete, 9300 lbs dried meat, 274 horses, 144 mules, $1,500 in gold and bank notes captured (and re-captured).

The Dog Man Band survivors straggled south and joined up with the Southern Cheyenne on the South Fork of the Canadian, and stayed with them. Their power and spirit had been broken, so they joined the long ranks of defeated warriors and nations throughout history to be subjected to the will of their conquerors.

Cheyenne Dog Men, or Dog Soldiers, were considered highly aggressive warriors. Tradition states that in battle four brave men, who were elected each year to the position, carried a sash. They would "pin" themselves to a "chosen" piece of ground, through a "Dog Soldier Sash," or "No Retreat Sash," or—as they themselves called it—a Dog Rope, by using a lance, knife or one of four "Sacred Arrows" they would carry into battle. Some sashes came with a pre-carved wooden pin or stake, five to seven inches long, already attached to the end of the rope where there was a slit in the leather to accommodate the weapon used to stick it to the ground.

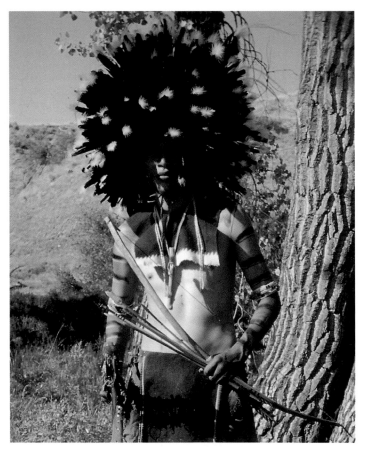

THE FOUR 'DOG ROPE WEARERS OR OWNERS' ALSO WORE THE DISTINCTIVE HEADDRESS.

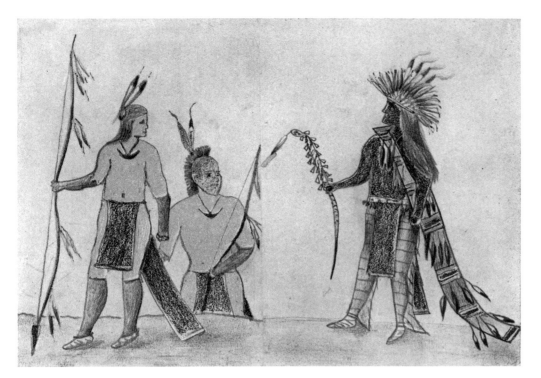

LEDGER DRAWING OF A CHEYENNE DOG MAN, FROM DORSEY

camp, dancing before the tipis of the head mean. In the dance, one leader is mounted and rides around the dancers as if forcing them up together. When they return to their tipi, the relatives of the candidate provide four kettles of food. Inside, a stick is set up before the candidate upon which his bonnet may be hung to keep it from the ground. When the food is brought inside, a morsel is thrown into the fire and one placed in the mouth of the candidate. There are four banner bearers and four small hand drums, but no rattles.

On the warpath, the four bonnet men must be in the lead for no one should go in front of them. In this and some other features they resemble the miwatani. Thus it is said, "You will see no others," the idea being that these four are so conspicuous. When mounted, their horses are painted red. The power of their regalia and medicine was so great that they were seldom wounded.

At home, these four could go into any tipi when meat was being cooked and after sounding their whistles take any or all of the meat. In all this, they moved very slowly and stealthily. (The dog society does the same, but runs fast.)

When the regalia of the four bonnet men get old, they cannot be thrown away, but at a ceremony are buried in the middle of the tipi. They must always be put on with four movements. Each of the four men has a tiny bag of medicine which he retains after retiring from office.

The bonnet is kept in a cylindrical rawhide case. No menstruating woman dare come near this at any time, nor any man recently with a woman. One of the bonnet men so associating must bathe early in the morning and refrain from smoking during the day.

Many tribes had these 'sash wearers.' Although the styles of construction and decoration varied, their general function was the same. The following reference to Lakota sash wearers is very similar to the Dog Men's sashes:

> The bonnet-braves wear headdresses with horns and are sometimes spoken of as sash bearers. They also have a small stake, or picket pin, with which they fasten or until the enemy is driven off. The manner of their selection and installation is similar to that of the kangi yuha." (American Museum of Natural History, p. 24)

The Lakota Black Chins Society (iku sapa) also had sash wearers. Their sashes were associated with specific headdresses, paints, and responsibilities. Their ceremonies were typical of many other Plains societies; how regalia was handled, worn and repaired were all prescribed and regulated.

Clark Wissler recorded many details about this group and many other societies. If it were not for him and several others, most of the traditional knowledge would have been lost. In some modern tribes, these societies still exist and are respected for the good they do their people and communities. However, most of the regalia, songs and ceremonies have been altered over the years, and no attempt to retain the old knowledge seemed necessary. This was typical of Plains societies in the old days, as well; they were always changing, adapting and incorporating new ideas and ceremonies. When speaking of the iku sapa, Wissler wrote:

> They sit opposite each other and sing the songs of the ritual while preparing the regalia, etc. There are twelve male singers, half sitting on one side of the tipi, half on the other. Four virgins are called, if quillwork or sewing is needed on the new regalia, but they sit outside. When a sash bearer has been chosen, they make a bed of sage grass for his seat; paint his face red with a black circle around over the chin. With four movements, the headdress, the sash, and the whistle are put on him. Then the whole society marches around the

The Crow had society lances that were used in the same manner as sashes or ropes, according to Two Leggings:

> The Foxes and Lumpwoods, which emerged as the dominant societies when Two Leggings was reaching manhood, were very similar in insignia and organization. In each two officials, elected for one summer season, bore otter-skin wrapped crooked staffs, while two other officers carried straight staffs. These positions were often regretted; the straight-staff bearer must plant his emblem into the ground during a fight. If no fellow member passed between him and the enemy he was duty bound to stand until he "dropped his robe."

Like all Cheyenne society regalia, these 'dog ropes' were always porcupine quill, embroidered and not beaded. Some of the early pieces of society regalia have quillwork that is not the finest in the world. We believe this is because, in the springtime, when all of this regalia was made, renewed or repaired, it was made by young virgin girls who had never been defiled by a man. The men did not want adult women to touch their powerful and protective war and society regalia. The young girls, of course, being early or pre-teens, were not the skilled quillworkers in the tribe, so their

The Cheyenne    33

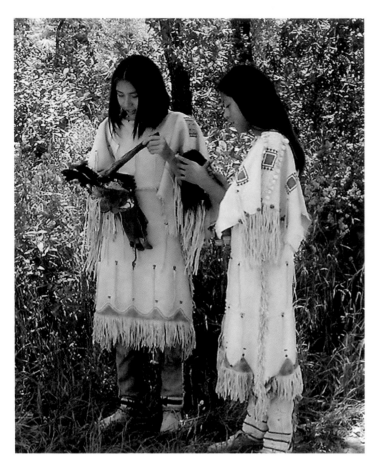

leave the field with honor intact was for the enemy to be driven from the field, or the emergency at hand that caused him to pin himself down to be positively resolved. If one of their fellow Society members were able to cross between the Dog Rope Owner and the enemy, he might beseech him to 'go back, get back to the people, you are a bad dog,' lashing at the Dog Man with his quirts and striking at him with their bows.

It was a great honor to rescue a Dog Rope Owner who was pinned down and in danger, and this brought many men back to the front of the battle where they needed to be.

The Dog Men may pull their sashes and retreat, and have to stop again and pin themselves down again, if the people were not yet in a secure spot.

Most of the tribes that had sash wearers also had specific headdresses that went along with the sashes. Generally, this was a globular headdress made by covering a conical hide cap with feathers.

Other tribes that had dog societies also practiced the custom of bringing up the rear of the march, just as the dogs did.

George Bent described the Dog Man's bonnet as made of crow feathers, and he wrote that the men wore war whistles on a cord of beaded buckskin, which warded off bullets.

Other society sash wearing tribes were:
-Sioux
-Crow Owners, with two short lances (otter and crow) and sashes
-The Braves, with two horned headdresses and sashes
-Miwatani, with owl feather headdresses of a two-owl-feather bonnet with sashes
-Crow feathers with a crest of turkey buzzard tails and a sash with stripes of quillwork and white plumes on the end, also ermine
-Eagle in row on crest, crow on sides, with back Eagle and crow hanging down
-Lay members had a conical cap of owl feathers without crest wing and tail, both used fastened to a hide and with a stick to tie in the hair
-Miwatani, four sashes with a headdress
-Sioux Dogs did not wear a sash or a bonnet
-Atsina, two leaders with an owl-feather headdress and sashes
-Crow
-Big Dogs had no bonnet 4 sash wearers red, blue, green or black wool
-Muddy Hands, two wearers, each with two long sashes of red wool
-Crazy Dogs had two sashes of red wool (2-4)

work would never be the best. Also, generally the work had to be done over a four-day ceremonial period when the men would feast and usually give the girls payment for their services.

The use of the Dog Rope has often been misinterpreted as a suicide or death wish that warriors would deploy when they wished to throw or give away their lives and sacrifice themselves in battle with a heroic death. In fact, most Plains men, like everyone else, wanted to live as long as possible, and these ropes were generally employed when the men needed to do what is referred to as a 'holding retreat' in military jargon. That is, he must give ground, but only in small increments, because to panic, break and run in the face of the enemy can be disastrous.

For example, a tribe with women, children and old ones all present and in danger of being overtaken by an enemy desperately needed to get across a river or into some sort of cover. Under such circumstances, the men would usually not flee and abandon the people. If, however, the women, etc. were not there, then it was always an honorable thing to flee a battle in which you felt you could not win or your 'medicine' told you it was a bad day to fight.

To get needed time under stress, Dog Rope Owners would dismount and secure themselves to the ground with their sashes to draw a rallying point for the other warriors. This brought other warriors back to the point of the battle and allowed them to make an effective temporary defense. The only way for the Dog Man to pull his rope up and

"DOGS OF WAR" PAINTING BY
STEVEN LANG

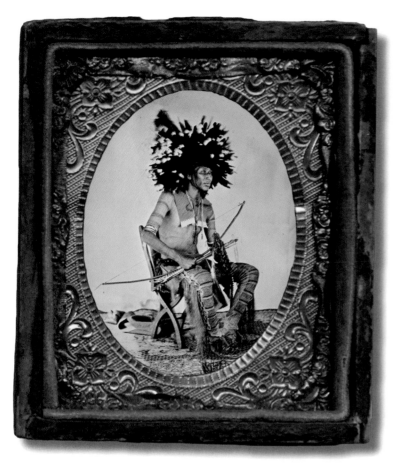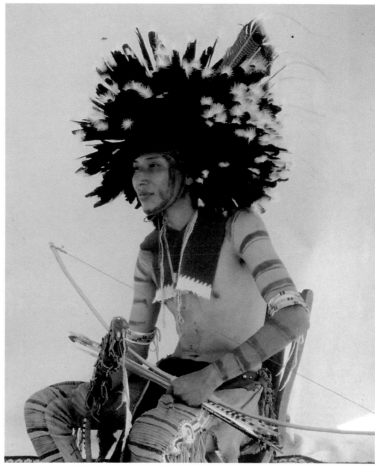

SOUTHERN CHEYENNE DOG ROPE MAN, 1860s, CONTEMPORARY TINTYPE PHOTOGRAPH AND COLOR PHOTOGRAPH

-Little Dogs- 2-4 red
-Crow Owners, two
-Hidatsa, Dogs
-Mandan, Dogs with three sashes: ½ green with feathers and ½ yellow
-Arapaho Dog Men, with four sashes, 6" x 7-8' long, no bonnet
-Blackfoot, red wool sash 8" x 7' and four rows of eagle feathers with hair fringe, a leather, black-rope bonnet, and owl feathers with an owl trailer to the mid-back

The Cheyenne man shown above is very tall for a 19th century Cheyenne, who stood generally around 5'8" to 5'9." We know from George Bent and other authors that the tallest Cheyenne of all was Nah-Mouste, who stood 6'2 1/4" and was considered unusually tall. It was said that he was a great arrow maker, and as he got older he became too large for the small Indian horses. (*Western America*, 1846-1847)

Before donning his headdress, a Dog Man would have painted his face and shoulders red, and then smudged the headdress before taking it out of its case. Then he raised it four times to the sun and the four directions. The headdress, though bulky and large, is lightweight, and, like all headdresses, had to be made to fold up small enough to be put away in its protective case.

The headdress was made from a thick, but soft, piece of leather, to help support the feathers and enable them to stand upright. Using around 500 or more crow or magpie feathers, or combinations of these, the headdress was individually sewn to the leather cap, beginning in the center and spiraling out from there.

The feathers were prepared by cutting a small notch approximately 15cm long into the quill, a short distance from its lower end. The bottom end of the quill was then folded back on itself and inserted into the cut and the shaft of the feather. Hide glue or any other glue could then be used, if needed, to hold the loop in place under extreme conditions. Items designed to actually be worn while riding a fast horse in a strong wind have to be made to withstand the stress. An extra drop of glue into or onto the folded quill helps a lot, but was not necessary nor always done.

As more and more feathers were added and the mass grew, the feathers could slowly be spaced out a bit, by 10 to 15 cm. If the feathers were not sewn on tight, and with the bases touching, at least at the first 5 or 6 cm or so of the crown, then the feathers would not stand erect, but would sag and be limp. Strips of white ermine or feather fluffs were glued to the tips. A crest of golden eagle tail feathers completed the top. The crests could be removable to make storage easier. It was common to take a folded piece of rawhide and attach the feather crest to this, which could then be held to the leather cap by tied cords.

As with all Cheyenne societal regalia, according to George Bent, no beadwork was used and a porcupine quill brow band completed the headdress. Although, in another description of Dog Men, he described the Dog Soldiers with bonnets of Crow feathers and with bone whistles on cords of beaded buckskin. The whistles, he wrote, helped to ward off the bullets

In the picture, his red wool dog rope is around his head and trails behind. He holds a bow and arrow and a Dog Man rattle made in the form of a snake effigy, with cut deer toes, or dew claws, for the rattles.

The Cheyenne    35

This style of rattle was owned by all Dog Men members. It has a wooden stick at the center, approximately 40cm long and 1.5cm wide, with deerskin sewn tightly over it. A snake's stylized head and tail are stuffed with buffalo fur and are flexible. Small eyes, mouth and scales are then worked onto it with dyed porcupine quills. The rattle was 'played' by holding it vertically and shaking it in an up and down motion.

A quill-wrapped war whistle and a skunk-skin belt completed the regalia necessary to be a Dog Man. The skunk-skin belts were made with four separate skunk skins cut across at the middle and sewn together, cut to cut. This made a belt that had two skunk heads that met in the back and two that met in the front. Cornhusk-wrapped dangles with cut deer dew claws hang from the belt at four places.

DOG MAN RATTLE CARRIED BY ALL MEMBERS. MADE AS A SNAKE EFFIGY FROM DEER HIDE SEWN OVER STICK, CUT DEER TOES OR DEW CLAW ATTACHED AS RATTLES AND, AS WITH ALL CHEYENNE SOCIETY REGALIA, IT WAS QUILLED, RATHER THAN BEADED

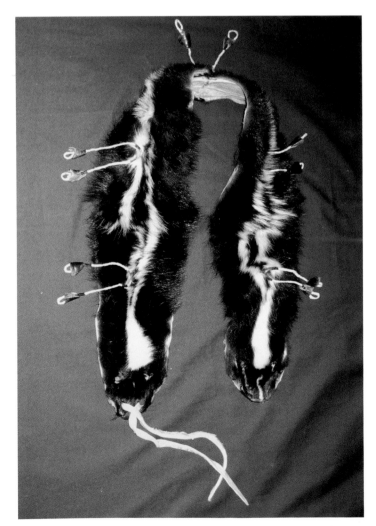

SKUNK SKIN BELT OF THE DOG MEN, MADE FROM FOUR SKUNKS MEETING HEAD TO HEAD, CORN HUSK WRAPPED DANGLES, WITH CUT DEER TOE RATTLES

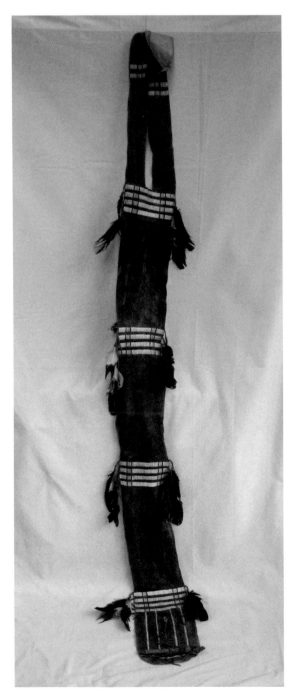

DOG ROPE OR SASH

# A Cheyenne Medicine Headdress

When the term "war bonnet" is mentioned, the image that instantly comes to most people's minds is the striking eagle feathered bonnet of the Plains Indian warrior, with about 28 to 32 tail feathers of the immature Golden Eagle. Tail feathers were the most sought-after feathers of this bird, and although known as an Eagle Tail Feather Headdress by most tribes, it has come to be known as the War Bonnet today. However, many other styles of "War Bonnet" were used by Plains Indians.

The story of one such headdress begins with the Battle of Slim Buttes, South Dakota. On the evening of September 8, 1876, Captain Anson Mills, with 150 men of the 2nd, 3rd and 5th Cavalries, was en route to Deadwood, South Dakota, for emergency supplies for General Crook's beleaguered column. East of Slim Buttes they discovered a village of 37 tipis under the Oglala American Horse, or Iron Plume.

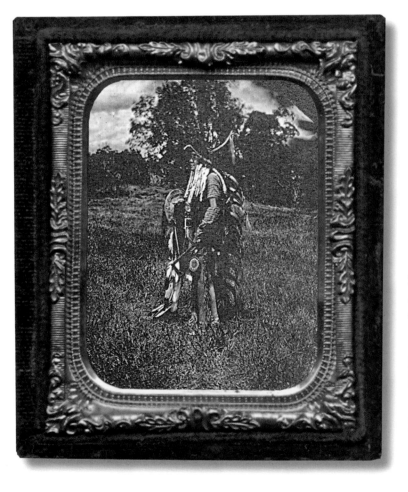

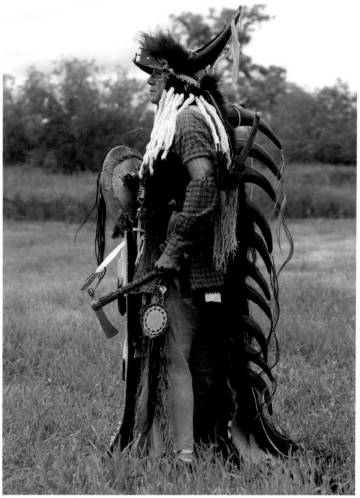

A CHEYENNE LIGHTNING HEADDRESS WITH A BUFFALO HORN TRAILER, 1875. THIS UNUSUAL HEADDRESS WITH VISOR WAS USED TO DEFLECT THE POWER OF LIGHTING BOLTS BEING THROWN AT THEM. CONTEMPORARY TINTYPE AND COLOR PHOTOGRAPHS

A RECONSTRUCTED IRON PLUME TIPI IN ITS FINAL HOME ON PERMANENT DISPLAY AT THE MUSEUM OF THE MOUNTAIN MAN IN PINEDALE, WYOMING

 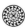

On the morning of September 9th, Mills attacked the village, noting that the tipis were closed up, due to rain that morning. As Mills attacked, some warriors escaped by cutting through the backs of their buffalo hide tipis. The man Iron Plume was one of them. He, his family, and six warriors fled into a dry coulee. After a six-hour fight, five warriors, including Iron Plume, were killed. The soldiers' losses were three killed and thirteen wounded. The village was destroyed and a great quantity of dried meat was taken away.

In the early afternoon, Crazy Horse and a large number of warriors arrived but did not attack, as General Crook arrived about the same time. On the morning of September 10th, an entire column of Crook, Mills and the Indian prisoners continued on to Deadwood.

Before the village was destroyed, many items were taken by Anson Mills and others, and they have been found in several different collections today. A few pieces are at the Little Bighorn Battlefield National Monument. This nice blanket strip and a guidon, captured from Custer's 7th Cavalry at Little Bighorn, are shown leaning against the American Horse tipi with a few Métis related items.

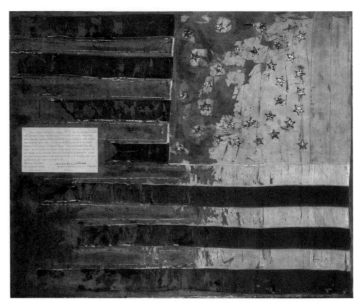

ORIGINAL 7TH CAVALRY COMPANY GUIDON, RE-CAPTURED AT SLIM BUTTES.

Today, the Smithsonian Institution's storage facility in Suitland, Maryland, contains the Iron Plume/American Horse buffalo hide tipi cover that was taken at Slim Buttes. Ken Woody and I examined it in detail in 2002. This tipi cover is very well made and preserved, covering 20' in diameter. Ken and I reproduced it the following year, with twenty sinew-sewn buffalo hides. We wanted to copy it because there was so much information available about it. It is the largest and most accurate buffalo hide tipi made since the 19th century. I have made two others based on the same pattern and size. After five years of good use, this tipi was placed on permanent indoor display in the Museum of the Mountain Man, in Pinedale, Wyoming.

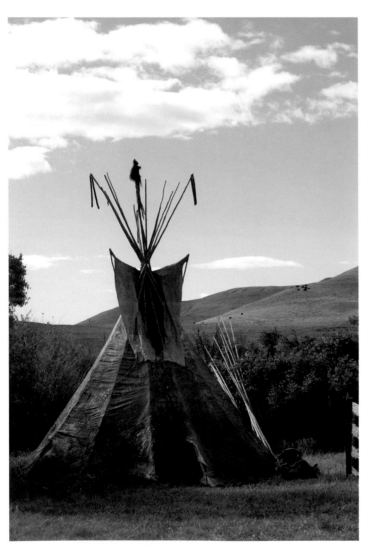

A RECONSTRUCTED AMERICAN HORSE TIPI MADE FROM TWENTY BRAIN-TANNED BUFFALO COW HIDES AND SEWN WITH BUFFALO SINEW. MADE DIRECTLY FROM THE PATTERN OF THE ORIGINAL IRON PLUME (AMERICAN HORSE) TIPI AND SET UP ON LITTLE PINEY CREEK IN WYOMING TERRITORY

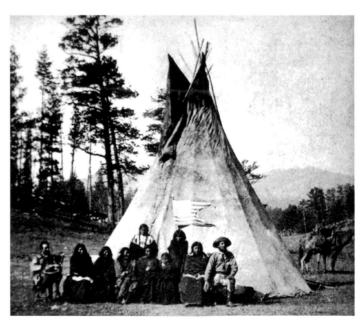

THE AMERICAN HORSE TIPI CAPTURED AT SLIM BUTTES, SOUTH DAKOTA, SEPTEMBER 9TH, 1876. ONE OF THE 7TH CAVALRY'S GUIDONS LOST AT THE BATTLE OF THE LITTLE BIGHORN WAS RE-CAPTURED AT SLIM BUTTES AND IS SHOWN IN THIS PHOTO LEANING AGAINST THE TIPI. THIS PHOTO, WITH CAPTURED INDIAN WOMEN AND CHILDREN, WAS TAKEN ON THE TRAIL BACK TO FORT ROBINSON.

LOOKING UP FROM INSIDE A BUFFALO HIDE TIPI,
SHOWING HOW TRANSLUCENT THEY ARE

Of special interest is the inside of the cover. From door to door, there were three rows of pictographic drawings, all done in a heavy black paint, of brass kettles, teapots, vertical hash marks, a few dogs and a couple of whiskey-shaped bottles. The Smithsonian storage facility staff was not aware that these drawings were on the inside of the cover and had no information on their meanings, as it had not been unrolled and examined in many years, until we looked at it.

We suggest that these drawings represented the many feasts hosted by Iron Plume's wife or wives. If a liner were in place, 'Women's honor marks,' which these designs may have represented, would not have been visible, but we believe that while hosting a large feast, typically the liner was removed along with the tipi furnishings. Then, the kettles of food were brought in and placed in a circle against the cover before the feasting.

INTERIOR OF THE IRON PLUME BUFFALO HIDE TIPI, SHOWING THE WOMEN'S
HONOR MARKS PAINTED ON THE INSIDE

We believe that is what is being represented in these drawings. The teapots (our guess) are interesting. We suggest that by 1876, Indian women may have been familiar with Anglo women's 'tea socials', and were emulating that practice. We have no written documentation to substantiate this.

A small local museum, the Jim Gatchell Museum in Buffalo, Wyoming, became the temporary custodian for some Slim Butte items when a private collection was donated to the Northern Cheyenne Tribe by Anson Mills' great-granddaughter. The tribe, in turn, wisely put these items in

the hands of the museum for preservation, until the tribe decides what to do with them. One piece is a great Cheyenne shield and another is an incredible quilled and beaded Cheyenne shirt, one of the nicest known.

## A Visor Headdress

Also in the tribe's collection is a unique, horned headdress, with a fully beaded visor and cut-out horns. We were granted permission from the Cheyenne delegates, who placed these items in the care of the museum, to take photographs and measurements of it.

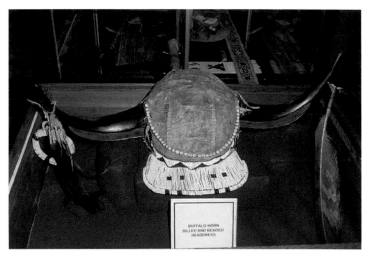

CHEYENNE, LIGHTING-DEFLECTING, VISORED HEADDRESS IN BUFFALO, WYOMING,
WITH IDENTICAL BLUE AND WHITE BEADED DESIGNS AS THE GREEN AND WHITE EX-
AMPLE IN THE NATIONAL MUSEUM OF THE AMERICAN INDIAN STORAGE FACILITY
IN SUITLAND, MARYLAND

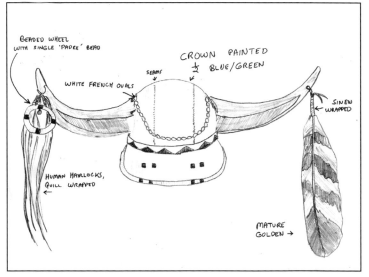

DETAILS OF HEADDRESS

Several unusual details caught my eye, beside the unusual visor, the woven basket-type liner that seemed to be original to the headdress, the cut out horns with their attachments of a mature Golden Eagle tail feather on the left horn, and a beaded hoop on the right horn that has a single blue padre bead attached and several quill wrapped human hair locks. An unusual feature was the single row of pigeon egg beads strung across the front, or back. But perhaps the most unique feature was the fully beaded visor, with its four, blue squares at the top and bottom.

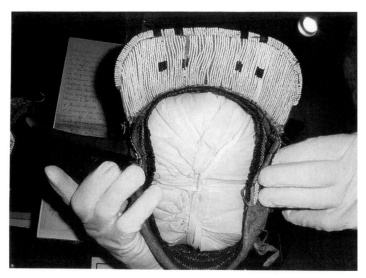

BLUE AND WHITE VISOR HEADDRESS IN THE BUFFALO, WYOMING, MUSEUM

The back of the crown was reinforced and appeared to have had a trailer attached at one time. The crown was made in three pieces. I filed this piece away in my mind as a probably one-of-a-kind, spiritually powerful headdress.

In January of 2000, while doing further research for our book on tipis (*The Buffalo Hide Tipi*) at the Smithsonian Storage Facility, we were looking in collection drawers for Cheyenne, hide, tipi liners. Something caught my eye in a double-thick artifact drawer above the liners, that I could just barely see. We asked the curators if we could examine that piece as well, and they allowed us to do so. Before our eyes was one of the most bizarre and unusual Native-made items I have ever seen. It was the headdress seen below. As we pulled the drawer out to expose the head-dress, I was shocked. Instantly the connection between the piece collected in 1872 from Mato Hanska, Tall Bear, Mato (bear) Hanska (tall), who was Chief of the Tokala or Kit Fox Society of the Kiyuska, (or Cut Off) Band of the Oglala Sioux] and the headdress in Wyoming was evident. Tall Bear was associated with the Cheyenne Dog Men and the Northern Cheyenne. Not only was there the same cut-out horns, row of pigeon-egg beads across the back, and fully beaded visor, but the visor was beaded with the same design as the Wyoming piece with the two series of four dots or squares, but now only done in green and white, instead of blue and white. One very obvious difference was that this headdress had its trailer intact, and quite the trailer it is!

My interest was very definitely piqued. We took some photos and many detailed notes with measurements, as they graciously allowed us full access to this wonderful piece. We finished up our tipi research there, and when I returned home, I began to search for information or evidence of these headdresses in pictographic, photographic or written records. I first recalled the drawing from Dorsey's *The Cheyenne Indians*, illustrating a headdress with a buffalo horn trailer (see below). The headdress to the left of it clearly shows the cut-out horns, and I believe the horn trailer bonnet drawing also shows cut-out horns, but not as clearly.

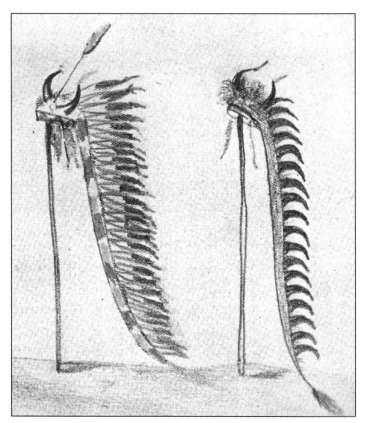

HEADDRESSES DRAWN BY CHEYENNE ARTISTS, ILLUSTRATING VARIOUS STYLES, THIS ONE SHOWS THE TRAILER OF BUFFALO HORNS ON THE FAR RIGHT EXAMPLE, AS WELL AS THE CUT-OUT HORNS ON THE OTHER HORNED HEADDRESS.

From the 1872 book by Belden, *The White Chief*, an illustration and description of a similar headdress is given. Belden wrote:

> A very popular style of Indian cap is made of buffalo hide and horns. It consists of a piece of hide taken from across the forehead of a buffalo, over the top of his head along the back of the neck and down the spine including the tail. The bone is taken out and the tail stuffed, then the piece is one unbroken strip from the head to the end of the tail. On each side of the head are set horns and frequently horns are fastened along the strip hanging down the back. The headdress of the Sioux Chief, Standing Bull, recently killed by Lieut. Mason, near Fort McPherson, was over six feet long and carried twelve horns. As the whole horns would be very heavy, they are split from top to base by sawing, and the thick part so hollowed out as to make them comparatively light. The horns are highly polished and set six or seven inches apart. Besides the horns, a great deal of beadwork and eight to ten bells are put on the headdress. I have seen four to five large sleigh bells fastened to the tail and not infrequently the tails are as much as nine feet long.

AN 1860S BUFFALO-HORNED TRAILER HEADDRESS, FROM BELDON'S *THE WHITE CHIEF*

This headdress is very close to the one Beldon described. Walker's description of it included:

*The headdress is the buffalo bonnet, made from a strip of buffalo skin from the shaggy fore head to the tail, the tail included, forming the lower part of the trailer while the shaggy part is the head piece. Small buffalo horns are attached, the larger at front and smaller behind. This is the war bonnet of the Heyoka.*

Obviously lacking from any of these drawings is the visor, so I continued my search. One day, when looking at one of my tipis, which I had painted several years previous with pictographic drawings of my friends, I recognized what should have been obvious. There was my friend, Oxydoous (Looks Away), wearing the visored, cut-out horn headdress. I now recalled basing my drawing of Looks Away on these ledger drawings that were then published in the book *Cheyenne Dog Soldiers*, not knowing exactly what I was looking at, other than an unusual-looking headdress.

Now it all hit me and came together! This was an original drawing of the headdress in Wyoming, showing the cut-out horns, beaded visor and Eagle tail feather tied to one horn. The visor in the pictographic ledger drawing was even beaded like the ones in Wyoming and Maryland, with the same four squares, and the brow band design was even beaded the same, with mountain or tipi designs.

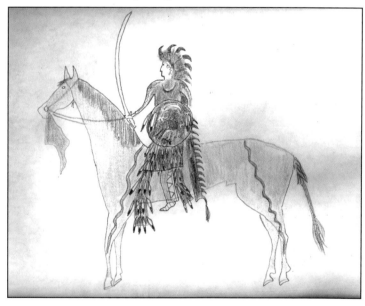

LAKOTA HEYOKA WARRIOR. THIS HEADDRESS, WITH BUFFALO-HORN TRAILER, IS RELATED TO THE THUNDER BEINGS, AS WERE THE HEYOKA. COLORADO HISTORICAL SOCIETY, WALKER COLLECTION

A Lakota ledger-style drawing (see below), in the Colorado Historical Society, Walker Collection, plate number 12, shows a similar headdress which was described by Thunder Bear as the headdress of a Heyoka, who were similar to the Cheyenne Contraries. Their power, or curse, came from Wakinyan, the thunder Bird or winged God, and lightning was its weapon. This lightning power was shown by painted zigzags across this man's forehead and down his face, along his arms and those of his horse's legs as well. Only Heyoka, among the Lakota, bound their horses' tails for war, and then left them to hang down free.

BOTTOM AND TOP OF GREEN VISOR, IN THE NATIONAL MUSEUM OF THE AMERICAN INDIAN STORAGE FACILITY, SHOWS IT IS IDENTICAL TO THE BLUE "LOW CAP" HEADDRESS IN WYOMING

The Cheyenne    41

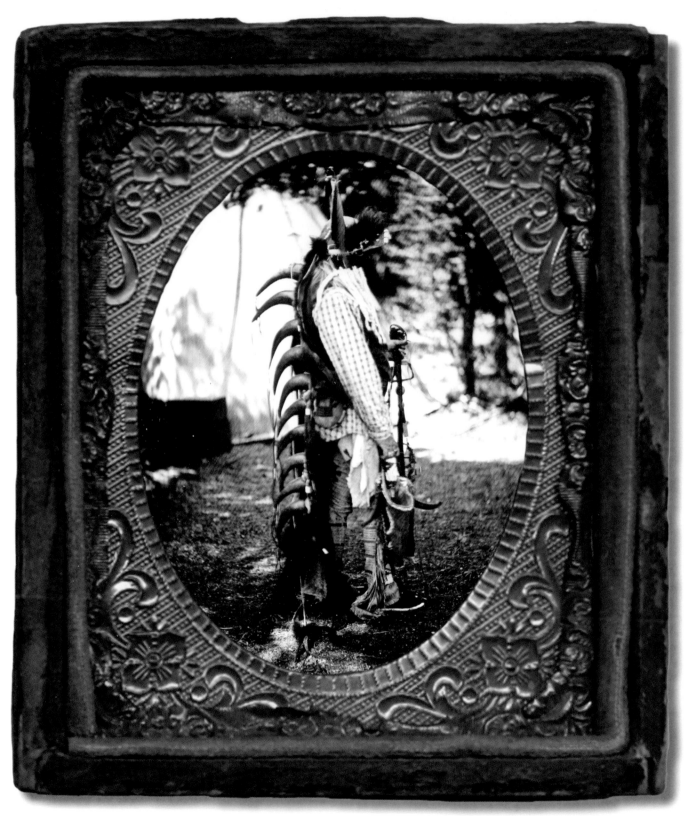

Cheyenne man carries a horse mask and bridle while wearing the "Low Cap" headdress, contemporary tintype photograph

At this point I thought the visor was drawn in an upright position, because that would be typical of how a Plains Indian might portray something like a straight-out visor, but shown as standing up to show the beaded designs in the drawing, as they must have had strong religious significance. After close examination of the original headdress, I could see that the visor has a small, leather tie that goes from the center of the visor to the middle of the headdress cap. The hole was large enough to allow the visor to be moved up and down, so it could be worn in either position, straight down or folded up, as shown in the ledger drawings.

From Colin Taylor's book, *Native American Weapons*, I saw another drawing of what appeared to be the same headdress, but with a different trailer. This drawing is from a set of eleven or more drawings collected by William Blackmore in 1874. Four of the eleven showed warriors with the visored headdress, but with three different trailers being attached to them. This does not surprise me, as most trailers on original headdresses are detachable. This drawing depicts White Horse with possibly a short, cloth and beaded trailer. It was accompanied by one headdress with a long cloth trailer with buffalo tail and one typical, full-length, immature Golden Eagle tail feather trailer, but with a buffalo tail on the bottom, and a buffalo leg belt.

All four drawings from the Blackmore collection and one from the Mark Landsburgh collection clearly showed the same beaded design on the visor and brow bands, cut-out horns, and single Eagle feathers tied on one horn. Through personal correspondence about this headdress style with Winfield Coleman, Mike Cowdrey and Imre Nagy, I was alerted to these additional drawings from the Blackmore Collection, and I thank them for their help. I, in turn, told them about the additional existing headdress of this style in the Jim Gatchell Museum, which they were not aware of.

Armed now with these new (but old) drawings and information, we returned to the Smithsonian Storage Facility in January, 2002, and made an appointment to examine the headdress again in greater detail. We took many photographs and measurements, and did detailed sketches of the construction techniques. There are other more qualified people than myself to go into the symbolism represented on these headdresses, but I will tell you what I see and what I believe some of the images on the green one represent. I preface this with acknowledging that I realize this is my own conjecture and there is danger in trying to read too much into some of the symbolism seen on the items. However, I believe a headdress such as this one has little if any arbitrary decorations on it.

Among some Plains tribes, such as the Blackfeet and Cheyenne (both Algonquin tribes), there is a belief that the earth, buffalo and grasshoppers are related, because the buffalo and grasshopper both travel in large groups and consume lots of grass. Sometimes grasshoppers were kept or caught to help determine the location of buffalo herds by pointing the way with their antenna.

I believe that this headdress may represent the relationship among grasshoppers, buffalo, earth and man. These are my reasons for that belief:

The colors used on the headdress—green, white, yellow, black and red— are the Cheyenne colors for Ka'Huts, or grasshopper, as these are the five color phases of the grasshopper.

On the beaded brow band, the two main design elements are white and green elongated diamonds, which is also the Cheyenne symbol for the grasshopper.

The background colors and/or design behind the diamonds is also the Cheyenne "man" symbol, which is represented by a rectangle with a concave notch or V.

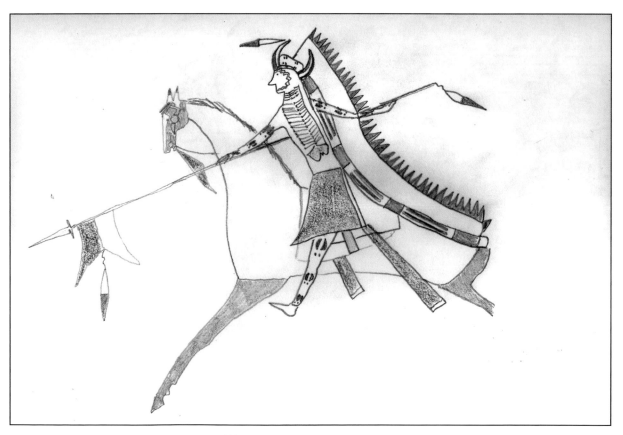

Sketch based on original drawings collected by William Blackmore shows the headdress being worn with a more typical full eagle tail trailer. Very obvious, though, are the hollowed-out horns, the beaded visor with the eight spots and the eagle feather tied to the right horn. He wears lightning bolts on his face and buffalo hoof paint designs on his arms and legs, which may represent the thunder powers of the herds. His lance has a cavalry company guidon or pennant, or at least an imitation of one.

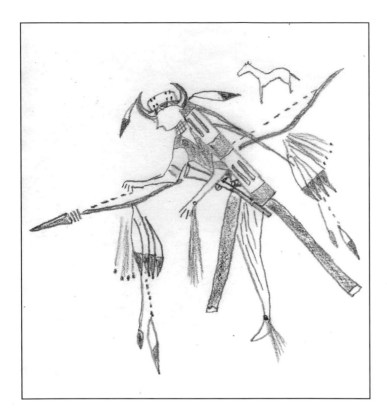

Here the "Low Cap" headdress wearer seems to be wearing the same blue and white visor headdress that is now in Wyoming and is more than likely the exact same headdress shown in the previous sketch. This headdress shows the same cut-out horns, beaded visor, eagle tail on right horn, except the full eagle tail feather trailer is replaced with what appears to be a cloth trailer. Oddly enough, it has the same vertical line designs as the eagle tail trailer version. We do not know the interpretation of these lines, but they must be integral with the headdress.

He also carries the Thunder Bow, so the combined protective and offensive powers of these two holy items would have made this man, though twice wounded here, a very powerful friend or foe on the battlefield.

The grasshopper colors used are the green for the beadwork as well as all of the horns on the headdress that have been rubbed with verdigris, just barely visible in some of the photos.

The white is represented by the sixteen ermine skins on each side, the yellow is represented by the yellow ochre rubbed into the buffalo hide trailer and buffalo leg belt. Black is in the buffalo dew claws and hair, and the crown of the cap has been blackened as well. The red is reflected by the ermine fur's red wool wraps and the red horse hair locks on the left horn. The original has its red hair locks intact on the crown horn, but all of the hair locks were missing on the ten horns of the trailer. All ten horns had been drilled out on the tips to attach something, and some of these holes were still filled with a double leather thong with their sinew wrappings to hold the hair locks, but the hair is now missing.

The trailer is 60" long and made from one piece of buffalo hide that has been split lengthwise for half is distance and then re-sewn together, presumably to remove the tough buffalo hump area. It has a total of nine buffalo tails attached, four on each side that are bead wrapped and one is sewn onto the bottom. At matching intervals to the eight tails are eight large buffalo dew claws cut off the buffalo's rear lower legs above their split hooves and applied separately to the trailer. A six-inch-wide yellow ochre center is bordered by one inch of buffalo hair, which was left on the hide while the center part was scraped clean and then yellow ochre was applied. A belt to tie around the wearers' waist to help support its weight is made from the actual forelegs of a buffalo, with the original dew claws left on, and two carved buffalo hooves are attached to each foreleg. The foreleg piece has also been scraped clean in the middle and ochre applied, and the edges are left with hair trim.

Four engraved brass bells are sewn on, as mentioned by Beldon, one on each leg and two on the trailer. This style of bell goes back to at least the 1830s and has been found at early Plains sites, such as Knife River in North Dakota.

On the inside of the crown, at the back, the original has a small piece of dried wood or root permanently affixed. This may be a piece of sweet root or sweet medicine, which is the plant root the Cheyenne Culture Hero has turned himself into and took on its name.

Before I decided to reproduce this item, I gave the idea a lot of thought. I realized that the original, at the time, was spiritually powerful and very sacred. I also realize that the one I made is just an assemblage of horns, hides, beads, etc., and is not sacred. I questioned if something as unique as this piece should be reproduced at all, but in the end I decided to remake it, in an attempt to learn more about it and to honor it as well. This also has allowed me to share the story and headdress with many more people than would have had the opportunity to examine the originals.

My good friend, Walking Water, wanted one, so I made him one as well. I thought it would make a nice photo to have the two shown side by side.

The four tipi designs may represent the four powers and spirits that reside at the four semi-cardinal points in Cheyenne spiritual belief.

I do not know why the horns are cut out, but I believe there is more to it than just to make them lighter in weight. The original horns on this headdress are seventeen inches long (that is huge). On the first one I reproduced, the largest horns I could locate at the time were fourteen and a half inches long; as you can see, these horns look very large for this headdress.

Likewise, I have no firm belief on the two sets of four white dots or squares. Dots or squares in Cheyenne pictographic art can sometimes represent animal tracks, and these could be that, possibly buffalo. More than likely, though, the dots on both sides of the visor represent lightning. The visor itself could have been used to shield the eyes of the wearer from the power of lightning thrown at them from other powerful warriors, such as Thunder Dreamers. These men often believed themselves to have been given the power to "kill with a glance," like their adoptive Father, the Thunderbird, by shooting lightning from their eyes. Lots of war paint designs show this power, which was seen as a protective paint design to help keep the wearer's family and friends from harm, by deflecting this lightning downward into the ground. When worn into battle, as the ledger drawings document, the visor was folded up so that the wearer could get a clear glance at the enemy.

Very similar and related to these two headdresses are the The Low Cap or Low Visor Clan of the Hidatsa, that got its name from this same, wide-spread belief about casting lightning and shielding from the same. The original visionary was adopted by Thunder and taught how to make the visored cap to protect his relatives. The "danger periods" were just after dawn or before dusk. The structural reason for this is that low-angle sunlight was sometimes seen to reflect from the water of springs, and these were thought to be the homes of Underwater Monsters who also were believed able to hurl lightning, which is what the early/late reflections of sunlight were thought to be. Both Beckwith, and Bowers made reference to these "low Cap" headdresses.

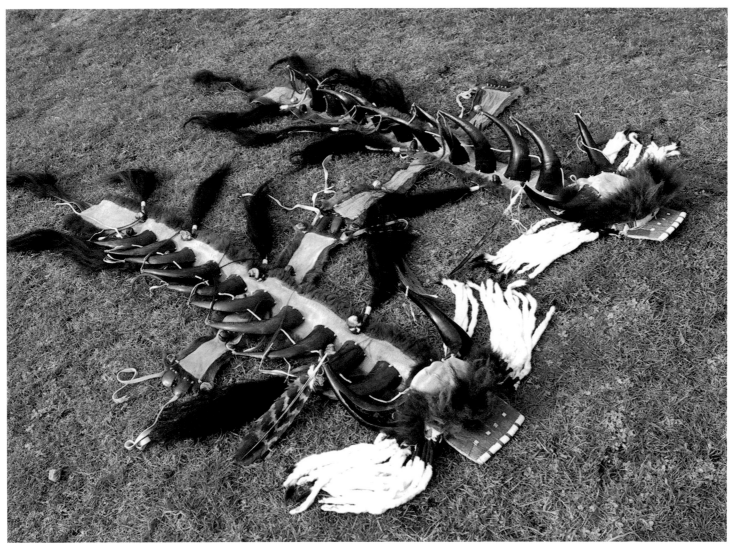

TWO LIGHTNING/VISOR BUFFALO HORN TRAILER HEADDRESSES

The headdress cap is made from a thick piece of hide, probably buffalo. It is made in an unusual pattern. Most headdresses are similar to the blue and white visor headdress in Wyoming, in that they are made of four to six wedge-shaped pieces sewn together, with their points all meeting at the top of the crown. This one, however, was made from one piece of leather and has only one seam that runs from the center of the back to the center top.

The visor is held on with three leather strips, one on each corner and one in the middle, along with the long cord mentioned before that goes from the center of the visor up to the front center of the headdress.

Just as on the Wyoming headdress, the beaded designs of four squares are repeated on both the top and bottom.

The horns down the back have all been split in half and polished. Green ochre had been rubbed into the horns. Originally they may have been painted green, but the impression I got was that, just like the one I made, the ochre had just been rubbed into the surface and polished. Each horn originally had hair locks, but they are all missing now. When I made this one, I chose to use two separate red hair locks on each horn, based on what I believe the original had.

As you can imagine, this is quite the heavy headdress to wear, especially when you are on horseback. Definitely, the broad buffalo leg belt is needed to support its weight. Today some may see this headdress as almost comical in appearance when worn, but in the days when it was originally made and used, this headdress would have been highly revered, respected and feared.

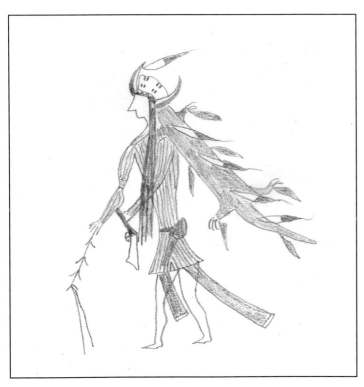

Wʜᴀᴛ ᴀᴘᴘᴇᴀʀꜱ ᴛᴏ ʙᴇ ᴛʜᴇ ꜱᴀᴍᴇ ʜᴇᴀᴅᴅʀᴇꜱꜱ, ᴇxᴄᴇᴘᴛ ɴᴏᴡ ɪᴛ ɪꜱ ᴡᴏʀɴ ᴡɪᴛʜ ᴀ ꜰᴜʟʟ ᴏᴛᴛᴇʀ ꜱᴋɪɴ

The Cheyenne warrior shown on the previous page is wearing a typical cotton checked shirt, so popular with many of the Arapaho, Cheyenne, Lakota and others during the late 1860s and 1870s. Pre-made shirts and bolts of cloth in a wide range of colors and patterns were readily available from trading companies as well as settlers heading West in wagon trains.

Stripes, checks, plaids, paisleys, flowers, stars, flags and more were all popular. These shirts were valued a this time at approximately $1.35 each, which was a handsome sum considering that most civilians at this time were not making even a dollar a day. (*Dog Soldier Justice*)

Pillow ticking, which came in the well known blue and white stripes, also came in green, brown and red stripes. Mary Smith, a Kansas settler woman in 1868, tells of the Indians' desire for their bedding, just for the fabric:

> ...*we saw them destroy our household goods, empty the feather beds, cut up the harness and lead off my two horses.*
>
> *They had taken feather beds, cut the ticks and emptied the feathers out, took the flour that was in the house, cut the sacks open and emptied the flour into the dug out. And took the sorgum, I think that there was two or three barrels, and emptied them among the flour and feathers and made a general mix up. They took all of the blankets and bed clothing that was around the house.* (*Dog Soldier Justice*)

Another pioneer, David Mortimer, escaped, but everything in his house was destroyed. West of Glasco, near the military camp, brothers William and Edward Abbot were attacked in their home. They, too, escaped to the camp. When the militia arrived at the Abbot home they discovered that the Indians had "cut the bed tick and pillows open and scattered the straw and feathers on the floor and took the ticks and pillow slips, the blankets and clothing with them." The warriors also scattered "the flour, meal, molasses, eggs and other provisions on the floor all mixed up with the straw and feathers, leaving nothing in said cabin but what was destroyed."

The Tanner-Hogan home was burned a few days later, as the Indians made another jaunt back into the area. They cut feather beds open and scattered the feathers and took the ticks with them.

Vests, usually made from wool, were the fashionable combination to be worn with the shirt and armbands. The vests also came in a variety of styles with many patterns and colors, but with black perhaps being the most common. Notice that all styles from this period had collars of some sorts, either rolled, lapeled or military-style stand-up. The collarless vest came into fashion in the 1880s. Plain bone and stained bone buttons, both generally a manufactured and not a hand-made item, were very common on civilian vests and all clothing, as well as porcelain, brass, tin, wood and cloth-covered metal buttons.

Armbands were made from just about anything, but very commonly from brass, copper, tin, nickel plated brass, flat brass wire and German silver, which became available in the early 1860s and is an alloy of copper, nickel and zinc. Being much cheaper than real silver, it became a very popular trade item and could be purchased in small squares or sheets at the trading post. Quilled and beaded buttons were equally popular, and are seen in photographs and represented in ledger art in about the same numbers. There is even an account, by Matthew C. Field, describing how, in 1844, he "met a Western Lakota near Fort Laramie who was wearing arm bands made out of two old iron trunk handles." (Matthew C. Field, *Prairie and Mountain Sketches*)

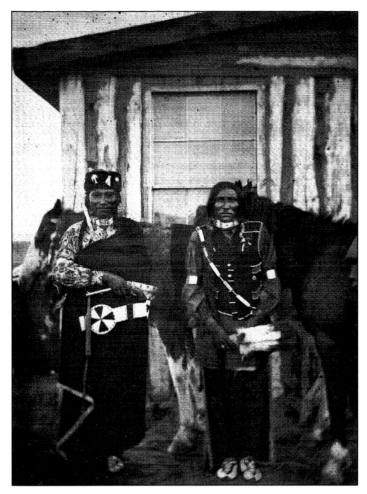

CHEYENNE MEN BUFFALO HUMP AND BOBTAIL HORSE, CA. 1879 WEARING
TYPICAL SOUTHERN CHEYENNE STYLE CLOTHING. ALSO NOTE THE SPLIT EARS
OF THE WAR HORSE.

In the collection associated with the Battle of Summit Springs now
housed in The Colorado Historical Society there is a pair of arm or leg
bands made from a pair of US Cavalry overcoat or blanket straps used
by the soldiers to secure those items to their saddles. This piece has been
split for seven or eight inches and then pieces of lead hammered flat have
been twisted around the strap where originally the adjustment holes would
have been. Then when worn and buckled into position the two split ends
would have dangled down and moved with its wearer.

This piece in the museum is not marked as being made from the
cavalry equipment piece, but it obviously is. I tried to let them know,
but as with many museums they understandably so I guess do not give
much credence to people that come 'off the street' so to speak and their
many opinions on what is in their collections. Some museums however
like the American Museum of Natural History in New York City gladly
and appreciatively relabeled many of their artifacts as we went through
their collection with them. It was nice to be able to make a small differ-
ence there.

CAVALRY OVERCOAT AND BLANKET STRAPS FOR SADDLE, AS USED BY SOLDIERS
AND AS CONVERTED TO ARM OR LEG BANDS BY CHEYENNE

The Cheyenne in my photo wears the multi-horned visor headdress
and appears as a typical Cheyenne may have appeared in the 1860s-1870s
when this headdress would have been made and worn. Typical Cheyenne
painted and beaded leggings and moccasins complete his clothing.

His weapons are a pipe tomahawk with scalp attached, and what was
called a "Flying Shield," which is the type with the long trade-cloth banner,
usually with many golden eagle tail feathers attached to it.

Pipe tomahawks were one of the greatest inventions and trade items
to many Indian men. Even today, most of my Indian men friends like my
tomahawk over all my other regalia. I think the same thing is attractive
about them now as was back then: it is a weapon for war as well as being
a vessel for smoking tobacco afterwards. When the pipe tomahawk is one
of the styles made from a rifle barrel, like mine, it has double the impact
to it, because now you incorporate the power of the Holy Iron (gun) with
the rest of it. These tomahawks could be hand forged by local blacksmiths,
who made a pretty good living on the side working for the Native business
as well as their normal clientele.

Other tomahawk types were made back East or in Europe and came
in several styles, such as the pontoon head, broad axe out of rifle barrels,
or even with detachable heads that had screw-on accessories, such as a
metal spike or hammerhead.

# Chapter 4
# The Comanche

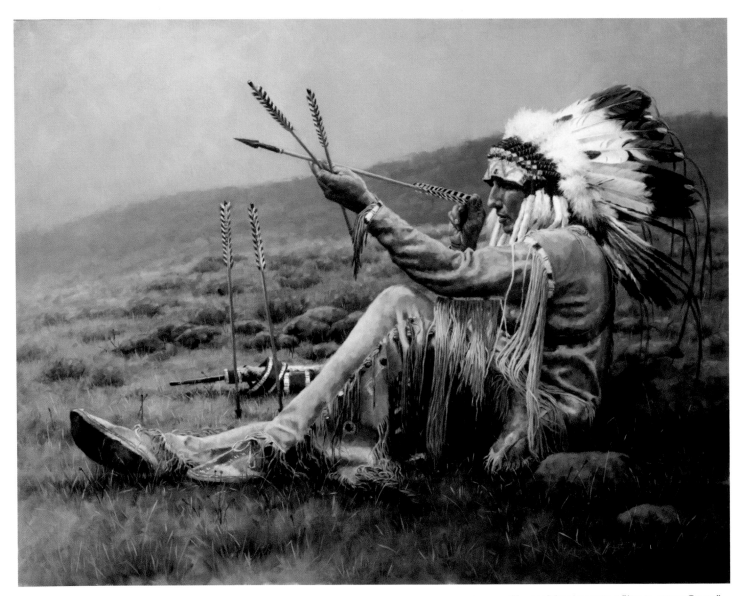

A COMANCHE CHECKS THE STRAIGHTNESS OF HIS ARROWS BEFORE GOING TO WAR OR ON A HUNT, IN A PAINTING BY KRYSTII MELAINE CALLED "AMMUNITION CHECK".

The Comanche are a Shoshonean-speaking people of the Uto-Aztecan language and, more specifically, they speak a Central Numic language. Their language, used as the trade language of the region, was more-or-less understood by all the neighboring tribes and is somewhat different from that of the Eastern Shoshone, of which the Comanche are an offshoot.

The names for the Shoshone and the Comanche in Indian sign language reflect this relationship and were basically the same. The sign for Shoshone is the right index finger moving forward in a swerving pattern, representing the movement of snakes, which was a common name for the Shoshone and sometimes the Comanche too. The sign for Comanche was the same, but done in reverse, swerving the finger back towards the speaker's body instead of away.

Captain W. P. Clark, of the 2nd U.S. Cavalry, in his great book *The Indian Sign Language*, 1885, gives an alternate and full description of the signs:

*Comanche. Conception: Snake. Hold the right hand, back up, well to front of body opposite right shoulder and height of waist, index finger extended pointed to the front, others and thumb closed: draw the hand to the rear, and by wrist action give a vibratory or sinuous motion to the index finger. The Southern Indians draw the hand to the rear, while in the North they push it to donate a Snake, or Comanche." {Shoshone}.*

His description of the sign for their cousins, the Shoshone, was:

*Shoshone (Indian). Hold the right hand, back to the right, in front of right shoulder at about height of waist and near it, first and second fingers extended, touching, and pointing to front, others and thumb closed; move the hand several inches to front, and, by wrist action, give a wavy, sinuous motion to extended fingers. Frequently only the index finger is extended (as for Comanche sign).*

Between roughly 1640 and 1650, the Shoshone obtained their first horses from the Ute. The wish of some tribal members to obtain more horses caused a tribal split about 1680, when fully half of the tribe headed south. In the Spring of 1700, the Ute and Shoshone came together to the Taos trade fair. Very soon the Spanish, for whom these Shoshone raiders proved the worst problem of the 18th century, were calling them "Los Comanches."

It is believed that the Comanche have lived on the southern plains since the 1500s. The Northern Comanche, or Quahadi, lived near the Black Hills in 1700, but were driven out by the Kiowa and Crow. The Southern Kiowa left when the Quahadi did. They were followed by the Northern Kiowa, or Cold Men, when they were driven out by the arrival of the Sioux around 1800. It was about this same time that the Eastern Shoshone withdrew from plains and into mountains, between 1787 and 1805.

The bands that would eventually make up the Comanche used the same southern route as other migrating tribes had for centuries and perhaps eons, when leaving the Black Hills, by following the Black Hills south to the headwaters of the Platte and Arkansas Rivers and on to the Canadians and Red Rivers down to Texas. However, by about 1820 the extent of their territory to the north was considered the Arkansas River. To the west they extended to the Pecos River along with the Sangre de Cristo Mountains, and to the east they went to the Cross Timbers River. The Kiowa say that when they, themselves, moved southward from the Black Hills region, the Arkansas was the north boundary of their land.

Although the tribal name Comanche is well known, it is uncertain from where it originated. One explanation is that it is a Spanish corruption of the name Ute, as they called them Kohmahts, meaning "those who are against us." Many of the other Indian tribes had their own name for the Comanche, many referring to them as the "snake people." It is unknown whether these descriptive titles referred to the area they lived in, which was also inhabited by various snakes types, the actual character of the Comanche themselves, or their relationship to the Snakes or Shoshone in the North. The Comanche referred to themselves as Nemene, meaning "our people."

By the late 1820s, the Cheyenne and Arapaho had forced the Comanche south from their northern-most territories, due in large part because of their wealth, in both horses and guns, and trade with Charles Bent in the mid-1820s, and later his trading post, established in 1832-1833. However, by about 1840, at the request of the Cheyenne, a lasting peace had been arranged between them and the Comanche/Kiowas. Although they were bitter enemies, Texans and the Comanche had also arranged a peace agreement by 1844, and a somewhat peaceful existence remained between the two for a decade. However, more raiding upon the Mexicans increased at this time south of the Rio Grande River.

The Comanche were nomadic buffalo hunters constantly on the move, cultivating little from the ground and living in hide tipis. White observers of the Comanche noted they had a higher sense of honor and held themselves superior to the other tribes with which they are associated (a common trait of all tribal peoples worldwide). In person, they were well built and rather corpulent.

Buffalo were the main staple of the Comanche Indian diet. However, the Comanche lived in the southern extreme of the buffalo grazing range and saw a decrease in the herds by 1850, while buffalo on the northern extreme of Comanche territory still flourished until about 1875. As with all tribes, once the herds disappeared, so did their power and domination of the Southern Plains.

Religion among the Comanche was more-or-less an individual concern, with men more than women seeking out power through vision quests and fasting. Although there could be a much variation in beliefs and practices, the fundamentals were held in common understanding by all. Like most all tribes, the sun was held in high regard, but the Comanche did not do a Sun Dance. The only one they ever performed, in imitation of the Kiowa, was just before the attack at Adobe Walls in 1875. The disastrous consequence and the war that followed immediately afterward were taken as supernatural sanction, indicating they should never make a similar mistake.

The Comanche were not a unified tribe as such, but were divided into eight to twelve autonomous sub-nations, which lacked the government and military organization of other Plains tribes. This may be due to their ancient heritage and relationship to the Shoshones, and their less organized, hunter/gatherer lifestyle, which they had maintained for centuries. Accordingly, the Comanche did not have war societies, but followed individual war leaders instead.

Most of the other Plains tribes were recent transplants onto the Plains from more organized agricultural societies from the lower Great Lakes and upper Mississippi regions. Those societies already had well developed and established ceremonies and forms of tribal government that they brought with them and adapted to their new lifestyle.

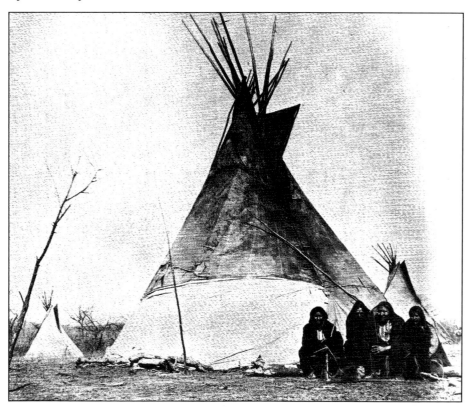

COMANCHE TIPIS

In former times, the Comanche had twelve recognized divisions or bands, and may have had others. Of these, all but five are extinct today. The Kwahari and Peneteka are the most important.

Others included the:

*Ditsakana, Widyu, Yapa, or Yamparika;*
*Kewatsana;*
*Kotsai;*
*Kotsoteka;*
*Kwahari or Kwahadi;*
*Motsai; Pagatsu;*
*Peneteka or Penande;*
*Pohoi;*
*Tanima;*
*Tenawa or Tenahwit;*
*Waaih.*

In addition to these, the following have also been mentioned by writers as Comanche divisions:

*Guage-johe*
*Keaston*
*Kwashi*
*Muvinabore*
*Nauniem*
*Parkeenaum*

In 1885 there were five bands of Comanche:

*Pene-teth-kas, the honey or sugar eaters*
*Cas-cho-teth-kas, the buffalo eaters*

*No-co-nys, moving in a circle*
*Yap-pa-reth-kas, the root eaters*
*Qua-ha-das, the antelope band*

The Comanche men's societies included:

*Big Horse People*
*Little Horse People*
*Black Knife People, also known as Crow*
*Crow Tassel*

The Comanche were considered some of the best horsemen ever, and created an image among the whites as fierce and brutal, and bore a reputation for dash and courage. Although, according to George Bent, the Cheyenne believed the Comanche, Kiowa and Prairie Apaches were not good fighters.

Population estimates in 1851 placed the Comanche population at about 3,000 warriors in a total population of 10.000 to 12,000. In 1870, Agent Lawrie Tatum estimated 3,742 Comanches. Their peak numbers seem to have been around 20,000 souls.

Of all the Plains tribes, the Comanche were the richest in horses, due to having early and direct access to the large Spanish and Mexican horse herds. At the height of their power and numbers, on average, there were twenty horses for each and every one of the approximately 20,000 Comanche. Colonel Dodge noted that while they were at their most powerful level, they were always at war. Again, this was typical, since the largest populations are usually the most war-like, as well.

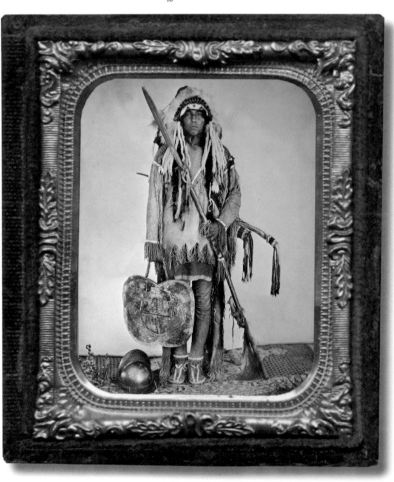

COMANCHE WAR CHIEF, **1860,** CONTEMPORARY TINTYPE
PHOTOGRAPH AND COLOR PHOTOGRAPH

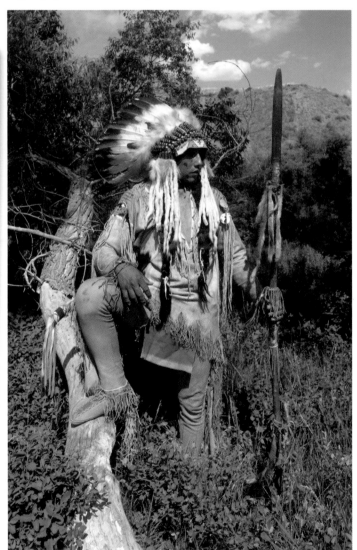

The warrior leader pictured opposite wears a typical outfit from the Southern Plains area. Clothing from the Comanche, Kiowa, some Southern Cheyenne, and Southern Arapaho share some similar characteristics. One of the most evident is the tight-fitting clothing. We have never been able to figure this out, as they all lived in the hottest areas, and without a doubt the tighter the leather the hotter it is. More Northern styles fit much looser, allowing a free flow of air, so even on hot days they can be quite comfortable, especially if they are on horseback. The action of moving on your horse, even at a walk, generates enough wind to keep you cool.

Not only are the Southern styles tight, but the sleeves and shirt body sides are sewn shut, allowing for no air flow at all. It does not make sense that they would be constructed this way. One theory, that is pure speculation, is that the Southern styles were inspired by Spanish and Mexican style jackets. Like most of the Comanche shirts, they were short, tight fitting, and had long sleeves that went over the wrists.

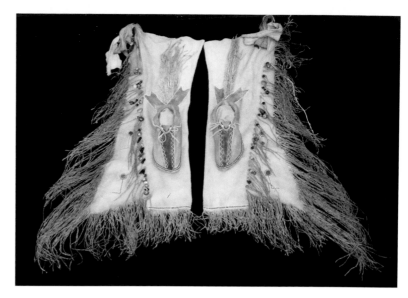

COMANCHE LEGGINGS AND MOCCASINS

These Comanche leggings are the side-flap style that has been colored red ochre on the inside of the flaps so that, when riding or walking (heaven forbid actually walking anywhere if you are a Comanche!), if this flap comes open it exposes for a brief moment the colored interior of the flaps, making a pleasing effect. The photograph shows well the horse sweat stains on the inner legs that most men's leggings would actually have had. Although saddles were common, there were always occasions when men rode a horse bareback. The key design represents the whirlwind to the Comanche. It is a very powerful and supernatural force that is feared and respected by all Plains tribes.

Comanche moccasins have a more elongated rawhide sole than most tribes, and later styles generally have a rosette design that is referred to by some as the "peyote button." Twisted fringe, 30 to 45 cms long off of the heels, can take some getting used to when walking. You must be aware of the fringe, especially when you move or spin on your heels. Otherwise, it is possible to take a step with one foot while the other foot is holding you back by standing on the fringe.

Ochre and pigment-colored clothing must be freshened up from time to time, as the colors wear off with use. This was often done in the Springtime, when society regalia and other articles of dress, war and religion were renewed. It was considered a great disgrace to use or wear any of these items when they were in an unkempt condition.

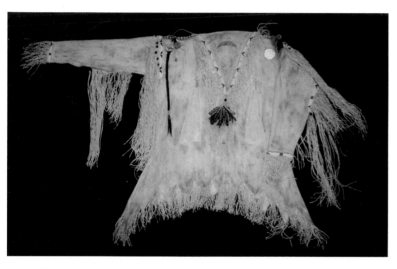

COMANCHE SHIRTS OFTEN TIMES HAD SMALL AMULETS AND TALISMANS ETC ATTACHED TO ADD SPIRITUAL POWER

The oversized bib, or necklace, on these shirts is uncharacteristic of other tribal styles and may have been an imitation of the long, wide lapels on the Mexican style jackets. The long neck flap pieces are actually helpful when trying to remove these tight fitting shirts.

The Southern styles generally use beadwork sparingly as accents and as thin, lined borders. You rarely see large beaded bands or panels as appear on Central and Northern Plains styles. Instead, small amounts of beadwork; long twisted painted fringes; and green, blue, red or yellow ochre bodies characterize them.

As seen on this shirt, small amulets appear, such as beaded "medicine" bags, that—in the case of the Comanche—are made of small pouches filled with sacred materials that are sewn shut and beaded. They commonly have a series of beaded loop fringes attached around the edges. Other items, such as watch faces (that represented the Four Winds), rattlesnake rattles, mescal beads or seeds, and small human scalp pieces are all tied to the shoulder area. Many of their shirts were quite short and cut off at the waist, with or without being fringed.

Comanche weapons—shield, lance, and bow and arrow—are typical, since the Southern tribes were generally not nearly as gun-rich as the more northern tribes, due to the Spanish ban on trading firearms to any indigenous peoples.

A quiver was made from a spotted buffalo or Spanish cow, or what is more commonly known today as a long-horn cow. The spotted hides were popular for their beautiful and varied patterns and colors. Consistent with the Comanche style of beading for the clothing, only the borders are beaded on this quiver.

The lance point is made from a United States Army, Ames Model 1832 Foot Artillery sword that has been converted for Indian use.

Strips of fur from the efficient killer, the otter, hang from the shaft, to give its user the quick-attack speed of the otter. A dried human hand, taken from an enemy, is bound to the lower staff with a strip of silk cloth torn from a United States Cavalry silk cavalry guidon.

His shield is not typical, but is the type rarely used by the Southern tribes that had access to Spanish goods. It is a Spanish Conquistador Adarga. These shields were carried by the early Spaniards and were made with three layers of bull rawhide, laced together with rawhide stitching, in the shape of a quatrefoil.

When captured or traded by Natives and converted to their own use, some of the original Adarga shields may be cut down and rounded off, and even turned over, with a more typical Indian shield design painted on what had been the reverse originally, but now is used as the front. Painted on the surface of this shield is the Coat of Arms of Spain, displaying the Castilian Castles and lions. Native additions have been made by adding brass tacks and large copper cones. On the back, a combination of Spanish shield straps and Indian ones are used to carry the shield in battle. Like a typical buffalo bull Indian shield, this one will turn an arrow or smoothbore musket ball, parry tomahawk and sword blows, but not stop or even slow down a rifled bullet from a hunter or soldier's weapon. This particular shield I made and aged so that it would look like an heirloom item of the 1860s and 1870s; and then I shot it with every conceivable firearm along with arrows, spears, clubs and sword slashes. The Spanish helmet in the photo is a corny touch perhaps, but I had it and could not resist using it.

Comanche men commonly braided their hair in two braids behind the ears, unlike many northern tribes whose men wore their hair braided over their ears, then wrapped them with otter fur strips. Flare headdresses were common during the time period 1860s to 1870s, as well as buffalo horn bonnets that are often associated with the Comanche.

SPANISH ADARGA SHIELD CAPTURED AND CONVERTED FOR COMANCHE USE

COMANCHE ELDER SPEAKS OF THE DEEDS OF HIS YOUTH, PAINTING BY STEVEN LANG

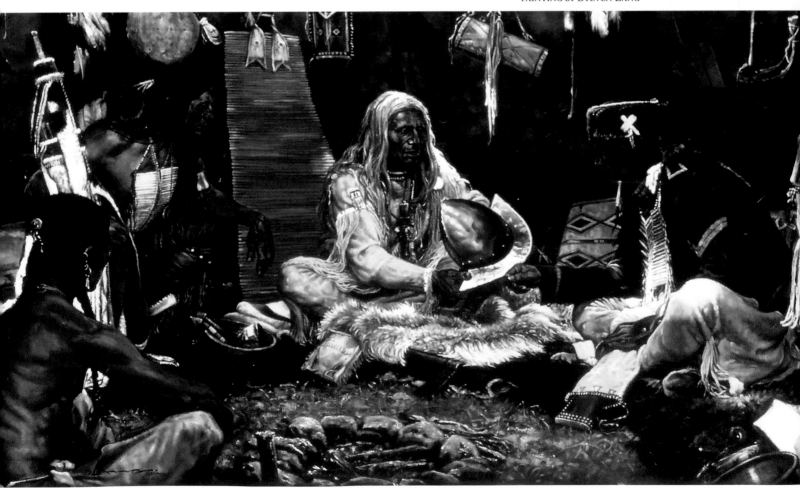

# Chapter 5
# The Crow, Hidatsa and Mandan

## The Crow

The two men in the tintype photograph are of the Mountain Crow tribe, named Eagle in the Wind and Like a Gros Ventre, from the Big Lodge and Greasy Mouth Clans. They were both very obviously powerful and wealthy men in their tribe in the 1870s.

Each has his haircut combed into the traditional Crow style for younger to middle-aged men. Like a Gros Ventre has painted his pompadour with white clay, while Eagle in the Wind has greased his with bear fat mixed with yellow ochre.

Both men have painted their faces in typical styles often seen in ledger drawings of Crow men. Shell and hoop earrings were popular with the Crow during this time, as seen on Like a Gros Ventre. He wears a cut shell loop necklace with abalone discs with a choker that is made from small beads and has a row of brass shoe buttons strung intermittently along the bottom row. The ermine on both of the men's shirts represent that the wearer has taken a gun from the hands of a live enemy, and so the shirt is called a 'gun snatchers shirt' or a 'gun takers shirt' by the Crow.

Like a Gros Ventres' shirt top has been blackened ceremoniously in the past, when he came back as a successful first coup counter. That black has all but worn off now. He grasps a pipe tomahawk that has hot file burn marks on the handle and a small tobacco bag tied to the end. His striped breechcloth is made of bed ticking, a popular cloth with many of the tribes; it came in a variety of colored stripes during the nineteenth century. Vertical striped breechcloths are another typical 'marker' used by all tribes when doing pictographic art representing Crow men.

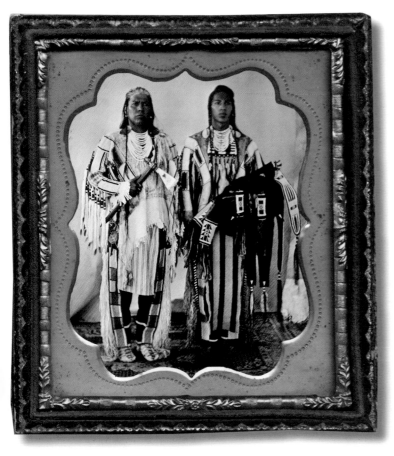

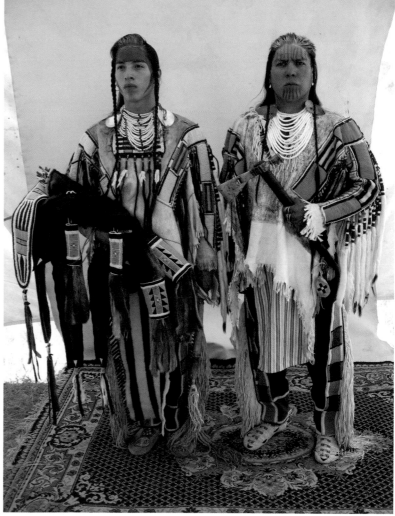

TWO CROW HEAD MEN IN 1870S STYLE CLOTHING, CONTEMPORARY TINTYPE AND COLOR PHOTOGRAPHS

All of the beadwork on his clothing represents the typical pastel colors and designs of the Crow and Plateau tribes. Large beaded panels on the leggings of both men are bordered with heavy fringe. One has braided his fringe and gathered it into groups of four fringes, and then the top five centimeters has been wrapped with red wool yarn. These wrapped fringe pieces are then strung together, from top to bottom, with a sinew string. Ten or more white seed beads are strung between each bunch of fringes. Connecting the fringes like this makes them stand out to the sides and not droop down.

Hanging on his wrist is a wooden carved quirt, and cradled in his other arm he holds a valuable otter fur quiver and bow case. This was a very expensive item and required three extra large otter skins to make. He also wears the vertical striped breechcloth, but his is made from a wool blanket and is worn, as many Crow did, with the front very long and the back very short.

The Crow call themselves Apsaalooke; "Children of the Large Beaked Bird." The Crow speak a Siouan language and formerly were part of the Hidatsa tribe living in North Dakota. The Crows' separation from the Hidatsa is believed to have happened in the 1600s. According to several stories, it was the result of a factional dispute between the distribution of food, and more particular over a buffalo stomach that the wives of two head men argued over. Another story places blame on two brothers and tobacco.

The Crow and Hidatsa were then residing on the Missouri River in earth lodge villages. When they split, the group that would become the Crow moved up the Yellowstone River basin and became year-round tipi people, while the Hidatsa remained in their earth lodge villages and only used tipis seasonally.

Since their separation from the Hidatsa their history has been similar to that of most tribes of the plains, one of perpetual war with the surrounding tribes, of which their chief enemies were the Blackfeet and the Sioux.

The country controlled by the Crows in historic times was in and near the Rocky Mountains of Montana and Wyoming. This area includes the sources of the Powder, Wind, and Bighorn rivers, on the south side of the Yellowstone River, and stretched as far south as the Laramie fork on the Platte River. The Crows also claimed the land on the west and north side of the Yellowstone River, as far north as the source of the Mussel shell and as far southwest as the mouth of the Yellowstone.

HIDATSA EARTH LODGE AND TIPI AT KNIFE RIVER

According to Prince Maximilian (1843), the tipis of the Crows were exactly like those of the Sioux, set up without any regular order. On the poles, instead of scalps, were small pieces of colored cloth, chiefly red, floating like streamers in the wind. The camp he visited swarmed with wolf-like dogs. They were a wandering tribe of hunters, making no plantations except a few small patches of tobacco. They lived at that time in some 400 tents, and are said to have possessed between 9,000 and 10,000 horses. Maximilian considered them the proudest of Indians, despising the whites: "they do not, however, kill them, but often plunder them." In stature and dress they corresponded with the Hidatsa, and were proud of their long hair. The women have been described as skillful in various kinds of work, and their shirts and dresses of bighorn leather, as well as there buffalo robes, were particularly handsome, embroidered and ornamented with dyed porcupine quills.

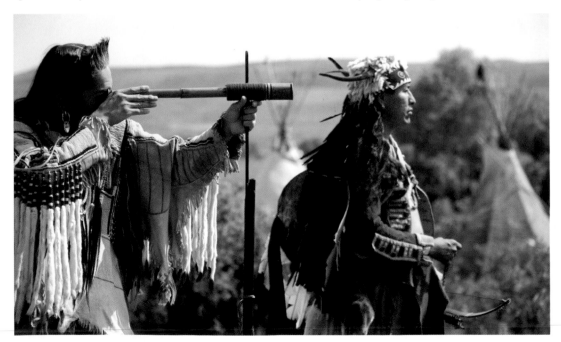

TWO CROW WARRIORS SCOUT THE COUNTRY NEAR THE WHITE MOUNTAINS (BIGHORN MOUNTAINS) FOR SIGNS OF ANY ENEMY

The men made their weapons very well and with much taste, especially their large bows covered with horn of the elk or bighorn and often with rattlesnake skin. The Crows have been described as extremely superstitious, very dissolute, and much given to unnatural practices. They were skillful horsemen, throwing themselves on one side in their attacks, as is done by many Asiatic tribes. Their dead were usually placed on stages elevated on poles in the prairie. The population was estimated by Lewis and Clark (1804) at 350 lodges and 3,500 individuals; in 1829 and 1834, at 4,500; Maximilian (1843) counted 400 tipis; Hayden (1862) said there were formerly about 800 lodges or families, in 1862 reduced to 460 lodges. Their number in 1890 was 2,287; in 1904, 1,826. Today, Crows number approximately 12,000 individuals and live in and around the Crow Agency area in Montana.

Though there are no full blooded Crow today, about half of the tribe practices traditional beliefs or incorporates those beliefs into their modern world, as do most Native peoples. Many still speak Crow as well as English.

Many Crow people partake in traditional ceremonies and often use the "a laa wau sau," which is the Crow word for a sweat lodge and it describes the structure itself as a 'dome.' The traditional Crow Alaawausau is often oblong in shape instead of round, and the pit may be placed to the right of the door as you enter, instead of the center.

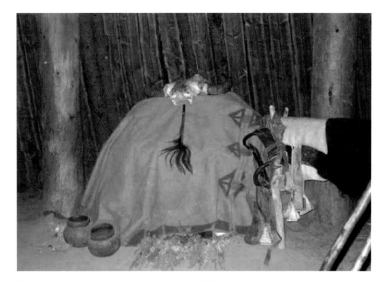

BEFORE THE CROW SPLIT AWAY FROM THE HIDTASA, THEY OFTEN HAD THEIR SWEAT LODGES BUILT INSIDE THEIR EARTH LODGE NEAR THE HORSES.

TWO PAINTED CROW WAR ROBES

The Crows are divided into two main groups: Mountain Crows and River Crows, the former so-called because of their custom of hunting and roaming near the mountains away from Missouri river. The River Crows usually ranged over the northern part of the lower Yellowstone River (called Elk River by many Native tribes) and as far north as the Marias and Milk rivers. The River Crows liked to hunt in and around the Judith Basin for the fall and winter hunt. The Mountain Crows stayed on the southern side of the Yellowstone River. The fur trader, Zenas Leonard, said many Mountain Crows spent their summers in the Yellowstone River valley and winters in the Wind River area.

All of the bands of the Mountain and River Crow would unite for a summer hunt. According to Pretty Shield, the division of the Mountain and River Crow happened approximately in 1832. However, Alfred Bowers has shown that both the Mountain and River Crow gradually came into existence during the 18th century, as various family bands separated from the Hidatsa groups on the Knife River and drifted out to the Yellowstone Valley for its better hunting. Those that became Mountain Crow originated from bands of the Awatixa (or Amahami), while those that became River Crow originated from bands of the Hidatsa proper. They were always separate, social entities, even before leaving the Missouri. About 1850, a third division developed out of the Mountain Crow, and they called themselves "Kicked in the Bellies."

The Crow tribe was organized politically through units of bands and kinship clans. The Crow were a matrilineal people, with all children belonging to the mother's clan, but at the same time were considered a "child" of the father's clan.

Following are the clans of the Crow:
Bad Leggings
Bad War Deeds
Big Lodges
Burnt Mouth
Eat Filth
Greasy Mouth
Kicked in the Belly
Newly Made Lodges
Packs Without Shooting
Piegan Lodge
Prairie Dog
Skunk
Streaked Lodge
Tied in a Bundle
Treacherous Lodges
Whistling Water
Some of these do not exist any longer, while others do.

Crow men's societies include:
Big Dog
Bull Owner
Crazy Dog Who Wishes to Die
Half-Shaved Head
Hammer Owner
Kit Fox
Little Dogs
Long Crazy Dog
Lumpwoods
Muddy Hand
Muddy Mouth

The Crow, Hidatsa and Mandan 55

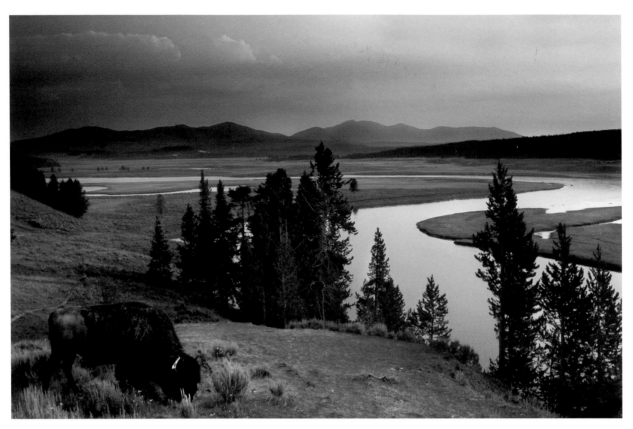

THE YELLOWSTONE RIVER VALLEY, WHICH THEY CALLED THE ELK RIVER, WAS THE HOME OF THE RIVER CROW.

## Clothing

The clothing of the Crow, by the 1830s, was already on its way to having a distinctive look. Prince Maximilian (1843) mentioned that the clothes of the various upper Missouri tribes were of the same basic cut, but that the ornamentations on the different tribal styles varied.

Many of the Euro–Americans of the 19th century, and still today, found the Crow/Plateau style very appealing, with its pastel color palette designs outlined with thin white beaded lines, cloth inserts incorporated within the beaded designs, and the simple but elegant design elements made up of elongated triangles, squares and rectangles.

Just a casual look at the Crow styles of beadwork and cloth work lets one see similarities of the Crow styles with some of the Plateau tribes, such as mainly the Cayuse, Flathead, Nez Perce and Umatilla. Some believe that the styles originated with the Plateau tribes and spread to the Crow, as their contact with each other grew in the 1840s and 1850s. Another take on this question is that the Crow, via their annual visits to the Hidatsa-Mandan villages, had access to glass beads by 1740, half a century earlier than any tribe on the Plateau, whose first beads came from American whalers in the 1790s; therefore, the Crow had a longer period to develop their distinctive styles.

Either way, the Plateau/Crow style is very appealing to many people today. I believe it is a very fine style, perhaps more appealing to non-Indians due to the fact that it is more regimented and uniform, and perhaps its pastel color palette is less wild. The overall appearance is especially so by the mid-1870s and going forward.

The Plateau/Crow style evolved over time. Most of these distinctive tribal styles were actually established relatively late, and in existence or established for only a matter of decades, though the styles had been evolving for a century or more. Previous to the mid-19th century, the styles of clothing and hair were more regionally distinctive rather than tribal.

What we think of today as unique and classic Crow style, Blackfeet style, Lakota style, etc. generally represents the peak of fashion at about the time the buffalo days ended. Peak does not necessarily always mean the best, just that by that time they had a full palette to deal with, combining all the natural elements that been used for centuries and a vast array of non-Indian items introduced via the trade, all were being combined and used in new ways. These styles were picked up, copied and modified by other tribes throughout the 19th century. This is still happening today with Native peoples, and many of the traditional styles of the mid-19th century look foreign or incorrect to many Indian people, unless they have studied the older designs and patterns; whereas some are still quite tribally identifiable.

Besides the obvious reason for changing styles, such as greater access to introduced raw materials, the style changes happened, in part, to having more horses that enabled the tribes to move farther and faster, coming into contact with other tribes and peoples along the way.

Like all other aspects of any isolated culture, once you begin to move and have more contact with other people, the faster your own culture and art grows. Broadening their horizons, by sharing their own, accepting other people's cultures, and modifying them for their own practical use helped the tribes grow and prosper as they moved forward.

Physically, the Crow were generally tall, with a lighter complexion and rounder face than many Plains tribes. The Earl of Dunraven, in his book, *The Great Divide-Travels in the Upper Yellowstone Summer in 1874*, described the Crow men as "tall and light colored, some over 6', but they lacked robust proportions like other Indians with long limbs, and rounded like a woman's."

# Scouts: Wolves For Both Sides

It is a pretty well established fact that the U.S. Army's use of Native scouts was crucial throughout all of the various Indian Wars, and without their help the army would have required considerably more resources and manpower to defeat and subjugate Indian people. This worldwide practice is as old as warfare and mankind itself. "Your enemy is my enemy, which makes us allies," is being used to this day and will always be around. Scouts could find the enemy, cut horses, then leave, and were not expected to fight unless they wanted to.

Some scouts were basically 'sub-contractors' who were hired for brief periods of time or for specific campaigns, while others were actually enlisted in the service with regular United States Army pay and pensions. They would be issued regulation United States military uniforms, which met with varying degrees of acceptance from Indian men. The Pawnee Scouts that worked for the North brothers were issued United States Cavalry uniforms, but soon discarded or altered most of those pieces.

When joining or offering their services to the U. S. Army, an oath was given to furnish true reports of what they found. Oaths like this were given in various ways, such as on the point of a knife, swearing on a gun barrel, a pipe, and even a hole in the ground. The thought behind these various oaths was that you would suffer wounds or death by such an object if you were not truthful, or—as in the case of a pipe—because it was a sacred item.

*The ages of the Crow scouts who signed on ranged from sixteen to sixty. It was the belief of White-Man-Runs-Him that the older men were enlisted to help 'advise and control the more youthful scouts' who would have to do the bulk of the hard scouting.*

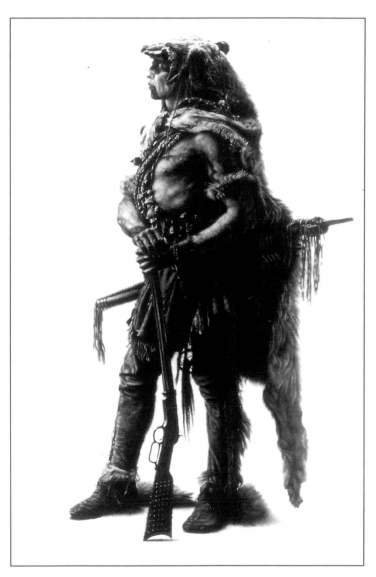

A WOLF WARRIOR, OR SCOUT FOR A WAR PARTY, IS PREPARED FOR HIS JOB, PAINTING BY JAMES BAMA

THE CROW SCOUT, WHITE MAN RUNS HIM

*White Man Runs Him and the other scouts were given an identification badge which consisted of a red piece of cloth that was to be worn on the left arm above the elbow. He was then informed his pay would be sixteen dollars per month with an additional twelve dollars per month being given for his horse. He was to be paid once every two months.*

*His identification arm band was a very essential item of the warrior/scouts kit. One of the disadvantages of being an army scout was the possibility of getting shot by a trigger happy soldier who thought all Indians looked a like. Scouts even fell victim of friendly fire from their own people as when White-Man-Runs-Him, Goes Ahead and Hairy Moccasin left General Custer at the Little Bighorn, they were soon joined by a number of Terry's Crows. The return to the Crow camp, now located on Arrow (today called Pryor) Creek, was uneventful until they were near their village. When the wolves (scouts) of the Crow camp saw the group coming, they mistook them for Sioux. Without waiting to identify the incoming scouts, a war party was quickly raised and charged out of the camp attacking the tired and unsuspecting group with White-Man-Runs-Him. The Custer scouts had no choice but to defend themselves against their own people. Goes Ahead shot and killed one horse and a second horse was killed by the spraying bullets before the group with White-Man-Runs-Him was recognized. (White Man Runs Him, page 123)*

Just like with Gibbons and Custer's scouts, the scouts of General Crook, known as Three Stars by the Indians, wore distinctive clothing of red shirts and red sashes. According to Dick Washakie, the young son of Chief Washakie who was prominent in the Rosebud fight, General Crook had all of his Shoshone and Crow scouts wear a strip of white cloth on their heads. Whatever method was used, some markings were generally given to Indian scouts in service of the government to prevent friendly-fire incidents. Red wool worsted sashes, as worn by United States Army Non-Commissioned Officers, were a common item used by Indian scouts and were worn as a head band, head wrapping, sash across the chest or around the waist. Any plain piece of red cloth was used, too. At the battle of the Little Big Horn, some of the Crow scouts painted the shoulders of their cloth shirts red. We do not know if most or all of them did this ,or if this was used only during that campaign, or in general use, or by just a few of the Crow scouts. What can be ascertained is that at least enough of them were known to do this for them to be able to be readily recognized as friendlies by soldiers and other Indians as well.

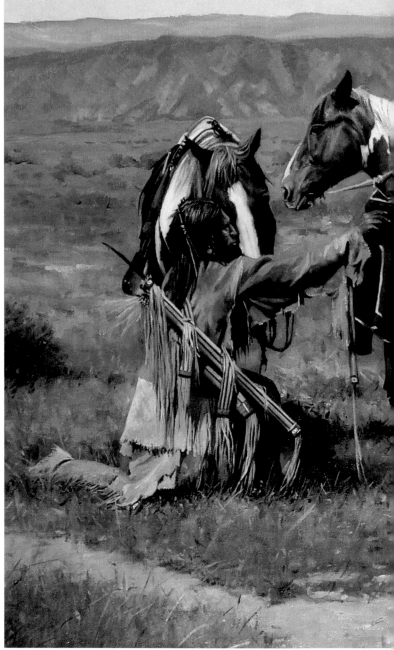

"THE OFFICER'S COAT" PAINTING BY JOHN FAWCETT

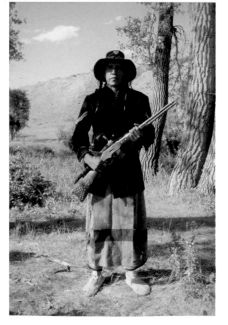

A CROW SCOUT FOR THE SOLDIERS STANDS READY FOR ACTION, 1876

In 1864, General Mitchell, of Nebraska, recruited eighty Pawnees as scouts, and uniformed them as Cavalry.

U.S. enlisted frock coats, especially those of the infantry, were available by the tens of thousands after the Civil War, along with sack or fatigue blouses, great coats (over coats with a cape, the infantry model was single breasted and had elbow-length capes, while the mounted version had a cuff-length cape and a double-breasted coat body), and mounted shell jackets, or round about, were all very popular. George Bent, the half-Cheyenne war leader, commonly wore a United States Army officer's frock coat, and Captain Howard Stansbury, from the United States Army Corps of Topographical Engineers, came across a Cheyenne traveling with a group of Lakota who were led by an old chief wearing green-lensed goggles. The old Cheyenne chief spoke no Lakota and wore a Major of Artillery frock coat. Many pairs of leggings were made from soldier trousers by simply cutting out the seat and crotch. This practice was illustrated quite often by Plains men in their ledger drawings.

*reason they stopped and turned toward the Dahl house. It was only a momentary diversion. When Charles realized his awful mistake, he "was paralyzed and unable to move from fright. (Dog Soldier Justice)*

## Scout Signals

A huge variety of signals and messages could be conveyed by utilizing the scout's own body, horses, mirrors, fires and smoke, fire arrows, blankets and robes. Special signals were designed to signal either the troops or the war/ hunting parties they were scouting for. Scout signals could easily vary from tribe to tribe and from war party to war party. New meanings to established signals could be agreed upon in advance and utilized on a new war party. Some were standard and understood by most. Many of these signals can easily be viewed across the prairies for several miles, and some, like fires and smoke, could be seen for fifty miles or more, depending on the conditions.

PRAIRIE FIRES WERE USED TO MOST TRIBES' BENEFIT FOR VARIOUS REASONS, BUT COULD ALSO BE A DANGER THEY HAD TO DEAL WITH FROM TIME TO TIME.

Blue Bead, the Crow, said that among the signals used by the Crow was the flashing of a mirror to indicate the sighting of the enemy. To signal someone to come nearer, a blanket was held out and turned. When the person to whom the message was to be given was very far off, the signaler ran back and forth to attract attention. Smoke signals were used in former days, but before Blue-bead's time. He said scouts sometimes used fire as a signal to show a war party where they were. (*Social Life of the Crow Indians*)

In her book, *Absaraka, Home of the Crows*, Mrs.. Carrington, the wife of Major Carrington, the commander of Fort Phil Kearney, noticed that local tribes used many looking glasses for signaling, along with flags for signaling, and many had field and spy glasses from Canada.

Even tribes hostile to the soldiers often wore a hodgepodge of U.S. Army clothing and equipment, so the presence of that alone was not always enough to say friend or foe. Sometimes it is easier and safer to fire first and ask questions later on the frontier.

An early settler along the Oregon Trail spoke of a group of Dog Men clad in soldier clothes:

> *Charles heard a noise, causing him to look in the direction of the Dahl home. To his surprise he saw about sixty men. Because they were all wearing blue overcoats, at first he thought they were cavalrymen. He proceeded outside to greet them. The Dog Soldiers saw him coming and brandished their spears in the air. One can imagine his fright as he realized his mistake. Shouting loud war whoops, the warriors advanced toward him and his brothers, who had followed him outside, but for an unknown*

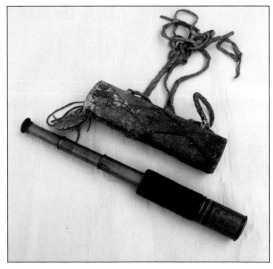

WHITE MAN'S SPY GLASSES WERE SEEN BOTH AS A TOOL AND A BADGE OF RANK AS ONLY THE HEAD OF ANY GROUP OF WHITE MEN CARRIED THE GLASS. HERE, ONE IS SEEN WITH AN INDIAN-MADE CASE.

The Crow, Hidatsa and Mandan     59

Scout signals could vary from tribe to tribe and war party to war party, but there are some typical ones we can document:

- Enemy Spotted "When the scouts rode in, waving their guns over their heads and howling, we all stood up. If they had only howled it would have meant buffalo, but the waving of their guns meant enemies." (Two Leggings)
- Buffalo spotted- scouts cross each others path at a distance when approaching party if great numbers seen they jump over chip pile, if only a thousand or less seen they quirt the pile in half. (Maximilian)
- Enemy spotted - run horses back and forth (Dodge)
- Enemy spotted - run in circles (Red Crow)
- Enemy spotted -howled like wolves and kicked a buff chip ahead of them, or howl three times like a wolf. (Plenty Coups)
- Enemies in sight - rider rides out away from main group then back to it.
- Approach of enemies - throw buffalo robes in the air (S. H. Long, *Expedition*)
- Enemies across the River - ride up and down the bluff, slowly, making motions with arms, then stopping and holding up buff robe to one side of head
- Enemy approaching- throw robes in air, (S.H. Long)
- Enemy village spotted- white goose or swan feather equals- Kurz
- Game in sight - riding up and down if game far away ride slow, if close, ride fast- if enemy far away hold up robe, if near ride directly towards camp. (George Bent)
- Enemy sighted – gallop ride up and down line then crosswise
- Buffalo sighted- slowly ride up and down in a straight line, often throwing dust in the air (Rudolf Frederick Kurz) Dodge also mentions the Métis scouts throwing handfuls of dust in the air when buffalo were sighted.
- "When we go to war, we generally send out a scouting party. If they find a camp they bark like a wolf." (White Man Runs Him)
- Buffalo spotted- scouts will cross each other's path at a distance when approaching. (*When Buffalo Ran*, George Grinnell (1849-1938))
- George Bird Grinnell gives several variations of the enemy or buffalo spotted. If enemy was close, instead of howling, stood sideways to war party and held heads down and barked like dogs. If enemy was moving away, ride in circles for the war party to come to them. (*When Buffalo Ran*, G. Grinnell )1849-1938))
- Danger, get together quick - riding rapidly in a circle (Dodge)
- Sign for retreat - ride horse back and forth (Plenty Coups)
- If one of their party has been killed, they run towards each other from opposite directions; as they pass, one falls to the ground (S.H. Long, *Expedition*)
- If any members were killed- scout arrived outside of camp and held a hand out and made a motion as though placing something on the ground, one motion for each dead (Red Crow)
- Scouts made imitation eagles nests in prairie trees to look out from ( Jonathan Carver)
- Scouts received sage in moccasins from Thunder Bow possessor so as not to tire (Grinnell, *The Cheyenne Indians*)
- Too many enemy, retreat- ride horse back and forth (Grinnell, *The Cheyenne Indians*)
- Water lily- spotted enemy 1st- tufts of grass in hair (Grinnell, *The Cheyenne Indians*)
- War party's members killed- scout approaches camp, makes motion of putting something on ground, one for each dead (Grinnell, *The Cheyenne Indians*)

Just as these various signals were used by Indians working for the Army or their own tribe, they also used the same methods of reporting to their leaders other news they had gathered. Some methods were variations of the approaching party of scouts kicking over or leaping over a pile of buffalo chips or sticks. Sometimes the sticks could represent horses or enemies, and the men would scramble to get one of the kicked sticks, believing each stick represented a horse or a man they would capture or kill. If the buffalo herd spotted were in great abundance, the scouts would jump over the chip or stick pile; if only 1000, then they would quirt the pile in half.

Generally an oath of sorts must be given before reporting what the scouts had seen. Some tribes required scouts to pass their hands down a pipe stem over the pipe, then rub their hands over their faces and head, arms, body, and legs.

As always, many variations existed for just about every aspect of Plains life, so returning Cheyenne scouts would build an earthen mound, then run around it four times, then sit facing the war party. Or this example of a Cheyenne scouting group:

*As they moved out in a body, the scouts began singing war songs. A stick was forced into the frozen ground and a blanket draped over it. Charging in, the two advance scouts knocked over the blanket, thus signaling that they would truthfully report what they had seen. – Sweet Medicine*

When an approaching scouting party was observed, the war party sat or stood in semi-circle waiting for the scouts report (Red Crow) Then the chief would lay his palm flat on ground when receiving news from scouts. (Stanley Vestal, *Warpath*) A pipe resting on a buffalo chip would be blessed and smoked after offering it to the east, south, west, north earth and sky. Then, when receiving the news, the chief would put his hand on the buffalo chip. This buffalo chip was moved closer to the chief each time a question was answered affirmatively. The burnt tobacco ashes were emptied from the pipe in four piles on chip. No one could pass between this chip and camp, everyone must go on the side toward the buffalo or they will scare the herd away.

One of the many fringe benefits of serving as a scout for the soldiers was that generally all the enemy horses captured by any actions involving the scouts were divided up among the scouts. To most non-Indians, the small, scraggly looking (but tough) Indian ponies were hardly worth riding or owning. Compared to a cavalry or settler's mount, the Indian ponies were much shorter, as they descended form Spanish Barbs. By the mid-1860s, Indian horses began to change in appearance as they interbred with European breeds. Being given the captured horses could still prove to be quite lucrative, considering the price of horses on the Plains. Once the enemy was found by the Native scouts and engaged by the soldiers, the scouts usually dropped out of the battle. They were paid to find the enemy and not necessarily fight them, though many times they joined in or were forced into the fray. They had come for the scalps and the spoils of the conflict, the Indian horses, and perhaps their women and any other booty they could capture or scavenge after the fight.

At the Battle of the Rosebud, June 17th, 1876, 250 Indian Scouts, consisting of 135 Crow Scouts and 115 Shoshone scouts, contributed greatly to the battle and helped turn the battle in favor of the soldiers and bring the fight to a draw.

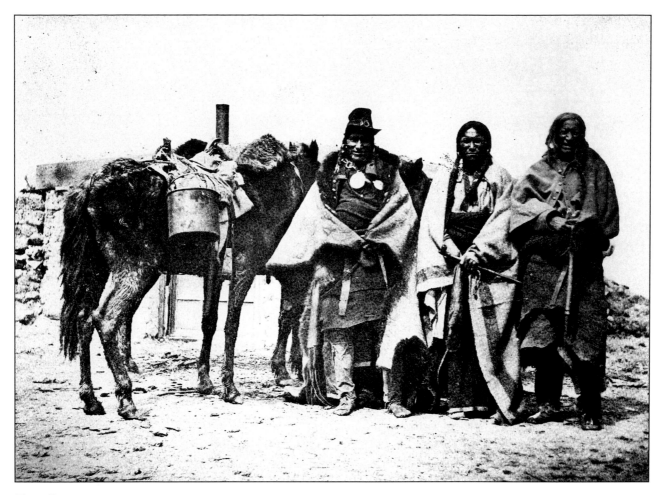

THESE CHEYENNE MEN WEAR A VARIETY OF SOLDIER UNIFORM ITEMS, INCLUDING AN OVERCOAT AND HARDEE HAT, AND GOODS ATTACHED TO THEIR SADDLES

Although the Cheyennes in this photo are not scouts, they are wearing a variety of U.S. military issue items, most of which were probably obtained peacefully in trade or as gifts. The man on the right has an enlisted, nine-button-front frock coat with branch of service in colored piping around the collar and cuffs. The main ones were light blue for infantry, red for artillery, and yellow for cavalry. Some others included green for medical, orange for dragoons, and black for engineers.

Another man wears a cut-down version of the dress Hardee or Jeff Davis hat. This was a high crowned and somewhat stiff hat with a full brim. This man has cut off the brim all the way around, except for right in the front, to make a visor out of the brim. This is more or less like the army's kepi cap. Regulation army style kettles hang from their saddles, too.

Musicians (including buglers and drummers as well as brass band members) wore an even flashier uniform with many rows of colored lace sewn to the chest. These jackets were highly prized by Plains men and are sometimes encountered in pictographic ledger drawings.

UNITED STATES ARMY ARTILLERY MUSICIAN'S SHELL JACKET

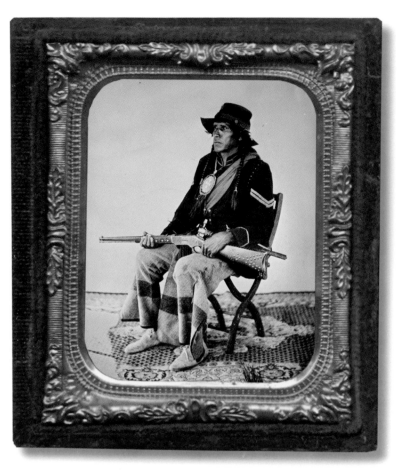

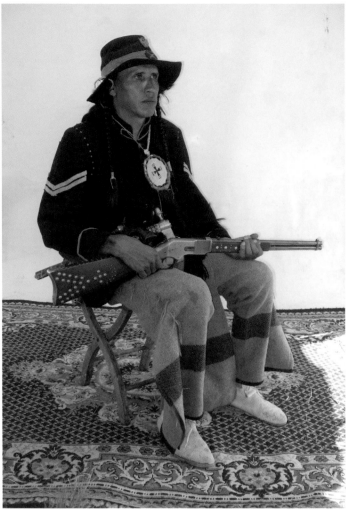

In the contemporary tintype pictured above, the Crow scout, Two Dogs, wears a United States Army 1851 Dress Hardee hat that has been modified and customized to his liking and particular taste. It has lost its naturally stiffened shape by prolonged use in the field by this warrior. An infantry officer's embroidered hat badge adorns the front, while flat 'coin' buttons are sewn around its edge. He wears the frock coat of a corporal in the infantry, with sky-blue piping for infantry and brass shoe buttons sewn around the shoulder and arm seams. A Lakota scalp adorned with black and white spotted 'skunk' or 'hail' beads hangs proudly around his neck. A beaded Maltese cross, or Morning Star design, has been beaded directly to the hide in its center, and a non-commissioned officer's wool worsted red sash crosses his chest and back and is tucked under his belt. Through this belt is thrust a brass-tack-studded pipe tomahawk and a Colt army revolver with the regulation 7.5 inch barrel. This is two inches longer than what people today would think of as your typical cowboy era pistol, which often had a 5- or 5.5-inch barrel. A favorite pistol of Indian scouts, and special ordered by the government for them, were nickel plated, Remington revolvers. The rifle he holds is an 1866 Winchester carbine, popularly dubbed the "Yellow Boy." It, too, has brass tacked designs worked into it.

NICKLE-PLATED REMINGTON 44 caliber cap and ball revolver and a SCHOFIELD SMITH AND WESSON 45, both favored by scouts and soldiers

INDIAN LONG ARMS, FROM TOP TO BOTTOM: HUDSON BAY TRADE MUSKET, LEHMAN PERCUSSION RIFLE, HENRY RIFLE, WINCHESTER 66 "YELLOW BOY" AND CUT-DOWN FLINTLOCK MUSKET

Of course, many designs we are able to interpret today, but many back then could have had different meanings to different people. A mountain has been tacked into the stock, crested by a star, and above that a crescent moon. When driving these tacks into any wooden handled items, it is a good idea to use a very small drill and make a hole half the depth of the tack shaft before driving the tack into the wood. This will help to keep your wood from splitting when driving in the tacks. I have never heard of this being done traditionally, though.

The 1866 Winchester carbine rifle is a good weapon within its limitations. It's first drawback is it is under-powered and short-ranged for a rifle. It actually fires a pistol cartridge, which gives the rifle a little more range and power than a pistol, but it is still a pistol cartridge nonetheless. It has more power and range because the longer barrel gives more time for the projectile to build up compression, which adds to the range. Also, the longer barrel adds accuracy, by giving the bullet more of a spin.

Plains men generally liked the Winchester 66 because they could get very close to engage with their weapons. This rifle held many rounds and could be fired at a rapid rate. The barrel came in several lengths, which determined how many cartridges could be held. Within 50 to 75 yards or so, this could be a deadly weapon. It is very hard to fire accurately from horseback at anything more than just a few yards away. All the soldiers' weapons were high powered and for long range.

The Henry rifle had a major flaw that the Winchester 66 addressed. It was the open loading and magazine tube that exposed ammunition to dirt and debris. Rifles like these were usually carried in the arms or across

the pommel of a saddle, but also were carried in leather gun cases. The best cases were made of elk leather, as it is strong and has a little stretch to keep its shape well. Some had straps, some did not. A simple leather or rawhide cord could just as easily be tied to the barrel and stock to carry it across the shoulders.

Covering the legs of the tintype-pictured Crow scout is a pair of wool leggings made from a United States Army Infantry blanket. These were large, heavy blankets weighing 5.5 pounds and generally measured 71" x 83." They were issued to soldiers as a double blanket, that is, two blankets still connected together as they came from the mill. Some soldiers preferred to keep them together while others cut them apart to make two blankets. (I have never seen it in print anywhere, but it has been my theory that the reason military or trade blankets have stripes on their ends is to easily discern which is the short end in the dark. The same holds true for socks, which have stripes on the open end. That practice has been in use for quite a while.)

The blankets had a large, eight-inch by five-inch, hand embroidered, black, US initials in the center. The cavalry blankets were blue with an orange stripe, and the artillery blankets were red with blue stripes. Many of these blankets were given out as gifts, annuity payments and were purchased by Plains Indians. Like most of the military items used by them, they were not generally captured items. The overall amount of items directly captured from soldiers was low, in comparison to the amount of warriors fighting and the amount of soldier-issue items actually worn and used by Indians.

Plain, side-seamed, soft-sole moccasins finish off this typical Crow scout's clothing (shown in the tintype image), as worn in the field.

Many warriors turned against their own kind, and even their own people, for various reasons. Once they had surrendered to the government, they realized they had few 'marketable skills,' other than being a hunter/warrior. George Bent wrote that Red Bead, or Red Drop, was the first Sioux to turn scout against his own people. Even well-known warriors and chiefs, such as Crazy Horse, put in time running down and bringing in other Indians. Most films and even documentaries leave the impression that Crazy Horse was captured, brought in to Fort Robinson, and murdered almost immediately. In fact, he had been in the service of the United States as a scout for almost four months prior to his death. These men cannot be faulted for turning to this work. They were predators on man and beast alike, and many just were not able to make the necessary transitions. It is hard for modern people to have the same thought processes and reasoning patterns as any less technologically primitive peoples, and they cannot understand why these men could not adapt.

Among the most famous scouts are the six Crow scouts who assisted General George Armstrong Custer's 7TH Cavalry at the Battle of the Little Bighorn. It is unfortunate that today animosities are held against the Crow and Arikara people for scouting for George Custer and the United States military against the Sioux in 1876. Many are unaware that Lakota men were also scouting for the Seventh Cavalry against Sitting Bull's camp that day, June 25th, 1876. The week before, 250 Crow and Shoshone were assisting General George Crook to find the same village, but they were attacked at the battle of the Rosebud. These tribes had held strong, vindictive grudges against each other for a century or more. The Crow had rather allied themselves with the United States than with traditional enemies. Chief Plenty Coups has said it best," We didn't side with the whites because we particularly loved them, it was because we wanted to save our beautiful land." They saw no hope in ever making peace with the Sioux and Cheyenne, and yet they saw strength with the United States to help defeat them. "Besides, we shall make the white man our friend. This is a fight for future peace, and I will carry the pipe for all who will go with me to the village of Three Stars." (Plenty Coups)

It was common for a scout to emulate and imitate the actions and look of the wolf, which was considered to be the best hunter in all the four directions. As most tribes did often, White Man Runs Him would paint his face, ears, arms and body with mud. When the mud dried it produced a whitish-gray color similar to the coat of a wolf. Sometimes the scouts would wear a wolf skin over their shoulders and back, with a wolf's head pulled down over the eyes, to hide their face from view.

Plenty Coups tells us that ears of mud were put on scouts to resemble wolves' ears, and they plastered mud to their hair with clay and even painted their horses with wolf-colored clay.

White Man Runs Him reminds us that "A real wolf watches everything that moves. So must a human wolf or scout." (White Man Runs Him) Scouts looked for birds flying to and fro that were watching for buffalo hunters or war parties in the anticipation of a free meal. They watched game fleeing in an unnatural direction or acting in unusual ways. Any bird that deviated from its flight path was observed as a sign of caution, or at least something requiring further investigation. Plenty Coups said they knew a buffalo hunt had recently happened near by, as the buffalo cows and calves were calling and looking for each other.

Whether working for the U.S. Army or for their own people, serving as a scout was a great honor and a step in the direction of eventually becoming a pipe carrier or war-party leader, and perhaps a social chief later on in life. The Indian scout, or wolf, was the modern-day, military equivalent of re-con units or forward observers who serve as radio and communications men by being able to deliver accurate information of an enemy's size, location, condition, etc. Only the most trustworthy men usually made up the scout ranks. Your duty as a scout was to find the enemy or buffalo and report back to the leaders who would decide what action was to be taken. This required the service of the most dependable men, as temptation could be great to capture or attack anyone they came across. Yellow Wolf said, "If scouts fired at enemy instead of reporting back, they were whipped by the warrior societies." (Yellow Wolf) Sometimes the temptation to stretch the truth or outright lie was strong enough because of the amount of praise and honor successful warriors received. In his book, *When Buffalo Ran*, George Grinnell wrote about a scout who admitted he lied about the number of buffalo spotted because he wanted to hear his name sung, etc. Luckily, it turned out to be true and no one ever knew.

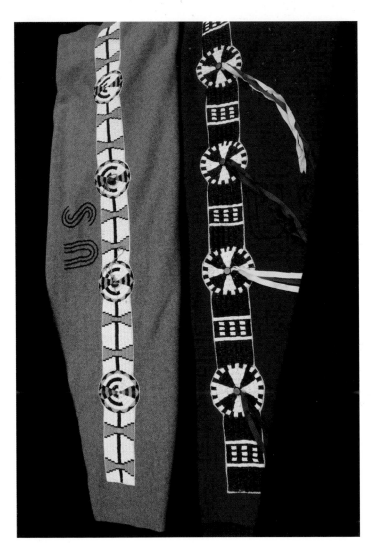

UNITED STATES INFANTRY AND ARTILLERY BLANKETS, WITH BEADED BLANKET STRIPS

# The Hidatsa

The Hidatsa are a Siouan speaking people who lived at the junction of the Knife and Missouri Rivers in North Dakota. Their closest allies were the Mandan and Arikara, with which they fought in common defense against the various Sioux factions. The Hidatsa language is closely akin to that of the Crows, with whom they were once a tribe before the historic period. The two separated in consequence of a quarrel over the division of a white buffalo stomach, while the Crow tell a story of two brothers who quarreled over tobacco. In the end, the Crow became permanent tipi dwellers, living further to the west, while the Hidatsa continued in their earth lodges along the Missouri and Knife Rivers. The Hidatsa and Crow continued as allies and traded and visited often with each another.

The name Hidatsa means "willows," and is said to have been the original name of a principal village on the Knife River. This became the name of the tribe after the smallpox epidemic of 1837, when the survivors of two villages consolidated there. The Mandan name for the Hidatsa is " Minitarí," signifying "they crossed the water," traditionally said to refer to their having crossed the Missouri River from the east. The Crow call the Hidatsa "Amashi," meaning "earth lodges," but often the Hidatsa are called "Gros Ventres." This is not to be confused with the "Atsina," who are also known as the "Gros Ventres of the prairie."

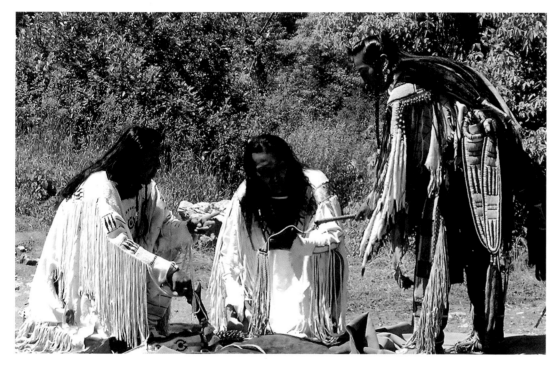

THE CROW, HIDATSA AND MANDAN WERE ALL ALLIES FROM AN EARLY DATE. HERE THEY ARE SEEN TRADING.

According to their own tradition, the Hidatsa came from the neighborhood of a lake north east of their later home, and identified by some of their traditionalists with Mini-wakan or Devils Lake, North Dakota. They had here the circular earth-covered log house, in use also by the Mandan, Arikara, and other tribes living close by along the upper Missouri River, in addition to the skin tipi occupied when on the hunt. Perhaps because of attacks by the Sioux, they moved southwest and allied themselves with the Mandan, who then lived on the west side of the Missouri River, near the mouth of Heart River. The three tribes, Hidatsa, Mandan, and Arikara, were all living in this vicinity about 1765. From the Mandan the Hidatsa learned agriculture.

WARRIOR MEN ON THE TOP OF A HIDATSA EARTH LODGE

VIEW FROM THE TOP LOOKING INTO THE SMOKE HOLE OF A HIDATSA EARTH LODGE

The Hidatsa learned much about Plains life from the well established Mandan, as did many of the other tribes that would be migrating through their territory from the east. Some time before 1796 the Mandan and Hidatsa tribes moved up the river to the vicinity of Knife River, where they were found by the explorers Lewis and Clark in 1804, the Hidatsa being then in three villages immediately on Knife river, while the Mandan, in two villages, were a few miles lower down, on the Missouri.

Much of their diet centered on the variety of crops they grew. Corn, beans, and squash were their staples, and several varieties of each crop were grown. These were supplemented with large annual communal buffalo hunts and year-round hunting of local small game, though game in the immediate vicinity of their villages was usually sparse, due to over hunting and the game being afraid of the tribes. Both the Mandan and Hidatsa were also great fishermen, as the thousands of bones littering their villages attest to.

Early writers describe the Hidatsa as somewhat superior intellectually and physically to their neighbors, although according to Matthews this is not so evident in later days. Various writers did describe the Hidatsa as neater and cleaner than many tribes, including the Mandan.

It was said that the men rarely wore shirts, having their arms and bodies painted, usually with red ochre. Tattoos were common, generally on half of the body only, either the right or left. The right side was tattooed often, as it was the side left exposed when wearing a buffalo robe.

In home life, religious beliefs and customs, house building, agriculture, the use of the skin boat, and general arts, Hidatsa taste closely resembled the Mandan with whom they were associated. Their great ceremony was the Sun dance, called by them Da-hpi-ke, which was accompanied with various forms of self-mutilation or blood sacrifice. On their chest, most Hidatsa men had three or four welts in parallel semicircular lines 20 centimeters wide, from flesh offerings and participating in the Sun Dance. Their warriors were organized into complex military societies, as is the case with most Plains tribes.

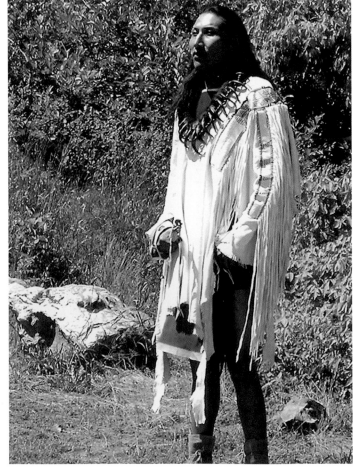

A HIDATSA MAN

The largest of the three villages of the tribe was called Hidatsa and was on the north bank of the Knife River. The other two, Amatiha and Amahami (or Mahaha) were on the south side. The last named was occupied by the Amahami (called Ahnahaway by Lewis and Clark), formerly a distinct but closely related tribe. In consequence of the inroads of the Sioux, they had been so far reduced that they were compelled to unite with the Hidatsa, and have long since been completely absorbed.

The three villages together had a population of about 600 warriors, equivalent to about 2,100 to 3000 souls. Of these, the Amahami counted about 50 warriors. There was no change in the location of the villages until after the smallpox epidemic of 1837, which so greatly reduced the Indian population of the upper Missouri, and as a result the survivors of the three villages consolidated into one. This consolidated village of the remaining Hidatsa, Mandan and Arikara was called "Like A Fish Hook Village." It was established even further north along the Missouri on a hard turn of the river, which resembled a fish hook. The trading post Fort Berthold was soon established near the village, to serve the three tribes. In 1862, the Arikara tribe moved into the village as well, because of continued pressure from the Sioux tribes.

They had a very elaborate system of pictorial ranking devices and war honor markings; their cousins the Mandan probably had the most advanced markings of all the Plains nations. Much of this was because the Hidatsa-Mandan had been organized as tribes longer, and more so because they were farmers, which, like the world over, allowed them more free time to devote to the arts, sciences and social development.

Arrowhead Earrings' hair is bunched and bound in the front and cut off so that it stands erect. This symbolizes that the warrior stood alone against the enemy when all others had fled. His head feathers show many honors. The two golden eagle tail feathers tipped with ermine and horse hair represent he having killed, scalped and counted first coup all on the same two men. Without having accomplished this feat, the additions of the horse hair and ermine could not have been added.

Two small arrows show he was wounded twice with arrows. A mass of blue heron feathers show he has spotted enemy villages or camps by seeing the smoke from their fires. Scouts earning such honors knew that the early morning was considered the best time to look for smoke, as it would rise and settle just above the village site before the day warmed up and lifted the smoke up and dispersed it away. Had he spotted a village by seeing their tipis, he would have been allowed to wear seagull wing feathers, because they look like a used tipi: they are white for the bottom two thirds and grey on the top.

The choker of human finger tips is more typical of the Ute and Cheyenne tribes, but could easily have been obtained in battle or trade, or his own design. A large grizzly bear claw necklace denotes both wealth and power, as only successful men who had the heart and power of the grizzly, or had killed a grizzly bear, could wear one. Prince Maximilian said one grizzly claw necklace made with large claws had the trade value of $12, or six to twelve buffalo robes.

The large deer skin shirt has been painted half black and half red ochre, along with the leggings, showing that he has gone in search of an enemy, hunted that enemy down, and single-handedly killed and scalped him. Only men performing this feat were allowed to paint their clothing in this half-and-half pattern.

As demonstrated in the photographs of the Hidatsa shirt and leggings owned by Arrowhead Earrings, shown below, beginning at the top and working our way down the markings.

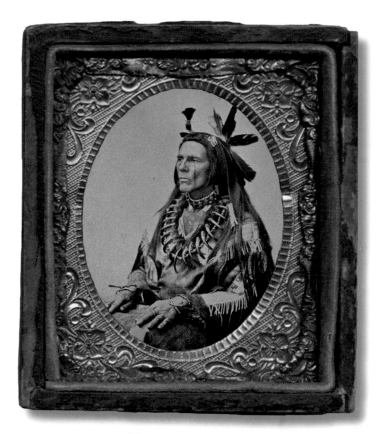

HIDATSA, CONTEMPORARY TINTYPE PHOTOGRAPH

TWO HIDATSA VILLAGE SITES TODAY. THE HIDATSA AND MANDAN VILLAGES WERE CLOSE ENOUGH TO SUPPORT EACH OTHER IN TIMES OF NEED, BUT FAR ENOUGH AWAY FOR COMPORT AND TO ALLOW EACH TRIBE THEIR OWN ROOM AND LAND.

The Crow, Hidatsa and Mandan    67

The black human hair locks that fringe the shirt and leggings denote a successful war party leader, and the dyed red horse hair locks show he has led men on successful horse-capturing expeditions. A small piece of real scalp with the skin attached has been attached to the upper end of both quilled sleeve strips, and the top of his legging quilled strips. This shows he has led more than four successful war parties where human scalps were taken. The long row of painted pipes on the left side of his shirt tell how many war parties he has led, the pipe being the symbol of the war party leader. Often times you will see a crude pipe drawn or painted across the waist line of a pictographic figure on a robe or shirt, or decades later in ledger drawings. The human stick figures on the right side represent his personal victims. As is commonly seen, women are included in this tally.

Other deeds drawn on to the shirt include numerous individual coup marks that have been painted on the left sleeve. The right sleeve has a series of four pairs of two red marks, which show that in a battle he had killed or counted coup on the last enemy killed or touched. Two crosses joined together tells the story of rescuing a dismounted warrior friend in battle under fire from the enemy. Most of these symbols could be painted or tattooed directly to the body and/or painted onto your robe, shirt, lodge or horse in battle or in parade.

The construction technique of the shirt is clearly shown when laid flat. It takes two large deer or big horn sheep hides to make a shirt on this early pattern. The entire animal is skinned from the tail, down past the knees and up to behind the ears and cheeks. The whole hide is then tanned with these appendages left intact. Three quarters of each hide makes up the shirt body, front and back. The upper one third, complete with both front legs and neck is folded in half to make each sleeve. The sleeves are generally only laced with thin leather thongs or sewn with sinew, from just above the elbow to the wrist. This is usually a fairly tight fit. The sides of the shirts may be left completely open or be held together with just two or three ties.

Like most men's clothing, the garment has been made with the hair side, or original outside of the animal facing out. Women's clothing was done the opposite way, with the flesh side facing outwards. We believe the reason women's clothing is usually made with the flesh side out is because women usually beaded directly onto their clothing; a man's bead or quillwork was usually done on a separate strip. Bead or quillwork is done easier on the flesh side than on the hair or surface side of a hide.

The men's strips were sewn on because men wore their dress clothing much more often than the women wore their's, and men's clothing tended to be made from thinner hides than women's. All of these reasons made men's leather wear out faster. In earlier style shirts especially, the hair trim around the edges of the hide may be retained on the finished garment, and therefore that leather was used hair-side out.

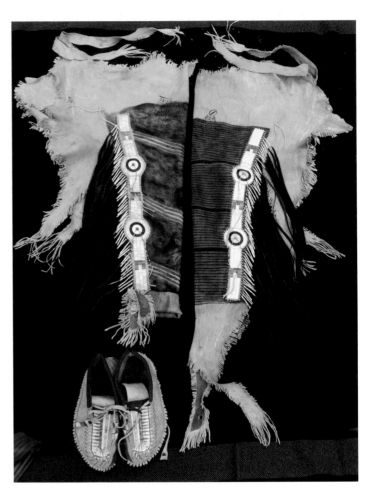

HIDATSA LEGGINGS AND MOCCASINS

Early style leggings, like those shown above, were simply made as well, using most of two deer, antelope or big horn sheep hides, one for each leg. The hides are placed head down and folded down the spine line of the animal. The hide legs are used to tie the legging to the belt. Sometimes this belt would be a separate one from the belt that held the breechcloth.

As with most Indian knots, this one would be a slip knot that would allows the leggings to be quickly tied or removed. A natural flap made from the animal's neck, or added-on flaps, were at the bottom of the legging. This flap or appendage, along with the legging fitting tightly to the calves, allowed for a snug fit, something necessary when riding horses, either bare-back or on a pad saddle. The flaps also facilitated rapid removal of the legging. By untying the legging at the belt and ankle, then stepping on the now-loosened flap with the opposite foot, you can easily pull your leg out of the legging without using your hands.

Among the Hidatsa, once a man had had counted four first coup, he was entitled to paint his left legging red. This left legging reflects, the same as the shirt, being a war party and horse raid leader, many coups, arrow, lance or knife wound on the thigh, and a scalp piece with scalp

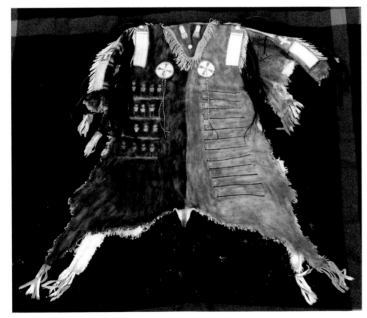

HIDATSA SHIRT

intact at the top of the legging strip indicates more than four war parties led where scalps were taken.

The right legging tells the same about war parties led, etc. as well as having killed the first enemy in a battle or among the first four to strike the same enemy in a battle. This was considered a lesser honor than striking or killing the last man in a battle. This feat was shown by the three sets of three diagonal lines painted on the legging. On the lower right calf, a red X surrounded by four dots placed within the angles of the X shows that in a battle, when only one enemy was killed or struck, the wearer was in on that feat.

A coup symbol similar to the X design, according to Mallery, was four lines crossed in "tic-tac-doe" fashion, which means "fought off the enemy from a barricaded position." This sign can be seen painted on the naked thigh of the Crow warrior Bull Snake, in the 1909 portrait by Joseph K. Dixon, shown in the book *Vanishing Race*.

Arrowhead Earring's moccasins have a horned headdress worked in porcupine quills on their tops, showing that he has given away such a headdress. Since he has scalped an enemy, a red stripe has been painted with Chinese vermillion from the toe to the heel. Having accomplished this one or more times, the other moccasin has been painted the same.

Many types of moccasin trailers could be made and worn, but some had very specific meanings and denoted certain honors. On the left moccasin, a kit fox tail is worn (indicting a successful scout for a war party that spotted the enemy and reported the find to the war party leader). It has a three-fingers-wide red stripe painted around its center (indicating that when his find was reported to the leader and he led the war party back, during the attack he killed or counted to coup on one of the enemy) and the end of the tail has four crow feathers that have had the feathers removed from the vein except for the very tip. (Human hair locks have been attached to these trailers too, showing that more than six successful war parties have been led.)

The right moccasin trailer is made from a skunk skin, and it, too, has human hair locks. The skunk skin trailer showed that the wearer had given up a war honor he felt he had coming to him, but when that war honor was contested by another who claimed the right to it, he gave it up to keep the peace, so to speak. This magnanimous act was rewarded with what could be considered by some today as a 'booby prize', but they actually saw it as a high honor. It is good to remember that Plains tribes respected the skunk for its ability to repel enemies without even a fight.

AN 1804 CHIEF'S FLAG, MADE BY THE U. S. WAR DEPARTMENT FOR INDIAN CHIEFS, AND CARRIED BY CAPTAINS MERIWETHER LEWIS AND WILLIAM CLARK TO PRESENT TO PROMINENT CHIEFS ALONG THEIR ROUTE TO OREGON

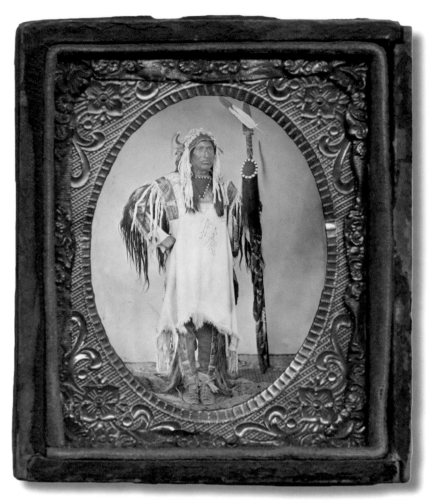

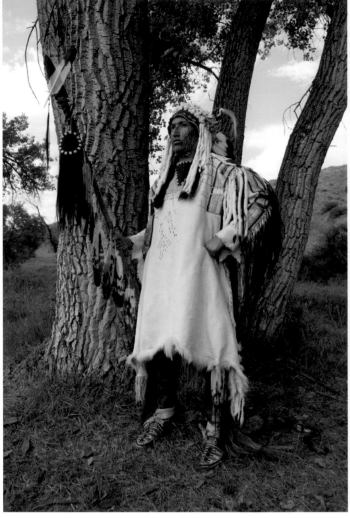

MATO TOPE, FOUR BEARS, MANDAN SECOND CHIEF, CONTEMPORARY TINTYPE AND COLOR PHOTOGRAPHS

# The Mandan

Four Bears, also known as "Mato-tope," is shown in the original tintype photograph above. He was the second chief of the Mandan, during the first half of the nineteenth century. He earned the name Four Bears after charging a group of Assiniboine in a battle, with the strength of four bears, it was said. Four Bears lived on the upper Missouri River in what is now North Dakota. His village was associated with four other villages of Hidatsa and Mandan people. Known as the Knife River Indian Villages today, they were actually separated into three Hidatsa Villages to the north, along the Knife River, and two Mandan villages to the south, along the Missouri River. The two Mandan villages were Metutanke and Ruptari, and were situated about four miles below the mouth of the Knife River.

These Siouan speaking peoples had slowly been working their villages up the Missouri River for a thousand years or more. During this slow migration north, and as their building skills improved, their lodges evolved from rectangular to the more difficult and familiar round earth style. Crude palisade walls with a trench in front were added for defense as more tribes worked their way west. Previous to the addition of these, other tribes' walls were not present around their villages.

When first entering one of these earth lodges, you are met with the smell of the cut willows that thickly line the ceiling under the log rafters. Then the odors of horses, earth and fire greet the visitor's senses.

A MANDAN VILLAGE.

The first recorded visit by a white man to the Mandan was made by the Sieur de la Verendrye in 1738. About 1750 the Mandan were settled near the mouth of the Heart River in nine villages, two on the east and seven on the west side.

The Mandan's closest allies were traditionally the Hidatsa, another earth lodge people who moved nearby for a common defense from the

Sioux. The Mandan and Hidatsa both realized the fine line between human relations, so agreed to build there villages "close enough to stay friends but not far enough to become enemies."

By 1805, the world of the Mandan and Hidatsa had shrunk to these five villages, due to persistent attacks by the Sioux and several waves of epidemics. Later, Fort Clark, a major trading post of the American Fur Company, was constructed next to these villages.

Four Bears belonged to the Mandan tribe who were a Siouan speaking tribe of people found living along the Missouri River during historic times. Linguists place the Mandan closest, language wise, to the Winnebego tribe further to the east. The Mandan name probably originated with the Sioux, and is believed to be a corruption of the Dakota Mawatani. Previous to 1830, however, the Mandan called themselves Numakiki, "people." Prince Maximilian wrote, "if they wish to particularize their descent they add the name of the village whence they came."

Four Bears was a favorite subject of artists who visited these villages early on, such as George Catlin and Karl Bodmer. Among his people he was known as a brave warrior, famous for killing a Cheyenne chief in hand-to-hand combat, of which he painted this and his other war exploits on several of his now-famous buffalo robes. George Catlin wrote of Four Bears:

> *The second chief of the tribe is Mah-to-toh-pa (The Four Bears). This extraordinary man, though second in office, is undoubtedly the first and most popular man in the nation. Free, generous, elegant and gentlemanly in his deportment -- handsome, brave and valiant; wearing a robe on his back, with the history of his battles emblazoned on it; which would fill a book of themselves, if properly translated. This, readers, is the most extraordinary man, perhaps, who lives at this day, in the atmosphere of Nature's noblemen; and I shall certainly tell you more of him anon." (George Catlin, Letters and Notes on the Manners, Customs, and Conditions of North American Indians)*

During his stay at the Mandan villages, George Catlin made friends with Four Bears, who was then 32 years old. While Catlin sketched the chief in many poses, Four Bears drew his own pictures of his war deeds, including the other four enemy chiefs he had killed in his lifetime. The two men ate, talked, and smoked together in Four Bears' earth lodge and shared a common admiration and respect for one another.

LOOKING UP AT INTERIOR CEILING OF A HIDATSA EARTH LODGE

INSIDE AN EARTH LODGE, WHERE BUFFALO HIDE TIPI LINERS ARE DRIED BY THE FIRE.

The Crow, Hidatsa and Mandan    71

Early explorers described the Mandan as vigorous, well made, rather above medium stature, many of them being robust, broad-shouldered, and muscular. Their noses, not so long and arched as those of the Sioux, were sometimes aquiline or slightly curved, sometimes quite straight, never broad; nor had they such high cheek bones as the Sioux. Some of the women were robust and rather tall, though usually they were short and broad shouldered. Tattooing was practiced to a limited extent, mostly on the right breast and area, with black parallel stripes and a few other figures.

The Mandan villages were assemblages of circular, sod-covered, slightly vaulted lodges placed close together without regard to order. In ancient times they were surrounded with palisades of strong posts. In the center of the roof was a square opening, for the exit of the smoke, over which was a circular screen of saplings, sometimes covered with bullboats for protection from heavy rain. The interior was spacious with four strong pillars in the middle and several crossbeams supporting the roof. The dwelling's outside was covered with matting made of sod, over which was laid hay or grass, and then a covering of earth. The beds stood against the wall of the hut. They consist of a large square case made of parchment or skins, with a square entrance, and are large enough to hold several persons, who lie very conveniently and warm on skins and blankets. They cultivated maize, beans, gourds, and the sunflower, and manufactured clay pots, the clay being tempered with flint or granite reduced to powder by the action of fire. Polygamy was common among them. Their beliefs and ceremonies were similar to those of the Plains tribes generally. The Mandan have generally always been friendly with whites.

In 1837 the Mandan were almost destroyed by smallpox, only 31 male heads of families survived, with a proportionate number of women and children, about two hundred people being left, according to one account, although other and probably more reliable accounts make the number of survivors from 125 to 145, which does not diminish the tragedy. The famous Four Bears died of smallpox as well, on July 30th, 1837. Smallpox was mistakenly brought up the Missouri River on the American Fur Company's steamboat *St. Peter*. Despite warnings from the captain about the smallpox-infected crewman aboard, some Indians boarded the vessel. Four Bears' hospitality to outsiders was no protection against the scourge that struck with a vengeance.

 The disease spread on to take half of the Hidatsa, who had just returned from their summer hunt. The Arikara, who would eventually ally with the Hidatsa-Mandan, were still in their nomadic phase following the Leavenworth attack of 1822, and were on the Yellowstone River when the smallpox struck. They were one of the few tribes who were unaffected, which is the reason they could show up at Knife River in force, in 1838, and take over the site of Mi-tutta-hang-kush village, after it had been burned by the Yanktonais.

Before his own death, Four Bears lost his wife and children to the disease, and in his last speech to the Mandan, it was recorded, he denounced the white man he had previously treated as a brother for bringing the disease to his people. Four Bears lamented that in death his scarred face would be so ugly even the wolves would turn away from him.

When the Hidatsa removed from the Knife River in 1838, some of the Mandan went with them and others followed at intervals. They moved up the Missouri River to various sites, finally settling at Fishhook bend in the winter of 1845-46. According to Mathews, some moved up to the village at Berthold as late as 1858.

In Lewis and Clark's time (1804), the Mandan were estimated to number 1,250. In 1837, about 1,600 souls, but they were reduced by smallpox to between 125 and 150. In 1850 the number given was 150, in 1852 it apparently increased to 385, in 1871 to 450, in 1877 the number given was 420, it was 410 in 1885, and was 249 in 1905.

The recreated color image of Four Bears, shown above on page 70, wears the dress regalia and clothing he chose to wear when Karl Bodmer, the Swiss artist, painted him in April of 1834. His face is painted in the black striped design of the Mandan Dog Society with red lightning bolt accents. His shirt is made on the early two hide style, but instead of small thin fringing around the edges, the natural hair of the animal has been left intact in a narrow border. On his left shoulder is a record of his many kills, and on his right his coup marks and weapons captured are recorded.

Like the Hidatsa the black hair locks denote a successful war party leader, and the red horsehair identifies a successful horse raid leader. The ermine strips' meaning can vary from tribe to tribe, but among the Mandan/Hidatsa/Crow it meant that a gun was taken from the hands of a live enemy. This did not include men who surrendered, which was a foreign concept to Plains men. At the top of each hair or ermine skin drop, a blue 'padre' trade bead has been added to further enhance the shirt's beauty and overall value.

Four arrow or knife wounds and one bullet wound have been painted on the shirt's body to represent his real-life wounds. These wounds may have been in different parts of the body, but it was common to paint the wound mark over the actual wound on the body, regardless of its esthetic or artistic value.

Elaborate porcupine quill embroidered strips bordered by blue, white and black pound beads adorn the shoulders and sleeves. Golden eagle tail feathers tied to his shirt sleeves tell that while leading a war party, he found a dead golden eagle.

The leggings, though having matching quilled strips, have been painted differently. The left legging has many coup marks painted on it. These do not show up well, as at some point they were painted over or stained with soot, more than likely during a scalp or victory ceremony where items may be blackened to symbolize victory. Likewise many tribes used the black on their faces to symbolize the same thing, as the black showed that the fires of vengeance and killing have been burned out of one's heart, temporarily anyway. The right legging is red ochred, and both have dyed yellow and blue horsehair locks, the tops of which have been wrapped with white, undyed porcupine quills. What appears to be tops of his moccasins are actually the bottoms of his leggings, rolled up and tied.

FOUR BEARS' LEGGING BOTTOM AND MOCCASIN TRAILERS

The moccasins are typical, soft-soled, and adorned with a combination of beads and porcupine quills; they have war-honor-marking, wolf-tail trailers or drags. The human hair locks on the ends prove that Four Bears led more than six successful war parties.

The lance Four Bears holds has sixteen mature golden eagle tail feathers, each individually tied to the shaft, more or less at random. The metal trade point head is painted red and is bound to the shaft, then wrapped with red ochre-stained leather. A human scalp has been backed with red wool and then the edge beaded with black and white beads.

Tied cross-wise to the lance point shaft is an immature golden eagle tail feather and a human hair lock. This represents the time Mato-tope went on a raid to avenge the death of his brother at the hands of an Arikara chief. He single-handedly went on this revenge raid and traveled six days to the Arikara villages, eating only parched corn along the way. He snuck into the chiefs earth lodge, rested, ate some of his food and smoked his pipe. Then he calmly kicked the ashes around for some more light, took his lance and drove it into the Arikara, killing him. As he did so, one of the eagle tail feathers from his lance fell off and stuck in the wound of his enemy. As Mato-tope was leaving, he turned and saw this feather as a sign from the Creator, so he retrieved the feather and never replaced it on his lance, but hung it to the point, as shown. The scalp lock hanging on the feather was from the scalped Arikara, too.

The horns on his split-buffalo-horn headdress have been carved and shaved thin, to make them lighter and add considerably to their elegance. It was then covered with thin slips of ermine fur. The strips can be sewn on individually or in overlapping pieces, approximately nineteen centimeters long by five centimeters wide. The strips are then fringed to the point where they have been sewn onto the leather cap in one piece. These pieces must be applied like shingles, in overlapping layers. When cutting any type of fur like this, it should be done from the back with a sharp knife or razor, not with scissors; otherwise, the fur will be cut in distinct lines.

'Coin' buttons, which were a common button used by civilians and military alike in the 18th and 19th centuries, were readily available at trading posts. They have been laced onto the red cloth brow band by punching a hole through the wool and inserting the eye of the button before threading the leather through.

A small carved and painted wooden knife is tied to the headdress crown to signify the time Mato-tope killed a Cheyenne chief with the Cheyenne's own knife. Bull, the Lakota, used a similar wooden knife painted red to signify his having taken a scalp.

Mato-tope (Four Bears) told his story of his fight to Prince Maximilian zu Wied. This is how it was transcribed:

*He had killed many enemies, among whom were five chiefs. He gave me a fac-simile of a representation of one of his exploits, painted by himself, of which he frequently gave me an account. He was, on that occasion, on foot, on a military expedition, with a few Mandan, when they encountered four Cheyenne, their most virulent foes, on horseback. The chief of the latter, seeing that their enemies were on foot, and that the combat would thereby be unequal, dismounted, and the two parties attacked each other. The two chiefs fired, missed, threw away their guns, and seized their naked weapons; the Cheyenne, a tall, powerful man, drew his knife, while Mato-Tope, who was lighter and more agile, took his battle-axe. The former attempted to stab Mato-Tope, who laid hold of the blade of the knife, by which he, indeed, wounded his hand, but wrested the weapon from his enemy, and stabbed him with it, on which the Cheyenne took flight. Mato-Tope's drawing of the scene in the above-named plated, shows the guns which they had discharged and thrown aside, the blood flowing from the wounded hand of the Mandan chief, the footsteps of the two warriors, and the wolf's tail at their heels-the Cheyenne being distinguished by the fillet of otter skin on his forehead. The buffalo robe, painted by Mato-Tope himself, and which I have fortunately brought to Europe, represents several exploits of this chief, and among others, in the lower figure of the left hand, the above-mentioned adventure with the Cheyenne chief. (April 9, 1834)*

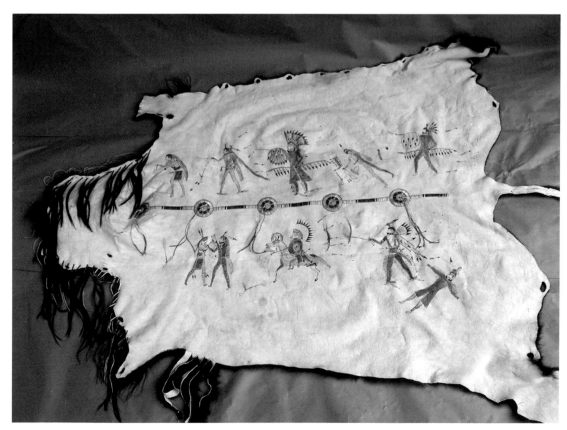

MATO TOPE, FOUR BEARS' WAR ROBE, PAINTED WITH HIS WAR EXPLOITS AND DECORATED WITH A BIRD-QUILL EMBROIDERED STRIPE

The Crow, Hidatsa and Mandan    73

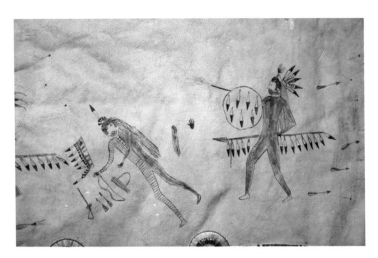

FOUR BEARS KILLS AND SCALPS AN ENEMY, FROM HIS BUFFALO ROBE

Four Bears carries a gun in the same hand as his shield, and he has probably shot the falling-forward victim in front of him. Even though we do not see any blood, we know he was killed and scalped, as well as coup counted on him, due to the scalp and black hand behind the enemy. He has dropped his quiver, bow and arrows, and gun.

The next figure, in the center, is Four Bears in more full battle regalia with an elaborate flare-style headdress, a red broad cloth chiefs coat and the same leggings, moccasin trailers, and lance as painted by Bodmer. He carries the same shield as the first painting too, and again he shoots his gun from under the shield.

Trying to accurately interpret such robes, shields and other items can, at best, sometimes be tricky and nothing more than an educated guess. With Four Bears robe we do have some of the actual meanings as told by Four Bears himself. Besides depicting some of his greatest exploits, the human and dyed horse hair locks that have been quill wrapped with blue and white quills and attached to the head of the buffalo robe tell a story, too. This award/decoration was reserved only for men who had led seven or more successful war parties where enemies had been killed while under his command.

Working from the upper right-hand side of the robe and reading it right to left, we find Four Bears in the midst of a major battle, with bullets and arrows flying thick about him. He carries what appears to be the same lance as illustrated by Bodmer and Catlin. His hair is gathered and bound and he wears the same feathered headpiece as painted by Bodmer, in his detailed portrait of Four Bears.

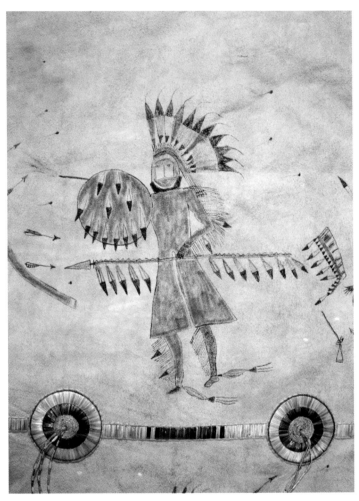

FOUR BEARS, WITH THE SAME LEGGINGS AND LANCE AS PAINTED BY BODMER

Moving to the left, we see what we can presume is Four Bears, as he has the same hair style and face paint as illustrated by Karl Bodmer. He wears the red no-retreat sash of the Dog Society and carries a trade tomahawk with a prepared scalp attached to the handle. He has just shot the man to his front, the enemy had faced him and fired but missed Four Bears, he was then shot by Mato-tope, and dropped his gun and tried to get away.

The chief bleeds profusely from numerous wounds to his torso, though he too must have just taken a life or wounded one of Four Bears friends, as the blade of his knife is red with blood and what is probably a fresh scalp is hung from his belt.

On the lower right hand side of the robe, we see him walking over a killed enemy who wears a multi-colored, hair-lock fringed chief's coat too. This man appears to be shot in the chest and black is used for blood instead of red, more than likely because he already wears a red coat. A typical way of portraying this

KARL BODMER'S PORTRAIT OF FOUR BEARS; HE WEARS THE
HEADDRESS HE DEPICTED IN SOME OF HIS OWN DRAWINGS

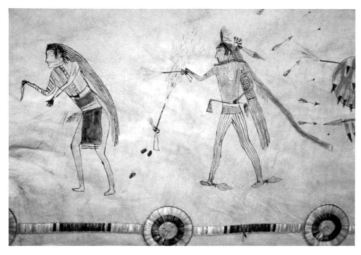

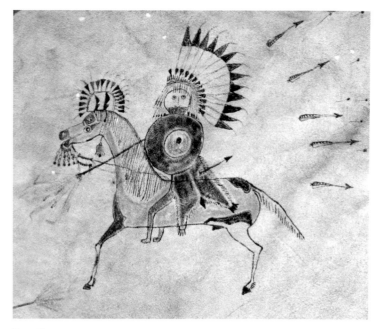

FOUR BEARS KILLS ANOTHER ENEMY WHILE WEARING A SOCIETY SASH, FROM HIS BUFFALO ROBE REPRODUCED BY THE AUTHOR.

same sort of thing by most Plains artists would be to leave the wound area on the coat unpainted red, and then painting the typical red streaks to signify a wound. Adding the wound may have been an afterthought to Mato-tope; we will never know.

Four Bears wears his same leggings (the left one blackened and the right one red ochred, both are fringed with colored hair locks) and his moccasin trailers. We see the war party leader's pipe drawn across his waist and that in the conflict his powder horn has been hit by a bullet and it leaks powder as he attacks.

He carries a white man's long knife in a green scabbard and his flare-style eagle feather headdress has fallen off or he has pulled back and it stays in place with the tie string that is still tied around his neck. A wolf or coyote skin hangs down his back and the head lies on his chest; this was sometimes used as a symbol of his rank as a war party leader.

The only mounted figure on the robe is Mato-tope wearing probably the same headdress as shown in the previous drawing. Once again, we see him charge into a shower of bullets and arrows, but carrying a different shield, and again firing his gun with the same hand. The shield has a banner hanging from it that was made from an entire animal skin, which appears to be a bear. The flesh side of this hide, like his leggings, has been painted red ochre on the right side and black on the left. We do not know, but can speculate that this design relates to the same honor depicted by

FOUR BEARS ON HORSEBACK, WITH HIMSELF AND HIS HORSE, BOTH WEARING EAGLE TAIL FEATHER HEADDRESSES. NOTE THE NOTCHED EARS OF HIS WAR HORSE, FROM HIS BUFFALO ROBE

his leggings' painting. We speculate that just like with the Hidatsa, this would represent that he went on a revenge raid to find a single enemy, killed him, scalped him and counted first coup on him, all of which he had done to an Arikara chief who killed Four Bears' brother.

Mato-tope's love and respect for his war horse is reflected in how ornate he has adorned the horse for battle. This prized, three-color painted horse has a headdress of his own. His ears have been notched to show he is a war horse, and a large brass bell hangs from his neck, representing the thunders and giving the horse that same power. A quill-embroidered face mask shows he is the war party leader, and an expensive Spanish or Mexican silver headstall and bit hangs from his mouth. This event took place before German silver was invented, so the fittings would have been real silver or iron; of course the bit itself would have been iron. Behind the bridle chains, the leather reins have been wrapped for a short distance with red wool. The top of his mane line has been painted with vermillion and perhaps the top of his tail, too, as it does not appeared to be a piece of tied cloth there.

The last painting shows his famous fight-to-the-death with the Cheyenne chief. Four Bears is leading the war party, as shown by the pipe drawn across his waist, and his whole body is now painted in the half red, half black scheme, like his leggings and shield banner.

Four bears has fired his gun and missed, and now has dropped it. Grabbing a tomahawk from his belt, he charges forward to attack the Cheyenne, who is also stripped to the basics and wears elaborate body and face paints and an otter turban to give him the speed and deadliness of the otter. He, too, had a gun, as is shown by the powder horn and bullet pouch he carries. On his right arm are clearly seen the marks that indicate he is a Cheyenne, and in this hand he carries the knife, which Four Bears has cut himself on in disarming his enemy, whom he then kills with his own knife. Sweet victory.

It is easy to forget the shear brutality of the warfare and how up-close and personal it can be. These men, though in one circumstance may be wise, mellow and benevolent, could, on an instant's notice, become extremely violent and aggressive, thriving on personal kills and the rush it gave them.

FOUR BEARS KILLS THE CHEYENNE CHIEF WITH THE CHIEF'S OWN KNIFE.

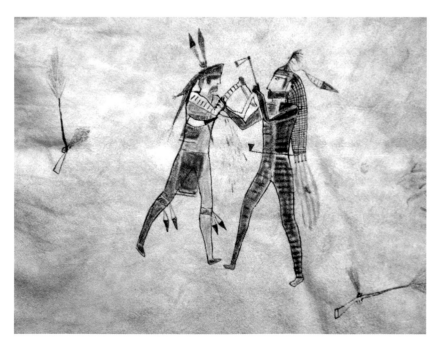

## The Crow, Hidatsa and Mandan

# Chapter 6
# The Lakota Sioux

The Lakota Sioux are probably one of the most well known tribes in North America. Due partly to the fact they were a very powerful tribe which resisted the United States they have captured the attention of novelist and movie maker alike, therefore increasing there exposure to many other peoples all over the world. Many other tribes have a lot of information recorded about them too, but sometimes this requires more of an effort to locate. One of the reasons we use many Lakota words in this text is because many of those words are readily available to research today. With some tribes finding the correct old time terminology can be difficult to impossible to locate.

The origin of the name Sioux is said to have come from their enemy the Ojibwa and means "snake." But the Sioux themselves call themselves Lakota or Dakota which means "Allies" or "friends."

The Sioux Tribe can be broken down into three divisions. These divisions were located and spread across the northern plains from Minnesota to western South Dakota. These divisions from east to west consisted of the Santee, Yankton/Yanktonai and the Teton. The Sioux themselves call these divisions from east to west "Dakota" (for Santee and the Yankton/Yanktonai together) and Lakota. Another division that had split off from

these divisions early on, were termed the "Nakota" [also spelled "Nakoda"] and reflect the Assiniboine and Stoney tribes of northern Montana and Canada. The Sioux speak and are a part of the Siouan Language family. Of most concern with this publication are the Lakota or western Sioux.

The Sioux origins were in Minnesota and vicinity, but by the 1850's they claimed a large are of western South Dakota and eastern Wyoming, with the Black Hills at its center. Their common creation story places them there since the beginning of time, but archaeological and written evidence does not support this, nor did the words of the Lakota leaders themselves from the 19th Century. Before the coming of the western Sioux to South Dakota, though, the Cheyenne and Kiowa have an even earlier claim to that region.

The territory which the western Sioux claimed, after the Cheyenne migrated out of that country, encompassed a large area or territory. The Oglala were the western most and they claimed the forks of the Platte River to the forks of the Cheyenne River. This included the Black Hills.

To the east of the Oglala were the Brule. Their territory included the upper portions of the Niobrara, White and Bad Rivers in South Dakota.

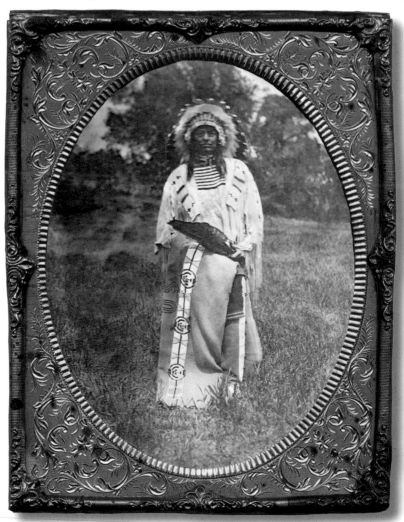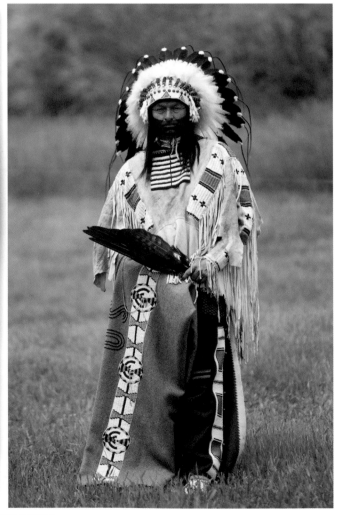

LAKOTA NACA, CONTEMPORARY TINTYPE AND COLOR PHOTOGRAPHS

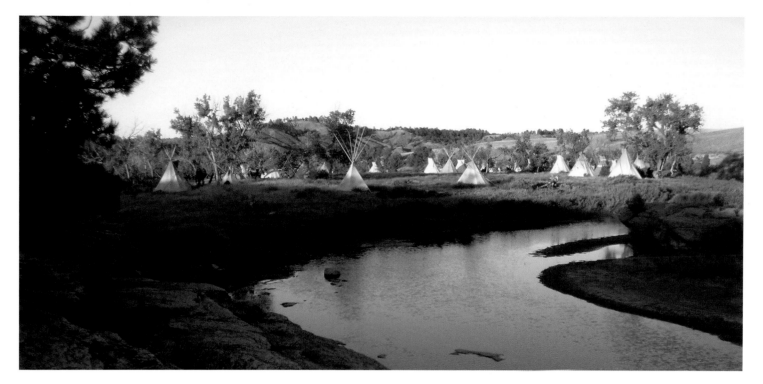

A TIPI VILLAGE ON THE CHEYENNE RIVER

North of there both of these divisions were the Saone, they claimed the different tributaries of the Missouri from the Cheyenne River north to the Heart River in North Dakota. The Saone, however, had divided into five tribes by the middle of the 1800's. These tribes included the Minneconjou, Hunkpapa, Sans Arc, Blackfeet and Two Kettles.

These Teton tribes were known as the "Seven Council Fires" of the Sioux. The relationship these tribes had with one another was an association of, "friendship, alliance and peace." The original "Seven Council Fires" were the four Santee tribes, the Yankton, Yanktonai and the Teton. The Teton were eventually also divided into seven tribal bands, but all of the Tetons together were never properly referred to as the "Seven Council Fires." All other peoples could be considered potential enemies. The Cheyenne, however, had become allies with the Lakota since 1840, and the Arapaho in turn. The Cheyennes say they have always been friends with the Lakota, and it was Lakota who gave them their first "west-side" horses after they crossed the Missouri following the smallpox pandemic of 1781-82. There is no evidence for the allegation—made by George Bent, I realize, on too little evidence—that it was "Sioux" who drove the Cheyenne from the Coteau. Their main enemies there were Assiniboin and

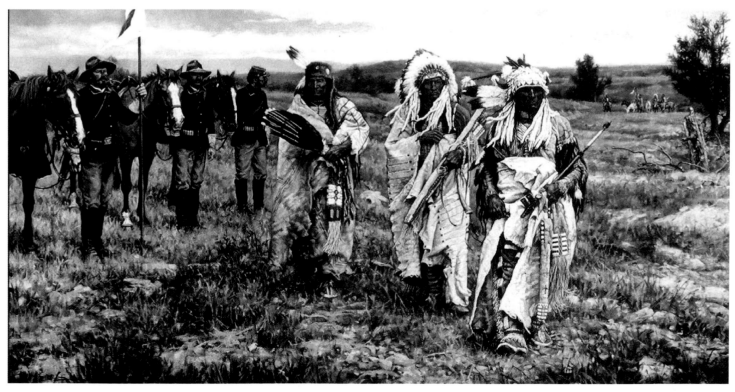

"THE CHIEFS GO TO COUNCIL" PAINTING BY STEVEN LANG

TRIBAL CHIEFS PREPARE FOR COUNCIL

Ojibwa. The Masikota, an early Cheyenne band, were already "half-Sioux," and Bent carefully documented this also.

According to the Sioux, the beginning of their way of life had a social foundation with the introduction of a sacred "Buffalo Calf Pipe." This pipe had been brought to the Sioux by a spirit in the form of a beautiful young woman known as the "White Buffalo Cow Woman." This spirit taught the Sioux the relationship between the Pipe, the People, the Great Spirit and the Buffalo, including sacred rituals.

The Sioux, like other tribes, were broken into bands, which in turn had a band leader or chief. Usually leaders of bands represented the people's concerns in tribal councils, and their decisions had to be met with consensus. Chiefs had to be thick skinned, and always placed the welfare of the people and tribe first, before his or another individual's needs and desires, be they family or friend.

Chief Iron Bull, seen in the original tintype photograh above, was a head man of his people. He wears an early style Lakota headdress made from immature eagle tail feathers. Each feather is tipped with a strip of ermine and a lock of black human hair. Each lock has been braided for most of its length. His headdress, like many, has a detachable blue cloth trailer down the length of his back. As was often done, this headdress was gifted to him, made by a fellow chief to honor his friend.

The porcupine quill embroidered shirt has horse hoof or track designs worked into the strips. It is fringed with human and horse hair locks, which all have been wrapped at the top with porcupine quills. The painted shirt body has a war party leader's pipes and human figures on both front and back. Plains Indians, being a mounted people, wanted to look well both coming and going.

A Jesuit wooden cross encased in a metal frame hangs from a blue 'padre'-bead necklace. Iron Bull is a traditionalist and follows the religion of his grandfathers, but borrowed or used any power from the white man too, if it would help him to protect his people.

His quilled pipe bag bears a thunderbird rosette and many horse tracks and pipes. This bag has been tied on to his pipe stem, which was a common practice. The ornate pipestem has much symbolism on it related to manpower. The bull elk represents power, and therefore for a man, power over females. The tortoise was a phallic symbol with many cultures, as it was with Plains people sometimes. Iron Bull's pipe bowl is carved from sacred pipestone and inlayed with elaborate lead designs. The designs were carved into the pipe first, then the pipe was wrapped tightly with a piece of soft leather and hot molten lead was poured down the inside of the leather where it filled-in the carved-out areas. Once the lead solidified it is filed, smoothed, and polished. A bear and a man sit on the pipe bowl's ledge, as the bear gives the man added power.

The rays and power of the Sun are represented by the almost 800 red- and blue-painted eagle feathers on the robe he clutches.

Among the Sioux, the Akicita were considered the police force, and often chiefs appointed certain individuals to these posts. In turn, the appointed Akicita's chose other Akicita to help enforce law; usually, these were men's societies. Some of the men's societies, such as among the Oglala, included Kit Fox, Crow Owner, Brave Heart, Black Chin, Does Not Flee, Badger Mouth, White Pack Strap, Owl Feather Headdress, War Leaders Prairie Dog, Shield and Orphans.

There was a wide variety of men's and women's societies serving many functions and representing numerous aspects of Native life and belief. Some were guilds, such as the ones for quillworkers or tanners, and many dream cults represented just about every animal in their environment. Like all aspects of any culture, these societies were constantly changing and evolving, as new dances, songs, regalia and ideas were introduced. There were variations among the individual bands, too, so one can never accept, today, that all the rules and regalia were the same throughout the 19th century.

OPPOSITE: CHIEF IRON BULL, OGLALA, CONTEMPORARY TINTYPE AND COLOR PHOTOGRAPHS

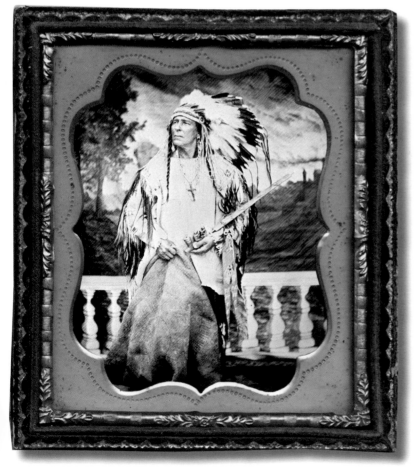

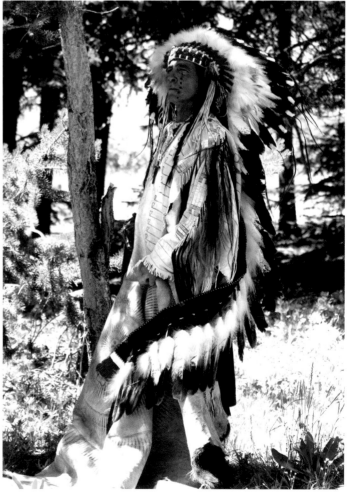

# Miwatani Society Member

According to Clark Wissler's book, *Oglala Societies* (1912), the Miwatani name is derived from an owl, in that, while conferring the societal rituals, it said: "My name is Miwatani." Some referred to the society as "iyuptala," or "to turn over" or "recycle." This refers to the danger to the sash wearers, who were often killed; hence, the position frequently "turned over." It was also called "hihasowapa," meaning a headdress of owl features: *Hinhan*(owl) *sun* (feathers) *wapaha* (headdress). *Miwatanni* is also the Lakota name for the Mandan tribe; it is said they obtained the rights to this society.

All the many warrior societies had distinctive regalia, and none more so than the Miwatani. If all the societies were together in their regalia, the Miwatani would stand out because they actually wore a 'uniform,' of sorts. Each lay member was dressed the same in moccasins, leggings, shirt, and headdress, with whistles, rattles, and body and face paint. The regalia for lay members, as shown in the photograph of the Lakota kola Fast Horse, consisted of a shirt made of deerskin with alternating blocks of black and white pound beads (a 19th century term for 'pony beads'). The fringe around shoulders was approximately 18 inches long, with no fringe along the beaded strips. The shirt bodies came to the waist, with fringe approximately 12 inches long around the bottom. This style of shirt was known as 'Ogle Hu Wi Yusda,' meaning "shirt back cut" or "cut back shirt." The triangular 'necklace' (a 19th century Indian term), or what people today call a bib or yoke piece, was about 12 inches long with one-inch fringe. It could be painted and beaded in whatever color the owner preferred.

The leggings were painted red, with black and white block beadwork to match the shirt, and had fringe approximately two inches long. Moccasins, like the leggings and the members' bodies, were painted red. Blue stripes were painted around their wrists, elbows and upper arms. These may have been symbolic challenges, manifested by representing the places on a body where warriors would dismember each other. A blue semi-circle ran from cheek to cheek in an arc over the brow. Two versions of the headdress are recorded, one being a bunch of owl wing and tail feathers sewn to a piece of buckskin, which was attached to a stick tied to the wearer's hair. The other version was a conical cap of owl feathers with red fluffs glued to the ends. These feathers were sewn to the crown of the headdress.

Two high-ranking officers had a similar headdress to the lay members (and to the Dog Men Society in the Southern Cheyenne and Hidatsa/Mandan). Its crown was covered with crow or magpie feathers tipped with red fluffs, and it had an upright centre ridge or crest of four (or more) eagle tail feathers. These crests were generally made with the feathers inserted into a removable rawhide folded piece that could be tied into position. This allowed the crest to be removed for storage and the headdress to be rolled and packed away in a rawhide container. There was also a collection of crow or magpie and owl feathers that were grouped together and hung down the back. The headdress wearers were allowed to wear whatever else they chose. The headdress men were also the "no-retreat sash wearers," like the Dog Men and others.

The sash bearers were important functionaries. They wore a headdress of owl feathers (this contradicts Wissler) and carried a rattle of dew claws. Their sashes had a hole in one end by which they staked themselves down before the enemy. They painted their bodies with red and black semicircles around the face,

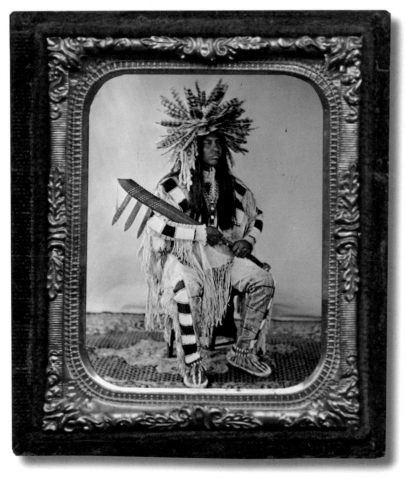

MIWATANI SOCIETY MEMBER IN 1850S CLOTHING, CONTEMPORARY TINTYPE PHOTOGRAPH

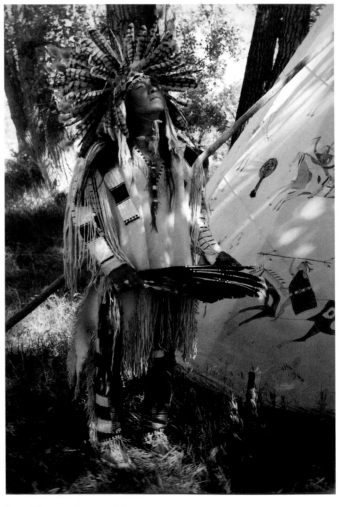

FAST HORSE, A LAKOTA MIWATANI

from one cheek bone around the forehead to the other cheek bone. They also painted black circles at their wrists, elbows, and shoulder joints. One of them could not resign his office alone; all had to leave together. Before the installation of the new sash men, it was necessary for the retiring members to make an entirely new set of regalia for them, for which each gave a horse in payment. In battle, they dressed in all their regalia, and when the enemy charged, the sash bearers staked themselves to the ground. They could be released only by another person. If he struck an enemy with the lance he used to stake himself to the ground during battle, the rules for staking could be suspended.

Lay members wore a conical cap made of owl feathers alone, without the eagle feathers that were worn only by chiefs. When dancing, members painted their bodies, leggings and moccasins red. Their shirts were made of buckskin, and the fringe from the sleeves, running from the shoulder down to the waist, was about eighteen inches long. The shirt, which came down to the waist, was called "ogle hu (shirt back) wi yus'da (out)," or "back-cut shirt." Fringe on the bottom of the shirt was about twelve inches long. At the front and back of the neck, triangular pieces were sewed that came down about twelve inches, surrounded by fringe about an inch long. This was beaded and painted any color. The beadwork (about 3 inches wide) was of large beads and ran from the front of the shirt to the back. This was done on a piece of buckskin and then sewed to the shirt; the beadwork on the sleeves, likewise. The beadwork was in alternating black and white. The fringe on the leggings was about two inches long, and the beadwork was the same as that on the shirt.

Every Miwatani member was obliged to have the owl headdress, eagle-bone whistle, and deer-hoof rattle. The owl headdress was made from a bunch of feathers from the wing and tail fastened to a piece of buckskin, and to this a small stick to tie to the wearer's hair. The eagle bone whistles were carried by a cord of buckskin around the neck. Usually some porcupine work was suspended where the whistle was tied to the cord, which was wrapped with porcupine quills. At a certain period in the dance, all blew their whistles.

Unlike the Cheyenne, Hidatsa and Mandan versions of this style of headdress that were worn by their Dog societies, the Miwatani officer's headdress had a row of eagle tail feathers and crow feathers that hung down across the back of the bonnet. There is also a reference to the sash wearers having owl feather headdresses, and another Lakota informant to Wissler said the two leaders of the society also wore sashes, making a total of four sash wearers. Discrepancies like these can sometimes be easily accepted,

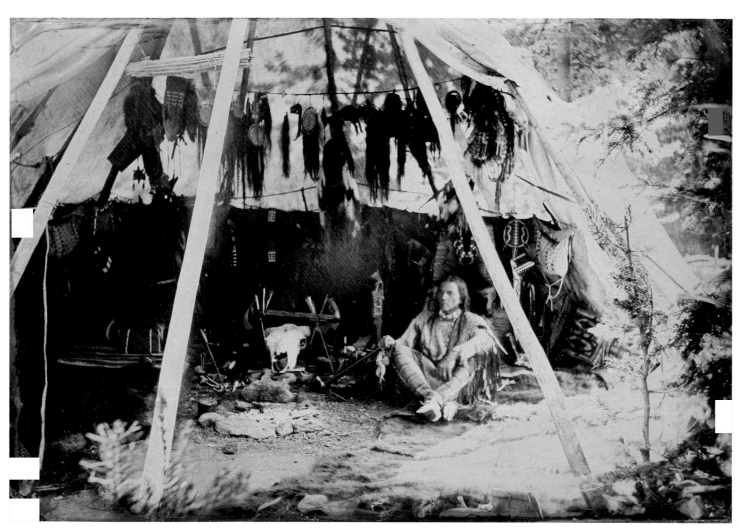

AKICITA TIPI, CONTEMPORARY TINTYPE

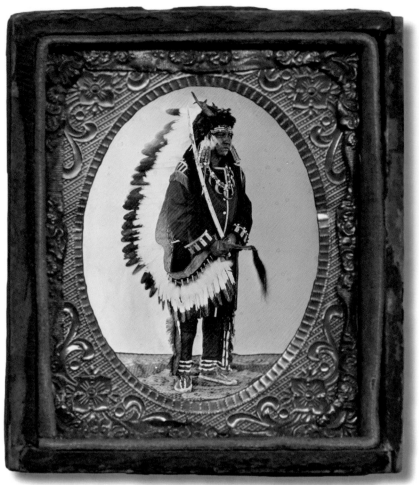

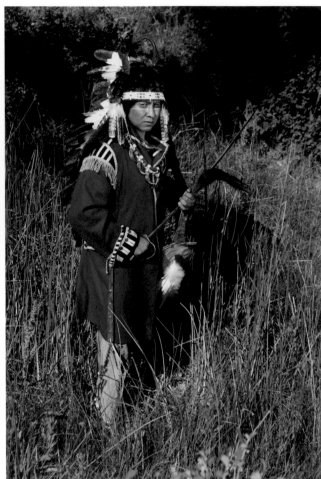

ANTELOPE HORNS AND OTTER FUR GIVE THE WEARER OF
THIS HEADDRESS ADDED SPEED IN COMBAT.

because between different bands of the same tribe there were major and minor adaptations. All Plains society regalia was in constant flux and change, so one must always be careful to not think there is one correct way to interpret any of this information. The Native people themselves knew this and evidently had few problems letting it evolve naturally.

This headdress is constructed using the same methods used and described already by the Cheyenne Dog Men.

The Miwatani was regarded by the Indians as different from Akicita societies, in that as an organization it was never called upon for akicita service. As far as we could learn, this was merely a matter of custom and not determined by the age or social position of the members. (Some informants insisted that it should be classed with the chief's societies, for on the average the members were older men than those in the Akicita societies.)

The Miwatani took in members, held ceremonies, and went to war just as did the Akicita societies. Again, we find an origin myth accounting for the Tokala, Cante tinza, Kangi yuha, and Miwatani as the result of a single vision. Typical of society origin stories, most originated in a dream from one of its founders. John Blunt-horn related parts of the Miwatani origin story:

> Then looking about he saw a man standing there. He wore a headdress of buckskin and crow feathers with a crest of turkey buzzards' tails, and on his right side hung the sash. It was marked with transverse stripes of quillwork, with white plumes at the ends.

*Once again the same man appeared to him in a vision and said, 'Dress as you saw me. Then you shall overcome everything. Medicine in small bags should be tied in your hair and a pair of white plumes should hang from each temple. There should also be some bags of medicine hung from the quills of plumes at the sides of your sash. Then like the Eagle you will overcome all enemies. He never misses that at which he strikes'. Typically, the members were instructed, or shown in these visions and dreams, specific regalia to make and taboos and rules to follow.*

They also had special tipis within the camp circle at equidistant points, the Kangi yuha at the northeast, the Cante tinza at the southeast, the Miwatani, at the northwest, and the Tokala at the southwest. Notwithstanding this, the Miwatani is positively not an Akicita society, though in its organization it is similar.

> "The chief of these people was Tatanka-Kta (The Dead Buffalo), a man of middling stature, with a very dark brown, expressive countenance, and his hair bound together over the forehead in a thick knot; he was dressed in a uniform of red cloth, with blue facings and collar, and ornamented with silver trimmings, such as the traders are used to give, or to sell to such chiefs as they desire to distinguish. In his hand he had the wing of an Eagle for a fan. (Early Western Travels)

The Lakota warrior in the original tintype photograph wears an unusual, and probably vision-inspired, headdress. The leather cap with antelope horns is covered with strips of otter fur instead of the more common ermine. Below the horns, on either side of a porcupine quill embroidered brow band, hang a variety of bird-of-prey feathers. As always, the headdress appendages and materials would have great spiritual protective meaning to the wearer.

The trailer on the back is made of one continuous piece, cut from the center of a buffalo bull's back and the tail intact at the end. The immature golden eagle tail feathers are laced through a piece of red wool and into the buffalo hide strip. The hide piece is edged with a thin strip of red wool sewn along each border and topped with white pound beads about every 5cm, or so.

His grizzly-claw necklace is atypical, too, as the claws are made to lay flat. Each of the extra heavy front claws are cleaned and usually somewhat shaped by carving away a small strip from the underside and then the inner part has been painted red. The top of each claw has been painted red ochre, and each has been beaded with blue and white pound beads. The claws are then sewn to a piece of rolled-up leather that has been bead wrapped.

He carries a United States Cavalry saber and a horse quirt made from a broken sinew, backed; a bow hangs from his wrist. His beaded leggings have been painted with yellow ochre, and the lanes between the beadwork is painted red ochre.

Another style of chief's coat, which may mimic the chief's coats introduced by the traders and given out by various government officials too, is worn by the young chief shown in the tintype photograph. All chiefs were not old men, and sometimes young men, through their bravery, leadership and success were able to acquire chief or war party leader status. His coat is made from an entire buffalo cow hide that has been heavily beaded with blue and white pound beads. Red, wool, saved list cloth has been sewn on the front cut and cuffs, in imitation of the folded lapels of an 18th century military frock coat, or like a chief's wool style coat. Simple leather tie thongs hold it shut in the front. Black horsehair represents human hair, and therefore a successful war party leader, and the white horse hair fringe shows he has led horse-capturing expeditions where enemy horses were taken. At the top of each sleeve and on each cuff, the claw of a Plains grizzly is attached, to give him the striking power of the great bear. His coat is a carryover from wearing war robes, in that it has the same pictographic image that would be seen on such a robe. Down the front on his left side appear a line of pipes, each one designating a time he led a war party to the enemy and back. Human figures that represent his victims are painted on the other front panel and the left rear panel.

On the right rear panel, four feathered sun designs represent the four great eagle feather headdresses he has ceremoniously given away. He wears beaded cloth leggings and simple beaded moccasins. A plain buffalo hide turban with fur on it and a single eagle tail feather suffice for his head ornamentation.

In the color picture, Comes Ready wears on his wrist the notched wooden quirt signifying his rank as an Akicita whip man. Since it is painted yellow ochre and uses a kit fox skin as a wrist strap, anyone would instantly recognize this piece as belonging to one of the two whip men in the Lakota Tokala or Kit Fox Society. It has been carved from a heavy piece of wood and can be used as a weapon if need be. The notched edge represents the power of lightning.

There were generally just two such elected men in each of the warrior societies. Whip bearers bring in candidates, eject members, punish absentees, and make sure everyone attends the meetings and dances. They

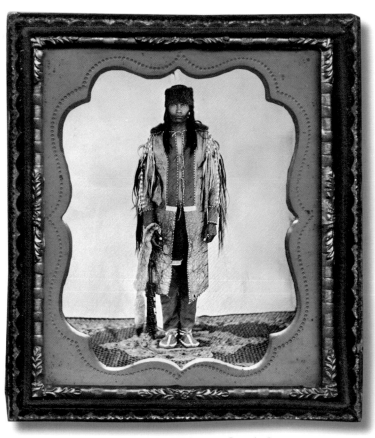

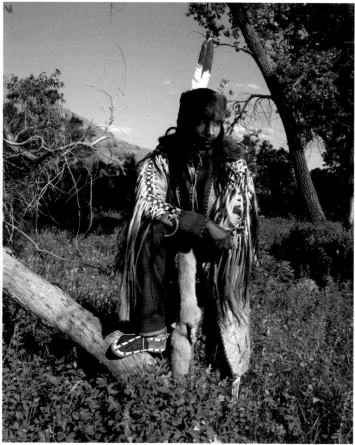

LAKOTA CHIEF'S COAT OF 1850S STYLE,
CONTEMPORARY TINTYPE AND COLOR PHOTOGRAPHS

may punish absentees by cutting up blankets or tearing up a good robe and, if resented, whip the culprit. The only way to get out of the beating or having their property destroyed was to pledge a feast or send over a very good gift.

In society or warrior parades, most societies followed the same order of procession in the march: the two mounted whip bearers, who always paraded mounted, led and brought up the rear, with one in front and the other behind. They were followed by the pipe man or pipe men, two crooked lances, two straight lances, two short lances (if their society had this rank), then the lay members and drummers followed. Of course, the amount of crooked and straight lances varied from society to society.

Many societies would make such a procession or march around the camp, dancing before certain tipis at the close of a formal ceremony. They would start at a trot, then slow down, then the singers would strike up, then the men face backward and dance. They would then proceed, as before, stopping again to dance, etc. When they came to a head man's tipi, they would form a circle around the singers and dance outward with shouting whoops and calls.

If celebrating from a recent war party, the whip men's horses were the ones painted with one horizontal stripe on their rear legs for each enemy killed by their society or by the war party. If the horses of the whip men had been wounded, then red spots were painted on them.

The men who held this rank had to be respected and somewhat feared for their spiritual and physical prowess, as they regulated the societies and were more or less the police of the police, making sure that all the members of their society followed the standards and rules set forth by the society founders.

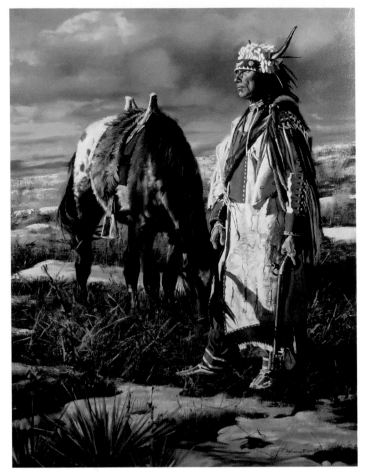

A Lakota chief's coat, painting by Ed Kucera

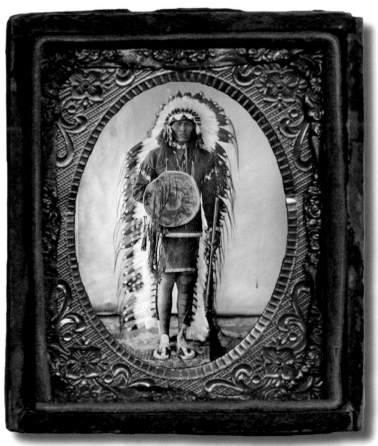

Lakota chief in a double-trailer bonnet, contemporary tintype and color photographs

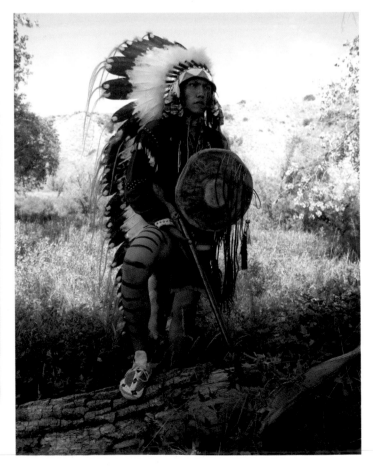

## Battle of the Rosebud Warriors June17th, 1876

Crow Like A Wolf is a fierce and powerful young warrior who has already reached the high-ranking position of head Akicita. These men were entitled to wear the eagle tail feather headdress, as Crow Like A Wolf does. The headdress itself, as well as the coup it represents, may belong to another individual or even a group of men, such as his society members. The red stripe on his face represents this.

The saved list cloth jackets worn by him and his friend, Rides Horse, were fashionable among many factions of the Lakota from the 1860s through the 1870s. They are generally tight fitting, pullover shirts made in imitation of soldiers' shell jackets. Many times the shoe button designs on them follow the same lines and decorations seen on the military jackets of the time. When working with any item where saved list cloth was used, the list—or selvedge—was always considered and its undyed white edge was used as part of the natural decoration.

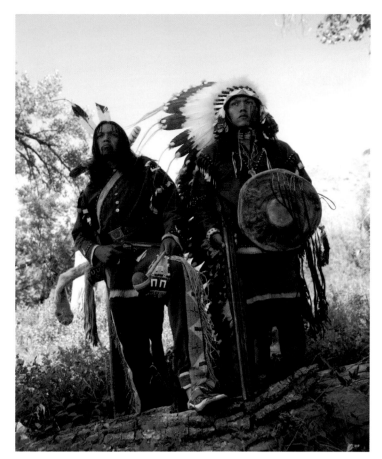

Two Lakota warriors with cloth jackets.

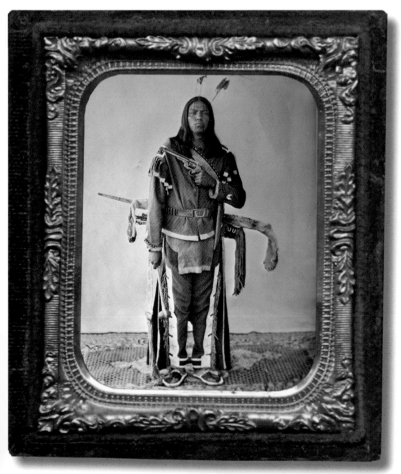

Lakota Warrior in cloth jacket, as was worn at the Battle of the Rosebud, June 17, 1876, contemporary tintype and color photographs

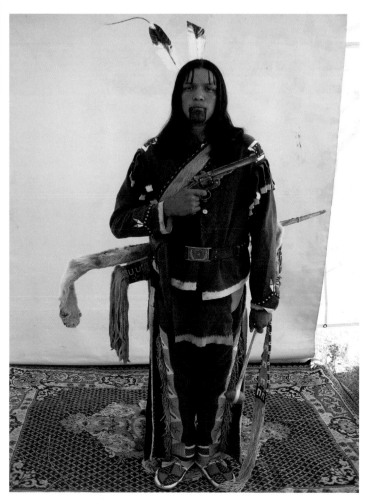

The Lakota Sioux 85

# Chapter 7
# Professional Hunters

Many examples of what we would consider waste today was recorded. It is worth noting that a typical Plains hunter did not see this as waste at all, because in their minds they never saw anything go to waste. When most Plains people thought of hunting they thought of 'the hunt,' or "Wanasapi" in Lakota, which, though, does not specifically mentioned buffalo all; when speaking they knew exactly what it meant, hunting of the bison.

The book, *In A Company of Adventurers*, gives a descriptive account of a buffalo hunt.

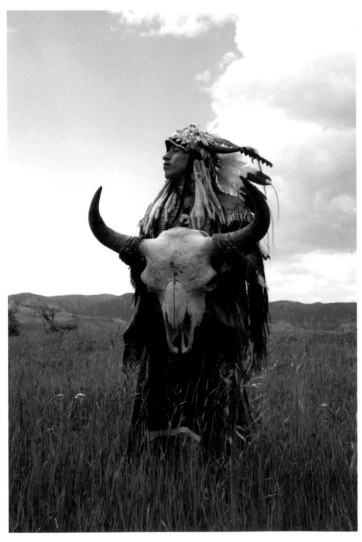

"Prayer for the Buffalo People," photograph of a Lakota with a bufalo skull.

"A Grand Buffalo Hunt"

*The horses, knowing what was coming, were restive and trembling with excitement and impatience to be off. By this time those buffalo on the alert had begun to move up-wind, and the rest, taking the alarm from them, quickly followed, until the whole herd was in ever-quickening motion, through which and over a country full of badger holes the hunters blindly charged. After passing through and emerging from the veil of dust the hunters were at the heels of the herd and commenced firing. The bolder men on the swifter steeds still pressed forward, firing as they went and reloading their flint-locks with almost incredible speed and dexterity. A few fell in the rush, tripped up by the badger holes or other mishap; but the majority pursued the now frantic animals, firing shot after shot at the fat cows, seemingly regardless of the presence of their fellows in the line of fire. And the slaughter continued till the ponies became out winded, and dropped behind the main herd or those cut out and scattered in the chase.*

There is one thing to the credit of the Indians that must be recorded—old, helpless men and widow women could go and help themselves freely to the best carcasses on the field and it were shame to say them nay, for to the widows and the weak belonged the spoils according to Indian tradition custom. It was generally from these widows that the finest marrow fat and tallow and the best dried meat and pemmican were obtained by the traders

*Here he interrupted himself with an oath, and exclaimed: "Look! Look! The 'Panther' is running an antelope!" The Panther, on his black-and-white horse, one of the best in the village, came at full speed over the hill in hot pursuit of an antelope, that darted away like lightning before him. The attempt was made in mere sport and bravado, for very few are the horses that can for a moment compete in swiftness with this little animal. The antelope ran down the hill toward the main body of the Indians, who were moving over the plain below. Sharp yells were given, and horsemen galloped out to intercept his flight. At this he turned sharply to the left, and scoured away with such incredible speed that he distanced all his pursuers, and even the vaunted horse of the Panther himself. A few moments after, we witnessed a more serious sport. A shaggy buffalo-bull bounded out from a neighboring hollow, and close behind him came a slender Indian boy, riding without stirrups or saddle, and lashing his eager little horse to full speed. Yard after yard he drew closer to his gigantic victim, though the bull, with his short tail erect and his tongue lolling out a foot from his foaming jaws, was straining his unwieldy strength to the utmost. A moment more and the boy was close alongside of him. It was our friend the Hail-Storm. He dropped the rein on his horse's neck, and jerked an arrow like lightning from the quiver at his shoulder. " I tell you," said Reynal, "that in a year's time that boy will match the best hunter in the village. There, he has given it to him! — and there goes another! You feel well, now, old bull, don't you, with two arrows stuck in your lights? There, he has given him another! Hear*

*how the Hail-Storm yells when he shoots! Yes, jump at him; try it again, old fellow! You may jump all day before you get your horns into that pony!" The bull sprang again and again at his assailant, but the horse kept dodging with wonderful celerity. At length the bull followed up his attack with a furious rush, and the Hail-Storm was put to flight, the shaggy monster following close behind. The boy clung to his seat like a leech, and secure in the speed of his little pony, looked around toward us and laughed. In a moment he was again alongside of the bull, who was now driven to complete desperation. His eyeballs glared through his tangled mane, and the blood flew from his mouth and nostrils. Thus, still battling with each other, the two enemies disappeared over the hill. Many of the Indians rode at full gallop toward the spot. We followed at a more moderate pace, and soon saw the bull lying dead on the side of the hill. The Indians were gathered around him, and several knives were already at work. These little instruments were plied with such wonderful address that the twisted sinews were cut apart, the ponderous bones fell asunder as if by magic, and in a moment the vast carcass was reduced to a heap of bloody ruins. The surrounding group of savages offered no very attractive spectacle to a civilized eye. Some were cracking the huge thigh-bones and devouring the marrow within; others were cutting away pieces of the liver and other approved morsels, and swallowing them on the spot with the appetite of wolves. The faces of most of them, besmeared with blood from ear to ear, looked grim and horrible enough. My friend, the White Shield, proffered me a marrow-bone, so skillfully laid open that all the rich substance within was exposed to view at once. Another Indian held out a large piece of the delicate lining of the paunch, but these courteous offerings I begged leave to decline. I noticed one little boy who was very busy with his knife about the jaws and throat of the buffalo, from which he extracted some morsel of peculiar delicacy. It is but fair to say that only certain parts of the animal are considered eligible in these extempore banquets. The Indians would look with abhorrence on any one who should partake indiscriminately of the newly-killed carcass.*

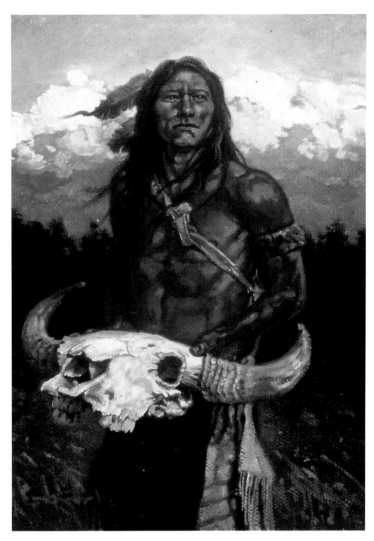

"Winds of Change" painting of a warrior with a buffalo skull, by Steven Lang

One must always keep in mind, as you read along, that the Indian people of yesteryear were in a constant flux between life or death at almost any moment. The food the Indian people ate had to be killed and processed themselves, and almost anything at anytime would or could be eaten to survive or thrive. Like humans all over the world, in times of plenty, there was waste.

Father DeSmet, in his book *Life & Travels Among the Native American Indians*, mentions, in the year 1840, great hunts were going on and Indians had taken loads of prime buffalo cuts, such as tongues, hump and ribs, etc., and that the rest of the buffalo carcass was left to wolves and buzzards

Colonel Dodge watched a hunt that lasted one hour, in which over 500 buffalo were killed. The carcasses were spread out over five or six square miles. By 1849-50, the buffalo had disappeared from Plains below Upper Fort Garry. Dodge also mentions seeing three herds driven into buffalo pounds in 10 to 12 days; the leftover, putrefying buffalo carcasses tainted the air all around. "The Indians in this manner destroy innumerable buffalo apparently for the mere pleasure of the thing." Sometimes so many buffalo are driven into the pound that the sides collapse. "Thousands are killed in this manner, but not one in twenty is used in any way by the Indians so that thousands are left to rot where they fall. Whole droves of buffalo were destroyed by them and they take only the choicest parts, so many that their carcasses fell upon each other." He goes on to relate that in a six-day period, he had experienced the greatest pleasures of Indian life, witnessing the greatest slaughter of buffalo he had seen, greater than he had witnessed on the Missouri River by those tribes such as the Hidatsa, Mandan or Arikara. He also witnessed Cheyenne surround a herd near their camp, killing over 250 fat cows and taking just the tongues for a feast for the Missouri River tribes they were to visit.

Other observers witnessed similar situations, such as the artist George Catlin, who wrote about the Teton Lakota whose slaughtering ended only when the last animal was driven over the cliff or into the corral. The Pawnee killed so many buffalo in a semi-surround that many spoiled before the women could harvest them. "This did not infrequently lead to a shocking waste of this valuable natural resource and was an active factor in bringing about the depletion of the buffalo stock." (Hind)

Kane & Simpson saw a buffalo pound with over 200 dead buffalo, all killed, and only cows harvested, the stench and flies were unbearable. In fact so many were killed by Indians that eventually some buffalo pounds were made of buffalo bones. Coronado, at a much earlier time of Spanish exploration, mentioned seeing piles of cow buffalo bones 12' high, 18' wide, several hundred feet long. (*Running Down and Driving of Game in North America*) Much later, George Bent said he saw hundreds of Comanche kill two thousand buffalo in one surround, with guns, pistols and arrows.

Zenas Leonard, a fur trader, saw seven hundred buffalo killed by Indians at one hunt. This was proudly showed him by the Chief Grizzly Bear.

These Indians were bringing in robes to trade as quick as they could be tanned. Red Crow was also proud to say that fourteen tipis brought in four hundred robes to trade, or twenty eight per family. Multiply that by the approximate twenty thousand tipis on the Plains at any given time and you can see what I high numbers of animals were being killed just for the trade. This would be over half a million killed each year just for trade, which is probably a low estimate. Hugh A. Dempsey

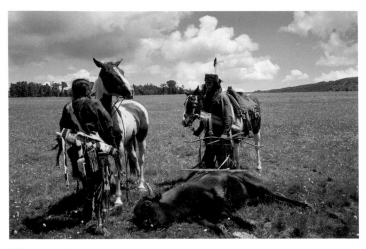

"WANASAPI"

This daily hunting for robes for trade by Indians and white alike thinned the buffalo herds and soon drove them across the Platte River seeking safety from all humans. (*Adventures of Zenas Leonard, Fur Trader*)

Per capita, Plains people were killing a huge amount, more than the whites were, since there were sixty five million non-Indians in the United States at the height of the buffalo slaughter, accounting for two million to four million killed annually, versus the approximately two million killed annually by Indian people for trade and sustenance. Both Indian and white alike can share the blame for the near-extermination of the herds, but only the non-Indians can take credit for preserving the remnants of the 19th century and building those numbers up, so that today of over half a million buffalo roam within the United States.

On numerous buffalo carcasses just the tongue and hump were taken, including the buffalo killed by Indians, who took only the choice pieces unless the tribe was starving. As far as the Indian was concerned, The Great Spirit would provide. No one is immune to human nature, including Indian people. Forethought just was not there when hunting buffalo or thinking about the future. Typical Plains hunters did not see any of this as waste; they never saw anything wasted in nature, as everything would be consumed by something, even the living earth, so in their minds there was no waste.

The buffalo herds were being hunted from all sides and by every tribe. Over-hunting by white hunters began in earnest in the years after the Civil War. Trading posts only helped to speed-up the demise of buffalo herds as Indian people came to be dependent upon the goods brought into the posts, and the trade was in buffalo hides. (*Travels in the Interior of America in the Years 1809–1811*) It was recorded that "Indians often kill many more than they can possibly use and wolves follow the hunting

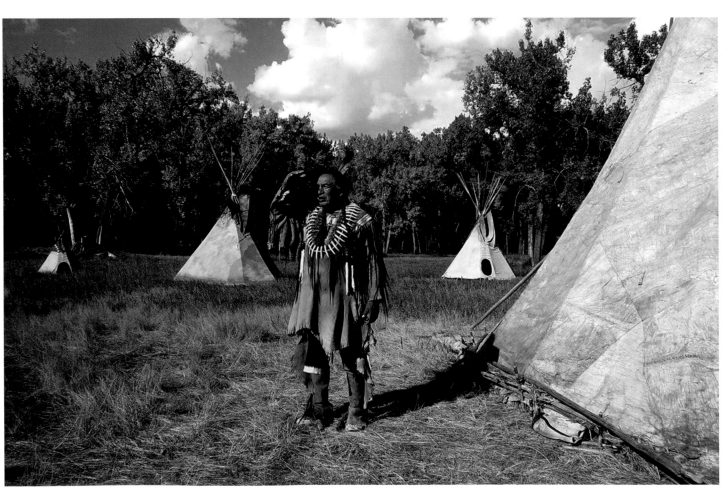

"LAKOTA ELDER LOOKS FOR THE RETURN OF THE HUNTING PARTY" BUFFALO HIDE TIPI VILLAGE

parties to clean up what is left behind." In the fall hunt, when plenty of animals were killed, "Indians take what they choose from buffalo and abandon the rest to wolves."

During Loisel's expedition on the upper Missouri River, he saw a Ree village of two hundred people with more than a hundred boned cows, which amounted to an estimated over 30,000, (300 lbs each) pounds of meat consumed in four days. (Tabeau, *Narrative of Loisel's Expedition to the Upper Missouri*, F 598)

Another comment made about the average yield of meat per buffalo was by White Bull, the Lakota. He said that one Metis cart carried about eight hundred pounds of meat, which equaled ten dried buffalo cows of eighty pounds each.

The practice of Indians focusing primarily on the younger buffalo cows due to their thin hides, better and more tender meat, and the fat needed for a healthy diet, all helped seal the fate and near extinction of the great herds. The young heifer cows were usually prime specimens, with a layer of coveted fat, since they were not yet devoting any of their intake to nursing calves. They were also much easier to hunt and kill and were usually frightened of humans, especially ones on horseback.

Previous to the days on horses, buffalo of all ages and both sexes were communally killed and consumed in drives, blinds, jumps, etc. The horse allowed hunters to focus on the more desirable young cows and yearlings. This was not an effective hunting and herd management technique. The new practice of destroying the prime breeding stock of the herds, combined with new pressures from Euro-American hunting hastened the decline of the herds. By the 1830s, many were already taking note of it.

Colonel Dodge mentions this in one of his books, *Plains of the Great West and Their Inhabitants, 1859-77*. He noticed in just a few years that buffalo could not be found due to the Sioux's overkill (the area south of the Cheyenne and north and east of the North Platte River), and that this area joined on the southwest to the Laramie Plains country, making a broad belt east to west from the Missouri River to the mountains with no buffalo. The southern buffalo range, after 1870, was from north Texas to 41 degrees 30' Northern range, from Lat. 43 to Powder River country and into Canada. Colonel Dodge also mentioned that Indians would not eat turkey, being afraid it would make them cowards and run away like turkeys. He went on to say that by the 1870s, the buffalo were gone from Cree lands.

Perhaps surprising to people today is that there were many non-Indians that predicted the demise of the buffalo and early-on sought and suggested ideas how to save them. Though impractical, at least they can be credited with the effort and forethought. George Catlin, the artist, was one of these. In his widely read book, he advocated that the entire Plains region be set aside as a national park to preserve both the buffalo and the Indian, who depended on buffalo for their livelihood. His thinking was too far ahead of his time to be taken seriously.

Edwin James, a chronicler of the Long Expedition and himself a naturalist, wrote in 1823: "It would be highly desirable that some law for the preservation of game might be extended to, and rigidly enforced in, the country where the bison is still met with." Influential citizens, even government officials, had financial interests in the Upper Missouri fur trade and saw the need to regulate the game.

Five years later, Father DeSmet accurately predicted that the plains from the Saskatchewan to the Yellowstone rivers would be the "last resort" of the buffalo. But his gloomy prediction that the many tribes of the region would themselves become extinct fighting over "the last buffalo steak" did not come to pass. The people of Canada and the United States did not permit the vanishing red men to disappear.

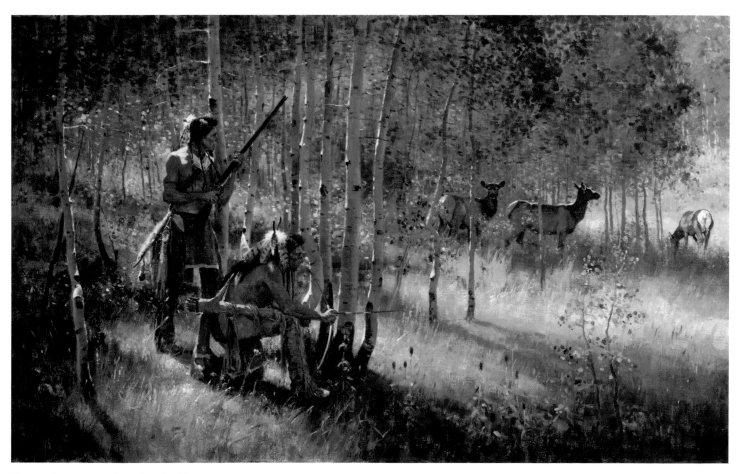

"At the Edge of the Aspen" by Jim Norton

From the 1850s on, treaty commissioners and Indian agents repeatedly warned the Indians of the coming extermination of their staff of life- the buffalo. But as long as there were buffalo to be hunted, their efforts to induce nomadic hunters to become sedentary farmers met with little success. The Indians were too thoroughly committed, by both experience and inclination, to the roving life and its hunting-trading economy to abandon them, as long as they had any choice in the matter.

There are many primary source accounts recording this reduction in numbers working its way east to west and south to north. By the 1870s the herds had permanently been divided into a northern and southern herds.

In 1835 Charles Murray said that "formerly the buffalo came down to and far below the Pawnee villages, now they must travel ten to twenty days to find buffalo. The buffalo are rapidly diminishing and will in time become extinct." Once the buffalo permanently left the hunting ranges of the Pawnee (due to their own over hunting), the Pawnee lost their power and former standing as a force to be reckoned with on the Plains. From 1840 on, they continued on a perpetual downward turn through the end of the nineteenth century. The Pawnee, like so many others during this time period, never believed all the buffalo could be killed. "This did not infrequently lead to a shocking waste of this valuable natural resource and was an active factor in bringing about the depletion of the buffalo stock."

Paul Wilhelm, Duke of Württemberg, in 1822-1824, noticed this happened to the Pawnees' neighbors, the Ponca and Omaha, as well, that they lost power, territory and guns due to the decrease in numbers of buffalo in their area. The herds had been over-hunted in their areas and permanently migrated west and northwest into Sioux country. Now that this tribe had more robes, they were able to buy more guns so could control more territory, thus as always in history their rise to power came on the heels of others' downfall. The wealth and power of the Indian depended on the hunt. By the 1870s the same had happened to the Cree.

As early as 1804 Charles Mckenzie wrote that the Missouri river tribes destroyed buffalo in immense numbers every winter. In this same year, Tabeau wrote that in a horrible famine and time of extreme hunger most Sioux women traded favors for small amounts of meat. It was said their husbands did not mind, if done with their knowledge. (Tabeau's *Narrative of Loisel's Expedition to the Upper Missouri*)

When traveling through the lands of the Omaha, author S. H. Long, in 1819 -1820, wrote that the young men had to hunt seventy to eighty miles around camp to find enough game, and that the elk were already becoming rare around Omaha.

In *Travels in North America, 1822- 1824*, Paul von Württemberg wrote that after seeing "so many buffalo uselessly sacrificed" he predicted the complications the decrease in numbers to cause serious problems.

Philander Prescott wrote that they searched the Vermillion River and Missouri River tributaries and saw no buffalo all winter. They ended up trading a cloth blanket for two pieces of meat, an expensive cut of meat for sure, considering a wool blanket was easily worth two or three tanned buffalo robes. (*The Recollection of Philander Prescott*)

Father DeSmet wrote of the Upper Missouri River tribes that in his area they were killing 100,000 buffalo every year just for their own consumption and another 70,000 just for trade to the whites (speaking of just one region, not the whole Plains area). When these numbers are combined with the fact that the wolves killed one third of all buffalo calves every year, it is easy to see the effect of over-hunting, trade and natural depredation on the herds. These were loses the herds could not absorb when combined with all the other natural deaths from freezing, drowning, old age, etc. They diminished the overall number of calves that could have been born each year

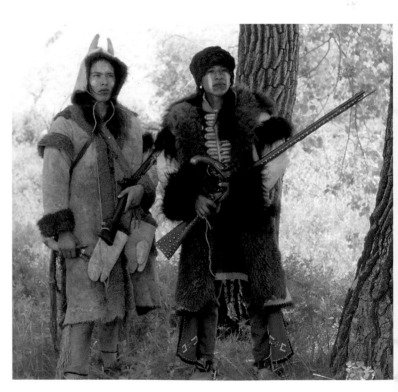

Hunters in Winter, contemporary tintype and color photographs.

# Clothing

Like all people who live in climates that vary quite a bit from one season to another, the Plains people had clothing for a variety of seasons and functions. Clothing made from old, smoked tipi tops and other heavily smoked hides may be favored in the spring, when one was apt to spend a lot of time both wet and dry. The oils in the smoke that is forced through the hide cells in the final stage of the tanning process make it possible for the hides to dry supple and ready for immediate use. Soaking wet clothing could be flash dried by taking it off and beating the clothing on the ground. Unsmoked hides must be re-worked by hand, if they get wet, to make them soft again and wearable.

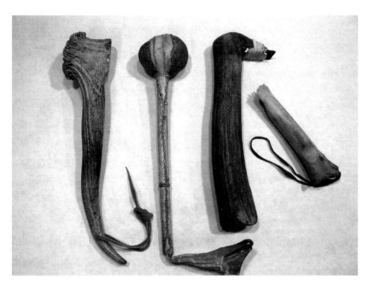

Hide-tanning tools

A 19th century observer describes the tanning process well:

*Several tools are in use for dressing skins. A chisel-shaped flesher (now generally made of iron, originally of a buffalo leg bone) is used to clean the inner surface of hides from fat and flesh. If the hair is to be removed, which is almost always the case unless a blanket is being made, an instrument made of elk-antler is used. The end of this extends at right angles to the handle, and is provided with a metal blade. This instrument is at times made of wood, but then has exactly the shape of those made of antler. With this instrument the hair is cut from the skin with little difficulty. Sometimes a stone hammer is used to pound the hairy side of the skin until the hair comes off. All hides used for clothing are thinned to a certain extent. The scraping obtained in this process are sometimes eaten. The elk-horn scrapers are usually marked with a number of parallel scratches or lines, which are a record of the ages of the children of the woman who owns the scraper. One woman kept count of the number of hides she had dressed with her instrument. Twenty-six scratches denoted so many buffalo-skins; forty small brass nails driven into the back of the instrument that she had worked. These scrapers are sometimes used for digging roots.*

*After the hair has been removed, the skin is stretched on the ground by means of pegs, and dried until stiff, if rawhide is to be made. If soft hide is desired, as for clothing, the skin is soaked and then scraped or rubbed with a blunt edge until it is dry. Now, pieces of tin, whose scraping edge is slightly curved stick of wood a foot long;*

*in the middle of the concave side of this is a metal blade. The whole object somewhat resembles a draw-knife. This instrument is used more particularly on buckskin, which is hung on an upright post or stick. It has carved upon it in outline the figure of a deer viewed from the front. On the other side of the handle is a similarly carved figure of an antelope. The lines representing the flanks of the two animals are run into each other along the two lines of the handle. Buffalo-hides are also softened by being drawn over a rope, twisted of sinew about one-third on an inch thick."*

Thin, summer killed deer and antelope were favored for men's summer cloths as they were light and cool to wear. Winter clothing was all about comfort and being practical. Little was wasted on ornamentation, though many pieces may still have some bits of cloth, beadwork or quill-work added here and there.

The most practical winter garments were made from smoked hides that were tanned with the fur intact. Plains tribes rarely tanned deer, elk, antelope or moose with the hair left on, as these hides lose their hair very easily. Buffalo, however, and fur bearing animals were the favored raw materials for their winter clothing. The dense hair's insulating effect makes incredibly warm garments. One can camp in the snow with nothing more than a buckskin shirt and leggings, buffalo hide with-hair-on moccasins, mittens, hat and coat and stay perfectly warm. Snow in the Plains is quite dry, except for the spring months. Grease could be added to leather to help make it water resistant.

For eons, a buffalo robe, with hair on, would be worn, generally with the hair side inside. Robes were sometimes worn hair side out, during a rain storm to shed the water.

In the painting shown above, the two hunters both wear buffalo coats made in the Native style, with the hair side in. High collars and long cuffs allow these to be pulled up or rolled down during blizzards. The coats could be worn open or belted, and there is usually a split in the back, to the waist, to allow the coat to be worn on horseback.

Several original 19th century coats are in existence today. One very nice one is in the Old Trail Town Museum in Cody, Wyoming. Old Trail Town is a typical frontier-era town made up of cabins and buildings gathered over the West and reconstructed in Cody. It is a great place to visit.

In the painting, one man wears a typical open-topped turban made from the great hunter and killer, the otter. The other man's hat is made from buffalo leather with the hair side in. (Buffalo is considered 'hair,' not 'fur.') Two fake ears have been sewn at the top to represent horse ears. According to the Hidatsa girl, Waheenee, ears could be made to mimic a wolf, coyote, deer, horse, or even jack rabbit, like her fathers' hat.

*I liked to play with my father's big hunting cap. It was made of buffalo skin, from the part near the tail where the hair is short. He wore it with the fur side in. Two ears of buffalo skin, stuffed with antelope hair to make them stand upright, were sewed one on each side. They were long, to look like a jack-rabbit's ears; but they looked more like the thumbs of two huge mittens. My father, I think, had had a dream from the jack-rabbit spirits, and wore the cap as a kind of prayer to them. Jack rabbits are hardy animals and fleet of foot. They live on the open prairies through the hardest winters; and a full grown rabbit can outrun a wolf. An Indian hunter had need to be nimble-footed and hardy, like a jack rabbit.*

*Small Ankle thought his cap a protection in other ways. It kept his head warm. Then, if he feared enemies were about, he could draw his cap down to hide his dark hair, creep up a hill and spy over the top. Being of dull color, like dead grass, the cap was not easily seen on the sky line. A Sioux, spying it, would likely think it a coyote, or wolf, with erect, pointed ears, peering over the hill, as these animals often did. There were many such caps worn by*

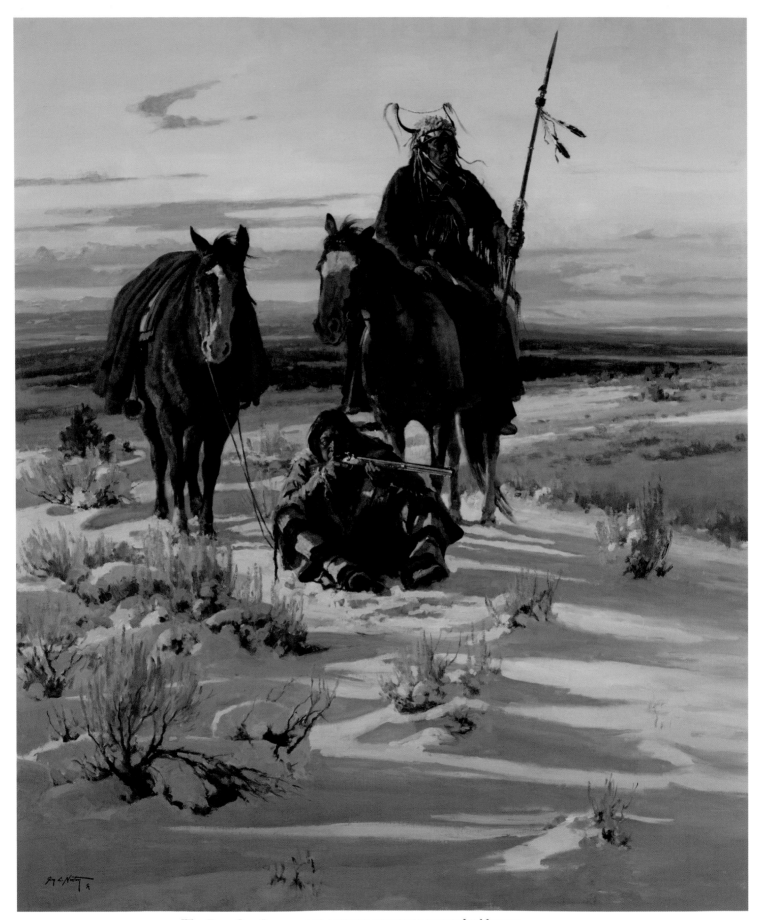

"The First Shot" painting of a winter hunting party by Jim Norton

*our hunters; but most of them had short pointed ears, like a coyote.*
(*Waheenee*, p. 22)

Author Henry Boller saw a Gros Ventre on a winter hunt with a white-blanket skull cap low on the forehead, a dirty white capote, rawhide knife scabbard, and a skin rifle scabbard. He and others mentioned that white blankets were the most popular with war parties, especially in the winter, with the red and blue blankets not as popular any more during his time, in the late 1850s and into the 1860s.

A variation on the cap and a quickly made hood was sometimes constructed from an old tipi cover and sometimes buffalo skin with the fur inside. Occasionally a man drew the side of his robe up over his head so that it formed a hood. The robe was drawn up on its side in such a way that neither the tail nor the head formed the hood. Holes were made in the edges and a stick thrust through. Women were never known to wear the robes as hoods in this fashion. (*Mandan Social and Ceremonial Organization*, p. 218)

An Arapaho woman described putting on a winter robe to protect her husband's nice clothing;

> *I had made my husband a fine skin shirt, embroidered with beads. Over it he drew his robe, fur side in. He spread his feet apart, drew the robe high enough to cover his head, and folded it, tail end first, over his right side; then the head end over his left, and belted the robe in place. He spread his feet apart when belting, to give the robe a loose skirt for walking in. (The Arapaho, p. 129)*

Sometimes men wore robes with a hole cut into it for their right arm to go through. (*Travels in the Interior of America in the Years 1809–1811*)

In the painting above, the hunter's coat is much older than that of his friend, Enemy Hunter; it's fur is quite worn and much shorter. Even in this condition, he may not wear a shirt of any type underneath the coat. He also wears a pair of buffalo mittens lined with hair. They have an extra finger to allow them to be worn while shooting your weapon. A long cord worn over or under the coat connects the two mittens. This is so the hunter can take one or both mittens off, for skinning or some other delicate task, and have them readily available when needed; it allows him to let go of them with no danger of loss. Most people went without gloves and tried to stay inside when the weather was so severe you had to worry about frostbite. Men may regularly rub their hands with snow in the winter to keep them and their fingers nimble. Leather leggings, which could be stuffed with dried grass or shed buffalo hair, and buffalo-hair-lined moccasins complete his outfit.

Under his buffalo coat, Enemy Hunter wears a British military jacket that he probably obtained in trade, either directly or through trade with another northern tribe.

His leggings are made from the sky-blue kersey from a United States Army overcoat and trimmed with silk ribbons. They have been decorated with brass tacks that are stuck through the cloth and into a narrow strip of rawhide, then the heads are cut off and braded-over. By the late 1850s, brass shoe buttons became more available from trade, and they could be sewn on or, more often, a small cut was made in the cloth and the eye of the button shoved through, to be held in place by a thin piece of knotted leather threaded through all the buttons. The horse track decorative designs may denote actual horses captured or his wish for wealth and success.

Both hunters in the painting carry flintlock trade guns that have leather ties attached to them, allowing them to be tied to lodge poles or other places. Tying them, barrel-down, to a tipi pole was a common way to store firearms in a tipi. It kept them off of the floor of the tipi, dry, and out of the way of the children. When tied in a slip knot, a pull on one cord put it in their hands.

Enemy Hunter has ornamented his musket stock with brass tacks, which were generally imported from France. Wadding, often in the form of dried and shredded willow bark, along with various sizes of shot was kept in the bullet or hunting bag. This bag and a buffalo or domestic cow horn powder horn completed the items needed for their weapons. A pistol, like the one stuffed into his belt, became more popular, especially after revolvers became available through trade and raid.

In extremely cold weather, leather and wool leggings could be stuffed with dried grass or buffalo hair collected from trees and shrubs (wherever there are large numbers of buffalo, their hair can be found because they shed or rubbed it off in large clumps).

Plains people improvised whenever the need arose. Two Leggings, the Crow warrior, received his name when wearing two pairs of leggings at once to protect himself from the cold. One can patch holes in moccasins, as he also did, by cutting a piece off of his leather breechcloth and gluing it inside the moccasin sole with pine pitch or hide glue from the glue stick commonly carried by men in their quiver. Winter or regular moccasins could also be stuffed with extra hair, grass or shredded cottonwood's inner bark for additional warmth. "They also put shredded cottonwood bark in their moccasins, packing it about their feet and ankles to keep them warm and dry." (*Waheenee*)

Karl Bodmer, who accompanied Prince Maximilian on his travels to the western United States territories, made a fine watercolor painting of an Assiniboine winter hunter wearing a similar coat. This man's simple winter hat, from a badger skin folded in half and sewn or laced together in the back, makes a good a hat that could be worn hair side in or out.

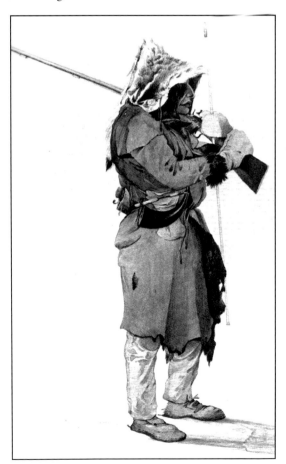

"Assiniboine Hunter in Winter" painting by Karl Bodmer

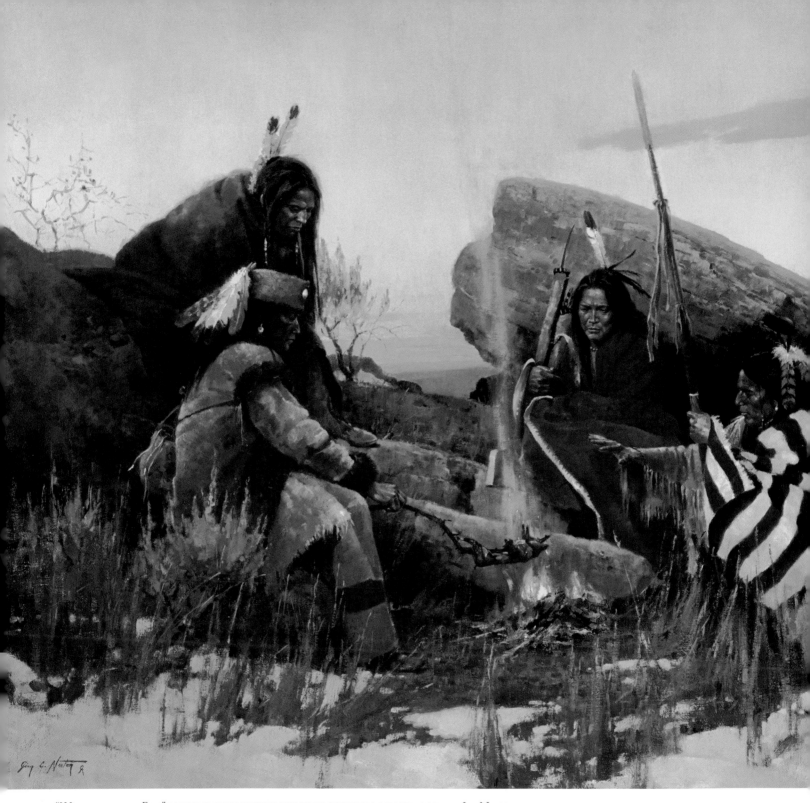

"Warmth of the Fire" painting of traveling warriors sharing a meager catch by Jim Norton

Young Hidatsa men learned quickly to put cloth directly to their skin in extreme cold:

> Many of my young men had head cloths which they bound over their hair and under their chins; but the wind was so strong that it blew the wet snow through the cloths, freezing them to the men's faces. I had on my fur cap, which kept my face warm. Also I think the jack-rabbit spirits helped me. (Waheenee, p. 31)

Patrick Gass noted the toughness of Indian people to the cold on Monday, September 4, 1804:

> Some snow fell last night, and the morning was cloudy and cold. We embarked early and went on. At 9 we saw 11 Indians of the Sioux nation coming down from the Mandan, who, notwithstanding the coldness of the weather, had not an article of clothing except their breech-clouts. At 1 o'clock the day became clear and pleasant and we encamped at night on the south side. (The Journals of Patrick Gass- 12-07, p. 72)

# Food

Many foods and drink of Indians' daily life would be repulsive to a modern palette, such as drinking the embryonic fluid first, then eating a cooked unborn calf. Blood pudding made from a porcupine was stirred with a chokecherry stick while it thickened, to give it flavor. Stories of boiling rawhide parfleche containers for food in emergencies are not uncommon, and though most would have preferred buffalo hump or tongue, probably did not turn up their noses too much at boiled rawhide.

Even in non-starvation situations, drinking the water that raw buffalo hides had been soaking in was considered quite potable; this would probably gag anyone who tried this today. If you have not seen it before, water that buffalo hides or any animal hides have been soaking in is a stinky gruel of grimy hair, dirt, blood and body oils all brewed together…nice!

Coronado tells of seeing early Indians opening the bellies of buffalo cows, then squeezing out the chewed grass and drinking the digestive fluids, and all the juices from the grasses eaten. They said the juice contains the essence of the stomach.

Fresh udder roasted on the fire was a favorite treat to many, and Colonel Dodge saw Indians draw their knives through freshly killed udders and sucking out the milk mixed with blood.

Indian people had voracious appetites when copious amounts of food was available. According to traders, the food rations for people at the trading post/fort was quite a bit of meat each day.

> At the fort the daily allowance for each child was one-quarter and for a woman one-half that for a man, which was twelve pounds fresh buffalo meat, or six pounds dried buffalo meat, or three pounds pemmican, or six rabbits, or six prairie chickens, or three large white fish, or three large or six small ducks, besides potatoes and some milk for the children, and occasionally dried berries, with a weekly allowance of tallow or fat. Rough barley was also given to those who cared to prepare it for themselves.

> Daily to feed the establishment required, in the form of fresh buffalo meat, the tongues, bosses, ribs, and fore and hind quarters of three animals, for the head, neck, shanks and inside were not considered worth freighting from the plains to the fort. The product of three buffalo in the concentrated form of pemmican was equivalent to the daily issue of fresh meat.

He continued with describing the harvesting of the buffalo:

> Next morning, the four lines of cart and travois tracks were fresher, and on every side the bones of the buffalo, off where the hides and flesh had been stripped by the hunters, were scattered over the undulating plain. Mixed with these were the bloated and blown-out carcasses of hundreds of the noble animals wantonly slain in the sheer love of slaughter, and left untouched by the young bucks to provide a festering feast for the flocks of villainous vultures, which, slimy with filthy gore, hovered over the field and disputed with the ravening wolves for the disgusting prey. For miles, the air stank with the foul odors of this willful waste, so soon to be followed by woeful want involving the innocent with the guilty. Neither warning nor entreaty of their elders could restrain the young men from the senseless massacre of the innocent herds of the universal purveyor of the prairie Indian. (Company of Adventurers)

Once the horse made his way into Plains Indian life, their hunting techniques changed and, due to the now relatively easy way to obtain meat, the slaughter increased and consequently the amount of meat actually harvested fell below what it had been in previous decades and centuries. Now, only the choice cuts were taken, unless the tribe was in a state of starvation; then, just as in pre-historic times, they took most of the animal killed.

Plains Indian people were more immune to harsh weather than a typical person today, but they were human and suffered severely from the harsh weather, including freezing to death. It could get so cold that Indian men waiting to get into Fort Union could be heard, standing outside the gates, by their teeth chattering together. Buffalo could die by the tens of thousands from blizzards and exposure, from time to time. Sudden blizzards were hazards if one had to move in the winter. This was generally avoided by settling into a sheltered river bottom over the winter.

# Chapter 8
# The Buffalo Dance

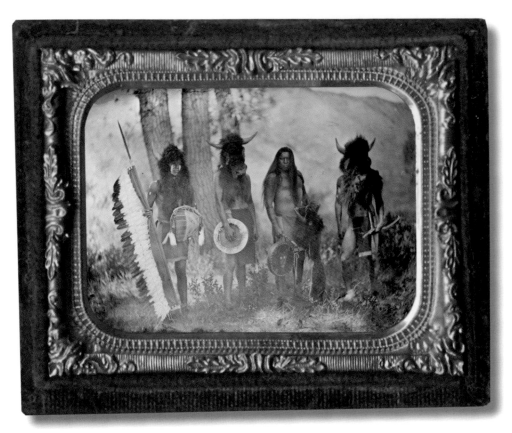

A romanticized view of the 19th century Plains are seemingly endless herds of buffalo covering the land as far as the eye could see. Though this may have happened from time to time, it was much more common to go many miles without seeing any large or small groups. The buffalo were constantly moving about seeking new grass. They could be easily spooked and driven off by careless hunters, prairie fires, droughts or just the incredible scent they knew and feared that arose from an Indian camp or group of Indians.

Vast amounts of buffalo were needed to keep a tribe alive, for as many as eight buffalo per family member each year were required just for subsistence. This would allow for the equivalent of six and half pounds of meat per day per family member. Allowing for three hundred pounds of meat from an average buffalo is generous and, unless under starvation conditions, is probably high. Keep in mind the favored buffalo for the hunt was the heifer cow buffalo, that may only weigh a total of six hundred to eight hundred pounds live weight.

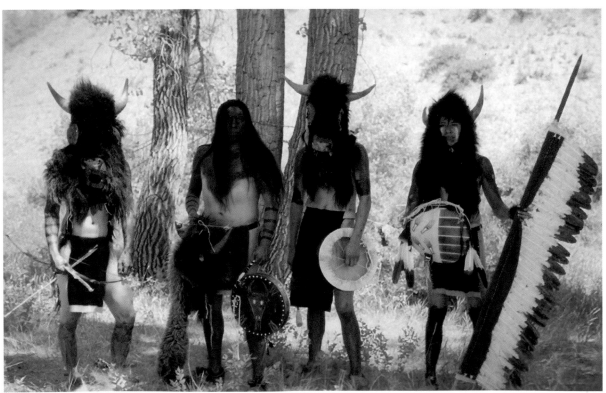

BUFFALO DANCERS ON THE GREASY GRASS RIVER, CONTEMPORARY
TINTYPE AND COLOR PHOTOGRAPHS

It took a lot of buffalo hides each year to keep the family going. Many hides became their tipi and liner, parfleches and other containers, ropes, saddles, etc. Many hair-on robes were used up every year for the floor and for wearing. A large tipi would have fifty to sixty buffalo hides in its construction and furnishings, many or all of which had to be renewed annually or every-other year.

To keep the meat parfleches full and to replenish the constantly used robes and hides, the men were always looking for the herds. If enough time went by without any major hunts being successful, and the meat supplies were getting low, the women would tell their men of this situation. They, in turn, would report to their leaders who would then tell the older social chiefs who may call the societies together and send the young men out in the four directions to locate the herds. At the same time, the older men who were beyond the age to hunting buffalo from horseback would lend what they could by performing the Buffalo Dance to call the buffalo to the tribe.

As with all ceremonial and religious activities, there were many 'right' ways to do the dance or ceremony in the Old Days. It could also vary from band to band within the same tribe and even within the band, depending on who was hosting or leading it and how that person was taught or shown to do it, either from another person who possessed that right or was given that right from a dream or vision. The Buffalo Dance would be just one of many ceremonies associated with the calling of or blessings from the buffalo.

One old buffalo ceremony was performed where people stood or sat in a big circle. In the middle of the circle there were buffalo heads on the ground, before which stood old men praying and offering sacrifices and passing their weapons and sacred implements over the skull.

There are other accounts of people coming across groups of buffalo heads, some painted red and others found all had red dyed eagle down feathers in their hair.

Many variations of the dance were recorded by observers who found the dance fascinating enough to put to paper their recollections and thoughts, by non-Indians and Indians too. Some choice examples include a Mandan Bull Dance witnessed in 1829. The two leaders wore full buffalo heads with blue beads for eyes, with eye slits below for the wearer to see through. These two leaders had spears with feathers at the top and horsetails dyed yellow, and weasel skins. Some had the lower half of the buffalo face (mask) was painted blue. Some of these dancers had dried erect buffalo tails on their backs. During the parade of dancers with headdresses, one man did not wear a headdress and was mounted. His horse, instead, had a headdress with sections of horns on a piece of buffalo fur tied to his head and a piece of yellow painted rawhide attached to its face. (*Mid-American Frontier— Tour To Prarie Du Chien*, 1829)

George Catlin tells of another sort of buffalo dance:

"Buffalo Dancer" based on an original drawing

*This and all the other tribes living within the country abounding in Buffaloes are in the habit of giving the Buffalo Dance, preparatory to starting out upon a Buffalo Hunt. For each animal that these people hunt, they believe there is some invisible spirit presiding over their peculiar destinies, and before they have any faith in their hunts for them, that spirit must needs be consulted in a song, and entertained with a dance. For this curious scene nearly every man in an Indian village, keeps hanging in his wigwam, a mask of the buffalo's head and horns, which he places on his head when he joins in this amusing masquerade, imagining himself looking like a buffalo.*

For the buffalo dance, or pte! watci, which was devoted to healing wounds, there were four leaders, two waiters, and a herald as officers. This society is now obsolete, as there is little call for the practice of surgery because there is no more war. If a man were wounded, the buffalo doctors got together and squirted water on the wound. They would dance in imitation of the buffalo, wearing robes, buffalo horn caps, and tails. They painted only with clay which is the buffalo's pigment. They painted only the upper or lower halves of their faces. The buffalo dancers were very waxobi, or powerful.

On April 9, 1834, Prince Maximilian zu Wied was privileged to see the Mandan buffalo dance.

Towards evening, nine men of the band of the buffalo bulls came to the fort to perform their dance, discharging their guns immediately on entering. Only one of them wore the entire buffalo head; the others had pieces of the skin of the forehead, a couple of fillets of red cloth, their shields decorated with the same material, and an appendage of feathers, intended to represent the bull's tail, hanging down their backs. They likewise carried long, elegantly ornamented banners in their hands. After dancing for a short time before us, they demanded presents.

The fifth band is that of the buffaloes. In their dance they wear the skin of the upper part of the head, the mane of the buffalo, with its horns, on their heads; but two select individuals, the bravest of all, who thenceforward never dare to fly from the enemy, wear a perfect imitation of the buffalo's head, with the horns, which they set on their heads, and in which there are holes left for the eyes, which are surrounded with an iron or tin ring. This band alone has a wooden war whistle, and in their union they have a woman, who, during the dance, goes round with a dish of water, to refresh the dancers, but she must give this water only to the bravest, who wear the whole buffalo's head. She is dressed, on these occasions, in a handsome new robe of bighorn leather, and colours her face with vermillion. The men have a piece of red cloth fastened behind, and a figure representing a buffalo's tail; they also carry their arms in their hands. The men with the buffaloes' heads always keep in the dance at the outside of the group, imitate all the motions and the voice of this animal, as it timidly and cautiously retreats, looking around in all directions.

Rudolf Frederick Kurz noted in his journal, on June 12, 1851, about an Omaha buffalo dance he saw:

I rode with Joseph La Fleche to the Omaha village and witnessed a buffalo dance around the wounded Tecumseh Fontanelle. We had a hazardous journey, fording the Papillon and clambering up precipitous slopes. The dance of the buffalo troop was held in a large, roomy clay hut. Ten dancers arranged in pairs imitated, in the most natural manner, the way that buffaloes drink, the way they wallow, how they jostle and horn one another, how they bellow- and all the while the performers sprinkle the wounded man with water. All the dancers wore decorated buffalo masks and buffalo tails fastened to their belts in the back. With the exception of the never-failing breechcloth they were nude. A throng of people looked on. (Journal of R. F. Kurz, p. 66)

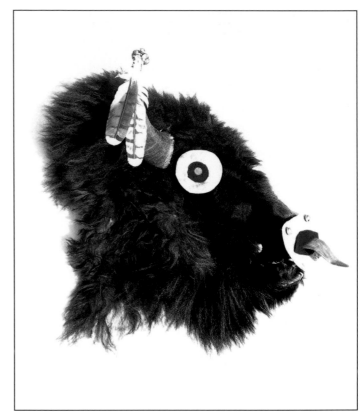

A BUFFALO DANCER'S MASK MADE FROM A WHOLE BUFFALO HEAD

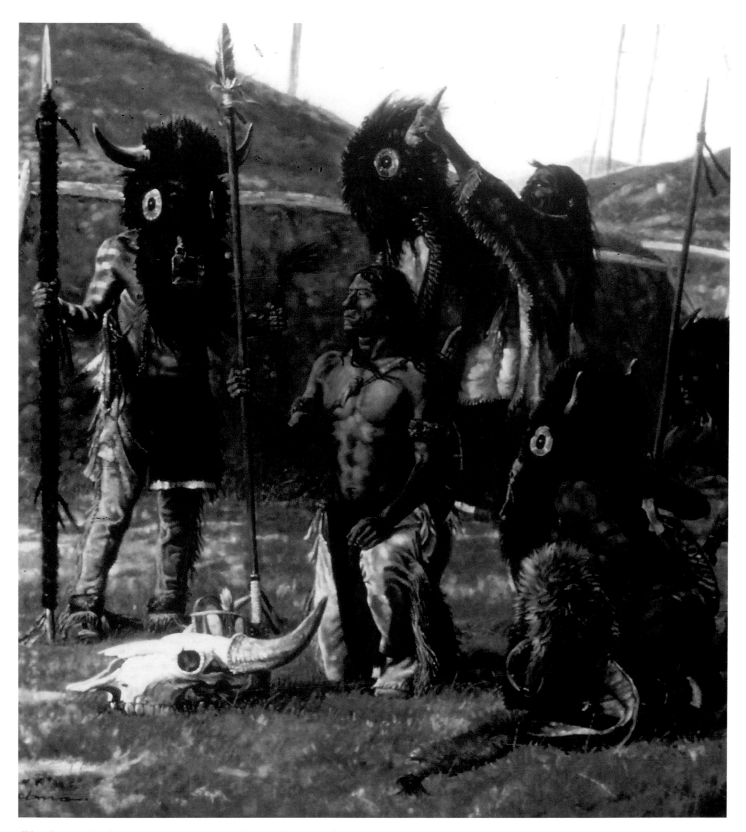

"The Chosen One" preparing for a Mandan Buffalo Dance, by Steven Lang

Boller's account, which is of considerably later date, contributes the important fact that in case of a famine, the White Buffalo Cow women were expected to make buffalo herds come nearer to the village. A similar function is attributed by George Catlin to male buffalo dancers wearing masks of a type described in this paper, in connection with the Bull society (p. 315). Catlin, however, does not connect his buffalo dance with any organization, for though only about ten or fifteen men are said to have joined in the dance at one time, he states that every Mandan was obliged to keep a buffalo mask for possible use in the buffalo-calling ceremony, on the request of the chiefs. Oddly enough, both Catlin and Boller say that their respective Buffalo dancers never failed to bring in the herds for the reason that they continued their performance for weeks, if necessary, until buffalo were actually sighted. The dance of the society is thus described by Boller:

> The different members of the White-Cow band began to assemble, and soon the regular taps of the drum notified the camp that the great and important ceremony was in full progress. At one end of the lodge sat the musicians or drummers, three in number, who were untiring in their efforts, and aided their instrumentation by singing in a monotonous chanting strain. The women, comprising some forty or fifty matrons of the village, most of whose charms had unmistakably faded, were all attired in their quaintly garnished deer-skin dresses. Each had a spot of vermillion on either cheek, and their long black hair, which was carefully combed out and dressed with marrow grease, fell full and flowing over their shoulders, confined around the forehead with a fillet of white buffalo cow-skin. One of them had a white robe (which is very scarce, and held in the highest esteem) wrapped around her. This white robe was the common property of the band, and in its great power as a "medicine" were centered their hopes of bringing in the buffalo.

J. O. Dorsey said of the Omaha buffalo (or horn) dance, which could be performed by any of the bands, that it was declared by one informant to have been the greatest of all the dances. During its performance anyone having a horned bonnet would wear it. The dancers were lined up in a row and would advance a considerable distance in the dance step. Ahead of them was a line of mounted men, while behind them came a row of musicians, and behind these the group of spectators, including women, ranged in the arc of a circle. J. O. Dorsey and Fletcher and La Flesche record this dance among the Omaha in *The Old North Trail*, p. 99.

The Assiniboine themselves believe that the Buffalo dance was derived from the Hidatsa.

For a Blackfeet version of the buffalo dance, Walter McClintock carefully observed:

> Gives To The Sun and Natokema arose, wearing headdresses having horns, in imitation of buffalo cows. Mad Wolf handed to Gives To The Sun a string of buffalo horns which had been added to the Beaver Bundle as the symbol of the buffalo by the chief, who secured the Buffalo Tipi from the Sacred Buffalo Bull. The Indians found both interest and amusement in this dance, because it represented the mating of buffalo by women choosing their men. Gives To The Sun and Natokema knelt before the Beaver Bundle with heads lowered, making motions of hooking the ground in imitation of buffalo cows digging wallows in the autumn. They pawed the ground and bellowed, simulating buffalo throwing dirt and catching it upon their backs, then shaking themselves and making the dust rise into the air.

> Gives To The Sun and Natokema then danced, imitating the capers of mating buffaloes. They stood before their mates pawing the ground and hooking at them with their horns. Mad Wolf and O-mis-tai-po-kah then joined in the dance. The men followed the women around the fire like buffalo bulls following cows. They danced in pairs until Gives To The Sun threw the hoofs to Snake Woman. All then sat down and, amid laughter, Snake Woman danced in front of Medicine Wolf, her relative. When Medicine Wolf arose and joined her, she threw the hoofs to Strikes On Both Sides, who came gracefully across the lodge and danced before me. While my Indian sister stood there, dancing with quick, short steps and swaying her body in time with the singing and the beating of rattles, I heard them calling, "Get up! A-pe-ech-eken, you are a chief now and should enter the dance." Grasping the string of buffalo hoofs lying before me, I danced, following Strikes On Both Sides around the fire, swaying my body, turning, holding my feet together and bending at the knees. I heard many shrill war cries from both men and women and exclamations of "Good boy, A-pe-ech-eken!" I stopped at intervals to mimic the call of the buffalo and to imitate its movements, digging wallows, kicking, hooking, pawing the ground and throwing dust. When Strikes On Both Sides brought our dance to a close, I completed the circle and, throwing the hoofs to Bear Child's wife, sat down.

Among the Santee Sioux, the men who had visions of the buffalo would be the ones performing the Buffalo dance (tata k watci pi), though apparently the sons of such men were also entitled to join.

Just like the dreamers of buffalo, if someone constantly had the buffalo dance on his mind, yet failed to have it performed, the thunder would strike him or a buffalo would trample him to death, or some other unnatural form of death would befall him.

Whale's account of Standing Buffalo's buffalo dance told several details about the dance, such as:

> When the cherries were ripe and the Sioux were on a buffalo hunt they would propose to have a Buffalo dance. The regalia consisted of forty-four headdresses prepared preferably from the heads of buffalo killed on the same day. The heads were cut off, stuffed until they were dry, and then served as masks. These headdresses could not be bought, but if one of the forty-four members died, his son inherited the mask and the membership privilege. Obviously one who was not a regular member might sometimes take part in a performance, for my informant did so four times as a substitute for a sick member. In addition to the forty-four dancers, there were four singers.

> For a performance the members either painted themselves with vermillion or blackened themselves with mud. They hooked one another and otherwise imitated buffalo. The people had prepared for them large buckets of sweetened water, and the Buffalo would bend down and drink.

According to Whale, the organization did not meet for the sake of mere amusements, but only to perform their dance. However, if many lodges were camped together, they would circle round the camp, singing here and there and receiving gifts. He also said there was once a man who did not himself perform the dance, because he felt unprepared for it, but exhorted his son to do so after his death. Those who had witnessed his brave deeds, he said, would naturally participate in the performance. When Whale was a young boy, a Sisseton named Standing Buffalo revived the ceremony. Standing Bull is said to have

originated the performance before my informant's day, and his son kept up the dance. The Buffalo dance as described by Little Fish was rather different in character, the esoteric elements being apparently absent among the Sisseton.

The headdress consisting of a buffalo head, with all the hair and the horns, was worn by all participants, and each had a buffalo tail fixed in the back. Some had little feathers on the buffalo head, and others little shells. Each member prepared his own headdress, slicing down the skin lest it should be too heavy. The paint differed with different individuals. There were no officers and about twenty members. Only good singers were asked to sing. The society does not seem to have been especially connected with warlike activities. At the close of a dance, the members bellowed like buffalo and a large tub of sweetened water was put down for the dancers to drink from.

Red Beads (Sisseton) said that he never joined the buffalo dance because no one made a headdress for him. The dancers might be of all ages, provided only that they could get the headdress. During the dance they held a painted disc of rawhide over the left shoulder, for the visionary had dreamt of the use of such shields.

The buffalo dance seems to have been merely a variant of a widely spread custom found among the Central Algonquin, the Iroquois, and the Plains tribes. Among the Bungi, it was held to heal the sick and to bring the buffalo in times of scarcity. From the last statement I am inclined to think it may have been held in connection with making the buffalo pound.

Certain men, who had dreamed of the buffalo, had the right to get up such a feast and dance. A dog feast was prepared, and afterwards four men, wearing buffalo head caps or masks, danced while four others sang. Eight women took part, and there was, as usual, a skaupewis to fill the pipes. Each participant brought his or her own special dish, kept for this occasion.

A small boy's buffalo skin cap, made in representation of a spike horned calf, was obtained. It had been cut down from the larger buffalo headdress of the lad's father, who was a buffalo dreamer and used his outfit for the ceremony, because the child was ill and he thought the buffalo might cure the little fellow.

The buffalo dance was held in order to secure an abundance of buffalo, not to cure the sick, as is the case in many other tribes. At the Crooked Lake Reserves, it has not been held for a long time, owing to the fact that the old men who "owned" it are now all dead and their paraphernalia have been buried with them. The men wore masks of bull hide completely covering the head and the women participants had similar masks of cow skin. These masks were made from the entire head of the buffalo. The dancers imitated the action of the buffalo, bellowing, stamping, and hooking the ground. Mrs. Paget, who was probably an eye-witness of such a dance, wrote:

*The Buffalo Dance was a very peculiar one, and was indulged in by very few of the Indians. Those taking part in it would paint or color all their bodies with red clay, and would wear a buffalo head or mask, which has been skinned and dried, with horns complete, and which looked wonderfully natural; into their belts at the back they would stick the tail of a buffalo, and around their ankles they wore strips of buffalo hide.*

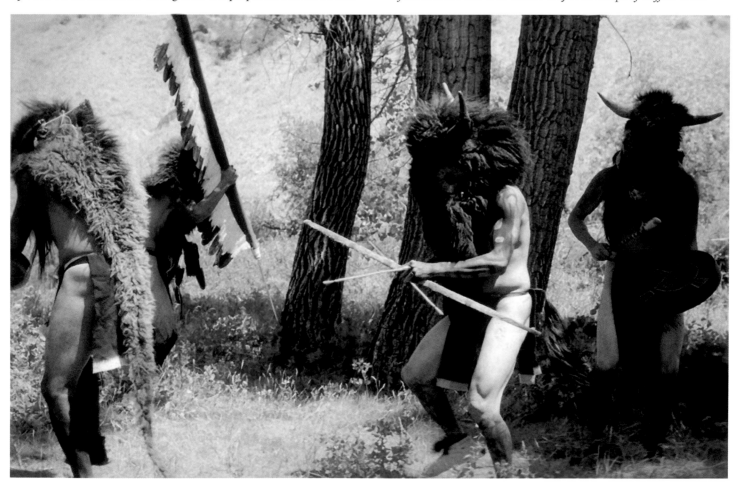

In the cottonwoods along the Greasy Grass River, a Wacipi Tatanka is peformed.

 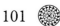

The very heaviest part of the fur, taken from the boss or hump, was used for these anklets. In their hands the dancers carried long spears, decorated with buffalo tails, and colored strips of dressed buffalo-skin. The dancers were formed in a very large circle, but no confined to it, the centre of which stood a young boy and girl, holding in their hands a small vessel containing some kind of medicine. These children would be kept standing for hours at a time while the Indians danced around them; and as the dancers could sit down and rest between intervals of singing and drumming, they never seemed to realize how very tired the two youngsters could become, or if the day was very hot, how harmful it was for them. Upon the last celebration of this dance at Fort Qu'Appelle, the little girl fainted before the ceremony was finished.

The Indians, daubed with the rusty-red clay, bearing their grotesque and hideous masks, and armed with long spears from which flaunted colored streamers, rushed hither and thither, charging the spectator as if an infuriated buffalo were about to impale him upon his horns, and, with the cessation of the drumming, sand exhausted to the ground. The airs the musicians sang, for this dance were really very tuneful, were an inspiration to the dancers.

An interesting ceremony and dance that has some connections with the buffalo dance was recorded by Prince Maximilian, though it relates more directly to the buffalo drive and pound.

"The medicine dance of the women does not occur every year. It is a medicine feast for the latter, at which, however, some men likewise appear. A large wooden hut is erected; the women dress themselves as handsomely as they can, and all wear a large feather cap. Some of the women take no part in the dance, and these, with the men, are spectators. Men beat the drum, and shake the schischikue, the last day of the feast; when the dance is finished, the buffalo park is imitated; the men, the children, and the remaining women form two diverging lines, which proceed from the medicine lodge, out of which the women creep, crawling on all-fours, and endeavor to imitate the manners of the buffalo cows. Several men represent buffalo bulls, and are at first driven back by the women; but then, as is the practice in this kind of hunting, a fire is kindled to windward, and the women, or buffalo cows, as soon as they smell the smoke, retreat into the medicine lodge, which concludes the festival. They sometimes perform this dance in the summer, when the fancy takes them. (Thawaite, Early Western Travels)

Another version of the dance, that is linked to the various chiefs' or bulls' societies, is an account told by the Lakota Calico. According to Calico, the original name of the chiefs society was The Wearers of the Buffalo Bonnet. Since about 1870, they have been known as The Big-Bellies And The Short-Hairs. About twenty generations ago, the Bull Society was founded in the Red Cloud division. According to one account, a shaman had a vision in which a buffalo appeared to him, sang songs, and gave out the necessary instructions for the ceremony. The members wore headdresses made of the skin from the neck and head of the buffalo with the horns attached. The horns were painted blue, red, or white, according to the preference of the wearer. To make the headdress waken, a small bag of medicine was tied to it. It is said that in course of time the eagle feather bonnets gradually displaced the buffalo headdresses, though many men now living remember seeing a buffalo dance in which the original headdresses were worn (during Calicos' lifetime).

Each member carried a shield and a lance. The headdresses were worn only during dances and on the warpath. At all other times they were kept wrapped up in rawhide cases and hung together with the shields and lances upon poles outside of the tipis. They were never brought inside for fear they would be contaminated by the presence of women. The rule was to keep all war medicines outside of the camp circle about one hundred feet from the tipi of the owner, supported by a tripod. If enemies were expected the regalia might be brought to the rear of the tipi, but must be left on the outside. When on the march, the shield was hung to the rear horn of the saddle, the headdress to the front horn, and the lance carried in the hand.

In the dance, the members paint their bodies white, also their lances. Originally, it is said that there were but ten bearers of lances who also wore the headdresses. In the dance they imitated the buffalo by bellowing and whooping at each other. The man who founded the society was named, Paints His Ear White. (The Buffalo Horse Dancer)

Contemporary Glass plate and color photographs of the buffalo horse Apache

The Buffalo Dance 103

## The Buffalo People are Coming! The Buffalo People are Coming!

In a hidden hollow, the darkness shrouds The People gathered around the fire in a tight circle. They hear the cry of warning…"The Buffalo People are Coming! The Buffalo People are Coming!"

Out of the blackness a horse and rider leap over the tall pile of wood and into the circle of people! Round and round horse and rider dash, both clad with real buffalo heads on their own heads and buffalo leggings made from the same. A loud necklace of forty four buffalo hooves clatter as they bash together, imitating the same sounds a large herd makes when they stampede. The People's wild eyes dancing in the firelight glaring at the apparition are pressed back away as if a cyclone is blowing them, the horses' hooves almost trampling them all. Four times around between the fire and the People the buffalo-man-horse run summoning the Four Winds and the Buffalo to give themselves to the People. Then, as quick as they had appeared…… they became a memory.

Buffalo masks made from the whole head of a buffalo fit the mans' and a horses' head. Leggings are made from the buffalo's hide with the hair left on, and buffalo tails tied to the horse's tail and stuffed into the breechcloth belt of the rider all were worn for ceremonial activities and even in war. Necklaces and arm bands or leg garters made from strips of buffalo hide could be added to enhance the power of the ceremony, by allowing the warrior to feel the part more deeply and therefore increasing his confidence and chances of success.

An Indian horse already used to the wild and bizarre array of items a warrior might tie on him, easily accepted wearing such masks. Modern horses are not as likely to like such trappings, and many will bolt just by approaching them with some of this regalia.

The mask is somewhat crudely made from the real tanned face of a buffalo. A small triangular cut is taken out of the sides under the ears which reduces that area enough so it will easily fit a horses head shape and size. The nose of the buffalo rests on top of the horses and the eyes have been cut out for the horse to see thru. Ties under the chin and neck hold it on along with slits through the top of the head for the horse's ears to go thru. Real buffalo horns that have been removed from the skull, cleaned and dried or just a set picked up off of the thousands to be found on the prairie

CONTEMPORARY TINTYPE PHOTOGRAPH OF A BUFFALO HORSE

are attached to the buffalo head mask with tanned leather thongs.

This same procedure was used when making the mask for the men's buffalo dance regalia and just when those masks were made a broad range of individuality would be expressed and allowed when decorating them.

*{See chapter on The Buffalo Dance} Brass, copper or tin metal rings could be placed around the eyes, or rawhide circles, beaded, quilled amulets and accents, feather and fur bunches, the varieties and choices were many.

The buffalo dance was principally performed when the people were in need of buffalo.

As with all ceremonial and religious activities there were many 'right' ways to do the dance, so it could vary from band to band within the same tribe and even within the band depending on who was hosting or leading it and how that person was taught or shown to do it either from another person that possessed that right or given that right from a dream or vision.

One way of performing the dance that I was taught by an Oglala who had inherited the right through their great-uncle Sitting Bull was done as follows;

Four mature men are chosen to be the buffalo bulls. Dressed with buffalo head masks, a buffalo tail stuck into the backs of their belts, their bodies then painted red or black or both colors and carrying a spear and shield. As they enter the dance area one at a time they dance with the sun... i.e. in a clockwise motion, the four men each take up a spot at the four cardinal points. They continue dancing imitating the motions and sounds of a buffalo bull forming a cross as each one stays an equal distance from each other.

A man carrying a bow and blunt arrows enters the dance representing a hunter and dances around and in and out of the buffalo choosing a buffalo.

After four passes he fires into one of the buffalo men with a blunt tipped arrow. This 'wounded' buffalo will now make four turns around the center before finally dying.

The older men dancing could go on for days at a time sparing each other as they tired out, while the younger men were out actively seeking the missing herds.

The same procedure was used when making the mask for the men's buffalo dance regalia as was used when making the buffalo masks for their horses. Just as with the horses masks there was a broad range of individuality that could be expressed and allowed when decorating their own masks. Brass, copper, tin, German silver, wood, bone or rawhide circles could be placed around the eyes, nose and mouth. Beaded, painted or quilled amulets and accents of feathers and fur strips or fringes could all be applied at will or as directed by a mentor or vision. The varieties and choices were many and limited only to what they could obtain in their wide and varied environment and what they could get through trade from non-Indians.

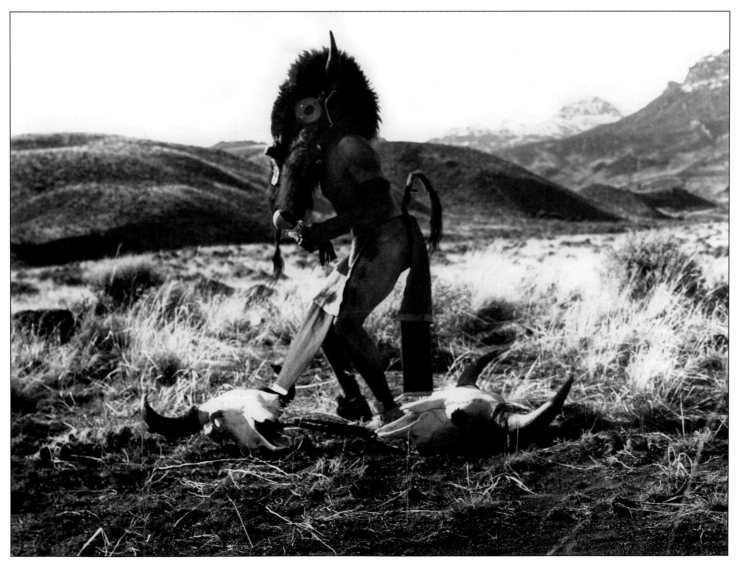

"Calling the Buffalo People" photograph by James Bama

The Buffalo Dance     105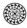

# Chapter 9
# Horses for War and Hunting

*"To be alone with our war horses at such a time teaches them to understand us and us to understand them. My horse fights with me and fasts with me because if he is to carry me in battle he must know my heart and I must know his or we shall never become brothers. I have been told that the white man who is almost a god, but a great fool, does not believe that his horse had a soul. This cannot be true. I have many times seen my horse soul in his eyes."* —Plenty Coups, Crow

The tintype and color photograph shown above show a true war horse, bred and raised specifically to run down human and animal alike and do the bidding of his brother/rider. One of these highly trained horses would cost you a minimum of ten or more regular saddle horses.

The beaded face mask shows he and the rider are the war party leader or pipe carrier. Rawhide painted cut outs in the shape of animal horns give the horse the speed of the antelope; painted forks come out of the eyes evoking the power of lightning to blind and send fear into his enemies and his enemies horses as well.

Various birds of prey feathers are tied to his forelock, helping his vision and giving him the combined attacking and killing skills of all of those efficient hunters. The human scalp signifies the rider and horse have run down and over a dismounted enemy. Often, this human scalp was substituted with a less valuable horse scalp. I believe horse hair substitutes were used due to the fact it is very easy for your horse to step on the dangling scalp when they reach down to graze. Then, when they raise their head, they break the buckskin thong holding the scalp to the bridle or mask. This achievement could also be represented by a large stick figure of a man drawn on a horses' chest. Among the Crow, accomplishing the same feat earned you the right to paint a handprint on your horse's body.

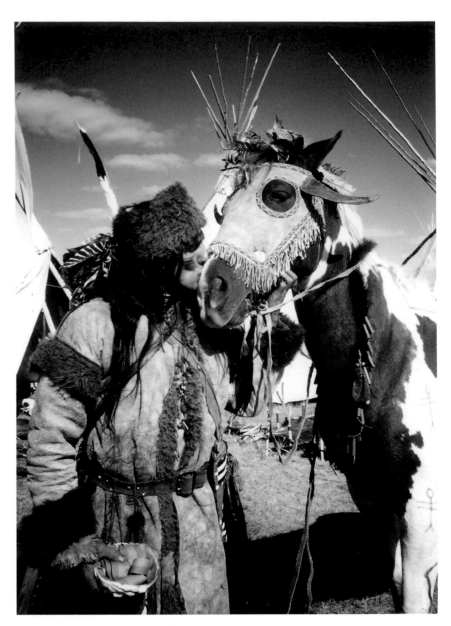

"I Know My Horse Has A Soul"

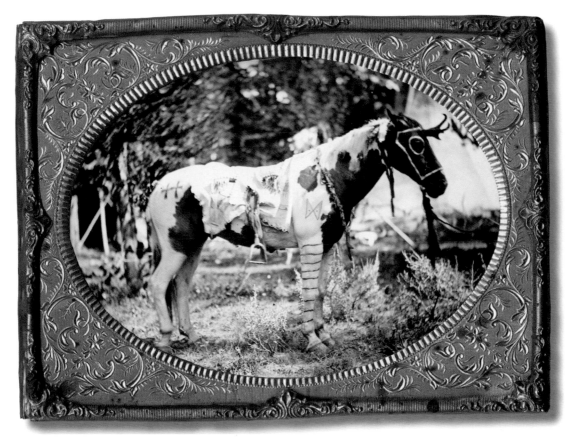

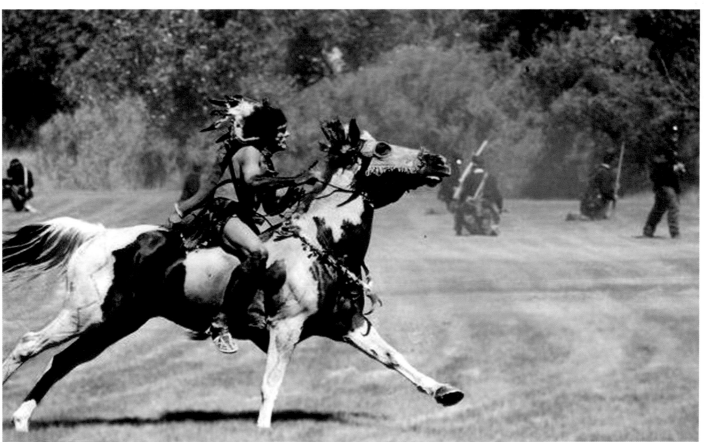

WAR HORSE APACHE, CONTEMPORARY TINTYPE. APACHE AND RIDER, COLOR PHOTOGRAPH

Horses for War and Hunting     107

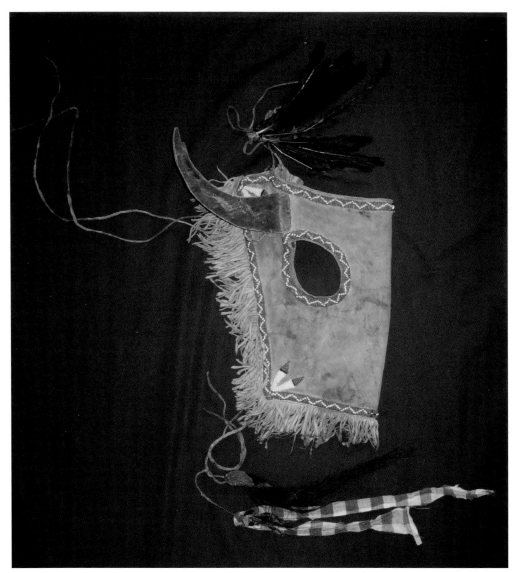

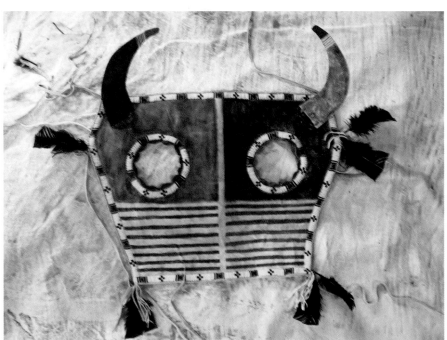

ANOTHER HORSE MASK

The strip of red and white silk cloth hanging with the scalp is a fragment of a United States cavalry company guidon. It denotes that the horse has been ridden in battle under fire of the enemy. This honor mark is for the horse and acknowledges the riders respect for his animal and how he would be nothing without him.

A necklace made from a strip of white horsehide with buffalo dew claw dangles prevents the horse from stumbling, just like buffalo never do, and again the antelope imagery is repeated with a real antelope horn hung from this strip.

Rather than having the beautiful full mane of a movie horse, this horse has the mane of one that has been used and its mane pulled left, right, backwards and forwards, with hanks of hair ripped out while swinging weapons or getting caught in rawhide ropes or bow strings.

A summer buffalo hide has been painted with the feathered sun design and has been used as a saddle pad for the beaded pad saddle which has been stuffed with antelope hair.

A cluster of owl feathers and otter fur strips adorn the tail to give the horse the ability of silent approach, just like the owl, and the swift efficient killing ability of the otter.

Painted stripes on the front legs shows how any times coup has been counted from that side of the horse; one of them has been painted red to show the rider was wounded in that attempt.

The Cheyenne would spit sweet root on their horses hooves to add speed and aid in agility. Two Leggings, the Crow, also used physical medicines mixed with spiritual power. "When I noticed a horse tiring, I shouted and untied a little medicine bag which was always fastened to my shirt. With a small bone spoon I took out some powdered herbs and rubbed them into my horse's mouth and nostrils and on its jaw. After mounting again I sang my horse a medicine song: "My horse is fast. My horse is faster."

A painted butterfly flies on the horses' shoulder, which will make it appear to move like a butterfly in battle and to make it hard to hit with bullets or arrows. This butterfly design is a great example of something you may see painted on a fierce warrior horse. Remember the famous boxer Mohammed Ali's saying, "Float like a butterfly and sting like a bee!" This was how you were supposed to move and handle yourself in battle, moving constantly and unpredictably to confuse and intimidate your enemy.

On the hind quarters, a double cross shows the rider has rescued a dismounted comrade while under fire of the enemy while on horseback.

Though an average Indian horse was unshod, some wealthier men had their horses shod by the white man, more as a sign of distinction, wealth and style than as a protective device for their mount's hooves. According to Stanley Vestal and White Bull, in *Warpath*, the Lakota called them "Iron Claws."

Prescott recorded his blacksmith, Chatel over an eight month period, from December 1848 through July 1849, shod sixty-one Indian horses, fixed 228 guns, 224 traps, 143 axes and for Good Roads village he made 73 kettle chains, 265 fire steels, 50 spears, 208 pair of fish spears, 24 stirrup pairs, 230 axes, 199 hoes, 63 crooked knives, 16 melting ladles for lead.

Since most Indian horses were unshod, most Indian men preferred dark and/or hard-hoofed horses, as they were easier to keep care of their feet. The darker, harder-hoofed horses generally keep their own feet more or less evenly worn down by use, but if they or any other horses needed help with their feet, many men knew how to deal with them. Large horse-hoof files could be purchased from most trading posts. If they could not afford this more or less luxury item, a hoof file could be made by their own hands.

An elder berry stalk, which has natural hollow pith, was cut around 30 to 50 centimeters, or so. It was split in half lengthwise and the hollowed-out pith was filled with a mixture of hide glue and pulverized flint. This dried and became a rigid and course surface that could file the horse's feet. If the flint became dull, then hot water was poured over it to remove the outer layer of worn-down grit and expose the sharper unused stone below.

If a hoof needed surface work done on cracks or bad chips, men would put pitch in the cracks on the horse's hooves when they are worn and then rub with a hot stone to make it smooth.

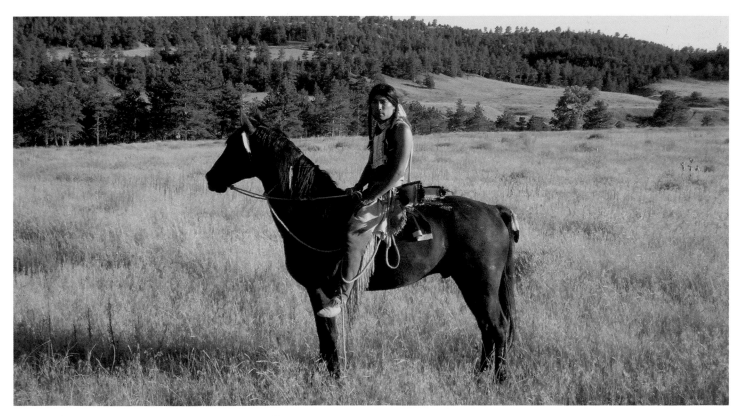

Wapaha Ota, Many Hats, goes on a raid, Cheyenne River

A valuable horse like Many Hats, seen in the image on the previous page, could make you a wealthy and powerful man within the tribe and help keep you and your family protected and well fed. Unfortunately, good horses were not always easy to keep around and, just as in many other societies, a family fortune could be wiped out overnight by numerous catastrophes. Many songs of praise and thanks would be sung for such a horse, in both life and death.

Once a man had obtained a fast horse, it usually was gelded at a young age, between two and four years old. Some tribes, like the Hidatsa, wanted to do every thing possible to assure the horse's speed and success. Therefore, a man who specialized in gelding horses would ask the owner what kind of sinew he would like to used when sewing up the freshly cut geldings. Sinews chosen from different animals could effect the way it would run in the future. Choices were elk, antelope and deer, each transferring a different ability or power.

If you used elk sinews to do the sewing, the horse would run long and steady with lots of endurance, but not too fast. Using antelope sinew resulted in the horse being able to run rapidly, but for short distances. A jack rabbit sinew would make your horse able to make fast turns, but you could never tell when he might stop all of a sudden.

The horses chosen, trained and ridden in war were a special horse indeed. Just as today, few horses then had the natural combination of genetics and abilities of speed, agility, endurance, intelligence and—perhaps most important of all for a war horse—bravery, a trait many horses do not share. The eons of time evolving horses has made horses realize all they had to do was flee from a situation that alarmed them. The typical horse's reaction to anything that scares them is to bolt off and run a hundred yards, spin about, and defiantly (and safely!) snort at whatever it was that spooked them.

When looking for a potential war horse, you notice out of a herd the young horse that, instead of blindly fleeing from the unknown, faces and focuses on it. As you see the horse exhibit this trait over time, you watch him to see how fast and inquisitive he is. Of course, if you were a poor man with few horses, you would train and ride into battle whatever horse you could find. However, you would expect to achieve little on such a horse, other than carrying you to the battle; the other warriors mounted on superior horses would spot you and other riders on inferior mounts

right away. In any horseback competition, which is what a horseback battle is, victory is based on the best horses and who can stay on them under any circumstance and use their weapons most successfully.

A valuable horse like Many Hats, seen in the image above, could make you a wealthy and powerful man within the tribe and help keep you and your family protected and well fed. Unfortunately, good horses were not always easy to keep around and, just as in many other societies, a family fortune could be wiped out overnight by numerous catastrophes. Many songs of praise and thanks would be sung for such a horse, in both life and death.

Once a man had obtained a fast horse, it usually was gelded at a young age, between two and four years old. Some tribes, like the Hidatsa, wanted to do every thing possible to assure the horse's speed and success. Therefore, a man who specialized in gelding horses would ask the owner what kind of sinew he would like to used when sewing up the freshly cut geldings. Sinews chosen from different animals could effect the way it would run in the future. Choices were elk, antelope and deer, each transferring a different ability or power.

If you used elk sinews to do the sewing, the horse would run long and steady with lots of endurance, but not too fast. Using antelope sinew resulted in the horse being able to run rapidly, but for short distances. A jack rabbit sinew would make your horse able to make fast turns, but you could never tell when he might stop all of a sudden.

The horses chosen, trained and ridden in war were a special horse indeed. Just as today, few horses then had the natural combination of genetics and abilities of speed, agility, endurance, intelligence and—perhaps most important of all for a war horse—bravery, a trait many horses do not share. The eons of time evolving horses has made horses realize all they had to do was flee from a situation that alarmed them. The typical horse's reaction to anything that scares them is to bolt off and run a hundred yards, spin about, and defiantly (and safely!) snort at whatever it was that spooked them.

When looking for a potential war horse, you notice out of a herd the young horse that, instead of blindly fleeing from the unknown, faces and focuses on it. As you see the horse exhibit this trait over time, you watch him to see how fast and inquisitive he is. Of course, if you were a poor man with few horses, you would train and ride into battle whatever horse you could find. However, you would expect to achieve little on such a horse, other than carrying you to the battle; the other warriors mounted on superior horses would spot you and other riders on inferior mounts right away. In any horseback competition, which is what a horseback battle is, victory is based on the best horses and who can stay on them under any circumstance and use their weapons most successfully.

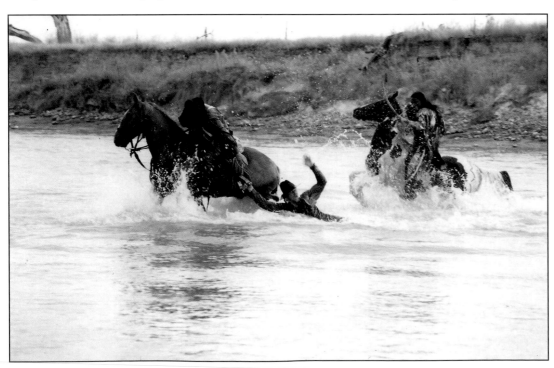

A War Horse must be able to perform bravely under any situation, allowing its rider to use his weapons and make his kills.

A valuable horse like Many Hats, seen in the image above, could make you a wealthy and powerful man within the tribe and help keep you and your family protected and well fed. Unfortunately, good horses were not always easy to keep around and, just as in many other societies, a family fortune could be wiped out overnight by numerous catastrophes. Many songs of praise and thanks would be sung for such a horse, in both life and death.

Once a man had obtained a fast horse, it usually was gelded at a young age, between two and four years old. Some tribes, like the Hidatsa, wanted to do every thing possible to assure the horse's speed and success. Therefore, a man who specialized in gelding horses would ask the owner what kind of sinew he would like to used when sewing up the freshly cut geldings. Sinews chosen from different animals could effect the way it would run in the future. Choices were elk, antelope and deer, each transferring a different ability or power.

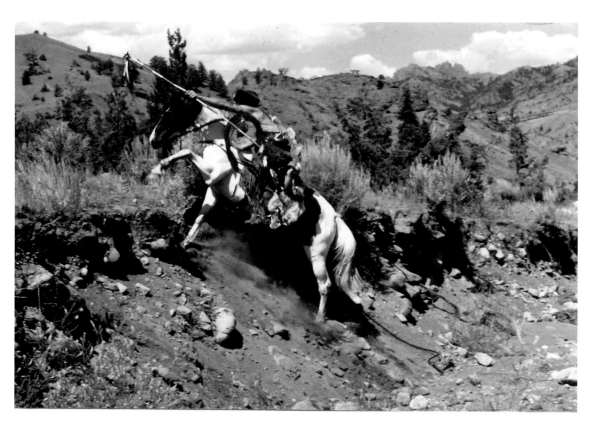

Wapaha, the war horse, goes to attack charging up a hill.

If you used elk sinews to do the sewing, the horse would run long and steady with lots of endurance, but not too fast. Using antelope sinew resulted in the horse being able to run rapidly, but for short distances. A jack rabbit sinew would make your horse able to make fast turns, but you could never tell when he might stop all of a sudden.

The horses chosen, trained and ridden in war were a special horse indeed. Just as today, few horses then had the natural combination of genetics and abilities of speed, agility, endurance, intelligence and—perhaps most important of all for a war horse—bravery, a trait many horses do not share. The eons of time evolving horses has made horses realize all they had to do was flee from a situation that alarmed them. The typical horse's reaction to anything that scares them is to bolt off and run a hundred yards, spin about, and defiantly (and safely!) snort at whatever it was that spooked them.

When looking for a potential war horse, you notice out of a herd the young horse that, instead of blindly fleeing from the unknown, faces and focuses on it. As you see the horse exhibit this trait over time, you watch him to see how fast and inquisitive he is. Of course, if you were a poor man with few horses, you would train and ride into battle whatever horse you could find. However, you would expect to achieve little on such a horse, other than carrying you to the battle; the other warriors mounted on superior horses would spot you and other riders on inferior mounts right away. In any horseback competition, which is what a horseback battle is, victory is based on the best horses and who can stay on them under any circumstance and use their weapons most successfully.

Endurance was another horse trait deemed necessary when living on the plains; the horse may have to run for miles to the nearest coulee, rock outcropping, or trees to find cover and rest. Many accounts by soldiers and warriors include stories of running, chasing and fleeing from each other.

If caught on the open prairie when he felt his horse playing out, a defensive option could be, as Red Crow witnessed of some Cree; they killed their horses to make a breastwork, and it was a fairly common tactic. If a man were with his warrior brothers and all were on experienced horses, an option was to construct an impromptu barricade by laying the horses down and forming a triangle out of their bodies. Their legs were then tied together, one horse's front legs to the next one's rear legs, and so forth around a circle, with their bellies facing in (Dodge). This made quite an exciting and dangerous breastwork, as the horses squirmed and reacted to gunfire, arrows, charging enemy, and being wounded. Luckily, horses can take some pretty massive wounds and lose a considerable amount of blood and, unless a vital organ, vein or artery is hit, they can continue to perform well with what appears to be a severe wound. The same can be said for a human, under the right circumstances. There is a lot to be said for adrenalin, what one can accomplish, and how focused and powerful it can make you feel.

Horses have only a few miles of full-tilt running in them. After that, they drop down a notch where they can run for a long way, but at quite a reduced speed. If you keep pushing them they will keep at this pace until they literally drop. As they near total exhaustion, they begin to ignore commands and it becomes difficult to turn or stop them, which are the two most important commands for riding a horse.

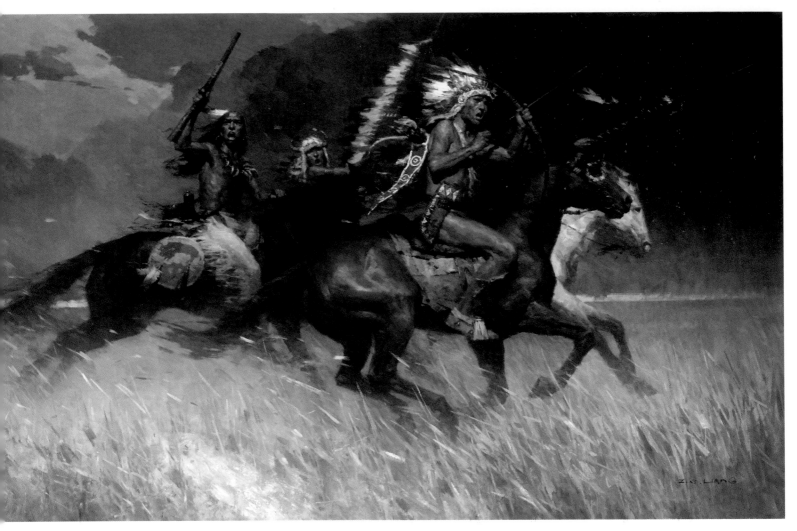

"Circling the Enemy" painting by Z. S. Liang

If a rider has the luxury of time and security while fleeing an enemy or trying to cover a long distance quickly, a good way to rest a horse considerably is to run your horse for a mile or so, then dismount at a run with the rider running along side the horse for a mile or so, then get back on the horse and repeat the process until the horse's heart rate and internal temperature gets back down close to normal. In battle, the rider would have dropped out of the action long before the horse got to this point.

A good horse will keep up a sustained and fast walk for hours on end. Horses that grew up on the prairie under a nomadic lifestyle, where home was wherever the village was set up, were more apt to walk rapidly everywhere. Horses used to moving stock, such as sheep or cattle, have a slow and deliberate walk; once they have grown up walking at that pace, that is how they walk forever. Also, all horses know where their barn is, and on the trail they may drag and plod along, but as soon as you turn them in the direction of home, they are off at a rapid walk.

Horses are like people. You may be able to get them to do things for you out of respect or fear, but they will put more energy into it if the respect is based on admiration and mutual friendship first. Intelligence and bravery go hand-in-hand, because a quick-learning and smart horse can figure out rapidly what to fear and avoid, such as a wounded buffalo, a sudden cliff, or a deep ditch that appears out of the dust of battle or a chase. The more you are around them the more you communicate with them with gestures and looks, or if you are on their back, the slightest leg squeeze or touch with your toe or ankle can get a desired response from them. This is when they are ready to be a War Horse or a modern competition horse, one you can expect to survive and win. You need a relationship with them to respond to your wishes instantly. Riding anything else was a quick ride to the end.

Original accounts by warriors often tell how they focused on the enemy's horses before and during an attack, to figure out which ones were most dangerous and which would be the easy kills. They assessed the military offensive and defensive strengths of their enemy before attacking, and the strengths laid mainly in their horses. There are many variables to take into consideration when rating them. When Alexander Henry viewed the horses of the Hidatsa, he wrote that they had heard many stories about how Indian horses were superior, but could not find one to their liking among 1500 Hidatsa horses. Charles McKenzie, Henry's employee, wrote that there were many fine horses, and Henry was an idiot. (Charles McKenzie, *Narratives*) One important factor was how useful they were when the horses were being used for work, such as hauling, pulling or packing people or supplies.

An advantage the Indians and their horses had were the shear numbers of them and the pool they generally had to draw from. Also, Indian's horses were necessarily toughened to the abusive and harsh life they led, never having shelter and seldom any supplemental feed, except for the finer war and buffalo horses whose diets were supplemented to keep them more fit.

Indian wives were usually given the tasks of chopping or burning down a cottonwood tree, or breaking the branches and pulling them down with a short and heavy log tied to a long, rawhide rope. The log was thrown up and over branches out of reach, and then pulled downward to break off the branches. This worked well for fire wood, but not nearly so well for green, live branches. Often the women would split open the bark of green branches and allow the horses to help themselves. During winter months, some tribes allowed their horses to feed on a green tubular plant called a 'Ghost Whistle' (horse tail, Equistrum arvense, that grew mainly along river bottoms. They had to be careful about letting their horses overgraze, as it could make them sick.

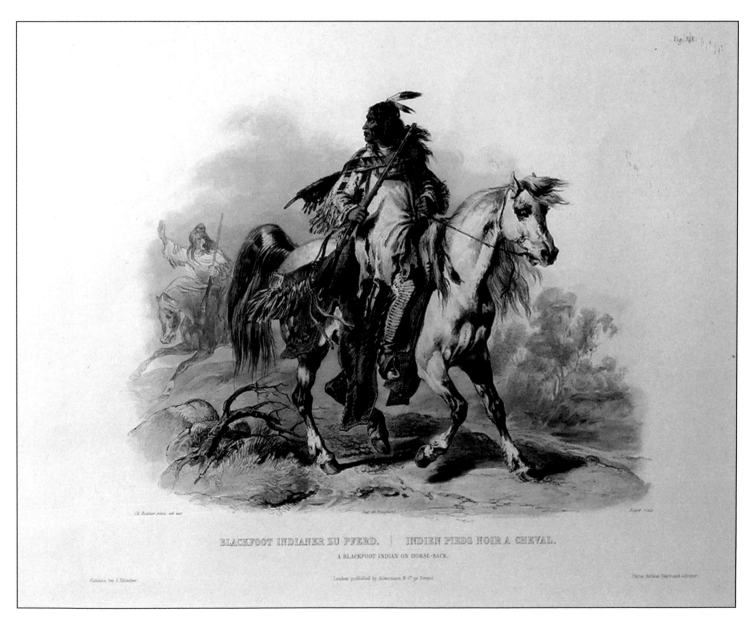

BLACKFEET WARRIOR WITH RIFLE ON HORSEBACK, PAINTING BY KARL BODMER

A BUFFALO HIDE TIPI VILLAGE ON THE MILK RIVER

The horse's lack of shelter, proper feeding, and general care was the undoing of many tribes, in that they made their horses unfit for service for a good portion of the year. Generally, Indian horses were in poor condition and unable to carry heavy loads over long distances for most of the winter and well into the spring, when fresh grasses made their reappearance.

In contrast, the Army's soldier horses were well fed and cared for year-round. In 1850 it cost $34.24 to feed one Cavalry horse per month at Fort Laramie. That is more than twice what the trooper riding it was making per month! On average, soldiers' horses were superior to the average Indian horse, if based on year-round service availability. However, soldiers' horses tended to suffer greatly from prolonged use and being in the field under constant work and stress, and only being fed grasses. Therefore, soldiers' horses usually died soon after being captured by Indians.

In one instance, when cavalry horses were worn out during an attack, the soldiers put their saddles on captured Indian ponies to continue on. A similar thing happened when a group of Cheyenne ran off a group of soldiers and found eighty of their fully equipped cavalry horses tied to the brush. The horses were broken down and useless, but the warriors fought over the saddles and tack of the soldiers. (George Bent)

The speed of a horse depended on genetics and training, and on the circumstance, terrain and distance to be run. In a short burst, the Indian pony would usually gain ground quicker and, as Dodge wrote, the smaller, quick Indian ponies would generally win at races or a combat chase if it was only one to three hundred yards long. If the race or chase were six hundred yards to two miles long, the cavalry horses' long legs gained the advantage and won. If the chase lasted farther, then the Indian pony won, due to its better endurance, which built up from being used so much.

War horses, like a man's body, could be used as a walking war record robe or tipi liner, proclaiming not only the accomplishments and war honors of the rider but the horse as well. The various paintings, ornaments and devices attached to a horse could be spiritually protective designs beseeching the power of God. This power was given through various effigies, dried bird and animal parts, feathers, painted designs, etc. that served to protect and give power to the horse and rider. Examples of protective devices could be anything within the varied palate and realm of the territory. A stuffed and dried king fisher bird worn in a rider's hair or a horse's mane could have a dual purpose of making the rider hard to hit with bullets or arrows (just like a kingfisher, due to the pattern in which they fly).

Kingfishers generally fly in a straight line not very long before dropping or elevating their flight path. A belief shared by many was that they were useful in healing and closing wounds, if you were unfortunate to be hit by a weapon. Observing the streamlined shape of the kingfisher's body, they noticed that when they enter the water to catch a fish, they make no splash and the water closes up behind them. The function of this is to allow a kingfisher to catch fast and elusive small minnow-sized fish. The slightest splash on the water's surface would alert the fish to the oncoming predator, enabling them to escape. Therefore, an Indian making these observations felt that if everything was working in his favor, and the Grandfathers and animal spirit helpers wanted to help him, then they would work their spiritual power through the kingfisher and enable your wounds to close rapidly, just like the water does behind the bird.

The dragonfly's power was desired, too, and used for several reasons. For tribes where water was a bit scarce and the distance farther between watering places, dragonflies represented water and good luck. Among many tribes, dragonflies were seen as being related to whirlwinds, due to the minute dust-off they create when they fly off of the ground. Like the swallow, kingfisher, butterfly and others, dragonflies are hard to hit with an arrow or a bullet, and they can lend you their power, if they and the creator so chose.

Lightning bolts painted down a horse's legs gave his legs the striking and destructive power of the thunderbird. Swallows, dried or done in effigy, may be used along with lightning imagery. Since they always flew ahead of big storms, they were thought to travel with the thunder birds.

Butterflies painted on a fierce warrior horse indicate how you were to move and handle your self in battle, moving constantly and unpredictably to confuse and intimidate the enemy. A rainbow may be painted

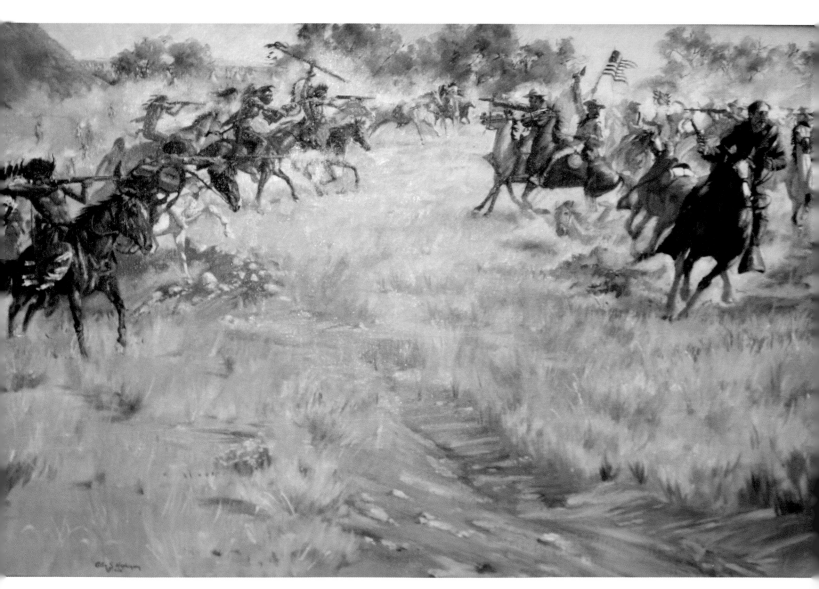

"Attack at Medicine Tail Coulee" painting by Glen Hopkinson

**Horses for War and Hunting**   115

across a horse's chest or down his legs to signify that the enemy would flee before you, just like a rainbow always will. Some marks on a war horse or a buffalo runner may be permanent, as when their ears were split, notched or holes plugged through them to readily identify them as having reached the 'rank' of a successful buffalo runner. Elite war horses were often gathered and distributed in the dark, or just before dawn. Ear markings made it possible to distinguish individual horses, either by feel or having the head silhouetted against the sky or the moon. This worked in reverse, too. When horse-stealing parties reached the herd of an enemy at night, the first thing they did was to check the ears of all the horses, to learn which were the best.

In Cheyenne tribes, only the war party leader was allowed to wear a mask on his horse's face so he stood out in battle and his men would know where he was and whom to follow, something important in the confusion of a rapidly developing and intense horseback battle. An elder Cheyenne said his father had told him this when he was a young boy. A primary source for it is not known.

Horse masks among the Blackfeet were related to particular bundles. Among some tribes they were personal emblems related to visionary instruction. On the hind quarters, the leader may paint a large red square, too, so that all behind him knew he was the leader.

Wounds the horse had received in battle were represented on his body, too. Arrow, lance and knife wounds would be shown as a slash, either red or black and perhaps with blood flowing from it imitated with red vermillion. Bullet wounds were painted as a dot. Painted rings around the eyes, nose, or ears gave extra power from the sun and spirit world to help the horse see, smell and hear better. Weapons captured and scalps taken could be displayed on the horse, too

Enemy horses captured could be shown on the horse by red and yellow horse-hoof marks. Horses given away may be shown as green or blue tracks, as described by Prince Maximilian when writing about painted buffalo robes. Individual coup marks of the rider could be shown as painted horizontal lines on the horse's legs. If the warrior was wounded in the process of counting a specific coup, then that line may be painted red. The number of lines on each horse's legs corresponded to the number of times the rider had counted coup on that side of the horse. Ten times from the right side, then ten painted coup marks were on the right leg, etc.

A horse's tail would be tied up in a variety of ways when going to war. According to LaForge and others, the were tied up so they could run faster. Some claim it was to show they were at war, while some thought it was to help dismounted warrior brothers by giving them an easy hand-hold to grab when needing a lift. Additional astute observations by Colonel Dodge concern the Indian's riding style: "when traveling under ordinary conditions a more unromantic or less dangerous looking specimen could not be found than Indians. The seat and carriage of Indians is usually ungraceful, short stirrups force him to sit almost on the small of his back, rounded into curve. Heels in constant motion against horses ribs. Though ungraceful, they perform feats of incredible horsemanship."

Indian people had no notion of how one should look and comport themselves while on horseback. When traveling to and fro they could not have cared less, and were more concerned with comfort and safety. Along the lines of security while on the march, "they scarcely turn their head or body, but are always watchful." Dodge also made some notes on Indian horse racing;

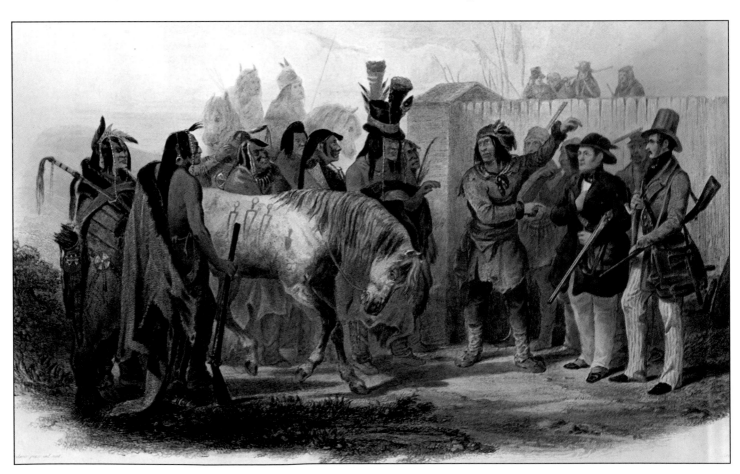

HORSE BEING TRADED, PAINING BY KARL BODMER

 116    Horses for War and Hunting

*They would race to tree on horses, the first to touch the tree wins. They would place a heavy pole six feet from the ground crosswise. Riders would race at it to touch, if they stopped too soon they can not touch it, if too late they will get knocked from their horse. Men would race at two buffalo hide strips, or logs on ground six to ten feet apart, they must jump and clear the first strip or log with all four feet and no feet over second the strip. Indians disliked racing with whites.*

A sweat lodge provided a place with the openness and ease of communication that seems to enable people to share deep and true feelings and emotions. Some of the more profound things I have heard from Indian people have been related within the circle of the sweat lodge. In the summer of 1998, while sitting on the banks of the Little Big Horn River, in Montana, on the Crow reservation, doing a sweat, one of the Crow elders spoke and said something that has stuck with me for years. As the rocks hissed and the smell of flat cedar purifying incense filled the air, he said, "The Crow people have an old saying that goes way back to our early days, we said that no matter how many horses a man has in his life he will only have four good horses....we all here know that Bad Hand right now has the best horse he will ever have." Everyone grunted their approval and I was deeply moved by it all. It was a true and timeless moment that could have occurred anytime in the past two hundred years or so.

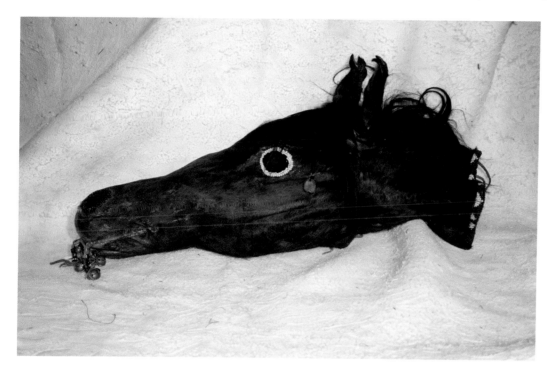

A MEDICINE BUNDLE, MADE FROM A HORSE'S HEAD THAT HAS BEEN SKINNED OUT WHOLE AND TANNED. IT COULD HAVE BEEN USED IN A VARIETY OF CONTEXTS, BY A HORSE DOCTOR OR A MAN, AS A MEDICINE BUNDLE REPRESENTING THE POWER AND WEALTH ASSOCIATED WITH HORSES.

I have been through so much with my horse, Apache, that I feel all of our extreme experiences together has given me some slight insight into what it was like to have a daily life and existence with these awesome animals, and to know the spirit that lies within them.

The amount of horses varied from tribe to tribe, depending on many factors. A general rule of thumb is the farther south one traveled the richer the tribes were in horses. George Bent saw horse herds of the Kiowa, Comanche and Apache, along the Arkansas River near Bents' Fort, stretch for fifty miles. At the other end of the scale, in 1804, Alexander Henry met three hundred Cree/Assiniboine warriors and only half were mounted. In 1808, Henry wrote that some Blackfeet owned forty to fifty horses each, with the Piegans having the greatest number. In 1833, Maximilian reported as many as 4000-5000 horses were owned by one very wealthy Piegan chief. Such a man would be the modern day equivalent of a billionaire, with much power and influence not only within his tribe, but within the region he lived in. He would have used his wealth in horses to his advantage, by 'leasing' out the finer ones for war parties and buffalo hunts, using the fastest ones for gambling and racing, and offering stud services for a fee to his fellow tribesmen. He could also use this wealth to gain friends and allies, by always being generous and loaning or giving many horses away to

friends, family and tribesmen that were in need or who deserved to be rewarded in some manner.

In a much earlier account, left by Hennepin while visiting the eastern the Sioux in 1680-1681, he wrote that they had "numerous horses." (Hennepin, *Among the Sioux 1680, 1681,* in LaSalle, 1901, v. 3)

Zenas Leonard visited a horseless "Bannock" village, in 1834, which journeyed to the Plains once a year to hunt buffalo, where they remained "until they jerk as much meat as their females can lug home on their backs." (Leonard, 1904, p. 148)

Miller's watercolor of Pawnee Indians moving camp (1837) portrays a number of women carrying heavy loads on their backs, as well as loaded horses and dog travois. (Ross, 1951, p. 66) The Pawnee, were poor in horses.

La Verendrye noted that "the women and dogs carry all the baggage" among the horseless Assiniboin whom he accompanied on a visit to the Mandan in 1738. (La Verendrye, 1927, p. 317) Later, traders who met horse-using tribes of the western Plains commented on the improvement in the status of women due to their possession of horses.

In 1772, Cocking (1908, p. 111) noted that the Gros Ventres "use pack-Horses, which give their Women a great advantage over other Women who are either carrying or hauling sledges every day in the year."

By the time they were ten and older, they were beginning to help quite a bit with skinning, butchering, tanning and processing of the various animal by-products harvested from each animal. Once they were of the acceptable marrying age, at fourteen to sixteen, they were expected to be proficient with all chores and duties of an adult woman and ready to be a man' wife. All through these ages, according to Long, girls were informed at an early age about sexual relations and were warned against the arts of men that would be aimed against them.

Unlike small boys, young girls were generally covered with some sort of clothing, though some were allowed to go naked early on in life. This had nothing to do with modesty, as until that thought was forced on Indian people by missionaries, they had no concept of it. (Notes on the Hidatsa Indians are based on data recorded by the late Gilbert L. Wilson, *Buffalo Bird Woman's Garden*, page 17)

Maximilian wrote of this in his journal:

> *Since Indian women are accustomed to the nudity of Indian men and look upon that condition as in the nature of things, to be taken as a matter of course, no immoral effect is produced on them; while the men, who have opportunities all the time to see naked women, children, and girls in bathing, are just as little affected. They regard clothes more as protection from sun and weather. Girls go naked even to their third year; boys to their sixth. Often both are also suckling's at that age.*

For their first three years, little boys and girls had their hair cut short. A tuft left on either side of the head was said to resemble the horns of an owl. In Wolf-chief's time the hair was cut with scissors. As the cutting was rather unskilled, the hair frequently seemed to be spotted, especially when the scalp was exposed because of excessively close clipping. Children sometimes wore their hair in this fashion until the age of ten.

> *Until I was about nine years old, my hair was cut short, with a tuft on either side of my head, like the horns of an owl. Turtle used to cut my hair. She used a big, steel knife. In old times, I have heard, a thick blade of flint was used. I did not like Turtle's hair cutting a bit, because she pulled."* (Waheenee, page 59)

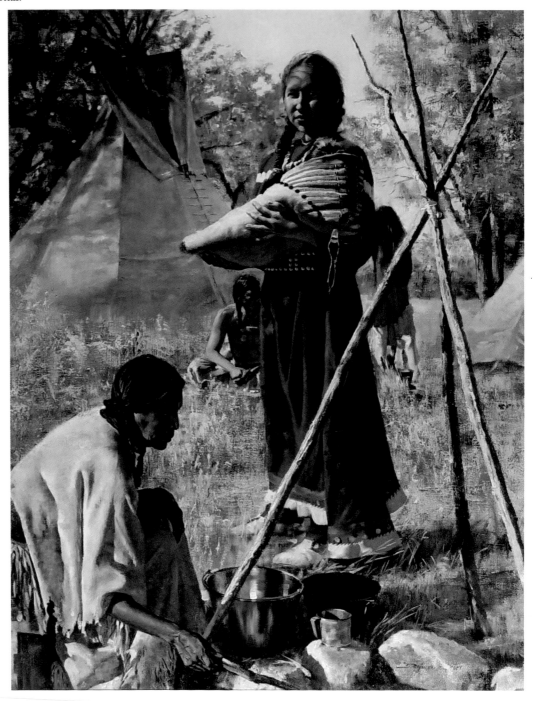

"MOTHER AND DAUGHTER" PAINTING BY ED KUCERA. YOUNG GIRLS AND GRANDMOTHERS HELPED RAISE THE BABIES WHILE THE MOTHERS WORKED.

Following the so-called owl haircut, both boys and girls wore their hair in a single braid hanging down the back. Girls changed to women's hair dress when about 12 years old, boys to men's styles at 16, at which time the hair was parted in a median line and each side braided and allowed to hang loosely over each ear. (*Mandan Social and Ceremonial Organization*, page 65)

Grandson directed the owl to build his dwelling near the people. He also told the owl, "Because you are near them, their children will grow up prosperously. If the children become peevish, their parents may warn them. 'The owl is coming. The children will be frightened and behave.' Grandson told the people, 'I have transformed that bad thing into an owl, a good bird. You may frighten your children with the owl which will never hurt them, but never say, 'That bad thing with a tail is coming.' If you should do so, a mysterious influence will prevail over them."

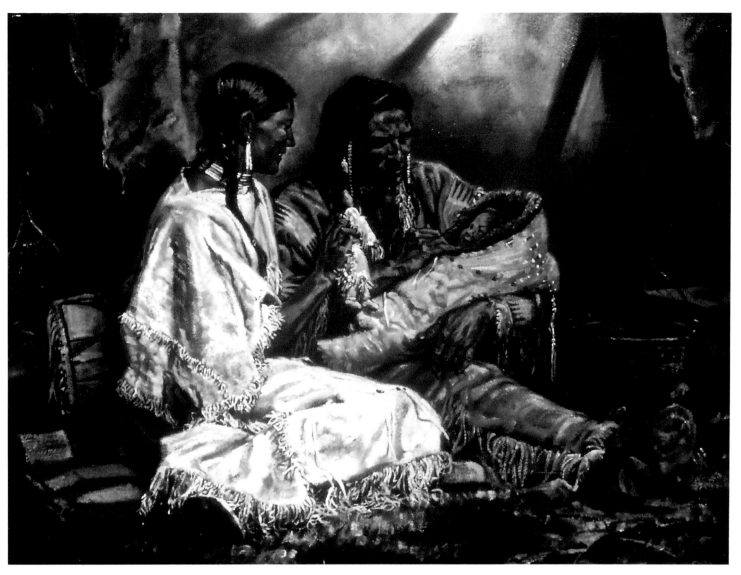

"Wakan's Gift" showing a young mother sharing her newborn with her father, painting by Steven Lang

Since then, the Hidatsa always warn a weeping child, saying "The owl is coming. He might catch you. Stop crying."

Hennepin said the early Sioux shaved their children's heads. (LaSalle - Hennepin, *Among the Sioux 1680-1681*)

Traditionally, most tribes saw the owl as a powerful and good helper in war and religion, and you see many owl feathers used on original 19th century items. Though some, like the Blackfeet, did see some types of owls as ghosts of medicine men and respected/feared them. However today, among many Native Americans, all owls are considered evil and to be avoided, and you will see very few items using owl feathers or parts. This new custom or belief evolved out of just such a custom as the one mentioned above, where owls were used as the 'boogie man' to frighten young children.

## Babies and Childbirth

When a Crow woman was expecting a child, she might travel to The Baby Place, which is near Pryor, Montana. From Plenty Coups' house you can see the rocks that hide it. The sandstone rims above Arrow Creek jut out and overhang a tiny pool of water roofed by rock above and concealed by birches during the summer and fall. When the water is low, it has a smooth muddy shore that leads into a small cave. It was believed a tiny boy and girl lived there who could foretell the sex of the child to come. Women made four arrows, 1 red, 1 blue, 1 black, 1 yellow, and left them there along with a hoop and stick game. If the arrows were gone, the child would be a boy. If the stick and hoop game have been taken, then it would be a girl. (Plenty Coups)

From Buffalo Bird Woman's memories:

*The morning sky was growing light when Son-of-a-Star came into the tent. His eyes were smiling as he stepped to the fireplace, for they saw a pretty sight. Red Blossom was giving my baby a bath. She had laid him on a piece of soft skin, before the fire. With horn spoon she filled her mouth with water, held it in her cheeks until it was warm, and blew it over my baby's body. I do not think he liked his bath for he squalled loudly. My husband laughed, "It is a lusty cry," he said, "I am sure my son will be a warrior.*

*Having bathed my baby, Red Blossom bound him in his wrapping skins. She had a square piece of tent cover, folded and sewed along the edges of one end into a kind of sack. Into this she slipped my baby, with his feet against the sewed end. About his little body she packed cattail down.*

In the tintype photograph above, Greenstone Woman, of the Black-feet tribe, is carrying her baby in one of these buffalo hide carriers. It is ornamented with beads and porcupine quills and small blue wool tufts made from yarn or unraveled blue wool blankets.

Her dress is made in the Upper Missouri style of a two-hide dress made from two medium size elk. The dress is made by placing the head of the animal down and this neck area is shown in the center of the hem of her dress and it has been beaded with three rows of what the Blackfeet called "real beads," which meant large pound beads.

Unlike the more central and southern style dresses, which have the bottom fringes applied singly, the northern women generally applied their fringe to the hems with a doubled-over layer of hide sewn directly to the dress and then cut, or fringed out.

She carries a heavily tacked knife sheath popular with the Blackfeet and as a younger wife she wears or owns very little jewelry.

Mothers began to feed their babies tender soft morsels of meat very early in life, allowing the infant to suck on the meat, but not swallow it. Nursing might last six to seven years and that task may be shared by several women acting as wet nurses.

Goodbird, the Hidatsa, was certain that his mother nursed him until he was about seven years old. He elaborated, explaining however that had his Mother had other children the nursing period would not have been so extended.

Rudolf Kurz observed children of six who were still nursing and was greatly amused by boys of four or five who carried bows and arrows, but were still being suckled. (p. 209)

Owing to this same repugnance on the part of their husbands, mothers suckle their children until the fourth or fifth year. Alexander Culbertson, in the 1850s ,also noted four or five year old children nursing among the Arikara.

S. H. Long said parents and visitors would ridicule children to eventually wean them. Of much younger children who were just cutting their teeth, he said they did not follow the white man's practice of cutting the gums to allow new teeth (hence "cutting teeth").

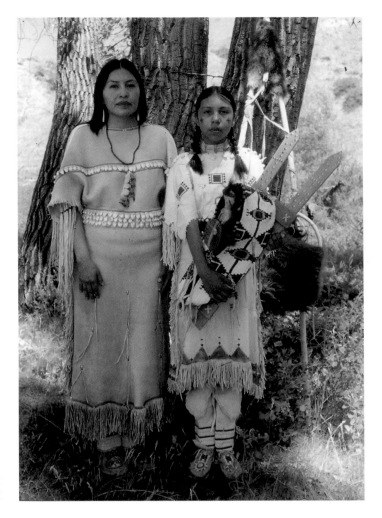

# Training of Girls

Although boys were encouraged to express themselves and be as wild as possible while growing up, the exact opposite was expected of girls. Their lives were much more supervised and regimented, always being under the scrutiny and protection of the women.

Serious training was begun when a girl was 13 years old. At this time a mother taught her daughter the skills needed to meet the demands of a Hidatsa woman's life, including, among many others, to chop wood, to hoe the garden, to dress skins, to embroider with beads and quills, and to prepare and cook food. According to Buffalo Bird Woman, girls usually learned to cook by observing their mothers, not through direct, even informal, instruction.

Quarrels among the children of the three tribes (Hidatsa, Mandan, Arikara) who lived at Like-a-fishhook village with Buffalo Bird Woman often resulted in clawing, kicking, and stone throwing, but invoked no parental interference. However, if a child were injured, under such circumstances, payment was demanded and received from the transgressor.

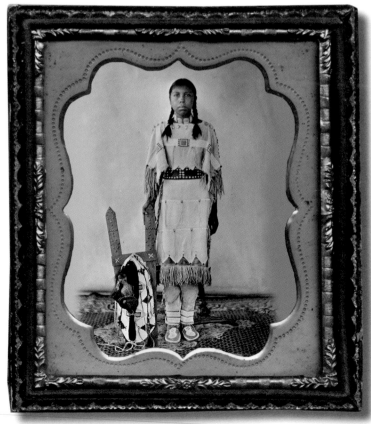

CHEYENNE MOTHER AND DAUGHTER, 1872, COLOR
PHOTOGRAPH AND CONTEMPORARY TINTYPE

In the tintype photograph shown above, Wind Rider Woman is just such a young girl. Her hair and clothing show she is a Cheyenne. Her nice deer skin dress is made form three hides and is heavily beaded in the Cheyenne style and also adorned with rows of elk ivories. This would show she was probably from a wealthy family.

Just like today, children at certain ages went through growth spurts and she is about to outgrow her dress. [Author's note: We intentionally used this dress on her just to illustrate that fact.] These dresses required many hours of work and not all women or girls had such nice dresses and most certainly only had one, so she will have to wait and use this dress one more ceremonial season. Her Cheyenne, fully beaded cradle board carries a doll for now, but within a few years this family piece may have a child of her own within it.

Crying was frowned upon by the Crow because it might draw the attention of a potential or real enemy to the camp. "If a youngster cried or whined too much, then he was placed on his back, and water was poured up his nose. The next time a parent called for water, the child usually stopped crying." (White Man Runs Him) [Author's note: This is in obvious contradiction to other statements left by Indian and non-Indian alike, as documented within these pages.]

Customarily, a scolding suffices as punishment for a recalcitrant child. However, if a child were persistently obdurate and disobedient, the parents summoned a clan member—a man for a boy, a woman for a girl—saying, "Brother, take your bad brother down to the Missouri and throw him in." The clan member made a pretense at carrying out these instructions, frightening the child and obtaining a promise of future obedience. Sometimes, the clan member thrust the child's head into a bucket of water, or in winter, tossed him into a snow bank (see Wilson, 1914, p. 23-23). Again, he might threaten the culprit with an arrow, saying, "I will pierce your skin with this arrow."

Occasionally, parents struck a child with the hand, pushed him to the floor, or whipped him with a stick; the last was said to be an unusual method of chastisement. The Hidatsa believed that too frequent punishment was harmful. They tended to place greater reliance on patient and gentle admonishment of the wrong-doer. Pretty Shield said that her tribe did not usually whip children. This could vary from one family to the next.

Long did write that some mothers would hit girls when necessary, and that the girls kept in a state of considerable subjection under mothers.

An essential part of training for boys and girls, after the Hidatsa had acquired horses was, to learn to ride. Girls were said to ride only gentle horses that could be led; boys, on the other hand, rode any horse, even the most spirited.

One explanatory reason for the necessity that girls acquire skills in riding was to facilitate their capability to escape in time of danger, from a tribal enemy, for example. Some typical motherly advice may be like the Nakoda mothers who spoke to their daughters, "Don't rummage through bags that belong to others for if you do, warts will grow on your hands. Repeated acts will make the warts grow larger and, in time, they will cover your hands."

Or, "When company comes to our lodge, play outside and don't listen to grown-ups when they are talking as you may thoughtlessly repeat some bit of gossip and cause trouble between families." This warning is typical of the open and somewhat blunt way of talking with children about reality and adult life. (*Land of the Nakoda*, p. 49)

Waheenee described some of the games she and her friends enjoyed as a child:

> We liked to play at housekeeping, especially in the warm spring days, when we had returned from winter camp and could again play out –of- doors. With the help of the neighbors' children we

fetched long forked sticks. These we stacked like a tepee frame and covered with robes that we borrowed. To this play tent we brought foods and had a feast.

> I had a doll, woven of rushes that Turtle made me. It really was not a doll but a cradle, such as Indian women used for carrying a small child. In winter I had my deer-skin doll, with the beads for eyes. My grandmother had made me a little bed for my dolls. The frame was of willows, and it was covered with gopher skins, tanned and sewed together. In this little bed my sister and I used to put our dollies to sleep.

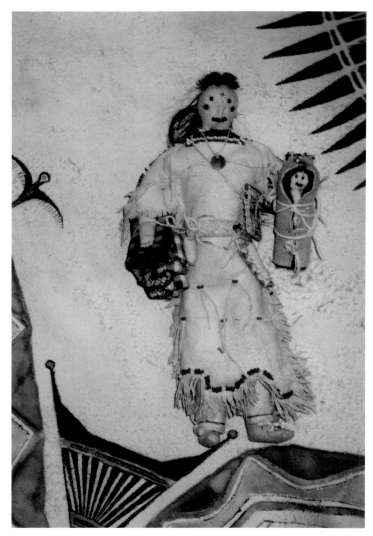

A Plains Indian Doll

We had a game of ball much like shinny. It was a woman's game, but we little girls played it with hooked sticks. We also had a big, soft ball, stuffed with antelope hair, which we would bounce in the air with the foot. The game was to see how long a girl could bounce the ball without letting it touch the ground. Some girls could bounce it more than a hundred times. It was lots of fun.

Sometimes, when children played at moving camp, they used a discarded kinnikinnick stick to represent a horse. A small piece of hide cut so that it would curl upward at both ends, to imitate horns, served as a saddle. A little figure representing a rider was set on the saddle, or bits of skin were hung on either side of it to imitate parfleche.

Small girls of eight or ten amused themselves with dolls. In summer, the dolls were often fashioned of mud; in winter, they were more likely to be made of deerskin. The mud dolls were usually modeled to represent a man, a woman or a child. They were customarily three-legged to permit them to stand. The girls also played with rush dolls, which were usually made by the child's mother or grandmother. These eight or ten year old girls like to imitate the household activities of their elders. They played at housekeeping in tipis made from borrowed robes. Each participant in the game contributed her share of food; boiled buffalo tongue was the favorite. They made little beds of tanned gopher skin for their dolls. (Waheenee, pages 55-57)

Pretty Shield, like Waheenee, also had a girl's ball they kicked that was made from a pericardium stuffed with antelope hair. Another favorite girls game and toy she recalled were stilts. Henry Boller noted that India rubber balls from the traders were given to boys to play with. (Boller, *Among The Indians*.)

The tintype photograph shown above is the Crow woman, Pretty On Top. She has posed with a trsvois, one of her favorite tools that she used on almost a daily basis, even when not moving camp. The dogs that belonged to the women were in constant use hauling firewood, water, butchered meat, fresh hides and various other loads. Most any early account of an Indian village or tribe on the move mentions these wedge-shaped sleds attached to the dogs' and horses' backs that were used to carry all of their belongings.

CONTEMPORARY TINTYPE OF
WOMAN WITH TRAVOIS

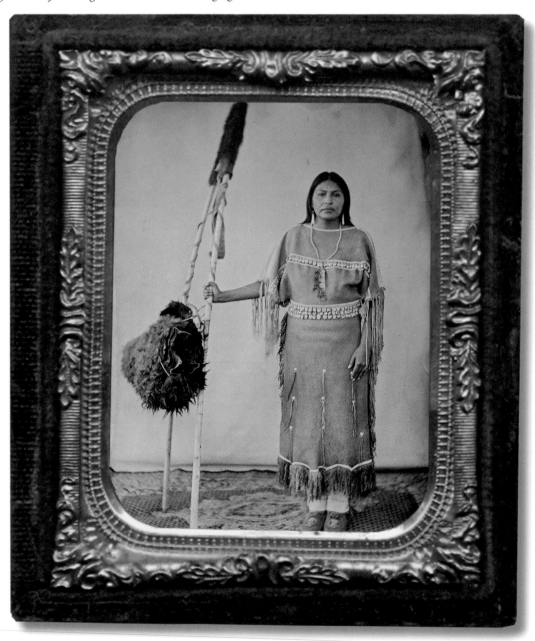

In 1723, the Frenchman, Monsieur La Renaudiere, posted himself on a trail where all had to pass. He counted three hundred (Kansa) warriors with two great chiefs (Grande Chefs) of their tribe and fourteen war chiefs, and about 300 women and 500 children, and at least 300 dogs that dragged part of their baggage. He observed:

> They contrive this (travois) as follows: They put a skin with the hair on it onto the dog's back, and strap it on. Next they attach a breast strap. Then they take two large poles, the thickness of a man's arm and about twelve feet long, and they tie the two poles together at about a half-foot distance from the smaller ends. Using a thong, they attach the said poles to the dog's saddle. They fasten a webbed circle between the two poles behind the dog, and on this they place their loads. One dog drags the skins to make a shelter big enough to sleep ten to twelve persons, along with their dishes, pots, and other utensils, weighing around three hundred pounds.
>
> The women carry loads that astonish the Frenchmen who have never before seen this tribe. They carry as much as a dog drags. Girls of ten or twelve carry at least 100 pounds, but it is true that they can carry such a load for only two to three leagues. As soon as they arrive at their camp, they (the women) must build their shelters to sleep in and prepare dinner for their husbands and children. 136 Mandan social and ceremonial

Though hard workers, the Duke of Württemberg noted that women and girls "were awkward and clumsy, little physical skill except swimming due to heavy burden and rough life."

Maximilian, talking of travois, said:

> We already saw about a hundred of them, with many dogs, some of which drew sledges, and others wooden boards, fastened to their backs, and the ends trailing on the ground, to which the baggage was attached with leather straps.

Among the Assiniboine, the dog-travois was still in use as late as 1901, by older people. To construct a travois, Buffalo Bird Woman went into great detail, which hints at the importance this tool held in the life of a woman.

> When I needed a new dog travois frame I made it of two long cottonwood poles or of poplar (birch?). It is very light and for that reason valuable for a travois.
>
> We always kept new travois poles on hand. My father cut the green poles in the timber, peeled off the bark, and laid them on the corn-drying stage to dry. They were always dried thoroughly before binding them together to make a frame. The poles of a travois frame had to be replaced about every two years, but the basket and its woven cushion were merely transferred to the new travois.
>
> The travois frame poles were usually about one and one-quarter inches in diameter at the upper ends and increased to about one and three-quarter inches at the lower ends which were cut flat so they could rest on the ground like runners. The best travois poles were a little curved and were so bound together that the curve arched upward so that the basket was carried on the top of the arch. The weight of the loads tended to bear the poles down so that if a travois were made of new, straight poles, it was not long before the frame sagged out of shape. The travois frames built to arch upward a little were only straightened by the basket weight and therefore lasted much longer. For this reason, when we went out to cut travois poles we were careful to search for young trees that were slightly bent.

> To make a new travois frame, I notched two poles at the upper or smaller ends, trying them firmly with itsuta tendon of the buffalo. There were two of these tendons, one lying on either side of the neck vertebrae. One of these was cut into strips about three-eights of an inch wide. The green tendon was drawn around the poles three times and tied. When it dried it held the poles firmly together. A green rawhide did not make a very good tie as it was apt to loosen as it dried.
>
> The stumps of the joint were very short, only a couple of inches long. I cut the green ash pole for the basket hoop in the timber myself. I cut a pole tall enough to reach to my shoulder when standing and about five-eights of an inch in diameter.
>
> After cutting the pole, I tested it, bending it under my foot to see if it was tough and elastic. At home I heated it over a fire, passing it back and forth over the coals to keep it from burning. When it was well heated, I bent it under my feet, moving it around and treading on it to make it pliable. I shaved down the heavier end for the joint, bent the pole to form an oval, and tied it with thong. As the bark formed a protection against breaking while heating and making the pole pliable, it was not peeled off until the hoop was bent into shape. Then a rawhide thong was tied across the center of the hoop to make it hold its shape while it dried. It was now left on the drying pole in the earth-lodge near or over the fire, for three or four days. I always hung it just a little way from the chain on which the pot was hung.
>
> Then I soaked a dry rawhide with the hair scraped off, either in a pail of water or in the broth made by boiling dried meat. The broth had to be tepid; if too warm, the hide would spoil. We saved this meat broth to drink. When the hide was well soaked and softened, I took it to my father, Small Ankle, to be cut. To do this, he cut the corners round, and then cut a spiral toward the center, resulting in a long thong about three-eights of an inch wide, which he colored red by drawing the thong through the palm of his hand in which he held some moistened red paint such as we obtained in the hills. It was a rule that all our travois baskets tied one end to the basket hoop and looped the rest into a bundle tied with a strip of hide. As he wove the thong back and forth on the frame, the looped bundle unraveled, loop by loop, without tangling or knotting.
>
> Drawn from a small model I have made but the principle of the weave and the pattern hold for the full-sized travois basket. In the small model sections between the thong are one-half an inch in diameter; in the full-size model they average roughly one and one half inches. This type of weave is used both for the dog travois and the hoop game basket; that for the horse travois basket is different.

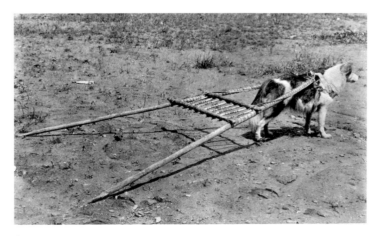

A DOG TRAVOIS

*When Small Ankle finished weaving the basket, I hung it to one of the posts of the corn-drying scaffold by a string. The wet thongs dried in about a day. Then I bound the basket to the travois poles with thongs of tent skin at the four places where the basket crossed the poles. It will be noted that the joint of the basket hoop always lays upper-most. This was always true of the dog travois basket. On the horse travois, however, the basket might have a joint on either side, either on the side toward the top or the bottom of the frame. On neither a dog nor a horse travois was the joint placed on the sides of the basket where it was bound to the travois poles.*

*A dog travois was in almost daily use, while the horse travois was used less frequently. We regarded the horse travois as having been recently introduced into our tribe, but we had the dog travois from very old times.*

*After the travois frame was completed and the basket bound on, I put on the buffalo skin saddle, or cushion, to protect the dog's back and shoulders from the hard poles. This was made of buffalo skin, hair side out, and was sewed on so that the seam was uppermost and the smooth fur rested on the dog's shoulders. Then I sewed on the two oiled rawhide loops, one longitudinally and the other transversely with the poles. Then I fastened on two rawhide packing thongs. The breast band and neck collar were also of rawhide.*

*We used red a great deal for decoration. I never saw new, unpainted, dog travois baskets; they were always painted red, as were also the game hoops. Horse travois were unpainted.*

*The red-painted thongs for the basket lacings signified that the weaver had obtained an honor mark for striking an enemy. For example, Small Ankle, who had been a successful leader of war parties, had the privilege of painting his face red as a symbol of joy. Thus, if a woman whose husband had never been to war should come to Small Ankle to have her travois basket woven he had the privilege of painting it red because of his war record. The red paint on the basket always referred to the deeds of the weaver and not the owner. There were, however, unpainted travois baskets in the village because the maker had no honor marks. ("Making a Dog Travois," Reprints in Anthropology, vol. 10, p. 217)*

Pretty On Top, shown in the tintype photograph, wears her hair in a typical mid-19th century northern Plains women's hairstyle, which was commonly cut short at shoulder length and sometimes left loose. Many mature women cut their hair as it became too much of an additional chore for them to keep up with, as their days were already busy enough.

Dentalia shell earrings are suspended from her ears. These are made from two shells hanging from each hoop. Her dress has simple porcupine quill embroidered shoulder strips edged with blue beads. A double row of beadwork across her chest outline a row of valuable real elk ivories. Elk teeth were much prized as ornaments on women's dresses, and as many as 600 have been reported to have been used on a single garment. Elk teeth were a very expensive item, as only two of them are in each elk's mouth. Cow elk have them, but they are tiny and usually too small to use. The bulls have large ones, one located on each side of the upper jaw. They are used by the bulls to help grab hold of the cow elks' necks when breeding, and some say to help the bulls produce the wide variety of whistling noises they make. This may be true, but having watched many hundreds of bull elk bugle and whistle, I would say most all of their sounds come from their chest and throat, but of course these tusks could help put different pitch and tone to the calls.

Indian people saw the teeth as valuable because, beside their obvious beauty, they believed they represented and help with the power of a long life.

A DOG TRAVOIS

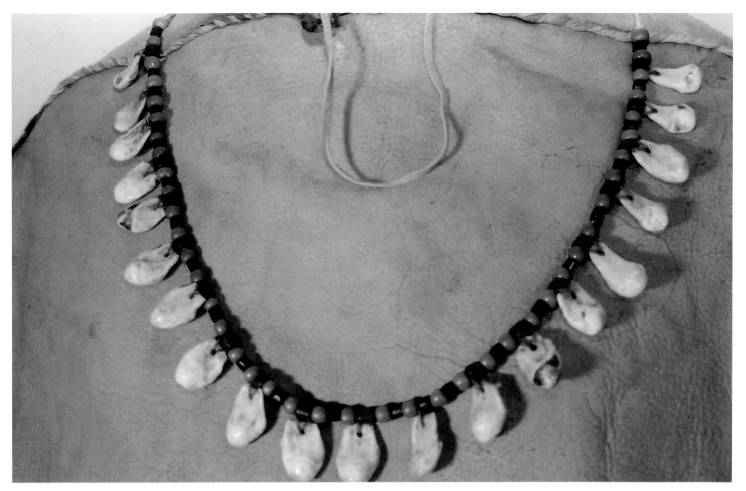

AN ELK IVORY NECKLACE

This belief originated from the fact that the elk teeth will remain for many years after the rest of the elk's body and skeleton has broken down and eroded away. The teeth, lasting beyond the normal life of the animal's remains, showed to Indian people there was power within them that, like everything else in nature, if the animal spirits and the creator want to lend its power to you, they will. Demand for these ivories was so great that many were reproduced and carved out of bone. A blind Mandan, who lived on Fort Berthold Reservation in 1910, used to make these artificial "elk teeth" from the leg bones of oxen.

Pretty On Top also has a prized belt made with many bull elk ivories, showing she is a much-loved woman. The teeth on it have been accented, just as on the dress, with an edge beaded with blue beads. Belts like this one could be tied or buckled.

Formerly, the seams on women's skin dresses were not closed from the shoulder to the elbow, resulting in a loosely fitting garment. To facilitate breast feeding, the under-arm seam on one side was also left open to the waist. [Notes on the Hidatsa Indians is based on data recorded by the late Gilbert L. Wilson, p. 17]

Once again, Rudolf Kurz gives a very observant description of Native attire, when he describes the use of robes, blankets and women's dresses:

*The fall of the Indian's blanket is similar to that of the Roman toga, but more graceful, because the drapery of a blanket is not so full- is less baggy in appearance. To put the blanket on, one takes hold of the longer upper edge with both hands, and bending forward,*

*draws it up somewhat above the head, so that its weight is distributed equally on both sides, and therefore it does not drop when the belt (usually a strap of tanned buffalo hide) is worn to confine the folds about the hips. Though Indian women always belt their blankets, men never do except on their wanderings. In the under side of the belt or girdle at the back there is a slit through which a knife, in its sheath, is carried. Beneath the folds of the blanket, above the belt, women carry their children or other belongings. The blanket serves both as covering for the head and, in a way, as veil. When the women are at work it is allowed to fall over the belt in order that they may move their arms freely. As I have said already, men use belts but rarely.*

*The Indian women wear, nowadays, a short, bright-colored calico shirt (this garment is worn also now and then by the men) made with collar and with sleeves that are finished with cuff or wristband; they wear, besides a sort of underskirt of red or blue woolen material that reaches to the calf of the leg and is held in place about the hips by a leather or woven girdle. Sometimes women use the same material for a kind of leggings that extend only to the knee and are fastened with knee bands, the straps and bands being often varicolored and richly ornamented with coral. On their arms they wear any number of bracelets, often as many as twenty, of brass wire that they themselves embellish in a really tasteful manner with files.* (Journal of Rudolph Frederick Kurz, p. 156)

Today I saw a Cree woman with the upper part of her body entirely uncovered, a sign, they say, of mourning for the loss of a child. She was walking and wore a buffalo robe. The Cree woman's garb is like that of the Sauteurs women; i.e., shoulders and arms bare, skirt held up by means of bands or straps.

When the weather is cold they put on sleeves that are knotted together in the back at the nape of the neck and on the breast. Assiniboine women wear frequently only one sleeve, leaving the right arm free; they wear shirt like skirts that, instead of being held in place by special straps, are made to extend over the shoulders.

J. O. Dorsey and Fletcher and La Flesche record this dance among the Omaha:

*Of greater comparative interest is the gwuda ke, War Singing. The night before starting on a war expedition the whole company of warriors assembled and any woman might join, but men only if they intended to go along. They got a big buffalo rawhide, and then all participants took hold of it, and beat it with sticks, at the same time singing a war song and marching through the entire camp. After they had passed through camp, they halted to smoke, and then continued the parade, possibly until daylight. My informant stated that this performance was shared by the Comanche. As a matter of fact I recorded it among this people, as well as in other tribes.*

# Mothers in Law

Many students of American Indian culture are aware of the mother in law taboos that many of the tribes had. Some tribes, like the Pawnee, had no such restrictions or taboos, according to S H. Long. Most all of the tribes, however, did, and they had ways to negate these taboos, so as to make life easier on all involved. Even if the taboos were dropped, the mother in law was still respected and somewhat avoided, unless a particular need arose. This could be said also at times of a man's married sister in law and, according to Pretty Shield, was against Crow tribal "law" for a man to do so. She did add that this sister in law rule was sometimes broken. Among the Crow, she said that just as with mothers in law, sisters in law could not sit in the same lodge with a sister's husband, and any messages must be sent via the woman's brother. (Pretty Shield)

Speaking of several tribes he had observed, Prince Maximilian wrote:

*The mother-in-law never speaks to her son-in-law; but if he comes home, and brings her the scalp of a slain enemy, and his gun, she is at liberty, from that moment, to converse with him. This custom is also found among the Minnetarees, who have, doubtless, borrowed it from the Mandan, but not among the Crows and Arikaras.*

The Mandan were accomplished at negating the taboo by having either the clan father or the real father carry the scalp through the village, and hold it up on a pole as he sang and called out the name of the warrior to be honored. After this display the mother-in-law received the scalp. She did not parade through the village, but stood in front of her lodge, singing.

Kurz later writes:

*Ours Fou again with me. To his great annoyance he found a young Crow already installed in my room, because, according to the custom of the Crow tribe, this young fellow dare not live in the same room with his mother-in-law. He dare not talk with her directly or allow her to see his face until his young wife bears him a child. The same custom is observed among the Dakotas, but only at the first marriage.*

A variation of this practice existed among the Cree, according to Paul Kane; in that the mother in law taboo can be broken, once the son in law has killed an enemy with white hair. This may never take place, as such an opportunity rarely presents itself.

The social reasons for these taboos can only be guessed at, as the exact reasoning behind it has not been found in our searches on the subject. Some suggest that it was done out of respect for the mother in law, which we are sure is partly true, but with all things, there were usually practical reasons behind it as well.

My own interpretation is primarily that it was a way to keep the mothers and their sons in laws from having any sexual relationships that could be damaging to the unity of the family.

Many of the girls, being only fourteen to sixteen years old when getting married, had mothers that could easily be only thirty to forty years old and therefore perhaps very sexually attractive to any of the younger men. This theory is not meant as disrespectful, just realistic.

Tabeau mentions this actually happening and said sons in law would sometimes secretly gratify their mothers in law. (Tabeau, *Narrative of Loisel's Expedition to the Upper Missouri*)

According to S. H. Long, with few exceptions, most all of the married women had affairs with men in their tribe.

I also believe it may have originated with the mothers in law themselves as a way to get their 'cut' or share of a dowry and some sort of financial commitment from their new sons in law.

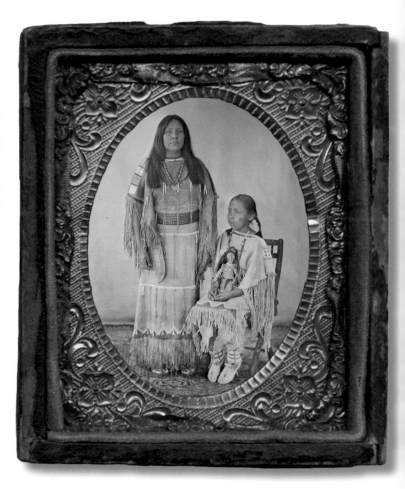

CHEYENNE MOTHER AND DAUGHTER IN 1876-STYLE CLOTHING, CONTEMPORARY TINTYPE

OPPOSITE PAGE: GIRL WITH A DOLL, COLOR PHOTOGRAPH

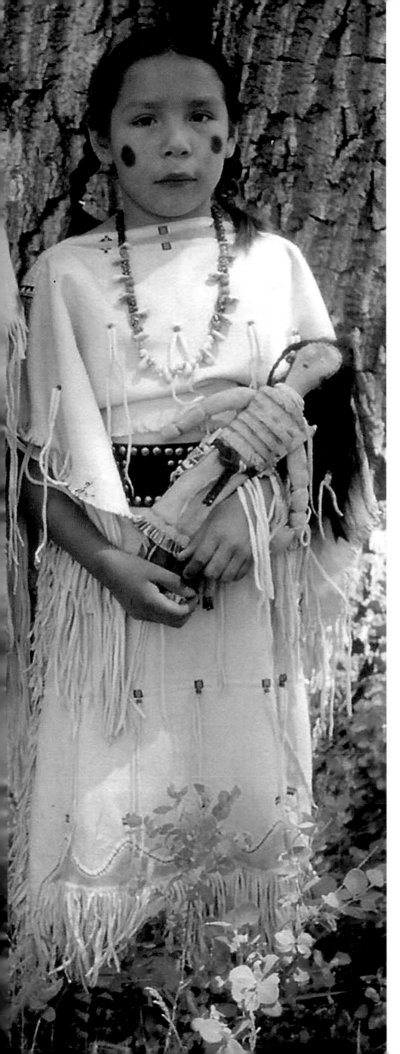

The mother of this girl will still be quite young and strong in another four to six years when this girl may marry. Both are dressed in classic 1870s Cheyenne women's clothing, with partially painted three hide dresses that have been beaded with shoulder panels and beaded edges and accents. The girl holds a porcupine quill embroidered doll perhaps made by her grandmother since it is all quilled and not beaded. Dolls were popular with girls as they are worldwide and they were one of the pre made toys they actually packed with them from village site to village site. Most are deer or some other soft leather stuffed with buffalo hair or cottonwood floss like as use don their pillows. Being soft they are flexible and therefore somewhat pose able. They could be everything form a crude corn husk doll to a complex design which required many hours of work and much love to complete.

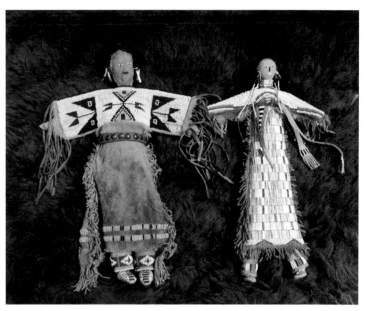

TWO PLAINS INDIAN DOLLS

## Menstrual Lodge

There is an oft repeated 'urban legend' that says that when groups of women live and are in close proximity to other women then eventually their cycles will be synchronized and occur all at approximately the same time. There is no proof of this existing among Plains Indian women, because if that had of been the case it would have certainly been recorded at least once if not many times. This would have also basically paralyzed the tribe while all of the women were basically out of commission during the days of her period. Menstrual synchrony has been proven in tests to not occur in any race and the presence of another woman nor the moon have no effect whatsoever on these cycles.

Another 'myth' in our mind that sounds good and believable, like so many other myths, is that the men out of respect for the women allowed them this time off so they could rest and relax. There is no proof whatsoever of this attitude and instead we do know it was because the men feared the women and the power of women during this time and wanted nothing to do with them, therefore they allowed a separate lodge to be built just for this purpose.

Many contemporary writers made note of the customs associated with the lodge such as Philander Prescott's observations;

Menstruating women could not approach any lodge where war implements were stored, or doctors lived and her lodge must be separate

from her family before returning to family. She must bath in a stream with her clothes on before returning to the family lodge.

Once she returns the fire in the family lodge is removed and a new one must be made with flint and steel. (*The Recollection of Philnder Prescott*)

And, from S. H. Long:

> *...the menstrual lodge was built and the women stayed in it for four days. They could not touch a horse during that time. Sometimes the women would falsely build a menstrual lodge so they could go off and be with a lover.*

Jonathan Carver said that men would not even look upon the menstrual lodge so the women may very well have easily gotten away with the ruse that Long had written about. He also said men would never light a pipe by a fire that had been used there.

In his book, *Social Life of the Crow Indians*, Robert H. Lowie wrote that with the Crow there could be various ways of handling the situation and customs associated with it.

> *...the former existence of menstrual lodges is affirmed by Child In His Mouth and his wife. They say that long ago menstruating women stayed in a special tipi, eating wild roots and abstaining from work for four days. Then they bathed, got new clothes, smoked them over a fire of evergreen leaves, put them on, and returned to their homes. The majority of my informants, however, deny the existence of menstrual huts. No feast was given in honor of a girl who menstruated for the first time; if she was unmarried, other girls poked fun at her.*
>
> *The only regulation that seems to persist is that menstruating women must not come near medicine bundles. These must be removed from the lodge until she recovers. In former times the women were obliged to ride inferior horses when in this condition and were not permitted to approach a wounded man or warriors setting out on a war party.* (*Social Life of the Crow Indians*, p. 220)

# Pregnancy and Childbirth

From S. H. Long's *Expedition*, we learn that pregnant Plains Indian women in some tribes might tie a small string to their belt with a knot in it and add one knot for each month until the child was born. These women were expected to work right up to the day they went into labor, as long as there were no complications with the pregnancy, which did occur from time to time.

Female relatives and even women that served as unofficial midwives supervised and aided with the births. They may want to instigate or hasten the birth by taking a belt and tying it around the waist and then the woman was shaken in a vertical direction with considerable violence. A vegetable decoction was sometimes given to facilitate the birth, along with rattlesnake rattles. They were pounded and ground in the hands and then mixed with warm water with two rattle segments equaling one dose.

Even in the 19th century, there were legends of Indian women's fortitude and their casual way of giving birth and then going right back to work. However, this was not the norm and, though Indian women did not get a maternity leave, they were still human beings that required a minimum amount of recuperation time after giving birth. Beldon backs this up by saying that the folklore about Indian women not having pain at childbirth was not true.

After the birth, a person may be feasted and gifted (paid) to perform a name-giving ceremony and an ear piercing. These two things may be done by different people on different days. Some tribes' people might wait until the fourth day of the child's life, or until the next Sun Dance, to have

their children's ears pierced; the customs varied, as with everything, from family to family and tribe to tribe.

Women generally were given strong-sounding names that they usually kept most of their lives, unless a sickness or some other tragedy befell them. Then, a new name may be taken, given or bought, which would hopefully give the woman a new lease on life. It was more common for men to have several names as they grew older or had great achievements warranting a name change.

Colonel Dodge wrote that, on average, there were two children per woman. He never saw over four, and usually children were more plentiful than wives. He also noted that there were many barren women.

In the Nakoda tribe, whenever a father decided that there were to be no more children, the last child's hair was tied in a knot on top of its head, a sign to everyone that the child did not have a younger brother or sister. Both boys and girls wore their hair in that style until they grew up when the knot was taken down. (*Land of the Nakoda*, p. 46)

Abortions were fairly common and were achieved by blows to the abdomen or repeated and violent pressure. Women might roll on a stump of a tree or any other hard surface.

Infanticide was preformed if a child was excessively deformed or sometimes, as in the case with a girl infant, not needed or even pitied, due to the harsh life that was expected she would live. John Bradbury wrote in his book, *Travels in the Interior of America in the Years 1809–1811*, that the "squaws are most ill-treated among the Sioux," and that the women sometimes kill female babies because of that.

Although, on **average**, most Indian women were probably not mistreated on a regular basis, we do know that, just like in all societies, some women were abused and lived a hard life. Tabeau wrote that many Sioux women committed suicide, with strangulation being the most common method. They would tie a cord to a tree and pull on it until passing out. Others mentioned the same method, but running to the end of the rope as fast as possible. (Tabeau, *Narrative of Loisel's Expedition to the Upper Missouri*)

# Marriage

Red Crow the Blood Blackfoot said the parents of the girl usually chose the groom, especially with the first marriage. He said the girl's parents would send their daughter with many presents to the groom's family's tipi, with lodge robes, clothes, etc. as gifts. The bride would ride one horse and lead another with a loaded travois to the grooms' lodge where she gets off and goes to sit by her husband.

A variation on the girl riding a horse was that the groom's sisters would carry the bride, on a blanket, robe, or on the back of the mother in law, into the tipi, by the groom, where they ate. The ceremony was now considered finished.

New moccasins may have been made by the woman for her husband, and they may be put on at the end of the ceremony, but the non-Indian custom of exchanging rings was not usually done, although sometimes rings made of horn were given to a girlfriend, probably in imitation of the whites.

On the following day the groom's relatives tried to out-give the bride's family. Sometimes the aunts would arrange the marriage with other female relatives of the bride, after the male relatives had agreed on the wedding taking place.

The amount of wives any one man could have depended on how many he could afford to keep and feed. Jonathan Carver wrote that the "Sioux were great polygamists with three to six wives each." Prince Maximilian saw that three to four wives was common, and no man had more than six. Most had only one or two. He did mention that in the case of wealthy chiefs some had up to eight wives, and almost fifty years later, in 1874, Edwin T. Denig wrote, "I have known Blackfoot with as many as twenty to thirty women." It is not

The almost three-to-one preponderance of women over men did not exist in the days before the horse and gun. The women in pre-horse times would still out number the men, some due to the more dangerous life the men led as hunters, but nothing like the difference caused by increased inter-tribal warfare after horses and guns were introduced.

As was a common practice with many tribes, Pretty Shield said that, with the Crow, a man who married a woman with sisters had the right to demand unmarried sisters as wives as they became of age. In the latter half of the 19th century, age of marriage for girls was between ten and sixteen. For men, they were usually married by the age of thirty five, rarely less.

The marrying of girls at a very young age was common, and, according to Crow custom, "one old woman whose statement is confirmed by Bull-chief, said that girls more generally married before puberty, and that, accordingly, the Crow had no menstrual lodges. (*Social Life of the Crow Indians*)

Common sense implies and the accounts told by people such as Philander Prescott confirm that "many of the women very strong due to constant labor" lets us know that the women were generally stronger than the men. (*The Recollection of Philander Prescott*)

According to Long, the women usually talked louder than the men and their conversations with other women were usually more obscene.

Referring to the women's strength in breaking up drunken fights among the men, Beldon wrote, "But whenever combatants proceeded to actual blows, out rushed the women of the harem from the surging throng, and, their muscles hardened by continual exercise in all the hard work and drudgery of their lives, they would seize their spindle-armed sultans, bear them to their lodges, where trussed up in many plies of shaganappi (rawhide lines) they were placed on their couches of robes to sleep off their fury. Even man to man, or rather woman to man, these mighty strong females often mastered their males." The women would sometimes even tie up their drunk men! (Long)

Ministering angels of peace they were not, such as are depicted in art galleries, but brawny squaws whose services to-day might be welcomed to the ranks of militant suffragettes. To these latter, these simple Indian women might have appeared mere down-trodden slaves of man, but the able-bodied squaw despised any woman who allowed her men to do any work of the order ordained from women, and if the work so ordained for the Indian woman might be considered by the new women of civilization as shameful, the red-skinned wife gloried in the shame.

Anyhow, in that day, owing to their frequent loss in war and by other causes (seven hundred braves were killed in battle, by murder and by sudden death, in the circle of our acquaintance at Fort Qu'Appelle between 1867 and 1874), the number of females largely exceeded that of males, and had polygamy not been the custom, these surplus women would have had no one to hunt for them, and would have perished from starvation."

Regarding the toughness of the older women especially, Colonel Dodge wrote: "older women were good with weapons and fought back if attacked." He added that in fights with whites, Indian women were usually only killed by accident or if they fire back. "Much unnecessary sympathy is wasted on them by the white world," according to him. This attitude, which seems quite callous today, is somewhat understandable if you look at it from his point of view, of someone who had actually fought against Indian people. Like anyone then and there, once he saw the dangerous potential of these older women, he viewed them as adversaries to be killed or subjugated, and at the least respected and watched.

Indian men felt the same, and this is one reason why there were specific war honor marks for the killing or coup performed on an enemy woman. With the Hidatsa, a slender flat stick about one foot long, wrapped with porcupine quills, and surmounted by three or four crow wing feathers, was worn to indicate that its wearer had struck a woman. The stems or quills of the crow feathers were stripped down and cut in such a way that the soft end tufts fluttered in the wind. The stick was the ancient coup stick. Later, in Wolf-chief's time, no distinction was made between striking a man or a woman; an eagle feather was worn as a symbol for killing or striking either.

# Dances

The importance of women's strength, both mental and physical in daily life and success in warfare, was recognized during the various scalp or victory dances the tribes held.

During the 1860s through 1890s few, period photos of Plains Indian dances and ceremonies were ever taken. There are a few taken in the early reservation period of some ceremonies, such as the Ghost Dance. Since many of these photos were taken without Indian people's consent, we chose not to reproduce them here.

One rare photo shows an actual ceremonial smoke being done between Indian chiefs, soldier leaders and government representatives at Fort Laramie. It appears that one or two large buffalo hide tipis have been used to make a temporary awning with tipi 'ears,' or smoke flaps, hanging down. This was a common practice, and for a gathering or ceremony the women could quickly erect semi-circular awnings out of one or many tipi covers. All present appear to be rightfully respectful and seem to understand the solemnness of the occasion.

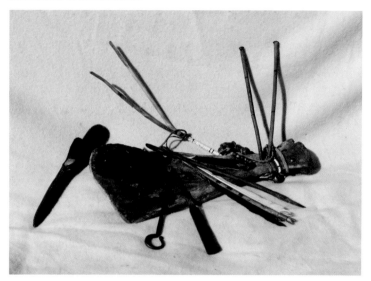

Typical smoking items: tobacco board, various tobaccos, beaver castor, buffalo heart fat, knife for cutting mixture and pipe tampers and cleaners

More rare than a pipe ceremony photo, or one showing the Ghost Dance, would be one of a 19th century scalp dance. No known photographs of a woman after a scalp or victory dance ceremony exist or would have ever been taken. The dance was witnessed by many non-Indians, and drawings and paintings were done of it, but never a photograph, to our knowledge.

The Lakota woman, Owns Many Things Woman, appeared on the evening of June 25th, 1876, in the huge Lakota and Cheyenne camps on the Greasy Grass River. The Arapaho were there too, but since there were only six of them present we do not call it a Lakota/Cheyenne/Arapaho village. This does not belittle the six Arapahos' contribution and effort. The Lakota wanted to kill the six Arapaho, thinking they were spies for the whites, but the Cheyenne convinced them they were brothers who had come to fight the whites and not other Indians. She wore her warrior husband's sacred Wiciska Society leader's headdress and, as accepted under the circumstances, the paint designs he wore during the battle. Women would generally not handle, use or wear war regalia, eagle feathers or headdresses, except for specific ceremonial activities such as a scalp/victory dance. The Wiciska Society had two such headdress wearers of equal rank. The headdresses were made of a rounded leather cap covered with ermine fur cut

into narrow strips. Split buffalo bull horns and an eagle tail feather crest, trailer and Sun Dance plume were all attached to the cap.

Thunder, in the form of the attached buffalo dew claws, and lighting bolts, painted on the trailer, give the wearer the power and protection of both. What can be interpreted as butterflies make the wearer move in that manner in battle, making him difficult to hit by bullet or arrow. The brow band was beaded in a stepped-mountain design; unlike Cheyenne society regalia, the Lakota pieces were not restricted to quillwork only.

Her flag represents one of eight captured from the soldiers at the Battle of the Little Big Horn. One of these company guidon flags was re-captured on September 9th, at the Battle of Slim Buttes and is preserved today at Little Bighorn Battlefield National Monument.

Another captured guidon was found at the Dull Knife Battle in 1876, and it had been made into an Indian pillow. These pillows are usually very small, approximately 30cm to 40cm long by 25cm to 30cm tall and stuffed with cottonwood tree floss that comes off in copious amounts in the early summer on the Plains. As in a man's pad saddle, antelope or any other hair or fur could also be used for the stuffing.

The first mention of Indian use of these pillows within their tipis comes from S. H. Long's journals chronicling the expedition west in 1819, which he was a part of. One of the other eight captured flags that had been carried by Sergeant Culbertson later resurfaced in Michigan.

Each company in a cavalry regiment had one of these silk guidons, and they measure 68.5 x 106.6cm (27 x 42 inches). The gold stars were silk screened or hand painted. The flags were used to help designate the different companies and guide their movements when performing drills and battle manoeuvres. Cavalry companies in the United States Army were re-named 'troops' in 1883.

In Owns Many Things Woman's other hand is a cut-down, United States Army, 1850 Heavy Dragoon saber made into a heavy knife suitable for a variety of chores, including mutilating the bodies of her nation's slain enemies. Mutilation will keep their spiritual bodies from reforming whole in the next, or spirit world. She keeps the knife in a simple, painted, buffalo rawhide sheath tied to her belt. The brass hilt has been removed and perhaps cut-up and made into something more serviceable, such as a hide-scraper blade or ear bobs or clothing bangles.

Her dress could serve dual function, as a nicer dress for dances and ceremonial activities, but is probably more appropriate for work, She has kept it on due to the excitement of the victory over so many Long Knives, and has not had time to prepare properly for the impromptu victory dances that followed the battle.

When the Arikara scouts attacked, with Major Reno in the opening stages of the battle, the Cheyenne had lost some women and children killed by them. Therefore, they were not celebrating the first afternoon and night as they were busy moving further down river among the Lakota. Many tribes had the custom of moving a camp when people had been killed within the village. This move by the Cheyenne gave the false impression that the village was actually much larger than it really was. When General Terry's men showed up on the 27th of June and examined the vacated camp site of the combined bands and tribes, he wrote that

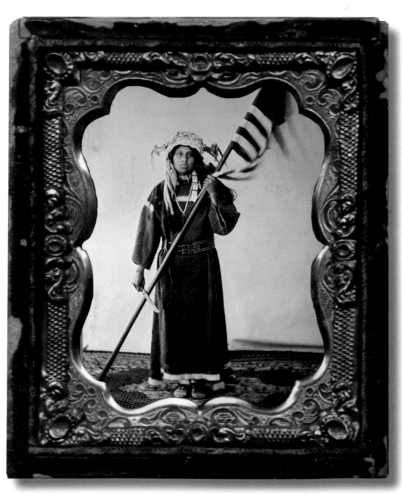

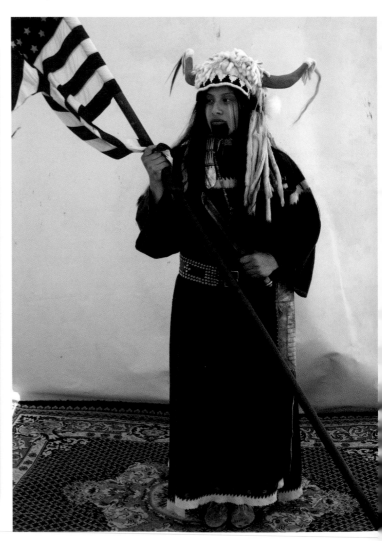

LAKOTA WOMAN IN 1876-STYLE CLOTHING, CONTEMPORARY TINTYPE PHOTOGRAPH. LAKOTA WOMAN WITH FLAG AND KNIFE, COLOR PHOTOGRAPH

the village was "three miles long and a mile wide." In reality, it was about one to one and a half miles long.

The dress is made of blue wool saved list, or selvedge cloth. This cloth is made by having the edges clamped or covered in the dying process to leave the 'list,' as it was called in the 19th century, 'saved.' Though made of cloth and not leather, these cloth dresses retained some of the traditional features of a leather dress, such as the rectangular leg projections on either side of the lower hem of the dress. Even when made of cloth, the dress did not have the right look to them without these leg pieces represented in cloth.

The seam across the chest represents the earlier hide dresses as well, and shows the seam that would have appeared on one. This cloth dress could have been made easier without this added seam and been cut from two pieces instead of four. Red silk ribbon and brass sequins adorn the edges.

Her white-man's, harness-leather belt is studded with brass tacks that have been driven through the leather, their points ground or filed off and hammered so they will hold in position. This was a typical Lakota woman's style belt during this period.

Long dentalium shell earrings with abalone pendants, both exotic and expensive items imported from the Pacific coast tribes, complete her outfit.

Before the white man's trading posts were established, there was an intertribal trade between the Northwest Coastal Indians, the Plateau tribes, and the few tribes that inhabited the plains that dealt with these shell items, among other things. The Euro-American traders soon realized the Plains tribes' desire for these shells and made them a regular part of their inventory. Depending on the time and place, the dentilium shells averaged 80-100 shells for a good horse, and the abalone shells were traded for three to five shells for one buffalo robe, which made them quite expensive.

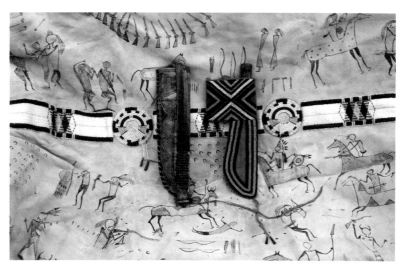

INDIAN HEAVY KNIFE MADE FROM 1840 DRAGOON SABER AND SHEATH MADE FROM A BUFFALO'S TAIL

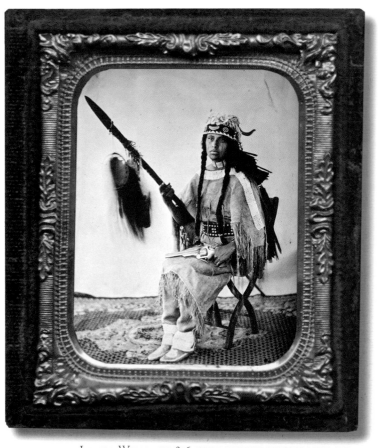

LAKOTA WOMAN IN 1876-STYLE CLOTHING WITH LANCE AND SCALP. CONTEMPORARY TINTYPE AND COLOR PHOTOGRAPHS

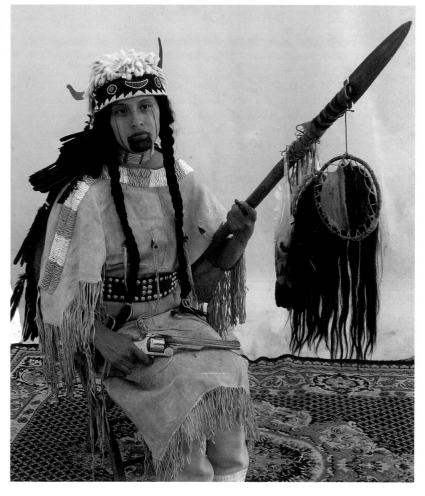

Women and Girls 145

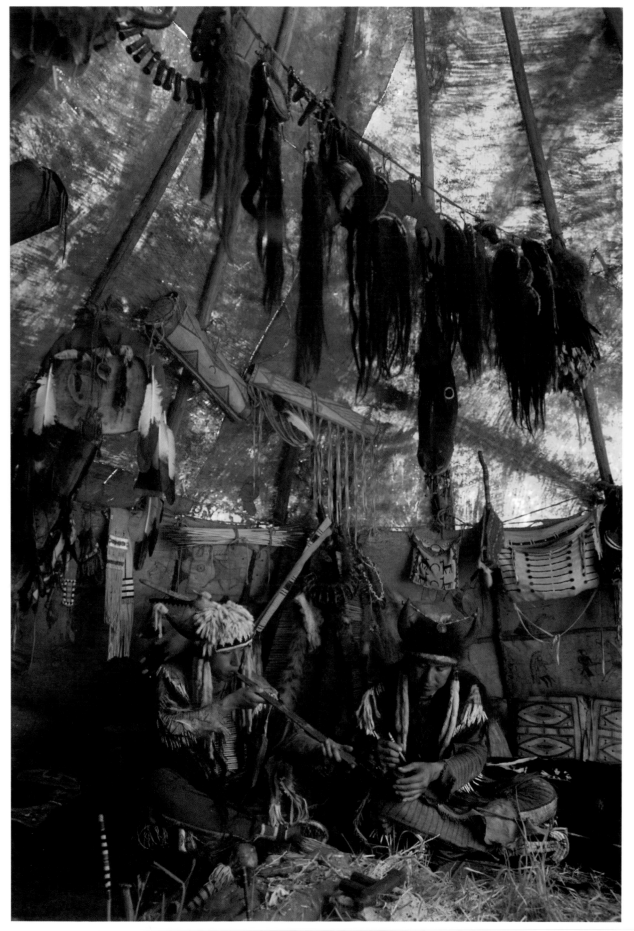

MEN SMOKING IN A TIPI

# Chapter 12
# Dandies and Two-spirit People

## Dandies

*For one morning a young Indian came to the fort and brought us evil tidings. The newcomer was a dandy of the first water. His ugly face was painted with vermillion; on his head fluttered the tail of a prairie-cock (a large species of pheasant, not found, as I have heard, eastward of the Rocky Mountains); in his ears were hung pendants of shell, and a flaming red blanket was wrapped around him. He carried a dragoon-sword in his hand solely for display, since the knife, the arrow, and the rifle are the arbiters of every prairie fight; but as no one in this country goes abroad unarmed, the dandy carried a bow and arrows in an otter-skin quiver at his back. In this guise, and bestriding his yellow horse with an air of extreme dignity, "The Horse," for that was his name, rode in at the gate, turning neither to the right nor the left, but casting glances askance at the groups of squaws who, with their mongrel progeny, were sitting in the sun before their doors."*
—Francis Parkman, Jr., The Oregon Trail

A good part of each day during the nicer months of the year, men of the tribes, especially the 17 to 25 year-old age group (though certainly not limited to them), spent a good portion of their time in pursuit of the women of the tribe or preparing for that chase. In the summer months, the young men may have been out until the wee hours of the morning—after all, they were young men and shared the characteristics of all young men around the world…they have a restless and roving energy that seeks adventure and women. Pretty basic stuff, but so was their lifestyle. These night-long romps and excursions to and fro meant that having sentries, or guards, for villages was usually unnecessary. S.H. Long was one of many authors who mention that sentinels were necessary to watch at night because young men were out after women. Many men 'partied' on a regular basis, and, as men are want to do, they did everything to excess. A big feast is described:

*There were full bellies in the camp during the following days, those of the little naked boys being ludicrously remarkable for their distention like unto tightly blown-up bladders. Neither were they the only gluttons, for many young men ate and ate for the pleasure of eating till they could hold no more, and then emptying their stomachs by artificial vomiting they would begin again. (Companie of Adventurers, p. 330)*

When they awoke, it may be after the sun has risen high, if there was nothing pressing going on in the village that day. George Bent, like

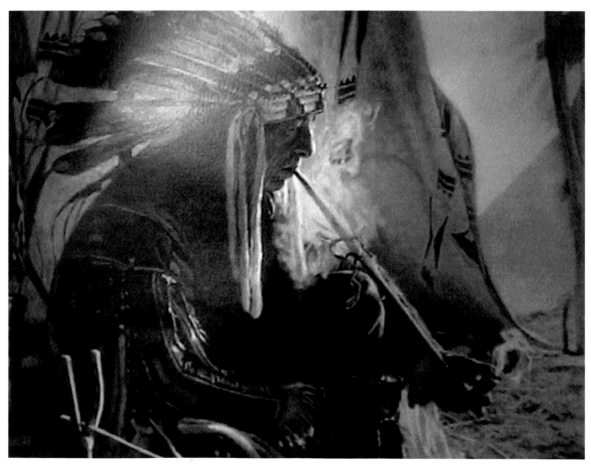

A MAN ENJOYS HIS TOBACCO

many other authors, tells us of many who danced all night, then slept during the day.

After relieving themselves, they may plunge into the water if they were one of the river tribes that had access to large amounts of water and were not afraid of the water and swimming in it. Or they may just splash some water on themselves, wash out their throats, and even purge themselves, using a feather, finger or sprig of fresh sage. Now it is time for a smoke and some food!

After their wife served whatever may be available at that given moment, they were ready to go check out what was happening around the village with the other men, especially their warrior society comrades.

As they entered the tipi they would come in and sit with usually no salutations whatsoever. They may have their own small, personal pipe and tobacco to take out and smoke, or one of their friends may fill one for them, hand it to them, and light it for them. Among many tribes it was a not-so-thinly-veiled insult to make a man light his own pipe. To send a message to a man, you may fill his pipe and just hand it to him, then sit back and let him light it himself, which would only be a slight affront. This practice is sometimes done while on war parties to warn a man he was not fulfilling his part, or was being a problem to the rest of the men. The men liked to prepare a relished delicacy called 'crow guts,' which is a fresh intestine which has been washed, turned inside out and stuffed with buffalo tenderloin or other choice cuts. This was tied on the ends with sinew, fresh cut strips from the hide, or leather. The ends could be twisted and knotted themselves before the stuffed intestine was roasted in the fire. Enough of the 'guts' would be made for each man, plus a special one for the offender, which would be stuffed with a piece of tough rawhide instead of tender meats. As the man sat by the fire with his greasy treat before him, and relishing the upcoming feast, the men around him were watching, out of the corners of their eyes, and holding back their laughter, as they watched the man's look go from glee to shame, as he bit into and pulled out the gut-roasted rawhide strip. When food was scarce, the rawhide-stuffed intestine would have actually been a welcomed feast.

After a man's smoke, he may inquire as to any activities of the day. As the men discuss this and their latest conquests, they prepare themselves for the afternoon and evening strut about the camp.

The young men could be found immaculately grooming and oiling their hair, exchanging jewelry pieces, paintings each other's faces, all the time laughing and talking bawdily, while admiring their own reflections in their wooden mirror boards thrust onto the tipi floor or hanging from their wrists. This adorning could be a serious endeavor preparing oneself for a serious event or a light-hearted frolic done with other warriors. Either way, a variety of potions, love medicines, perfumes, incantations, animal imageries and ceremonies might all add to a warrior's chances for success in love.

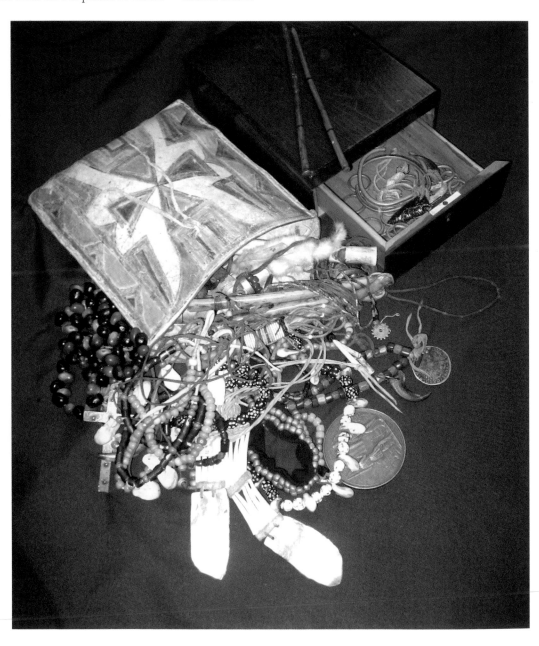

INDIAN CONTAINERS FOR JEWELRY

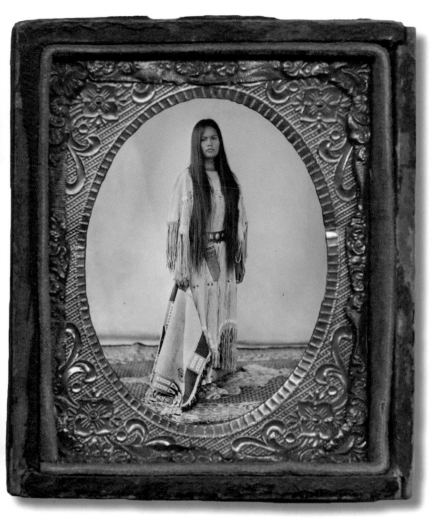

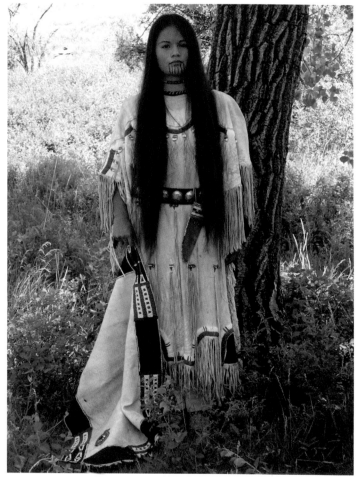

An Upper Missouri Woman in 1840s-style dress, contemporary tintype and color photographs

As seen in the contemporary tintype image above, appearing with her hair unbraided and very long and her nice dress, this young woman would be just the type the men were looking for to use their love medicines. She is both beautiful and strong, and her fine clothing and richly decorated saddle cloth all say she is from a good family. The brass concho belt, quilled knife sheath, and red and black skunk or hail bead necklace all announce to all her prominence in the tribal social hierarchy.

Her name, Stops to Fight Woman, will not scare off suitors, as many women were given strong-sounding men's names to help them through their lives. Most women will cut off such long hair after they are married and have children, but for now she will use it to attract the better men and potential husband who she surely will be seeking at this stage in her life.

A variety of incenses, perfumes and oils could be used in the man's attempt to 'capture women.' Of course, women could attempt their own physical and spiritual ways to attract men, but their's was not as common a practice, nor as overt. Necklaces of sweet grass were worn and small bags of it were suspended from their clothing. In the early days, when Hidatsa men were looking for a scent they thought would attract women, they gave it thought and perspective perhaps not understood today. Now, we have colognes for men to wear that make them smell manly: scents from musks and oils, old saddles and leather, or perhaps the desert. Hidatsa men reasoned it differently; they figured if you wanted to attract women you needed to smell like something women liked, and not necessarily what men liked. What do women like the most? ….Well, babies, of course, so the men decided to smell like beaver castors or scent glands, because they thought it made them smell like babies.

A small drop or two of the fresh beaver oil was often times dripped into a man's clothing back in the spring, and this would last all season.

Dried and pulverized beaver castor was added to other ingredients to make small bundles to be worn on the clothing, in the hair, or tied to or behind the feathers of their fans so that the smell wafted about with each wave. The use of beaver castor glands as a perfume was also mentioned by S.H. Long.

Buffalo Bird Woman, of the Hidatsa, said "the women of my tribe did not use this perfume, only the men. For women to use it would have provoked laughter. Among the Crow, women do use it, but they are fond of this perfume—inordinately so I think. To use it was not our Hidatsa women's custom."

Young women used perfume of stink grass (mika iditsi) mixed with needles of perfume pine, or maiditsitsi. Also, these latter were commonly used, and not necessarily mixed with stink grass seeds, but alone.

As with stink grass seeds, they often chewed up pine needles and spat or rubbed them over the clothing or in the hair. The usual way was to spit them into the palms and rub the hair or the sleeves of one's garment, for example. The pine needles were gathered, say about two quarts, and put in a bag for winter.

Pine needles smelled good, green or dry, just as sweet grass does, and they hold their scent several years. Young women and girls often filled a little bag of the needles that were suspended to the necklace on the back of the neck. In old days, also they took very thin deer skin and made a long sack sewed the whole length so that two apertures or tubes were filled and the sack was hung around a baby's neck like a necklace.

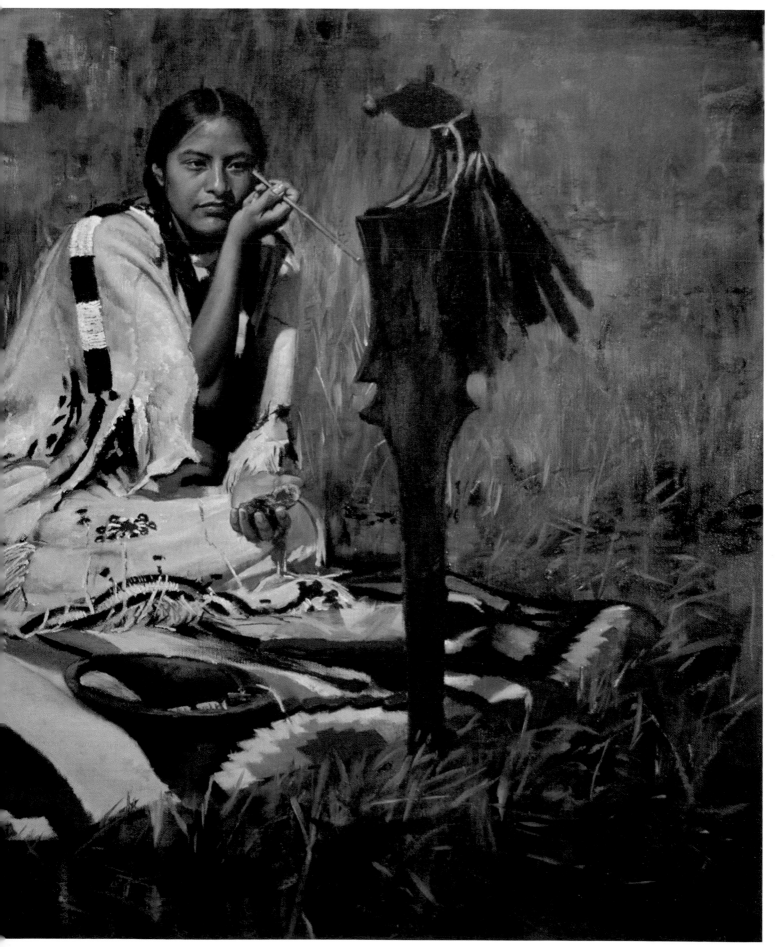

A GIRL PREPARES HERSELF FOR A DANCE, PAINTING BY ED KUCERA

Dandies and Two-spirit People     159

Besides wanting to smell nice, daters wanted fresh breath, too. In *Waheenee*, Red Blossom tells us , "We had other use for rose berries when I was a girl. If a young man went at evening to talk with sweetheart, he put a ripe rose berry in his mouth to make his breath sweet." A young beau might improvise a container if he came across some perfect rose hips, as Waheenee explains …"He had no basket to put them in, so he drew off his leggings, tied the bottoms shut with his moccasin strings, and, when he had filled the leggings with berries, he slung them over his horse's back like a pair of saddle bags."

Sticky gum was also used by the Hidatsa as a breath freshener. This is a gum found in a crack or broken place in the small branches of pine trees. Buffalo Bird Woman recalled:

> *I remember my father climbing a tree and scraping off the gum with a knife. I spread a saddle skin under the tree and the pieces of gum fell on it. [Evidently Buffalo Bird Woman means spruce. Goodbird always translates spruce as pine, apparently. — note from Gilbert L. Wilson.] The gum was brown as it came from the tree. On some smaller trees I have found some of this gum white, and found it good to chew. That gum was cooked by some prairie fire, said my father.*
>
> *My father and I gathered a mass as big as one's two fists and took it home, and I boiled it. With a stick thrust into the boiling mass, I tried a little with my teeth; when it did not stick to my teeth, I knew it was done.*
>
> *The gum was carried in a heart skin both before and after boiling. If boiled too long, the gum became like sand.*
>
> *This gum we liked to chew and it smelled good, too. Men and women both chewed it. Women chewing the gum would make it "crack" or "snap" with a sharp sound. It was liked because it was a breath perfume; perhaps that is how the custom began. Chewing the gum was our custom.*

Of course, any of the Creators' helpers could aid in success in life or love, but bull elk and stallion horses were at the top of the list to help in one's amorous activities. These two creatures are totally adamant and focused on two things during their rutting season, gathering up all the females you can and driving off all the competing males you can. These are the same things a man wanted to do.

So much animal imagery was used along with a large variety of natural and artificial items that they believed would give them the extra edge needed to obtain their desires.

The Blackfeet had a love medicine they called Ito-wa-mami-wa-natsi (Cree medicine), because it was generally obtained from the Crees, who were specialists in its manufacture. In talking with E-kum-makon about the Cree medicine, he said that he had used it to regain the affection of his young wife. When she left him and returned to her father's lodge, he made a long journey north, to visit a Cree medicine man, from whom he purchased some of the love medicine. It consisted of a small beaded buckskin bag containing a sweet-smelling powder. As the Cree magician had directed, he secured one of his wife's hairs and, winding it with one of his own, placed them together in the medicine bag. He carried it with him everywhere, fastened around his neck by a buckskin string and wore it beneath his shirt. He firmly believed in its power, because his wife had returned and became so much attached to him, that she was unwilling to leave his side and they went everywhere together. Soon after this E-kum-makon had a severe illness, lasting so long he thought he must be bewitched by Little Plume, who owned a Porcupine-Quill medicine. It consisted of a small stone, or wooden image of a person, a porcupine quill, and some red paint, by which the owner was able to cast an evil spell over people.

If he placed the red paint between the eyes of the image, the one whom he desired to injure became ill; if over the lungs, he had a hemorrhage; if on the top of the head, be became crazy; if over the heart, it caused death. E-kum-makon became so worried over his health, that he again sought the advice of the Cree medicine man, who informed him that his sickness was caused by the improper use of the love medicine. It should not have been carried around with him, but left inside his tipi, tied to one of the lodge poles, where it properly belonged. The medicine man also explained that it was wrong to put the hair into the bag without the burning of incense, which was necessary to ward off the Evil Power.

There was also a medicine for counteracting the Love Power. This was employed, whenever it was discovered that the love medicine was used by anyone who was unacceptable and therefore to be resisted.

The Blackfeet have always been ready purchasers of love medicine, for which they paid the Cree a horse, or even more. They have also secured it from the Flathead and Pend d'Oreille. The Blackfeet say that the Sioux and Assiniboine also made a love medicine, but that the Crow and Cheyenne bought theirs from other tribes.

Anyone visiting an Indian camp for more than a few days would have to notice and accept the fact that sex and sexuality was very open and considered a perfectly normal part of the human existence. This was due in part to the total lack of privacy and therefore no modesty in a tipi. In his book, *Travels in the Interior of America in the Years 1809–1811*, John Bradbury wrote that the Mandan women were not shy as they dressed in front of the white visitors in their husbands' clothing when they prepared for the Squaw Dance.

Colonel Dodge said sex was performed without hesitation in the presence of adults and children of both sexes, especially during the long winter months. He also said the women and children's presence caused no restraint on the men's actions or words.

People watch and make comments, though lovers under a blanket would not be disturbed. Indian men gave in to the gratification of their passions at any time or place, including, according to Charles McKenzie, even with women and children present.

Dodge said that all wives sleep in the same bed if its clear enough (with husband) but older ones were turned out to separate bed if not enough room.

While the tribe and parents were busy at the Sun Dance, the Akicita were busy with the peoples' daughters. Dodge did note, too, that the young unmarried girls were usually more chaste than the married women.

The close lifestyle and living in a natural state, as they were, made public nudity a daily affair. McKenzie noted that men and women both appear in public swimming naked and are not ashamed.

In his book, *Early Fur Trade on the Northern Plains*, McKenzie added more to our knowledge on this subject:

> *Since Indian women are accustomed to the nudity of Indian men and look upon that condition as in the nature of things, to be taken as a matter of course, no immoral effect is produced on them; while the men, who have opportunities all the time to see naked women, children, and girls in bathing, are just as little affected. They regard clothes more as protection from sun and weather. Girls go naked even to their third year; boys to their sixth. Often both are also sucklings at that age.*

Boller noticed too, in his book ,*Among The Indians*, that lovers were very open and spent lots of time painting each other with various designs in vermillion. Beldon and Maximilian both spoke of lovers painting each other in cosmetic paint designs, which may or may not have had any meaning other than unto them.

Since the beginning of humankind there have been deviant, or at least not the normal, behavior when it came to anything sexual. McKenzie and Maximilian both noted both sodomy and bestiality. One warrior was called over to tell of his experiences with animals, and he calmly told of having sex with five different species of animals, but some he said were dead or nearly so and did not know if that counted. The point was made that this usually only happened on long war parties.

The young warrior men were as proud of their sexual conquests as they were of their war victories. Just like keeping track of their war stories, some men in some tribes, like the Hidatsa and Mandan, kept women tally sticks, or love conquest bundles. These bundles were made of peeled osier twigs painted red at the tips for around 10cm and others were 13 to 15 centimeters. The longer ones, carried singly, had white with red rings alternating, equal to the number of conquests; the shorter sticks each equaled one conquest.

A variation on that was practiced among the Hidatsa, where usually one stick in the bundle is larger and has a tuft of black feathers to indicate his favorite. If the woman had the honor of wearing a white buff robe or a red blanket, a piece of either of those items was sewn to the stick.

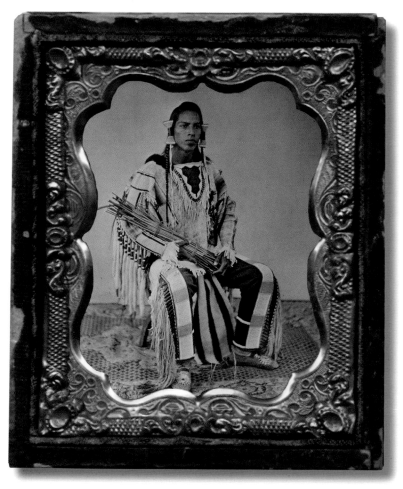

A Crow dandy with his Love Conquest Bundle, contemporary tintype photograph

Much activity went on between the sexes, as would be expected when people were living in such close proximity to each other. According to S.H. Long, no sentinels were usually needed to watch the village at night because often many young men were out after women and therefore were more or less on guard. If enemies had been recently sighted, then guards were put out. Long added that some of the unmarried men were wont to pry about the lodges at night. If they got to a tent in which there was a girl they coveted who was sleeping, they would pull up the pegs outside and lift the cover up, so as to be with the woman in "genitalia minibus tangere possent," as he put it. Knowing this, many husbands, when they were to be absent at night, would tie ropes around the waist, legs and ankles of their wives to protect her from other men. (Dodge, *Social Life of Crow Indians*)

Men in some tribes had no problem with their wives prostituting themselves to other men, as long as they were aware of the fact and cut in on 'the deal.' Husbands in some tribes loaned their wives and sometimes their daughters to honored guests. As in so many other cultures worldwide in the past, no stigma was put on this and it all seemed perfectly normal.

Colonel Dodge noted that with the Arapahoe, infidelities were not specifically regarded as immoral or wrong, and nothing much was done about it. Unlike them, the Blackfeet and Comanche both split the noses of unfaithful wives. In a lop-sided, male-dominated society, the penalties for women were usually much more severe than for a man for the same offense. Women could 'legally' be beaten or gang raped by her husbands' warrior society and by the husband or her own relatives. A man could merely give a 'gift,' or actually a payment/fine, to the husband of the woman he had been with, and all was good.

In the tintype image of the seated man shown above, we find just such a Crow Dandy from the 1870s, as he appears ready to go out among the people to attract potential dates or wives. His hair has been done in the traditional Crow style that had developed for over fifty years or more. This well known Pompadour style may be caked with red, yellow or white paint or clay and was greased, tied and trained to stand up in the front.

The artist E.A. Burbank watched the Crow chief Plenty Coups getting coiffed, painted and dressed to have his portrait painted. Plenty Coup's wife dipped his forelock in a solution of sugar water, then combed it upward until it air-dried in position. Then it was painted red and white. A long braid gathered to the front of each ear on the temples has Crow-style hair bows threaded onto them. The hair bows were popular with several upper Missouri tribes, but by the 1860s and 1870s they were becoming a predominantly Crow feature.

The Crow hair bows are made by threading pieces of rawhide with wedge shaped ends through metal tubes (shell, carved wood, or rolled rawhide tubes could also be used). A variation has wedge shaped pieces of rawhide attached to the ends. Dentiltium shells are attached to the stiff rawhide in a vertical row, then beads are applied above them. The tube is left open in the center to enable the wearer to pull a braid of hair through. The hair bows were then usually held in place by taking carved sticks pointed on one end and ornamented on the other with feathers, etc. This stick is wedged into the tube to hold it to the braid.

After coming back from a war party, young men would dress up, mount their best horses, and invite young women to ride behind them. Together they would go to some lodge and sing in front of it. This was called "singing before a tipi."

## Notes on Dandies and Love

Long's *Expedition*:
  -The Omaha – gifts given to parents of young girls by men
  -Girls 9-12 visit with future husbands to learn his ways, marry by 13 to 14
  -Husbands talks other wives into necessity of having another wife and helper around

-Usually take favorite wife with him on trips
-Will leave favorite wife for "on business" trips away from her to visit other wives
-Women enter medicine lodge and strip, medicine men dip sticks in water and spray on seeds and women to fertilize them
-Hidatsa large enclosure covered with dried meat instead of skins, warriors summon the prettiest young married squaws who came with permission of their husbands. Women disrobed in front of all warriors. Warriors give halter rein to woman if she accepts she immediately admits him to her favor. Took place in day in presence of everyone.
-Another ceremony women pick men by tapping on shoulder and running out of lodge in bushes where he follows and takes her.
-If he declines he places his hand on her breast and they return to lodge
-In Omaha, to dance and sexual intercourse the same word

# Berdaches and Warrior Women

*"Among all the North American Indian nations there are men dressed and treated like women, called by the Canadians, Bardaches, but there are only one such among the Mandans, and two or three among the Minnetarees."* —Prince Maximilian zu Wied, 1833

*"Men dressed like women and married other men as wives."* —Francisco Coronado

Like any culture that has ever existed, among the Plains Indians there were several different types of individuals who did not fit into the norm of a warrior/hunter or mother/wife. People such as contraries, doctors, holy men and holy women, heyoka and winkte, etc. represented a minority in any village. Among Native Americans today, these minorities still exist and one type would be the winkte, which is the commonly recognized word for a gay male. This word originated among the Lakota and is a shortened version of the old Lakota worked "Winyanktehca." The word Winkte can be broken down as the following in Lakota: Win (Woman) Kte (to be like), or "wants to be like a woman."

Other accepted terms are "Bote" (Crow), "Hemonee" (Cheyenne), and "Dino" (Navajo). "Berdache" is an older word used to describe all non-heterosexual members of their societies. It is considered offensive by some today, and therefore it is not usually encountered. The word itself was widely used in Europe before being brought to the New World by the French. The French "Berdache," derived from the Spanish word "Bardaxa," via the Italian "Bardasso," from the Persion "Bardaj/Yartak', then the Old Iranian "Varta," all of which translate to: a vulnerable male prostitute, catomite, that was kept or seized as a prisoner. A politically correct term used today by many is "two-spirit" or "two-spirit person."

As with any subject pertaining to sexuality, there will be countless ways of viewing and interpreting it, all based on and biased by religion, societal mores, personal experiences, when and where someone was born, and many other factors. This holds true for modern American Indian people also. Among Native American people, the tribally accepted view and treatment of Two-spirit People can vary from tribe to tribe. This, slowly and sometimes subtly, changes over time.

Two-spirit people are often mentioned in primary accounts from the 18th and 19th centuries and, as with many aspects of this culture, only a general and incomplete picture can be gleaned. The amount of documented and/or primary source information we have to study and form opinions on are very limited. For sure, attempting to describe in detail such a complex side of Plains culture is impossible in this brief work.

A good summary from the Hidatsa informants of Alfred W. Bowers tells of the duties and life of two-spirit people:

> *Another organized group was that of the berdaches. These people were men who, during their late teens and after many dreams from the Holy-Woman-Above, changed their clothing to that worn by women and assumed special roles in the community.*

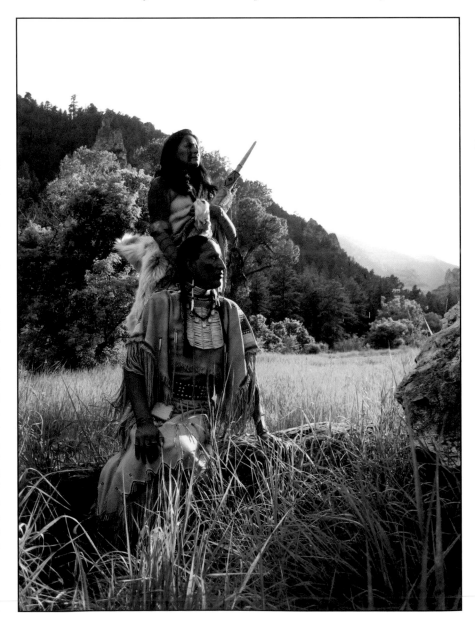

Two Spirit People

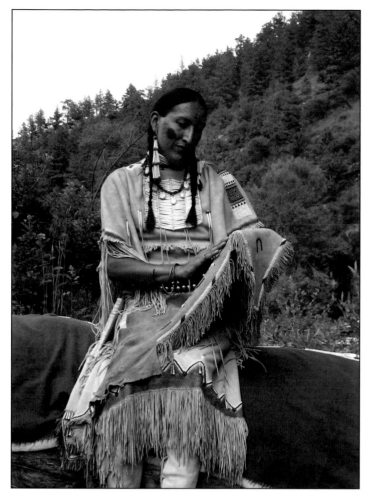

driftwood in the river. Whenever a major ceremony was being given, the berdache would dress like the other members of the Holy Woman Society and receive gifts as an equal member with the women of the society.

The berdaches comprised the most active ceremonial class in the village. Their roles in ceremonies were many and exceeded those of the most distinguished tribal ceremonial leaders. There was an atmosphere of mystery about them. Not being bound as firmly by traditional teachings coming down from the older generations through the ceremonies, but more as a result of their own individual and unique experiences with the supernatural, their conduct was less traditional than that of the other ceremonial leaders.

Like certain male medicine men, they surrounded themselves with many individual rules of conduct for guests in the lodge. This limited the activities of people associating with them and, like several outstanding male medicine men surrounded by these many rules, people tend to fear, respect, and avoid them. In this sense they resembled in their social position males possessing unique and special mysterious supernatural powers. Berdaches tended to disappear once warfare had ceased and their ceremonial system had collapsed. (Hidatsa Social and Ceremonial Organization p. 166)

Representing more of a white mans' view is a 19th century Caucasian interpretation from Captain Clark, and a 20th century one from the author, James P. Ronda, which can both be found in *Lewis and Clark Among The Indians*, p. 130:

Ritual behavior or social customs often eluded their grasp, especially if they had no counterparts in white American life. Berdaches, those plains Indian men who dressed and acted as women, caught the captains' attention but evaded their understanding. First mentioned by Clark in late December 1804, the berdaches were described as "men dressed in squares clothes." In conversation with Biddle, Clark amplified their original description, adding that young Hidatsa boys showing "any symptoms of effeminacy or girlish inclinations" were raised as women, married men, and fulfilled all the functions assigned to Hidatsa women. But Clark had missed the spiritual nature of the berdache while imposing an interpretation of sexual deviation where none belonged. What he perceived as gender confusion or homosexuality was actually something quite outside his own experience. Men became berdaches not early in life but usually as teenagers or later.

The berdache role could be assumed only after a series of dreams from the Holy Woman Above. Only brothers or sons of men owning ceremonial rights to the Woman Above and Holy Woman bundles could become berdaches. After having the required dreams and assuming women's clothing, berdaches were viewed as persons of great and sometimes mysterious spirit power.

It can be stated that Two Spirit People were generally allowed the freedom to be themselves and were often seen as having a special medicine or holy power.

This acceptance of any Tribal member to be as much of an individual as they wanted to be was common, as long as it was not detrimental to the Tribe as a whole.

Though revered and respected, they could often times be equally feared and avoided. The same could be said for any Holy Man or Holy Woman in that anything that appeared to have spiritual power was both respected and feared at the same time.

To try and help understand how Plains men view themselves is best done by trying to put yourself into their mind set. This can be difficult due to cultural, social and time frame differences.

A CHEYENNE HEMANEE ADMIRES A PAIR OF LEGGINGS HE HAS MADE FOR HIS HUSBAND

They usually formed attachments to older men, generally men without children and having trouble keeping their wives, and set up separate households. At the time this study was made, informants could remember two such people in the generation above them, but they had heard that in former times there were sometimes as many as 15 to 25 berdaches in their village.

Since the berdaches were viewed as mystic possessors of unique ritual instructions secured directly from the mysterious Holy Woman, they were treated as a special class of religious leaders. Although a berdache might have lived within an extended household as one of the co-wives, informants thought that separate households more commonly were maintained. According to tradition, these were well-to-do households. The "man-woman" worked in the garden, did beadwork, and butchered as did the women. Being stronger (since unlike most men he did physical labor) and more active than the women, the berdache could do many things more efficiently and was never burdened down with childbearing. Accounts we have of the berdaches tell of industrious individuals working harder than the women of the village and exceeding the women in many common activities. Informants felt that separate households established around the berdaches were very often better fixed than those where the men carried on active military duties.

The berdache performed many ceremonial roles. When the Sun Dance ceremonies (NaxpikE) were to be performed, it was the berdache's duty to locate the log for the central post from

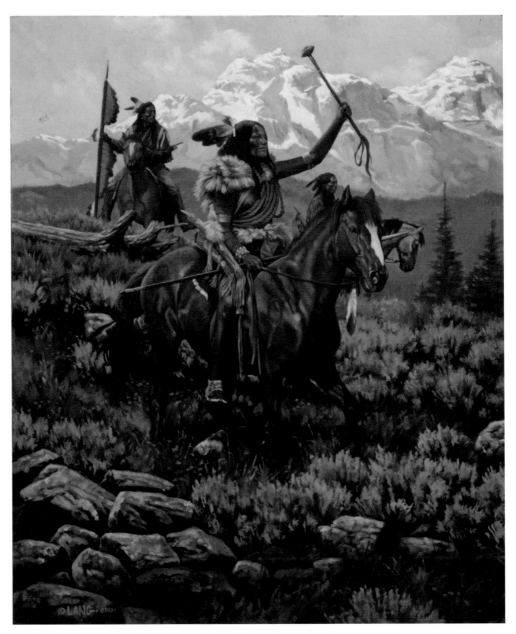

WARRIOR WOMAN KOKIPA HIYA, NOT AFRAID, PAINTING BY STEVEN LANG

Women warriors were women who dedicated their life to being a warrior and usually lived the lifestyle of a man. One class of them may have been heterosexual or lesbian women, with more male hormones and testosterone and therefore were naturally drawn to a man's world and lifestyle. Others may have just been drawn to the warriors life or, as with many people, were thrust into that lifestyle by a long progression of events.

Although there may have been more women that fit into this category than showed it, they, however, did not express it and kept their sexuality to themselves, due in part because of the peer pressure, family pressure and responsibilities put on girls and young women. So this type of Indian woman was few and far between.

In his book, *The Sioux*, Hasserick touched on the subject a bit, but had little information to go on.

*Lesbianism seems to have played a much less obvious part in the life of the Sioux. Certain dream instructions given to young women- in particular, the Double Woman's Appearance- hint at a kind of sanction for female perversion. Rattling Blanket Woman, for example, underwent a true choice situation during her dream experience, and selected, albeit unwittingly, the role of wife and mother in opposition to a career of professional craftsmanship and suggested spinsterhood. And yet there exists no record of old maids among the Sioux. Furthermore, there seem to be no examples of female inversion, and the role of women within the society appears to obviate the development of any meaningful causes. (The Sioux)*

Not Afraid was just such a warrior woman. She was chosen by the spirits and Creator to lead the life of a man, although she was born with the body of a woman. Her clothing and regalia shows she achieved many honors and would have been accepted among the tribe as a warrior and perhaps even a war party leader. She set off for horse-capturing raids or a war party, where she expected to bring home horses to give away and to keep for her own herd.

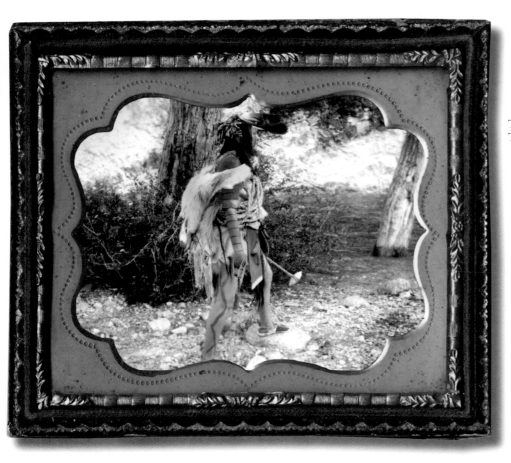

Three large mature Golden Eagle tail feathers marking her coup adorn her lose hair. She has these feathers attached to a scalp lock, just like a man would wear, and owl feathers, both natural and dyed red, are also tied there. This will give her the silent approach on her enemies, just like an owls' attack on its prey.

Her face and body are painted to reflect her many coup, the lightning bolts down her legs make her move like lightning and give her the powers of the thunderbird. A grey prairie wolf is thrown across her shoulders and hangs down her back. She will use this as a disguise and badge of rank, too, when she acts as a scout and spies on the enemy. A long braided buffalo rawhide plaited rope is coiled about her body where a horse necklace amulet also hangs. These, along with her antelope horn-handled horse quirt, are three things she hopes to use when she finds the enemy's horses.

On her belt hangs a heavy, man's style knife and a preserved scalp that has been beaded on the inner surface. On top of her belt she wears the skunk-skin belt worn by all members of the Cheyenne Dog Man society, which has been gifted to her by her Cheyenne brothers out of respect for her bravery and power.

She carries an expensive, heavily beaded, Lakota quiver and bow case that reflect her wealth, along with her beaded and porcupine-quill embroidered moccasins. Not Afraid carries no gun and her weapon of choice is the traditional stone war club.

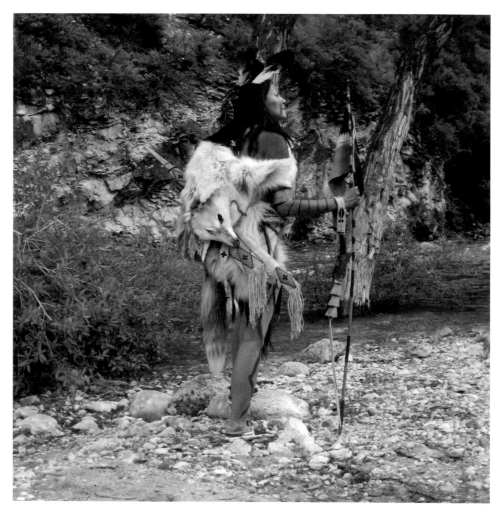

Dandies and Two-spirit People    167

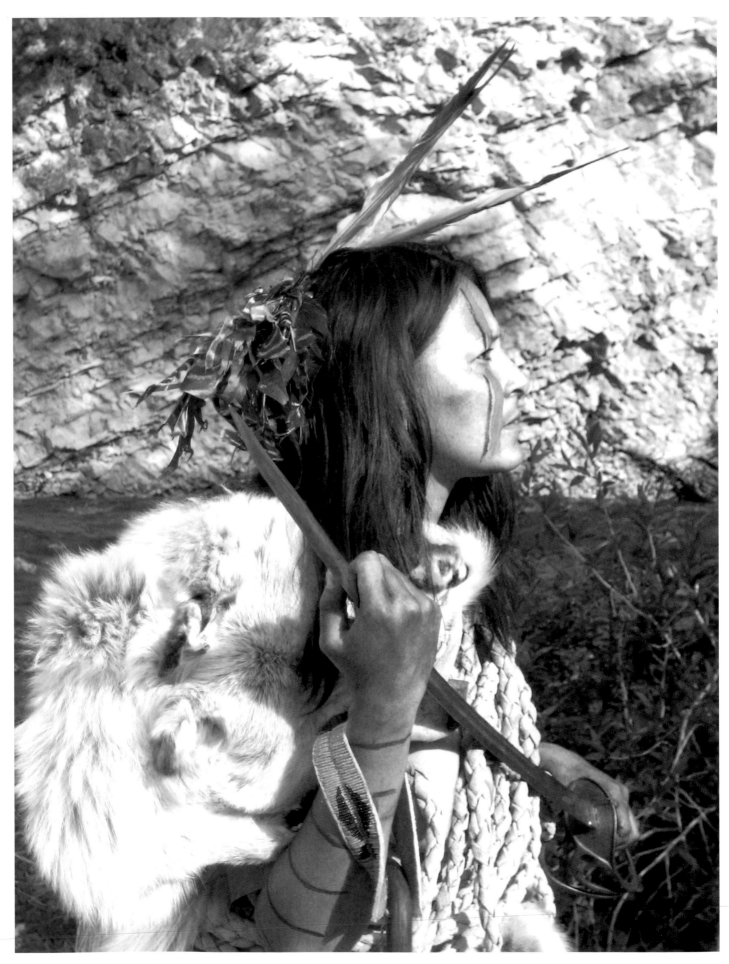

A DEPICTION OF NOT AFRAID

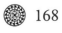

168    Dandies and Two-spirit People

Unlike Not Afraid, who was a warrior in every sense of the word, there were countless women who bravely and expertly defended themselves and their families when attacked. Most, however, were women who were thrust into battle or self-defense situations where they performed well, just as any human would when their life or the lives of their loved ones were threatened. They were not considered warriors per se for doing this. They were still applauded for their bravery, as they well should have been, but in an Indian way of thinking being in a battle did not qualify you as a warrior, as chances were, at some point, in all of their lives, they were involved in a battle in one way or the other.

Another version of the warrior woman is the woman who may have lived her life as a woman, but experienced a life-changing incident when she proved herself to be exceptionally brave and performed a heroic feat. If these deeds were witnessed and verified by others, then she had the right to many privileges that other warrior men did, and from that point on she may participate in or gravitate more and more toward a warrior role.

In 1913 there were still two of these warrior women living at Long Plains. One was out with a party who were digging turnips on the prairie. They were attacked and surrounded by the Sioux, who rode round and round them, firing. The men fought them off, while the women hastily dug a rifle pit to conceal the party. The building of defensive works by the women while under attack was a common tactic. In the meantime, the men were all wounded. The pit being finished, this woman crept out under the fire and rescued each of the men, dragging them back to the pit. In this manner, she became an Okitcitakwe (warrior woman).

Another such woman was Cinoskinige, who obtained her title of Okitcitakwe in this manner: She always went out with the warriors. On one occasion, when a Sioux was shot from his horse, she ran to count coup upon him. Being a woman, she was outstripped in the race by three men, but succeeded in striking the fourth coup, killing the Dakota with her turnip-digging stick. The men then scalped him and she painted her face with his blood.

By such actions, women did achieve great fame as warriors. Sometimes, when a man went to war, his wife would insist on accompanying him and sometimes she was lucky enough to succeed in obtaining a war honor before the return of the party. Thereby, she received the customary feather insignia, but never wore them herself, designating one of her male relatives, preferably a son or grandson, to wear it for her. She was also called by the title Okitcitakwe, or "Okitcita woman." Just like a warrior man, a warrior woman may sometimes take on a new name after a brave deed. George Bent related that Buffalo Calf Trail Woman's name was changed to Brave Woman, after the Battle of the Little Bighorn.

An Okitcitakwe was entitled to go to the soldiers' tent at any time when the warriors were dancing, and to join them, dancing by herself at one side. When the warriors reenacted their valorous deeds, and counted their coups, she was entitled to do the same, and her narration was received with the same respect. She might not remain in the tent overnight, however.

A Bungi woman stated that her husband had seen a Cree woman, who was allowed to abide in a soldiers' tent with the men as a reward for some brave deed, and later some Cree assured me that the head Okitcita might keep his wife in the lodge.

Speaking of Mandan women who had achieved war honors, Alred W. Bowers noted, "Women also qualified for war honors and were eligible to wear the same decorations as men. Informants remembered a number of women who had struck an enemy and had displayed their war honors during the Scalp Dance. One woman concealed herself at the entrance to her lodge and hit an Assiniboine on the head with a stone hammer. She scalped him and, during the dances, received a hearty applause whenever she was leader of the line of dancers, carrying her scalp on a stick.

Wolf-chief had never heard of a Hidatsa woman shooting or striking an enemy and, as a consequence, "winning a warrior's honor marks." This was more common, and among some tribes they were totally unknown. (Mandan Social and Ceremonial Organization, page 65)

There are several well-known examples of women war leaders, such as Woman Chief. She was born a Gros Ventre, but was captured by the Crows when she was twelve. They raised her and she became a well-known war leader that whites, like Edwin T. Denig, the trader, and the Swiss artist, Rudolf Kurz, both knew during the 1850s. She was eventually killed by the Gros Ventre, her own people, when she once attempted to make a peaceful visit.

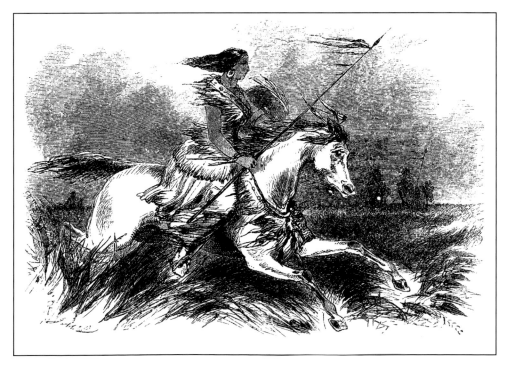

PINE LEAF, A TWO-SPIRIT, WARRIOR WOMAN

Denig also had heard of an Assiniboine woman who was killed on her first war party against the enemy when she attempted the feats of Woman Chief. There was also a Piegan woman war leader, named Running Eagle. She was a large woman who wore men's leggings, an undershirt doubled in the manner of a breechcloth, a woman's dress, and a capote like a man. (Capotes were usually considered a man's garment.)

Old Chief White Grass told Weasel Tail that he had gone on several war parties with Running Eagle. He said that the men who followed her on war parties highly respected her and she was not too proud. She always insisted that she was a woman, and she cooked for her war parties and mended the men's moccasins. When one of the men protested that it was not right for the party leader to do that kind of work, she replied, "I am a woman. Men do not know how to sew."

When Running Eagle was young, she married a Piegan, but her husband was soon killed by the Crows. She asked Natosi the Sun to avenge her husband's death. Sun told her, "I will give you great power in war, but if you have intercourse with any other man, you will be killed."

On one of several horse raids against the Flathead Indians, west of the Rockies, she met her end. When the Flathead learned that it was a woman who had been leading the successful raids, they decided to kill her. As she entered a Flathead camp, they were on the lookout for a strange woman. A man saw her, and in his Salish language asked her name. She did not answer, but backed away. He lifted his gun and shot her dead. Later, some of the Blackfeet said the reason she was killed was they claimed that Running Eagle had not been faithful to her vow to the Sun and that she had sexual relations with one of the men of her war parties. (Ewers, *Plains Indian History and Cultures*)

There was a famous Cheyenne, Nut-uhk-E-A, or Cheyenne for warrior woman. Her name was probably Heo'vaee, or Yellow Haired Woman. She fought at Beechers Island during a great fight between the Shoshone and Cheyenne, in late fall of 1868. She dressed as a man with breechcloth and went shirtless just like a man.

Another group of women, who were not true warriors, but some today may interpret as such. They were young, childless women who sometimes went on war parties with their husbands as helpers, to gather wood and water, cook, mend clothes and moccasins, and pack extra gear. Just like the young boys who accompanied these war parties as helpers, these women were not considered warriors, just for coming along to assist the warriors.

George Bent talked of Cheyenne women who went on raids, but they waited in the hills with the pack horses and boys when the men raided stage lines, ranches and settlements.

Heo'vaee, or Yellow Haired Woman, Warrior Woman of the Cheyenne

As with most subjects pertaining to Plains culture, there are exceptions and variations, both tribal and personal. The Mandan informants had never heard of any Mandan women going to war, but Weasel Tail, the Blackfeet, told of his wife accompanying him on some war expeditions.

> My wife said she loved me, and if I was to be killed on a war party she wanted to be killed, too. I took her with me on five raids. Some of them I led, and my wife was not required to perform the cooking or other chores. She carried a six-shooter.
>
> On one occasion she stole a horse with a saddle, ammunition bag and war club.
>
> I was frequently a leader of war parties. On those parties my wife did not have to do the cooking or other chores. We took boys 14 to 20 years old who cooked, rustled food and firewood for us in my day.

Weasel Tail knew of a Blood woman and two Piegan women who, while accompanying their husbands, had taken guns from the enemy, a great war honor with the Blackfeet. Elk Hollering In The Water, the wife of Bear Chief, was one of the Piegan women who had accomplished this war honor.

So only people, male or female who devoted their lives to warfare or the active pursuit of being a warrior/protector of the people, or people who had incidents in their lives that changed them and sent them in the direction of a warrior were considered true warriors. This does not belittle the brave Indian women that did fight and many times died for their people. Most all Plains women would fight if need be, and were far from being helpless pushovers. These women were tough and had grown up living a very rough life, constantly exposed to a harsh environment and circumstances. The movie image of a frightened and helpless woman would have been far from the norm.

Like men who followed the path of the two-spirit people, these women warriors took on the full lifestyle of a man and were both respected and feared, due to their unusual life, which could only be interpreted as having been touched by the spirit world.

# Chapter 13
# Captives

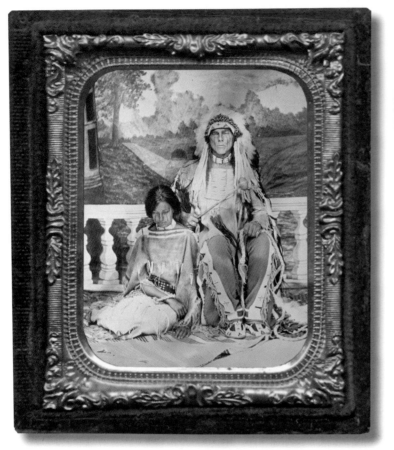
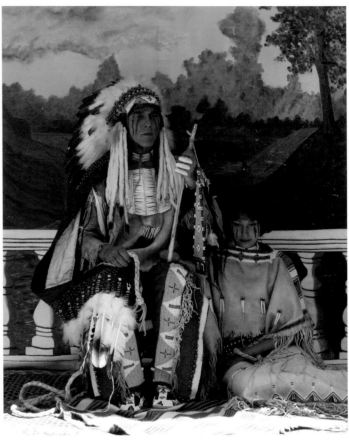

OGLALA CHIEF AND A WHITE CAPTIVE DEPICTED IN 1860S CLOTHING. CONTEMPORARY TINTYPE AND COLOR PHOTOGRAPHS

*If we could only bathe in the blood of your cursed nation and eat the hearts of your young ones." Shoshone woman to captured Blackfeet women.*—Father DeSmet

The fate of a person of any race captured by a Plains Indian warrior might face a broad range of possibilities, depending on how that particular warrior or war party felt at that given moment. If you were a man, your chances of living very long were slim. There are rare instances when very brave warriors that fought well in desperate situations were spared, but that was not the norm. The same could be said for a particularly cowardly warrior or man. Generally, Plains Indians had no desire to capture any man. What good were they and what were you going to do with them? The only thing a captured man did was to constantly be thinking how they were going to get away, and how they were going to come back with their friends and kill you for being stupid enough for not killing them when you had the chance. It was so much easier just to finish them off, when given the chance.

Red Crow said that one time a group of young warriors wanted to kill a cowardly Cree they had captured, but painted his face black and gave him as a gift to the sun, then they released him. This had never been done before. They said he was not worth killing. Running Wolf, at Cyprus Hills battle, spared the life of a Cree but another Blackfeet killed him. Non-Indians soon learned what Indian men already knew, to not allow themselves to be captured alive.

Unlike the Eastern Woodland tribes that relished and mastered the art of torture, on the Plains it was not nearly as common. In the East, tribes would try to capture and torture the bravest warriors and slowly pull their power from them through the torture. In the West, they were more concerned with protecting their afterlife by destroying the soul and physical body of their victims, so most people were killed outright without torture.

Being taken captive and adopted into the tribe later was no guarantee of long-term safety. George Bent told of a group of Crow prisoners that had been adopted by Cheyenne families over time. Years after they had

172

been taken prisoner, some Cheyenne were killed by a Crow War Party. When the relatives of the slain Cheyenne heard of the fate of their loved ones, they dragged the adopted Crow out of their tipis and killed them all. Then, they were laid on the ground around the edges of the burial lodges of the killed Cheyenne warriors that had the burial scaffolds inside. It was still a crime as they had been adopted by the People and the Chiefs were very worried over this event, as to shed blood of tribal members within the village was a crime. The Medicine Arrows were spotted with blood at the next renewal ceremony, which was proof enough of the Cheyenne families wrongdoing.

People considered prisoners, and not actually adopted into the tribe, generally faced a summary execution if the tribe were attacked. S. H. Long noticed that the Omaha prisoners are guarded and treated well, but instantly put to death if their enemies were in pursuit

Nor could just being a woman guarantee you a secure future. One chief bragged of killing several Snake women and children and had captured a very pretty women several times and that she had escaped several times. None of his tribes women were equal to her beauty; he knew white the men would love her. So he saved her life when she was captured, because he knew they would pay highly for her. However, she finally escaped again. On her journey back to her people she had killed a buffalo and was trying to dry it, when four young warriors caught and killed her. They cut off her head and put it on a pole, but left her scalp intact for the women of their tribe, as they said a woman's scalp was below their dignity to take. The women kicked her severed head about the village, and then the boys used it as an arrow target. (C. McKenzie's *Narratives*)

Father DeSmet wrote that the women were sometimes worse than the men, and that most people would watch all of these tortures and mutilations totally unmoved. He watched as the Snakes would take captive Blackfeet women and give them to women to kill with knives and hatchets. Nor did they give any thought to the torture of male prisoners, as they tore out their nails, chewed flesh off of their fingers, then stuck cut-off fingers into their pipes and smoked them or crushed toes between stones, applied red hot irons, then skinned them alive and ate parts of them. (This is one of several rare documented instances of Plains Indian torture.)

WHITE CAPTIVES LAURA ROPER WITH ISABELLA EUBANKS, DANNY MARBLE AND AMBROSE ASHER WERE PHOTOGRAPHED SOON AFTER THEIR RESCUE. THEY HAVE THE 'THOUSAND MILE STARE' USUALLY ONLY SEEN IN HARD-CORE, COMBAT SOLDIERS.

Many tales of white women being taken captive by Plains Indians were recorded in the 19th century. Many of the stories may be embellished and sensationalized due to typical 19th racial prejudices and rhetoric, but most of them sound believable enough.

Col. Richard Dodge graphically summarized the rape experience:

> The rule is this. When a woman is captured by a party she belongs equally to each and all, so long as that party is out. When it returns to the home encampment, she may be abandoned for a few days to the gratification of any of the tribe who may wish her, after which she becomes exclusive property of the individual who captured her, and hence-forward has protection as his wife.

> No words can express the horror of the situation of that most unhappy woman who falls into the hands of the savage fiends… she is borne off in triumph to where the Indians make their first camp. Here, if she makes no resistance, she is laid upon a buffalo robe, and each in turn violates her person, the others dancing, singing and yelling around her. If she resists all her clothing is torn from her person, four pegs are driven into the ground, and her arms and legs, stretched to the utmost, are tied fast to them by thongs. Here, with the howling band dancing and singing around her, she is subjected to violation after viola-tion, outrage after outrage, to every abuse and indignity, until not infrequently death releases her from suffering. The Indian woman, knowing this inevitable consequence of capture, makes no resistance, and gets off comparatively easy. The white woman naturally and instinctively resists, is 'staked out,' and subjected to the fury of passions fourfold increased by the fact of her being white and a novelty. This 'staking out' was a practice known to the Cheyenne as "staking a woman on the prairie (noha's-w-stan)." It had its origins in Cheyenne society as a punishment against an adulterous married Cheyenne woman. The woman would be placed away from the village and all Indians of the military society would take their turns raping her, allowing the release of "all the pent-up, subconscious, frustration-bred sexual aggression of the males."

Neither the unconsciousness nor even the death of a victim stops this horrible orgy and it is only when the fury of their passions has been glutted to satiety that she is released if alive, or scalped and mutilated if dead. If she lives, it is to go through the same horrible ordeal in every camp until the party gets to the home encampment.

But, by far the main motive for capturing frontier women was profit. Dodge:

174    Captives

*Indians always prefer to capture rather than kill women, they being merchantable property. White women are unusually valuable, one moderately good-looking being worth as many ponies as would buy from their fathers three or four Indian girls."* As Rister succinctly noted, *"The profit to be derived far out-weighed Indian grievances- misdeeds of the whites, slaughter of the buffalo, and settler occupation of favorite hunting grounds- as a motive for raids and outbreaks.*

As early as 1741, Snake Indians were trading the young women of Plains tribes to the seacoast tribes for horses and Spanish goods. ( The Plains Cree)

Indian men were quick to spare the life of a strong, young or beautiful woman.

*In 1804, group of Enasas (?) found four or five Flatheads tipis. They watched the village and waited for the warriors to ride off to hunt, then they attacked and killed all the women and children they could and stole all the property. A woman and two children escaped. When they were caught the chief was going to kill them, but the woman was very beautiful so he kept her as a slave.* (Charles McKenzie's Narratives)

Dodge further noted the typical experience of female captives:

*The life of such a woman is miserable beyond expression, the squaws forcing her to constant labor, and beating her on any reason, or without, provocation. She, however, fares and lodges exactly as the other members of the family of her owner, attends the dances, and is in no way socially ostracized. She brings her owner more or less revenue, dependent upon her beauty; and, as property, is worth quite as much as an equally good-looking girl of virtue. She is a favorite stake at the gambling-board, and may change masters half a dozen times in a day, as varies the fortune of the game; passing from hand to hand; one day the property of the chief, the next day, of a common warrior. No discredit attaches to the ownership or farming out of these unhappy women.*

A white captive girl named Nancy described the Indians beating her with whips, "and whip stock, and other things, and finally took hold of me, and threw me upon the horse, with a limb on either side, compelling me to go with them." One Indian took Daniel Marble [who is shown in the photograph of the captured children] and "whipped the little fellow severely because he too was crying." Five days later she miscarried her baby, "on account of my severe and ill treatment, and my eyes went blind." Regarding cruel treatment, Nancy also reported that the Indians would take fresh scalps of her dead relatives and throw them in her face, laughing as they did so. One scalp she recognized as that of her brother.

In 1874, western Kansas seventeen-year-old Catherine German, when riding into the main village three days after her capture, wrote:

*Men, women and children, also barking dogs, took after us. The Indians grabbed me from all sides as we passed them. I wondered if they intended to tear me into pieces. They did tear my dress skirt into strips. Later, I learned that it was their custom, at that time, to grab at a captive, and if anyone could pull her from the pony she rode, she would belong to the one thus obtaining possession of her.*

Catherine would elsewhere describe this experience:

*My clothes were torn form me. I was stripped naked, and painted by the old squaws, and made the wife of the chief who could catch me when fastened upon the back of a horse which was set loose*

*on the prairie. I was made the victim of their desires – nearly all in the tribe – and was beaten and whipped time and time again. They made me carry wood and water like the squaws.*

*I had to kill dogs and cook them for the Indians to eat. We had nothing but dog-meat and horse-meat.*

General Custer himself would write regarding the captivity of two more white girls, Morgan and White:

*The story of the two girls, containing accounts of wrongs and ill treatment sufficient to have ended the existence of less determined persons, is too long to be given here. Besides indignities and insults far more terrible than death itself, the physical suffering to which the two girls were subjected was too great almost to be believed. They were required to transport huge burdens on their backs, large enough to have made a load for a beast of burden. They were limited to barely enough food to sustain life; sometimes a small morsel of mule meat, not more than an inch square, was their allowance of food for twenty-four hours. The squaws beat them unmercifully with clubs whenever the men were not present {one wonders if this was as much out of spite and jealousy then pure racial hatred as they knew their men coveted these white captive women}. Upon one occasion one of the girls was felled to the ground by a blow from a club in the hands of one of the squaws. Their joy therefore at regaining their freedom after a captivity of nearly a year can be better imagined than described.*

There are quite a few instances of early colonial women in the eastern states being held captive by Indians and not wanting to leave, but this was a much more rare attitude for women in the west and the Plains tribes. This may have had something to do with the improved standard of living, the more secure United States versus when it was still a colony of Great Britain. The new pioneer spirit and the women of the 19th century were more educated and liberated, at least in a 19th century sort of way. But George Bent did know of a white woman captive who wanted to live with her captors, the Cheyenne, so she would darken her skin for deception if any whites were around.

Torture, as stated earlier, was rare among the Plains tribes and one of the few instances where it was recorded mentions a group of Cheyenne that had taken a captive and staked him out onto the ground. They filled his mouth with black powder, then bound his mouth shut with a rag. Next a hot ember was placed on top of the rag and they watched and patiently waited for it to burn through the rag and make contact with the black powder that was choking him. Once it ignited it would have resulted in eventual, if not instant, death depending on the severity of the explosion and amount of powder used.

Colonel Dodge also remembered when a fire was built on a captured man's chest and lit. He also told of how the Cheyenne took slivers of pitch wood and stuck them into a twelve-year-old captured drummer boy, then set the highly flammable pitch wood on fire. He later died.

According to the *Journals of Jonathan Carver*, victims to be tortured were first blackened all over and a crow or raven head put on the head of the victim. He said hey may burn older prisoners or males, but not women and children, as they were too valuable for trade.

Once the buffalo trade began in earnest after roughly 1830, captive women were no longer killed, traded or sold so readily. They were now valued too much for the additional robes each one would be able to process over a year's time, adding considerably to a family's annual income.

As with most war honors there were distinct devices and symbols used to denote prisoners taken. Prince Maximilian noted that among

the Mandan a painted yellow hand signified prisoners taken. He also informs us that 'he who takes a prisoner wears a particular bracelet," though unfortunately he does not describe that bracelet.

The contemporary tintype on page 172 shows an Oglala chief and his captive white girl, who he has had dressed in native attire to blend in with the tribe and to lay claim to her. He may eventually give her away, sell her or marry her, but ultimately her fate is in his hands.

A captured woman was likely to live a long and fruitful life if she survived the initial capture, made it through the physical abuse that would more than likely follow in order to intimidate and subjugate her, and if she never tried to escape, served her man well and eventually had children with her man—then she could live as normal a life as could be expected under the circumstances. Most women were satisfied with their fate in life and would not try to escape or cause trouble.

The trailer of the man's headdress is draped over his shoulder and shows the cloth or hide reinforcing piece that goes down the center of trailers to give added support for the feathers when they are laced into position. The trailer is dotted with white pound beads sewn on at random. These dots represent the power of hail stones associated with the power of thunder and lightening. His blue and yellow shirt has hair locks and, unlike the hair locks on a war party leaders shirt that represented the slain souls of enemies killed under his leadership, these—on this style of governing body shirt—represented the souls of the living people he served. The locks of hair would be donated by people within his tribe to remind him of his solemn duty and responsibility to his people.

Among the Lakota, two shirts like this, with half blue and half yellow, were made and issued out to two equal leaders, the blue representing the sky and the yellow the earth. Two similar shirts, also of equal rank, were painted half red and half green (or sometimes half red and half yellow); these colors represented rock and sun. Although Crazy Horse wore a shirt like this, it is a mistake to call it 'his' shirt, as the shirt belonged to the tribe and was given out to appointed leaders. The honor to hold this position and wear these shirts could be taken away, just as with Crazy Horse who had his taken away for having an adulterous affair with Black Shawl Woman. This was considered behavior unbefitting for a person so high up in the tribal government, as it risked disrupting the harmony and unity of the tribe.

In the tintype, his choker and breastplate are made of fine smooth dentalia. The Lakota preferred the longer varieties and to trade for shells up to two inches long. The rings on his finger are the long spoon type favored by Lakota, Cheyenne and Arapaho. Each one would have a rocker engraved design, which may be part ornamentation and part spiritually protective and powerful. His fingers without rings show stains from having worn brass rings that discolored his skin. A stone-headed war club is held on his knee, while the other hand holds a long buffalo rawhide, plaited rope that winds behind his back and is tied to the captive's wrist.

Trade wool leggings, with brass shoe buttons edging the saved list cloth, are adorned with large beaded panels. The smooth-sided 'mountains' design was not used by the Lakota allies, the Cheyenne. They used the 'stepped' design instead, which was also used by the Lakota.

The captive girl wears a Cheyenne dress the women have given her to wear. It probably belonged to one of his wives, who may have been a Cheyenne, a common occurrence. Her face is painted the same as his, so all will know who she belongs to.

# Indian Women As Captives

In 1832, the artist George Catlin found it hard to believe the war stories related on a painted buffalo robe that the Mandan chief, Four Bears, gave to Catlin as a gift. The robe portrayed the killing of women as well as men, which shocked Catlin's idealized view of Indians. Catlin wrote:

*"I incurred his ill-will for a while by asking him whether it was manly to boast of taking the scalps of women? And his pride prevented him from giving me any explanation or apology. The interpreter, however, explained to me that he had secreted himself in the most daring manner, in full sight of the Ojibwa [Chippewa] village, seeking to avenge a murder, where he remained six days with-out sustenance, and then killed two women in full view of the tribe, and made his escape, which entitled him to the credit of a victory though his victims were women."*

This attitude prevailed across the plains and other famous chiefs, like the Hunkpapa Sioux. Running Antelope proudly displayed his record of ten men and three women killed, all in the year 1856.

Ledger drawings by late nineteenth-century Cheyenne warriors portray women's deaths in warfare. A drawing in the Crazy Dog Lodger portrays a mounted Cheyenne warrior delivering an apparently fatal lance thrust to the breast of a Crow woman. Another drawing pictures a Cheyenne warrior chasing and killing two Kiowa women, and several others show babies being killed along with their mothers in the same blow.

The fur trader Edwin T. Denig, while in charge of the American Fur Company's post of Fort Union at the mouth of the Yellowstone River during the 1850s, wrote, "The Assiniboine, Blackfeet, Sioux, Cree, and Arikara also kill women and children and dance as much for their scalps as for those of men."

Rudolf Kurz related a story that typifies a common killing on the plains of two women out working, though this particular attack was rare in that one of the women was armed:

*Before I slept I found out all particulars about that heroic exploit. The two young Indians were 19 days on the warpath. They went as far as Fort Lookout, ostensibly on an expedition for scalps, in reality to steal {capture} horses. They had already seized four horses when they saw two well-clothed Indian women bending over their work in a cornfield. They rode swiftly by, flying an arrow at the women, and in an instant the deed was done. The older woman attempted to draw a pistol from her belt but did not succeed, because her blanket came in the way and in her too great haste she could not extricate the weapon (rash resort to a pistol has long been a matter of scorn among our Indians). As the attack was made in sight of the wigwams the two heroes satisfied their greed for glory by scalping the unfortunate, shrieking women, and fled to their horses. They were hotly pursued and finally were obliged to abandon their stolen booty, because the horses were too much exhausted to swim across the river. The two scalps were placed beside the dead Le Boeuf Court Queue as an expiatory offering.*

*As a goodly number of half-breeds live in the vicinity of Fort Lookout it is possible that the two luckless women were of that*

A ledger drawing showing Cheyenne Yellow Wolf attacking a woman, from the Spotted Nose-Yellow Wolf ledger

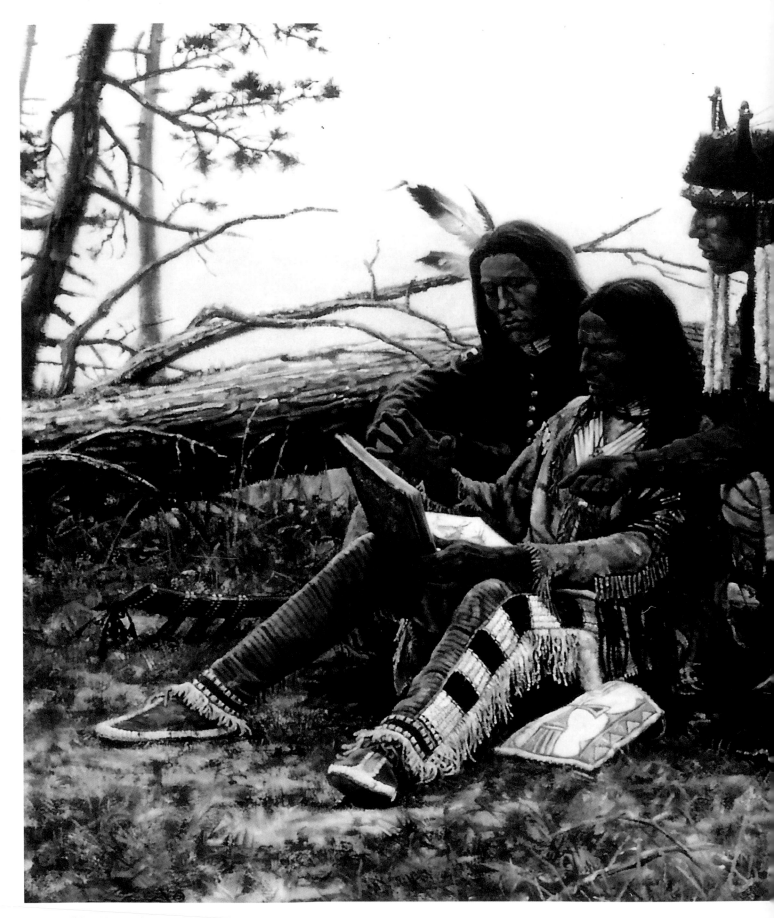

Painting "The Warrior's Ledgerbook" by Steven Lang. A
warrior retells deeds to his sons with his ledger drawings.

*caste. Judging by the good clothes and in the fact that Zephir's wife is the only woman having a pistol in her possession, one may very well suppose, as Alexis himself said, that the women must have been Zephir's wife and daughter. (The Journal of Rudolf Frederick Kurz)*

As a goodly number of half-breeds lived in the vicinity of Fort Lookout, it is possible that the two luckless women were of that caste. Judging by the good clothes and the fact that Zephir's wife is the only woman having a pistol in her possession, one may suppose, as Alexis himself said, that the women must have been Zephir's wife and daughter. Miles Gilbert saw some brave Plains women shooting pistols and even bows.

At the same time, Denig recognized that the Crows did not kill enemy women and children. Why this difference? At that time, the Crows were a relatively small tribe, but they occupied one of the best hunting grounds on the northern plains and needed as many women as possible. They were surrounded by four larger enemy tribes: the Sioux, Blackfeet, Cheyenne, and Eastern Shoshone. They needed to increase their numbers while they fought desperately for survival. So they captured, rather than killed, the women and children of enemy tribes who fell into their hands.

Throughout most of the historic period of intertribal warfare on the Great Plains, Indian women had more reason to fear being taken captive than being killed. Early in the historic period, young Indian women captives became valuable pawns in intertribal trade, passing from the west to the more easterly tribes and to white traders at their early outposts in the wilderness.

There were said to have been Blackfeet and Gros Ventre women captives among the English on Hudson's Bay before Anthony Henday became the first Englishman to explore westward to the Upper Saskatchewan River in 1754. He reported seeing "many fine girls who were captives" in the camps of those Indians. In 1772, Matthew Cocking found young people of both sexes taken as slaves and adopted into Gros Ventre families "who have lost their children, either by war or sickness." During the 1770s, the elder Alexander Henry saw Blackfeet women and children who were slaves among the Assiniboine, and during the first decade of the nineteenth century, the younger Alexander Henry found that the Cree and Assiniboine still referred to the Blackfeet and Gros Ventre as "slaves."

*Assiniboine women were openly bought, sold and exchanged as an everyday occurrence; and liquor was illegally, but freely used in the trade. The Americans were continually being killed and scalped by the Sioux, and many fatal fights occurred among themselves, for which no one was punished, although there were military posts planted at intervals all the way up to Benton.*

During the late seventeenth and early eighteenth centuries, the Illinois Indians made something of a business of capturing women and children from the Plains tribes, passing them on to other Indians and French outposts farther east. These captives came to be known by the French word pani, often translated as Pawnee. Similarities in the organization and procedures between those early slave raids and the later horse raids of Plains Indians suggest that the raid for captives may have furnished the model for the later horse raids of the Plains Indians.

*Spear-head bows in older times were sported in the village by young men who courted the village maidens. Eagle plumes and dried skins of yellow birds were fastened to the bows to make them look handsome. But such bows were also carried in war parties. When a warrior had shot away all his arrows, he might use his bow as a lance. I know no tradition handed down to us that tells of anyone being killed with a spear-head bow.*

*When I was eleven years old, Red-feather struck coup on an enemy with a spear-head bow. He did not kill his enemy with his bow but used the latter as a coup stick. However, afterwards he carried his spear head bow in the dance with the point painted red to represent blood. The spear head bows I saw in my boyhood were carried in the dance and were not made to be real fighting weapons.*

*These bows were bound to the sacred bundles of their owners and so kept as sacred.*

*He is the only Hidatsa I knew of who used a war club in war.*

*Guns were coming into use in my youth and I never saw war club or lance used in actual battle.*

## Crooked Lances

Generally mislabeled 'coup sticks', crooked lances are usually either specific society regalia, for example for the Cheyenne Crooked Lance or Elk Society, or badges of rank. Crooked lances were common societal regalia among many Plains tribes, including the Arapaho, Blackfeet Cheyenne, Crow, Lakota and others.

Wissler documents the Oglala practice of how, after a war party left its village, the pipe carrier/war party leader (Lakota Chanupatawa) would appoint assistants. Two men were assigned to carry crooked lances wrapped with wolf fur and with crow and owl feathers that outranked two additional assistants who carried straight lances wrapped with wolf fur and suspended crow and owl feathers. Men who hoped to be given this honor came prepared with the basic items necessary to construct either one of the two crooked lances or one of the two straight lances. Both lances bore symbolism that harkened back to earlier days, before their users became nomadic plains people instead of agriculturists. They represent two food crop staples. The crooked lance represents the mature sunflower plant and how it bends over when ripe, and the straight fur-wrapped lance represents a corn stalk. Among the Crow society, staff bearers counted double coup with each coup they counted while carrying society staffs, because of the extra danger involved in bearing one.

The Oglala version was originally made in the field and usually had a regular lance point, or it could be made out of a straight sapling. The crook on the end is a thinner sapling lashed on and bent into shape and held there by tying. The crook had no practical function as it was lightly constructed. The entire lance was wrapped with wolf fur and had four wolf fur strip appendages that had crow feathers on the end. The end of the crook had a spray of owl feathers. The reason for using the wolf, crow and owl feathers is that the wolf knows everything (especially about hunting and warfare, the crow can always find food, and the owl know everything.

These are the skills that an efficient war party assistant would need. This allows the war party leader to focus on planning and spiritual preparations needed for the war party to be successful and not the logistics of finding food for his men.

The lance bearers were chosen for the duration of that particular war party. Those four outranked all war party members except the pipe carrier. Officers of various warrior societies could wear and bear their individual societal regalia and ranking devices but they were honorary and not actual officers while on the war party, unless they too were appointed as one of the four main assistants.

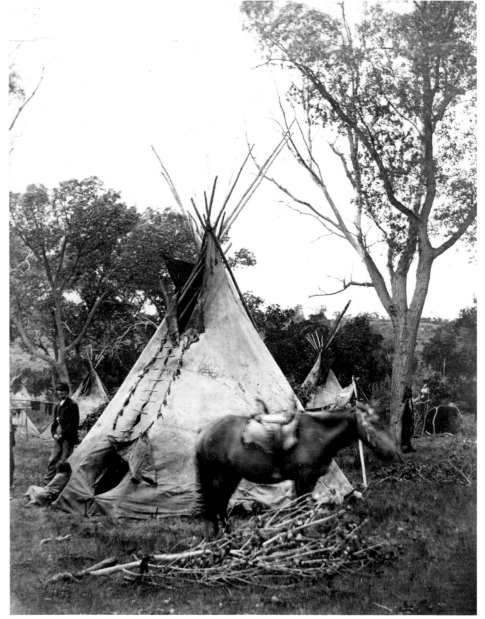

A CLASSIC PLAINS INDIAN TIPI
WITH A SHIELD AND A HORSE

# Shields

Shields, like headdresses, seem to epitomize the Plains Indian warrior culture, however just like headdresses many men did not own or have the rights to either. There were many responsibilities that went with shield ownership in some tribes. Most had specific songs and prayers (or prayers in the form of a song) that must be said while handling or putting on the shield. Just like a sacred pipe it generally had to be offered to the Sun and Earth and the Four Directions before it was used or put on. They must be kept covered in bad weather and taken in at night, or turned so its front always faces the sun to soak in the sun's power as it travels across the sky.

Pretty Shield recalled her fathers' half red/half blue shield that hung on a backrest at night and during the day on tripod outside at the rear of the tipi.

Some kept their shields covered at all times. Like everything the variations and personal taboos were endless.

There could also come honors for being a shield owner. George Bent said that only a warrior who owned a shield or headdress was allowed to paint others for battle and ceremony.

As early as 1540 to 1542, Francisco Coronado wrote that the warriors in the southern plains carry shields and wear colored leather jackets in battle.

LaSalle in the mid-1680s writes, "we saw a war party all with shields approximately thirty inches and faces painted with black and white stripes." He also noted numerous horses and guns among the tribes he came in contact with.

We know that in pre-horse times the shields were considerably larger to allow the warriors fighting on foot to have a good defensive weapon to hide behind and protect themselves from arrow shots and war club blows. With the coming of the horse the shields changed, as did so many other things in their lives and the shield became much smaller so as to be more maneuverable on horse back.

Shields were usually made from the neck or hump hide of a battle scarred buffalo bull. The skin in the neck area is very thick as well as the skin on the hump, however this thick skin on the hump area runs in a very narrow line only thirty to forty centimeters wide. It then becomes quite thin for about the same amount on both sides of the hump at which time it goes to a normal thickness of skin down and around the animals' belly. The skin along the hind legs and across the tail is the most uniform thickness area of all on a buffalo with a band that runs approximately forty to fifty centimeters wide across the entire back end. Some shields were made from this area due to that uniformity and the Cheyenne Red Shield Society very specifically made their shields from this area and left the tail attached to the hide which then hung down at the bottom of their red painted shields.

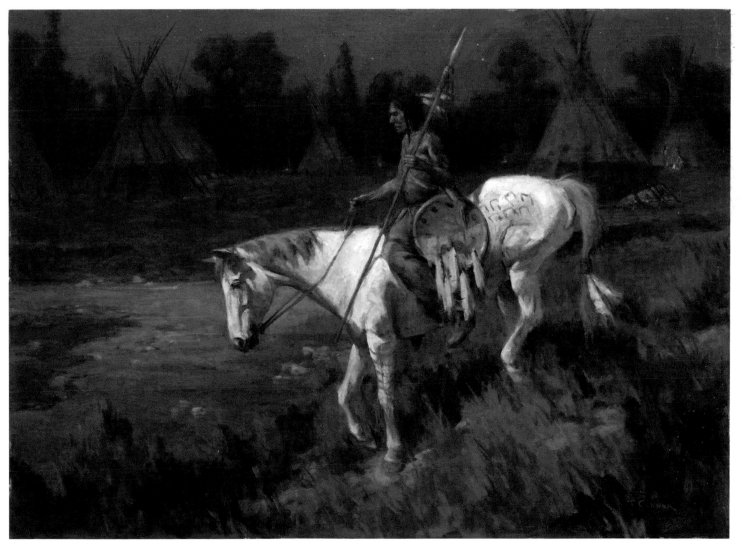

"Returning to Camp" painting by Todd Conner

 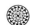

# Bows and Arrows

"We did not say 'arrow feather', but 'arrow wing' in speaking of the feathers of an arrow." — Wolf Chief

The bow and arrow, in the hands of any person who grew up using it, first as a toy and then as a tool, can be a rapid-firing and deadly weapon. Most all Indian boys were given their first bows at the age five or six, and from that point on it became an integral part of their life. After many years of practice, through hunting and war, any man could deftly use his bow in almost any position or situation.

Most men knew how to make their own arrows, but often this was an older man's specialty work. They would trade their handiwork to the younger men in exchange for meat. Arrow points could be made from numerous types of stone, with flint, chert and obsidian being the most common. Points were also made from buffalo and sheep horn, elk antler, beaver teeth, sinew, wood and metal. The metal points were a popular trade item, and many were manufactured specifically for the Indian market. Metal points are far superior to any stone or bone points. Stone points are fragile and break almost every time you use them. A Hidatsa told Gilbert Wilson about using stone points and how fragile they could be:

*In my time, we used iron heads. But when my father was young they still used flint heads. Flint arrows were put into the quiver, feathers down, with the heads sticking up out of the quiver. This was done because the flint points, rattling against one another, were apt to break off. As a protection, a bit of buffalo wool, from the buffalo's head was twisted about each arrow head. When the arrow was withdrawn from the quiver the tuft of hair was jerked off.*

The neck sinews used to make points were from connections at the back of the skull to along the spine. The Hidatsa called it it-su-ta, or 'big sinew.' Points made from it when dried were yellowish and very hard. The use of these points was dieing out by the last quarter of the 19th century. Wolf Chief said, "I never saw any of these arrow heads and do not know what shape they were."

He also told about other points, too:

*I was once told by some very old people that beaver teeth made good arrow points; I never saw such points myself.*

*I never heard of my people making arrow points from the shoulder blade of a buffalo. But I have heard that in old times arrow heads were sometimes made from the heavy ribs of a buffalo, and that a sharp fragment of such a rib made a good kind of a head.*

When making arrow heads from buffalo horns, he added:

*Only the points of the horns were used; they were cut off and split into pieces, each piece enough to make one arrow point. As I watched Seven Hands working, I remember, he used a kind of saw made of a knife with teeth on the edge and rough; but I do not remember how he split the pieces. Maybe in old time they used flint to saw off the points but this I do not know for certain.*

*Another thing I remember; as Seven Hands worked and had the arrow point done he would dip it in the warm grease and hold it over the fire and if the arrow head was not perfectly straight he would then straighten it and when it became cool it would not bend back into its original shape; it would just stay straight as he had bent it.*

*Arrow points were also made from elk horn and I have heard they were also made from the horns of Rocky Mountains sheep; but I never saw such points of either material, myself.*

*In my father's earth lodge was a stone sunk level with the floor, which Small-ankle used for an anvil. It stood near the fireplace and between it and the rear most of the posts from which swung the drying pole over the fire. I think every lodge in the village had such an anvil.*

*Upon his stone anvil my father pounded bits of metal he wished to straighten. Especially he used it for making iron arrow heads. He heated the iron in the fire red hot, laid it on the stone and cut out arrow heads with chisel and hammer. Small-ankle got his iron and chisels of the traders, and also a little pair of tongs which he used to pick up the hot iron.*

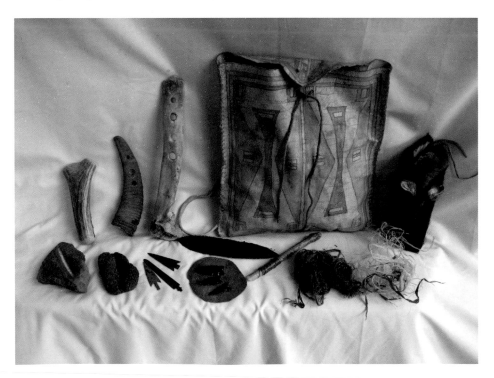

A CHEYENNE ARROW MAKER'S KIT, CONSISTED OF, FROM LEFT TO RIGHT, UPPER ROW: ANTLER TOOL FOR KNAPPING STONE, A BIGHORN SHEEP EWE'S HORN AND A BUFFALO DORSAL RIB BONE, BOTH USED AS ARROW STRAIGHTENERS, A PAINTED RAWHIDE CONTAINER AND A BUFFALO DEW CLAW BRACER, OR WRIST PROTECTOR, FOR SHOOTING AND/OR FOR USE AS A HAND PROTECTOR WHEN WORKING STONE. BOTTOM ROW: TWO PUMICE STONE ARROW SANDERS, THREE METAL TRADE POINTS AND THREE STONE POINTS RESTING ON A PAD OF 'SAND PAPER' MADE FROM FINELY GROUND FLINT MIXED WITH GLUE AND STUCK TO A PIECE OF HIDE, A STONE FOUR SIDED SKINNING KNIFE, A GLUE STICK, SHREDDED INNER COTTONWOOD BARK FOR FIRE ARROWS, AND BUFFALO BACK STRAP SINEW FOR ATTACHING HEADS AND FLETCHINGS.

"The Gamblers" painting by John Fawcett. "…men often used their valuable arrows to gamble with, a favored pastime of all Indian people regardless of age or sex"

*His hammer was made of an elk horn. Elk shed their horns every year, and their antlers were easily obtained. The pounding surface of a fresh elk horn was quite hard.*

*Metal points for arrows made an early appearance and over time many tens of thousands were made and traded. Metal arrows along with other metal items were seen among the Blackfoot, Cree and Assiniboine at early dates. (The Plains Cree, Travels in the Interior of America in the Years 1809–1811.)*

Ten years later and further east, S. H. Long remarked that arrows averaged twenty-four inches and had sheet iron points. (S. H. Long, *Expedition*, 1819) Mrs.. Carrington, at Fort Phil Kearney, agreed that arrows were twenty-five inches long, with iron points two inches to three-and-a-half inches long, and that they usually were not barbed. Traders were cutting heads from iron hoops or rolled iron.

between 1680 and 1700 from killed Assiniboine, who no doubt had obtained them from the French or British.

In 1728, the Piegan received their first European weapons from the Cree, that consisted of several guns, a little ammunition, iron tipped lances and arrows, some knives, and an axe. Although some of these references were made by people who had early contact with tribes a bit further east than the Plains, they are still representative of what was coming to the Plains very shortly.

Also, at such an early date as 1700, when Le Sueur went up the Mississippi River and saw many Canadian traders, there were not many Indian people living far out on the Plains anyway. They would arrive to the west along with the guns and horses, both of which allowed them to survive on the Plains. According to Le Sueur, the Sioux already had a good supply of guns and were given fifty pounds of powder, fifty pounds of bullets, six guns, ten hatchets, and one steel calumet on his visit to them.

Jonathan Carver, on the upper Mississippi in the 1760s, noted some firearms among those tribes ( Jonathan Carver, *Travels through the Interior Parts of North America*) and Regis Loisel (*Little Beaver or the Good Whiteman*) brought a large supply of firearms to the Tetons in 1790. The years between 1799 and 1802 is when many firearms arrived in large numbers to the Plains. George Drouillard, between the years 1807and1810, reported seeing Omaha Indians with firearms, spears, cutlass and bows, and steel or iron pointed arrows. (George Drouillard, of the Lewis and Clark Expedition and a fur trader, 1807-1810)

The guns averaged over the decades at around eight to ten buffalo robes per firearm and were considered a bargain at that price to most Plains men, because they could not begin to understand how they were made. By the time Plenty Coups, the Crow, was going to war, breech-loading, repeating rifles were still holding firm at around ten good buffalo robes per gun. He also noted that he put his bow away after he got his first breech loader, but many older men did not. The bow was still considered an essential weapon to have in war, as it allowed you a wider variety of shots to be made than could be done with a firearm alone. Colonel Dodge remarked that "the Indian was always found completely armed with the latest breech loaders."

Guns could be ornamented and/or with war honor markings and achievements added to them, just like most any other piece of a warrior's equipment. Many people commented on, painted and sketched Indian guns studded with brass tacks and decorated with bits of red wool ornamenting their ramrod ferrules. Many men carried an extra ramrod as well in their hands. War honors could be displayed on them, too: an enemy killed could be represented by a scalp tied to their gun, or white clay painted stripes for each kill.

## Notes on Guns
### Abasaroka, *Home of the Crows:*
- Revolver very common
- Inner bark of red willow used as a gun wadding on top of powder and ball.
- Buckled revolver belt around head when crossing river

### Beldon:
- saw many rifle scabbards among Sioux
- Out of 160 muzzle loaders captured from Sioux & Cheyenne in 1877, 94 were percussion Leman rifles, 6 Hawken, 3 Golcher, 14 U.S. muskets, 4 Enfields
- U.S. 45 Colt with 7 ½ barrel in 1873, U.S. stamped on left side of frames
- Indian grip repair- brass clock face

### Dodge:
- Short loop of rawhide attached to pommel, passes over his head and under his arm when throws himself to pony side with leg over cantle
- Uses only right side thusly, but used both sides when using pistol

### Maximilian:
- Trade horses and horn bows for knives, tobacco, etc.
- Shoshoni and Flatheads just beginning to trade guns with Er-erokas, (Crows)
- Poles near tipis stuck in ground to suspend utensils from
- Some tripods with bow-arrow, quiver, shields, spears, war clubs
- Dog and horse harness hung up on poles
- Twist leather gun case around head like turban when going into battle

### Tableau:
- Guns for war only

### Sweet Medicine:
- Limpy was wounded, but he recovered in time to ride against Custer's men. White Wolf's thigh was broken by an accidental discharge from his own repeating rifle. He, too, recovered. Next day, the tribes continued moving up the valley of the Little Big Horn. Here trouble struck again. This time Coffee was killed by his own rifle as he dismounted from his horse near the sacred tipi.

### Two Leggings:
- I made a powder horn by boiling out the core of a fresh buffalo horn, carving a driftwood plug to fit the large end which I fastened with hardwood pegs. I also made a buckskin bullet bag and hung both on a strap over my shoulder.
- Few lances among Blackfoot
- Many clubs taken from Flatheads

### J. Carter:
- Cheyenne used a stone club on a rope, 5-6 feet long, tied above the elbow

# Chapter 16
# Fire and Smoking

Fire was used in a variety of ways beyond cooking and keeping warm. It was put to good use in warfare, both for defense and offense. When being pursued by any enemies, it was desirable to turn and run into the wind if at all possible. Then fires could be lit behind you, which would burn into your enemy's faces, slowing their pursuit and blocking their view. Red Crow recalled using smoke screens to obscure movements.

It could be used to burn your enemies out of a position, too, when they were held up, and could flush them out into the open. If possible, to make the fire burn hotter and catch faster, dried grass would be rolled in grease or fat first and then fired. (Thomas H. LeForge, *Memoirs of a White Crow*) Or dried grasses could be twisted into thick ropes in advance and bundled on warrior's belts, when knowing in advance that burning and destruction of a village or non-Indian structure was the plan. S. H. Long mentioned seeing a group of Omahaw that intended to destroy the Otoe nation and carried such bundles to the Otoe village, and many lodges were burned as a result of their raid. He also wrote that large bodies of timber were destroyed by Indians firing the prairies (S. H. Long, *Expedition*)

Dodge also recorded how a group of Lakota drove off game ahead of an approaching party and then burnt the prairie behind them (Dodge, *Plains of the Great West...*)

Once, a group of Crows had cornered some Blackfeet into a small cave on the face of a cliff. They could not get to them, but they were able to locate a vent hole that went from the surface above the cave into the rear of it. So they proceeded to light bundles of green sage brush and throw it into the hole, trying to smoke them out. The Blackfeet were able to get to the edge of the face and the cave opening without being shot, however one of the Crows figured out how to still count a first coup on one of them. He took his long buffalo rawhide lariat and tossed the end down over the edge and was able to hit one of them with his rope. This counted as a first coup, as he was able to touch an enemy with something held in his hand.

Fire was used to control the buffalo and elk herds by keeping them in your range and away from your enemies' country, as well as frightening the game, for various reasons all utilized fire.

If large lakes or rivers were near dry prairies, it was a common tactic to fire the grasses and force the animals out onto either the ice or directly into water, where they could be easily killed. It was a common practice to fire the prairies in the early spring, to bring on new grasses and encourage the herds to either stay in your area or to attract them. This was also done in the late summer or early fall, when the plains are very dry. Once the game was safely behind the winds in your territory and it was blowing strongly towards your enemy's land, dried grasses would be set on fire to burn a wide belt. This would keep all the game within your lands and put stress on the enemy tribes, something they always were wanting to do. (Beldon, *The White Chief*) Any of these fires could be started in a variety of ways, from the primitive bow drill to flint and steel or magnifying glasses.

Other methods to make fire included kits carried specifically for the purpose that could be a piece of buff hide one foot square or so, with dry stuff and ashes. With a flint and steel, sparks were struck onto the material. This could be rolled up to carry and keep dry and ready for reuse. (Maximilian, *Travels in North America 1822-1824*)

In *Warpath*, White Bull said that when crossing rivers they were always careful to tie on top of their heads their moccasins, leggings and fire-making equipment. His own fire kit consisted of a small dry rag, black powder and a percussion cap laid in to the small rag, then this was twisted into a tight ball, and to light, was hit with the hilt of his knife, causing the rag to smolder and ignite. He would pre-make several of these and carry them in a pouch.

Instead of lighting fires to cook with on the trail, the people often lit a bunch of grass. They wrapped a piece of meat around the blazing grass, doing this until the meat was cooked. They were moving fast, and this was the quickest way to prepare food. (Sweet Medicine)

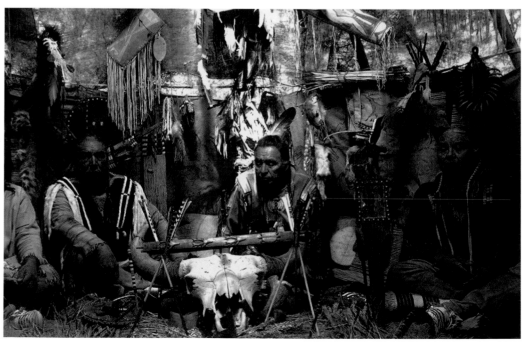

A Nakoda holy man fills a pipe

# Chapter 17
# Body Painting

In the old days, people commonly painted themselves and each other for a variety of reasons, not just as "war paint." Very early, people like Coronado noticed that Indian bodies and faces were generally all painted. Many years later though, Colonel Dodge thought that no taste or skills were used when applying paint, he saw that all ages and both sexes must have some paint on or not feel properly attired.

The earliest direct evidence for Plains body painting is the Segesser hides in the Governor's Palace at Santa Fe, done about 1726. They depict a huge Pawnee war party that attacked the Villasur Expedition in 1720. All of the Pawnee warriors are completely naked and either painted or tattooed. Also, the hides show the earliest evidence for lots of other types of material culture: Pawnee high-cuffed black moccasins, eagle feather headdresses, otter-wrapped lances, painted shields, walking shields, leather body armor, horse armor, etc. The basic reference is Gottfried Hotz, *Indian Skin Paintings from the American Southwest* (Norman, 1970) and a couple of newer editions in color. If you haven't seen the actual hides, they are worth a trip to Santa Fe.

Paints could be made from indigenous or traded pigments with many Native people preferring the newer and bolder colors available through trade. Alexander Henry, the trader, named ten colors used by the Blackfeet early in the 19th century. They were: dark red, Spanish brown, pale red vermillion, deep yellow, light yellow, dark blue, sky blue, green, white, charcoal, and a shiny glossy lead color. Maximilian also mentions the glossy lead color, while noting a warrior he saw who had a red face and forehead, and a stripe down his nose, and chin painted blue with a shiny earth from the mountains that was a clay with peroxide and iron particles in it.

By the 1860s, the St. Louis Company was making paints for Indians in a variety of colors, such as vermillion, yellow, chrome-green, indigo, lamp black and ink, made in small packages. (Beldon, *The White Chief*) Painting one's body or face could be anything from a very sacred act to a whimsical flirtation, depending on the paint design and circumstances under which it was applied.

## Religious Ceremonies

The main reasons paint was worn were: religious ceremonies, spiritual and physical protection, camouflage, war honors, society markings, and vanity. The most important body painting was for religious ceremonies. These designs were owned by the tribe as a whole and could only be used in specific ceremonies and applied and removed only by holy people granted that right. Sacred designs or things seen in visions could be interpreted by a holy person, and in doing so tell the dreamer what paint designs he must use based on the holy person's interpretation of the vision. Or, a sacred design could be custom tailored and made on the spot.

When the Crow Two Leggings received his designs from Sees The Living Bull, the elder asked him:

> ...if I wanted a red circle on my face or a had a circle painted over my forehead with the ends reaching from jawbone to jawbone. He also asked if I wanted my eyelids and lips painted red. When I narrowed my eyes the red lids would mean lightning, the power to see the enemy before they saw me. The red lips meant that my medicine songs would be more powerful. I wanted the red circle for the sun and also the red eyelids and red lips.
>
> For the rock medicine I was to paint my mouth red and for the tobacco medicine I must paint a red circle on my face. The streak over my eyes meant I could always see the enemy; the red over my mouth, good

luck and plenty to eat. The red circle on my face was the red clouds. If I saw a ring around the sun or moon or stars I should paint myself like that because it represented all three. The paint had been given to him by the star which always stands close to the moon. After I had my medicine, he said, I would never fear bad dreams. I could go my way and bring back horses and give him his share.

> After showing me a blackbird, a redheaded woodpecker, and a sparrow, he asked which I wanted on top of my medicine. I chose the blackbird sine these birds are usually found with horses. A man with their medicine always takes the lead on a horse raid. (Two Leggings)

As some examples of how people could use paint in a purely cosmetic way or as a sun screen, Waheenee tells us:

> Just before I got into my boat I had paused to wash my sweaty face in the river, and, with a little ochre and buffalo fat, I painted my cheeks a bright red. I thought this made me look handsome; and, too, the paint kept my face from being tanned by the sun, for I had a light skin. In those days everybody painted, and came to feasts with handsome faces, red or yellow.

## Protective Coating

Paint could be used as a protective coating against the ever-present wind and sun.

> The old women painted their entire faces. I think grease was first smeared over the face and then vermillion paint was put on. Young women merely painted their cheeks. The paint served two purposes—to improve their looks and to guard against sunburn.
>
> Women among the northern bands tattooed their chins in strips which ran from the corners of the mouth downward with two or three vertical stripes in between and below the lips. A few of the women tattooed dots on their foreheads. These were from one-eighth to one-quarter of an inch in diameter and were done by men skilled at tattooing. The large quills from the tails of the porcupines were used to prick the skin, and then charcoal was rubbed into the spot. When healed over, the spots were a dark, bluish color.
>
> When they were going to be out for considerable exposure in the weather, men painted their faces and hands to the wrists with vermillion paint. When at home they did not always paint themselves. (*Land of the Nakoda*, p. 102)

Henry Boller, who lived and worked among the Hidatsa and Mandan at Fishhook village in 1858 and traded with the Hunkpapa Lakota and Crow and other tribes during the years 1858-1866, wrote that the young and pretty women painted their cheeks with vermillion and yellow clay and vied for attention of the men; the older ones, he said, had dirty greasy dresses and stayed in the rear of crowds with the dogs and children. In emergencies, soot mixed with grease or even one's own urine was put on their cheeks to help protect from frostbite and cold.

Some paints had more or less universal meanings among all the different Plains tribes. Black is normally associated with victory or revenge, though according to Henry Boller the Gros Ventre paint their faces black when going to war and not like most tribes that used that afterwards. The Mandan often painted

their whole bodies black for victory and many tribes commonly spotted, striped or painted their entire clothing and robes with black as a sign of victory.

One way the Cheyenne made their black victory paint was by taking burnt willow branches or rye grass tied in bunches and burned, then the ashes were mixed with buffalo blood in a kettle and heated until it became black.

After a victory, the Cheyenne would then sometimes take this black blood paint and make vertical lines upon a robe and between those lines the tracks of wolves, foxes and rabbits were painted. The men then would take and cut the robe square and sew a border of wolf fur around the edges. Only men who had participated in such a rite previously were allowed to do the paintings on the robe. (Grinnell, *The Cheyenne*) Paint in the form of white clay could also be used as a sign of mourning and smeared onto clothing, hair and skin as camouflage or protection from the sun.

A CHEYENNE VICTORY ROBE. A BUFFALO ROBE WAS SQUARED OFF AND TRIMMED WITH WOLF FUR, AS DESCRIBED BY GRINNELL

## Notes on Paints and Painting
-A yellow dye made from lemon colored moss from the Rocky Mountains, which grows on fir trees, was called "wolf moss."

Beldon:
-Paint on robes seared in with hot iron
-Men paint part of their hair red
-Black with zigzag means leave alone
-Zigzag paint also means in love, melancholy
-Men and women both paint the hair part red
-Victory Paint equals red on each temple then arcs towards the eye
-Red stripe between eyes equals seen a girl he would like to love
-Men paint eyes yellow & blue, when courting they paint them red
-Sioux council have paint they use on themselves when about to pass death sentence.
-When men parade about and display they do so for two reasons: excite admiration of women and intimidate the other men. (*Travels in the Interior of America in the Years 1809 – 1811*)
-Saw war party, all with shields approximately 30" and faces painted with black and white stripes
-Drank blood of enemy, designated by a red handprint over the mouth

J. Carter:
-Chiefs tattoo, Chippewa, pricked from mouth to ear signifies chiefs need to both listen and speak to each other, essential if tribe is to survive

-Blue and black painted horse tracks means horses given away
-Red and yellow painted horse tracks means captured horses

Long, *Expedition*:
-Vermillion River, the old term was the Whitestone River tattoo artists tattoo people for a fee

Plenty Coups:
-Could not paint wife's face if not counted coup

C. McKenzie:
-Saw twelve men with heads in blown-up buffalo bladders, their bodies' were bare and painted half way with vermillion and half with white earth, emblem of punishment and pardon
-Used the bit of a Spanish bridle to burn design into chest

John C. Ewers, *Plains Indian Painting*:
-Lewis and Clark recorded items with green earth paint
-Cheyenne used vegetable coloring from brown gum covered cottonwood buds
-As early as 1877 reservation Indians made buffalo robe "pictorial forgeries" to sell or trade
-Only seven per cent of painted buffalo robes examined portrayed buffalo on them
-Coronado in northern Mexico saw buffalo and painted buffalo robes Aug. 3, 1540
-Articles brought back by Lewis and Clark contained commercial dyes

*Tableau, Narrative:*
-Faces white, blue, black and vermillion, Sioux

*Warpath:*
- War paint, black all over with white sun on forehead and star on right cheek
- Leather (rawhide) template cut-out used for star pattern

Paul Wilhelm, Duke of Württemberg:
- Saw tattooed Pawnees with light skin with black dots in designs from head to foot
- Painted figure on robes black, red, green, and yellow
- $6 - $10 paid for one porcupine quill decorated buffalo robe
- Many bright colors gotten from the whites and their goods for dyes
- Face painted red and in finest clothes at death but without weapons

Maximilian:
- Spat on hand with vermillion, rubbed face then lines with stick
- Blackfeet- no tattooing
- Blackfeet- some without pierced ears
- Blackfeet do not paint body
- Blackfeet paint has a shiny appearance
- Red around eyes, yellow face
- Women and children face red only
- Vermillion cost $10 a pound (or one to three buffalo robes)
- Yellow hand denotes prisoners taken (Mandan)
- Red dye from roots of Davoyenne or buffalo berries, blue and green from European substances

Hennepin:
- sweet flag (muskrat food) fever, toothache, colic chewed or smoked, Warriors chewed to a paste then spread on face to prevent fear and excitement in battle [included here because when used in the context of a protective coating/agent in battle, is the same as how paints could be used for the same purpose]

Body Painting     199

*They devise the method also of punishing the refractory-may inflict beatings or even the death penalty. Their decisions are proclaimed by a crier; for instance, suppose that buffaloes are discovered in the vicinity; now, if one individual hunter should set out after them, he would drive them away before the other huntsmen arrived, and so lessen their chances for means of livelihood.*

*Consequently, individual Indians are not permitted to go on the chase from a settlement or camp except in pursuit of animals found singly-never in pursuit of a herd. As soon as the news of approaching wild beasts is received, the soldiers assemble at once for deliberation as to the time and the manner that most of the soldiers are on the war path.*

George Bent agreed that the societies had great power among the Cheyenne, and noted the society police were very strict and punished anyone who broke rules or disobeyed orders, sometimes in a very arbitrary manner. Soldiers would quirt anyone who did not obey marching orders. The chiefs from friendlies "soldiered" warriors that took off on raiding parties on their own without permission by ordering their tipis cut up and shooting their horses and dogs. These sometimes impetuous young warriors did not always obey nor respect their elders and leaders. As hard as it is to believe, it is a well known fact that in 1837, forty two Cheyenne Bowstring Warriors ( Wolf Warriors) tried to force the Holy Man and Medicine Arrow Keeper, White Thunder, to open the bundle for its blessing on their war party against the Kiowa before the proper time to renew the Medicine Arrows. White Thunder refused so they fiercely beat him with their quirts until he gave in. They left on their war party feeling they had received the needed blessings, only to be killed to the last man by the Kiowa. Instant Karma.

## Notes on War Parties

### Colonel Dodge:
-Sioux most petted by Indian Bureau
-Chief exerts perfect control over war party
-Sioux most treacherous, meanest and cowardly
-Plains Indian contemptuous of Mountain Indians when on the Plains and fear them when in the mountains
-Indians riding double deposited warrior on rear next to enemy in charge by
-Money or wealth is equally desirable among Indian as white man
-Indian weakness is his trail

### Father DeSmet:
-Before war party Rees and Hidatsa fast for four days to induce delirium
-Warriors wait until rival warriors have left a village for hunt then attack village killing children, women, and old men and carry off any prisoners.
-Roll in blood of the dead
-Devour members of people still alive

### S. H. Long, *Expedition:*
-War party leader wears medicine bundle suspended on back or shoulders by belt around his neck
-Bundle cylindrical twelve inches long neatly wrapped with bark and tied with strips of bark
-Medicine bundle not allowed to touch ground
-If war parties split up they leave small painted sticks in the ground showing direction they took
-Successful war party stops in site of village when returning and sit and smoke

-Killed enemies made fun of if they begged for mercy or shrank from blows
-Omahaw peace envoy to Pawnee was beaten, hair cut off, pipe broken forced to drink urine and bison gall then driven away
-Two Ponca chiefs attempted peace with Omahaws both were shot
-Chief shot gun into footprints of enemy horse thieves to cripple
-Otoe and Konza never sit on ground during the day while on a war party
-Hidatsa chief One Eye snuck into enemy lodge at night found young squaw forced her at knife point to have sex then killed her and scalped her
-Revenge very strong desire
-Some approached dead and wounded enemies to count coup with no weapons, only shield
-Some fought entirely naked
-Man wounded painfully in knee killed himself with knife to heart
-Partially clothed war party clothed themselves with an untanned fresh killed buffalo hides in an emergency

### Plenty Coups:
-All Crow warrior had eaten a small part of the heart of a grizzly. In times of danger said to him self, "I have the heart of a grizzly"
-Cut heart of enemy into small pieces and ate it to make them brave (*The Recollection of Philander Prescott*, p. 74)
-Eagle breath feathers used on war regalia as a protection against bullets and arrows etc.
- Nothing can strike an Eagle breath feather because it is light as air
-"The complete destruction of our old enemies would please us."
- Dressed up and painted for war when time allowed
- rising, he gave the war cry drumming his mouth with his open hand, "Whooooooo"
-war whoop- shrill cry- render tremendous by repeatedly & suddenly striking mouth with hand

### Maximilian said too:
-"Good and bad luck always mixed themselves on these raids"
-Did bad shooting because his horse was afraid of his gun
-"Each held tightly to horse's rope knowing to be set afoot now meant certain death"
-Bull roarer used by Crows to scare horses, flat stick attached to a string and swung by holding end of the string
-Crow accidentally shot his horse while drawing rifle from its scabbard (it was a relatively common accident to shoot ones horse in battle or when deploying ones weapons.)
-Found a stack of coup sticks with the feathered ends up meant Sioux believed themselves to be victorious

### Zeb M. Pike:
-Sioux most warlike of all tribes, every passion subservient to war
-War of extermination between Sioux and Chippewa for two hundred years (*The Expedition of Zeb M. Pike 1805–1807*, p. 636. v.1)

### Maximilian:
-War Lodge- "Round the trunk of an old tree the Indians had built a conical hut with pieces of wood; but in the whole voyage from Fort Union to Fort McKenzie, such huts were the only signs of human beings, and we did not see a single Indian."

### Red Crow:
-Before and after starting on war party young men would not eat meat of the lower rib or shank or corresponding parts of their own

bodies would be wounded and bring ill luck to the group.

-Smoking not indulged in because induces thirst and cuts wind

-Each member took own medicine outfit war bonnets, shields, cross belts, fancy clothing on backs

-Took ten to fifteen pairs of moccasins

-Everyone dressed if time and Plenty Coups said too

-Morning favorite to attack camp

-Night favorite for horse raid

-Under no obligation to share captured horses even if others had to walk

Tabeau:

-Indians never enjoy complete security

-Will not attack without surprise

-Leaders must not loose men in war party

-Conquer without risks best

-War chiefs who have gained great victories are listened to less than he who has never lost a man

-Out of twenty war expeditions, fifteen given up

-Traders tried to promote peace, good for business

Stanley Vestal, *Warpath:*

-Rock means patron God of War

-Warrior groaned like bear when wounded to show strong heart

-Melee or skirmish called "Stirring Gravy" battle

Pretty Shield

-"My heart tried to Smother me" means scared

-"Picked up lots of head feathers," means counted many coup in that battle (*White Bull*)

The Plains Cree:

-Enemies receded like the rainbow, means stayed at distance no matter how far advanced

When Buffalo Ran:

-Many straight poles used for war lodge covered with brush then bark.

-Brush and bark put under their beds to keep snow off. Fire in the middle, feet always toward fire in war lodge

-Wolves are the smartest animal

-Wore wolf fur in hair and carried wolf bow case and quiver

-Almost cried when mother and girl friend were singing glad song on his return from war.

-Old men talked of old treaties made as well as war stories

-When scared his bones did not seem stiff enough to support his body

-Seemed to have three heads looked in so many different directions

Iowa Pipe Carriers:

-Tried to raise and complete four successful war parties in succession

-That was considered the greatest achievement

-When successful party returned two foot circumference white oak cut down, peeled, sharpened and set in ground.

-Pole painted red with recent war exploits done in charcoal

-Scalp dance done around the stake

-Leaders ambition to have one such pole at each four cardinal points

-Kept grass clear from them

-Two men could not eat of the same enemies heart lest it breed enmity between them

-Swallowed live turtles so as to be brave

The Bureau of American Ethnology reports:

-Large war parties may have four to seven leaders with pipes

-To be a chief man must have been pipe carrier, and then kill an enemy while not a pipe carrier. If he follows another leader twice, must discover enemy first killed and then poses white buffalo hide at some point

-Some performed all feats, but were not chiefs

-All scalps and horses belong to pipe carrier

Maximilian:

-Sioux, those killed in battle buried on the spot

-Daubed with white clay for mourning

-Horns on skull piles often marked with red stripes to signify number of war party

-500 settlers killed during the 1862 Sioux uprising

-In the Buffalo Dance (po quen) any of the societies might join. It was a sort of war dance and they performed it only before setting out on an expedition. War-bonnets were worn, and the participants carried shields, spears, and arrows. They would recite their martial exploits.

-Of greater comparative interest is the gwuda ke, War Singing. The night before starting on a war expedition the whole company of warriors assembled and any woman might join, but men only if they intended to go along. They got a big buffalo rawhide, then all participants took hold of it, and beat it with sticks, at the same time singing a war song and marching through the entire camp. After they had passed through camp, they halted to smoke, and then continued the parade, possibly until daylight. My informant stated that this performance was shared by the Comanche. As a matter of fact I recorded it among this people, as well as in other tribes. ( J. O. Dorsey and Fletcher and La Flesche record this dance among the Omaha, p. 911)

## Notes on Societies
### George Bent:

-Jan. 1875, Dog Soldiers came in to surrender

-Ice or White Bull, famous Northern Cheyenne Medicine Man, expelled from Crazy Dog Society because his uncle fired at another Cheyenne in a quarrel about a dog. Man not wounded

-Woksihitaneo + Kit Fox Men leader carried club with skin of kit fox hanging on the handle.

-Bowstrings- Himatanohis- leader carried bow lance, also called Wolf Warriors, very headstrong, wiped out by Crows 1819,

-Dog Soldier men brought wives to their camp, instead of going to wives band to live.

-Sash worn over right shoulder and under the left arm and was never beaded

-Rope (no retreat sash) wearing tribes were Arapaho, Blackfoot, Cheyenne, Crow, Hidatsa, Mandan, Kiowa

-Brule and Oglala great Sioux allies of Dog Men live on Republican and Smokey Hill Rivers

-Spotted Tail shot and killed by Big Mouth during a quarrel in 1869 after several months feud

-Then Spotted Tail killed in quarrel (1881) by Crow Dog

-Kiowas wore "dog rope" with porcupine quills only also

-All members had crooked lances, danced round and round with crooked lance

-Soldiers Societies held Shield Dance at night, huge fire in center of camp, danced around

-Societies punish hunting offenders – strike them senseless, cut up his tipi, break poles
-Murderers can be killed by Akicita
-In early white contact Akicita would kill people who had unauthorized contact with whites for fear that bacon, coffee and other foreign smells would scare buffalo
-Would still allow white traders, but no foods with odd smells
-Two black stripes put on face (and war bonnet on head) of head akicita by four chiefs
-Soldier lodge as head tipi is Tiyotipi
-Tokala is kit fox
-Ka Gi Yuha – crow owners, C'a Te Ti Za – Braves, Ihoka – badgers, Sotka Yuha – bare lance owners, Wiciska- white marked, Ihoka & Kangi Yuha (badgers & crow owners) most chosen for police duty during camp movement
-More honorable to be blotaunka than akicita officer
-Akicita main functions- control the hunt. When herd sited Akicita head men called in by chiefs and told to appoint their assistant
-Tokala (Kit Fox) men were supposed to be active and wily on warpath like kit fox
-Kit fox has great skill at finding things, even buried marrow bones, hence members regarded themselves as kit fox and their enemies as marrow bones.
-Kit fox leader takes filled pipe (not with stem) when he makes a charge- if successful in killing an enemy they connect stem and smoke
-When lance bearers (no retreat emblem) received lance they had to immediately leave for warpath to prove themselves
-Song "I am a Tokala: I am living in Uncertainty"
-Relatives of Tokala officer candidates give out presents to poor, but not to members or relatives of members
-Two beaded and two plain lances each with two Eagle feathers and a piece of kit fox skin tied on in two separate bunches- tied in the middle with crow, magpie or prairie chicken with a long one of Eagle down, iron tip, otter wrapped usually
-Two head bluthunka given wolf or coyote skin wrapped crooked lances with strips of pairs of skin in four different places
- Bluthunka lance wound with strips of wolf fur ending in crow feathers. -On the end are owl feathers.
-Reason for these wrappings and appendages; wolf knows everything about hunting and war; crow can find even dead things no matter where they are hidden; and owl can see, travel and hunt in the dark.
-To own one of these lances is considered a greater honor than to be lance bearer in the akicita societies, making them in fact the lances par excellence. The lances must be made by a man who has dreamed of a wolf.
-"Ho Ye" when accepting pipe
-Palani Ta C'anli is Pawnee tobacco
-When victorious, war party returned pipe seal broken and smoked. If emptied men symbolically smoked it then on to victory dance
-Heart sac cup for boy helpers- forked stick 5' long with crow feathers on the end
-Water pouch boys lance is Minieya Wahokeza
-Tate – the wind Yata and I Ya, the North and East wind
-If woman divorced husband, man saw to it that she was taken care of until she remarried
-If fellow tokala was wifeless and member had several wives, he would give one to him
-Society regalia is Ca Wowa Ye
-Earth square (alter) is Kolapapi

-Whips are Icasape
-The Crow Owners are Ka Gi Yoha – they that have the Crow
-Two members with short crow feathers lances with sashes no retreat obligations
-If candidate refuses, relatives give him presents; if still refuses, crowd ridicules and sings derision song about him until he gives in.
-Lances short with otter fur, one Eagle feather and owl on one end, spear on other, neck and head of crow fastened near spear
-Lay members' pieces of skunk skin tied at elbows and ankles, crow skin around neck, Eagle tail in hair over forehead, three to four in back
-Red painted stick in hair, notched for each wound
-Shot with arrow, feather split and painted red
-The Braves are Ca Te Ti Za (the Dauntless)
-Two war bonnet braves with sashes and picket pin
-Bonnet buckskin cap with split buff horns beaded brow band and yellow quill wrapped rawhide down back 12" wide
-Calamus root chewed to induce bravery
-When going to war, two black diagonal marks across face
-Hands of enemies on sticks
-At center of dance area, pole is placed with transverse stripes
-Black victory paint sometimes was blue and came from a stone found on Niobrara River
-Special society lances are Wapaho
-Regular lances for weapons are Wakakeza
-Though societies per se didn't go to war together if a member joined a war party he was still expected to wear regalia and follow rules
-No flight is Naprd'ni

Maximilian:
-Owl feathers dyed yellow with red tips–emblem of Mandan dog society
-Soldiers society wore whistle of crane wing bone
-Buffalo dance headdress, eyes and nose surrounded by iron or tin ring
-Mandan black tailed deer society wore garland of grizzly claws around their head
-Bow lance worth 100 to 250 florins or one horse
-Child's dart made from elk horn tip with feathers on hollowed out end
-Crooked society staffs represent the sunflower
-Straight, fur-wrapped society lances represent the corn stalk

Le Verendryer:
-During a dog feast, society warrior passed around a fine robe for everyone to wipe their greasy hands on to show his disdain for materialism
-Most chiefs or warriors of note had adopted orphans or poor children
-Warrior societies utilized old men as criers and servers of food, giving them a function and purpose in life.

# Chapter 19
## Prices Of Trade Goods

Approaching Fort Union

The prices of trade goods varied greatly, and like many businesses depended on supply and demand, weather conditions, quantity and quality of goods ordered that were actually delivered, and even inter-tribal wars and competition between the various companies. Many of the prices stayed fairly constant over a long period of time, and many people could easily tell you how much a gun, ten metal arrowheads, kettles, vermillion, etc, all cost in buffalo robes.

One of the main factors in the price of trade goods was the extremely high transportation costs associated with getting goods from all over the world to the Plains tribes.

When looking at the values and prices of these trade goods, it is important to remember that the prices quoted are 18th and 19th century prices. One must convert these to modern dollars to actually make any sense of them, and to put them into their proper perspective. Something quoted as being worth $10 in the early 1800s would actually mean many hundreds, if put into today's economy.

The French and English were the first to engage in heavy trade with the Plains and Prairie tribes, and some trade with the Spanish as well, but that was mainly through other Indian tribes acting as middle-men for the Spanish. In 1700, LeSueur, heading up the Missouri River, saw many Canadian traders with the eastern Sioux. (From the LaVerendryer Journals of 1733–1749)

In 1787 the English passed out coats and flags to Dakota Chiefs (at least one was Teton). Jacques d'Eglise, in 1790 ,traded to the Mandan. Hugh Hennepin traded with Oglalas and Asones, and Tabeau traded with Brules in 1800-1805. Lewis & Clark noted several traders traveling to and from Teton Villages in St. Louis )1804).

By 1833, we learn from Culbertson's journal that there were, per tipi, about one gun, one axe, one kettle, ten knives. Tobacco, he added, was precious and eagerly sought for. Indians generally received twenty balls and powder for all the flesh of a buffalo cow, less when the buffalo were numerous. The price could rise to as many as forty balls when buffalo were at a distance. Blackfoot would create artificial scarcity by setting fire to the prairies in areas around forts, to drive the buffalo away, knowing they would get a better price for their meat if it was further away. Culbertson also told some other trade and Indian made articles values, such as a medicine bundle valued at nine horses, later bundle prices were 30 to 60 horses.

## Notes on Trade Good Prices
-Kiowas brought horses and Mexican goods to an annual trade fair on the North Platte and received from the Crow, Arapaho, and Cheyenne guns, ammunition, feathers, ermine, and British goods.
-The Sioux broke up those fairs in 1813 (Bent)

### Travels in the Interior of America in the Years 1809–1811:
-One robe equals thirty loads of powder and ball
-A Cheyenne warrior purchased an Arapaho quilled robe with red and yellow horizontal row and dew claw dangles, finally sold for $10.00.

## Wages at Fort Union, 1851:
-Craftsman - $350/ year
-Assistant - $120/ year
-Hunter - $400/ year (plus all hides and horns)
-Interpreter - $500/ year
-Traders (experienced) - $800 to $1000/ year

## Origins of Trade Goods:
-Cologne - clay pipes
-England - wool blankets, guns
-France - merinos (wool), calicos
-Italy- beads
-Leipzig, Germany- hawk bells and mirrors
-New Orleans - sugar and coffee
-New York - clothing and knives
-Saint Louis - powder, shot, meal (Kurz)

## Henry:
-One good horse is worth: one gun, 400 balls and powder, one chief's coat, one copper kettle, one axe, one iron lance, one broad bead belt, two wampum hair pipes, two shell pipes, ½ lb blue beads, one dozen brass rings, one dozen hawk bells, ½ flints and worms, two awls, two knives, one saw, one handful white powder.(Authors note- This must have been an exceptional horse.)

## Palmer's Journal, 1845:
-In Nez Perce one horse equals $14.00 or four blankets
-Eagle tail feather set of twelve feathers equals one horse or six buffalo robes
-One buffalo robe equals sixty loads of powder and shot
- Six to ten robes equals one gun
-Earth pots, rare now on the Missouri, replaced by brass kettles (S.H. Long, 1819)
-Shoshoni-southern bands trade with whites in New Mexico for striped blankets, bridles, and battle axes traded for buff robes and deer skins {Maximilian}
-Ten cents allowed by traders for an arrow

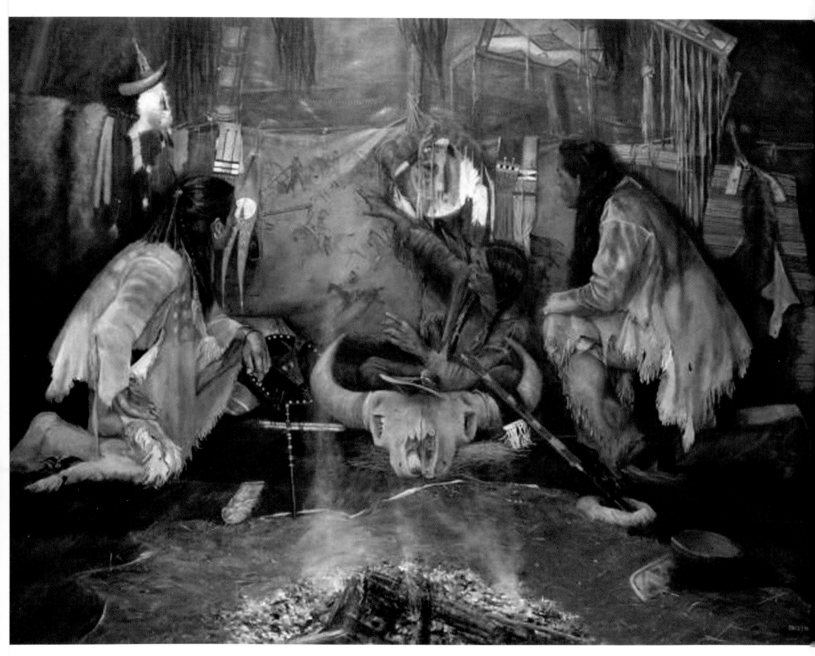

"Teller of Tales" painting by John Fawcett

# Chapter 20
# War Honors and Coups

*The complete destruction of our old enemies would please us.*
—Plenty Coups, Crow Chief

Coups were also recognized for other brave and warlike acts. Killing an adversary in hand-to-hand battle permitted the victor to paint a red hand on his clothing or upon his horse. Saving a friend in battle entitled a man to paint a cross on his clothing, and if the benefactor rode his friend to safety on the back of his horse, he might wear a double cross. Coups might be indicated by painting vertical stripes on leggings; red stripes indicated that the wearer had been wounded. Coup feathers dyed red also signified wounds; notched feathers showed the owner's horse to have been wounded.

Scouts who were successful in sighting an enemy were awarded coups. A black feather ripped down the center with the tip remaining was their badge.

Horse hoofs, painted on a coup feather or upon leggings or on a man's horse, indicated the number taken, while each hoof mark was colored to represent the color of the horse. A man's prowess and wealth were shown by the wearing of a miniature rope and moccasin at his belt to signify his capture of ten or more horses; the rope alone was worn when less than ten horses were brought back.

The symbols for coups varied among the Sioux divisions, and individual badges were occasionally honored. Thus, High Bald Eagle carried a small wooden knife, painted red, on the end of his walking stick. A lock of horse hair to indicate the Pawnees whom he had killed was attached to the knife.

Cutting or counting coup on the dance pole or piercing children's ears for wearing earrings were reserved for men who had struck coup, and with these rights frequently went the honorarium of a horse. Tabeau also noted that "piercing ears worth many presents," i.e. payment.

## Waheenee:

*I saw that Sacred Red Eagle Wing sat just opposite me. Next to him was a young man named Red Hand, with grass plumes in his hair. These meant that he had been in a war party and had been sent out to spy on the enemy. I saw Red Hand looking at me, and I was glad that I was wearing my elk teeth dress. "He is a young man," I thought, "not a boy, like Sacred Red Eagle Wing.*

*In some tribes women could actually win the same war honors as men, but more commonly the honors women earned were from domestic matters such as Waheenee tells us… "For my industry in dressing skins, my clan aunt, Sage, gave me a woman's belt. It was as broad as my three fingers, and covered with blue beads. One end was made long, to hang down before me. Only a very industrious girl was given such a belt. She could not buy or make one. No relative could give her the belt; for a clan aunt, remember, was not a blood relative. To wear a woman's belt was an honor, I was as proud of mine as a war leader of his first scalp.*

*I won other honors by my industry. For embroidering a robe for my father with porcupine quills I was given a brass ring, bought of the traders; and for embroidering a tent cover with gull quills dyed yellow and blue I was given a bracelet. There were few girls in the village who owned belt, ring and bracelet.*

Buffalo Bird Woman also recalled some women's honor marks:

*An industrious woman who had tanned hundreds of hides became eligible to receive the most coveted of honor marks, the "woman's belt" from her clan aunt. Such a bead-decorated belt, usually about 2 inches wide, was not purchasable, nor was it correct practice for any woman to make one for herself. Two additional special rewards for merit were cited; a bracelet, as a reward for decorating a tipi cover with quills, and a ring, for making a quill-embroidered robe.*

Curtis also said about these honor marks and devices:

*A woman who had good gardens and a well-kept lodge was permitted to wear a belt, about six inches wide, made of deerskin on which feathers were thickly sewn.*

## Buffalo Bird Woman:

*We reckoned the weasel cap and the war bonnet as worth each a horse; and, with these and our three horses, my father felt he was going his friend one horse better. It was a point of honor in an Indian family for the bride's father to make a more valuable return gift than that brought him by the bridegroom and his friends.*

*On the front of my paddle blade, Son-of-a-Star had painted a part of his war record, hoof prints as of a pony, and moccasin tracks such as a man makes with his right foot. Hoof and footprints had each a wound mark, as of flowing blood. Son-of-a-Star had drawn these marks with his finger, dipped in warm buffalo fat and red ochre.*

*The marks were for a brave deed of my husband. He once rode against a party of Sioux, firing his gun, when a bullet went through his right thigh, and killed his horse. The footprints with the wound marks meant that Son-of-a-Star had been shot in his right leg.*

*On his own paddle my husband had marked a cross within bars. These meant, "I was one of four warriors to count strike on an enemy."*

*The next morning when I went out of the lodge, I saw that the black-bear skin was bound to one of the posts at the entrance. This was a sign that my father was going to lead out a war party. I was almost afraid to pass the bear skin, for I knew it was very holy.*

Additional data on some of the points dealt with in the foregoing quotation, as well as on some other features, were given on another occasion by the same informant. Members of a victorious war party killed a buffalo on their return and put the blood into a paunch. Then all took their robes and whitened them with wetted clay. Dry wine wood and wild pu pue ("pampas") grass were burned separately to make distinct piles of ashes. The two kinds of charcoal and the blood were mixed in warm water, which was stirred. Four or five eminent men recited their deeds and began to paint each warrior's robe with the symbol of the first coup struck. A small stick is used for marking. In the meantime food has been prepared. Then each of the eminent men instructs the privates how to paint so many horse tracks or so many slain enemies, corresponding to their former exploits. Some human figures were painted crosswise to represent Sioux (or other enemies?). The entire shirts of the first coup-striker and gun-taker were blackened, the second and third men to count coup on the same enemy had only half their robe blackened, and the fourth counter on the same

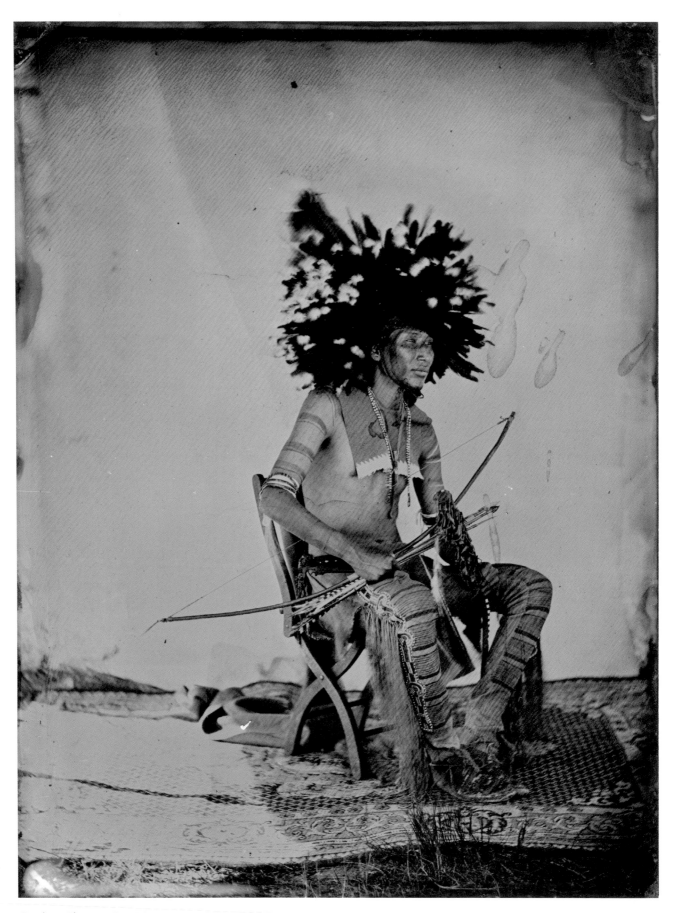

Southern Cheyenne Dog Man

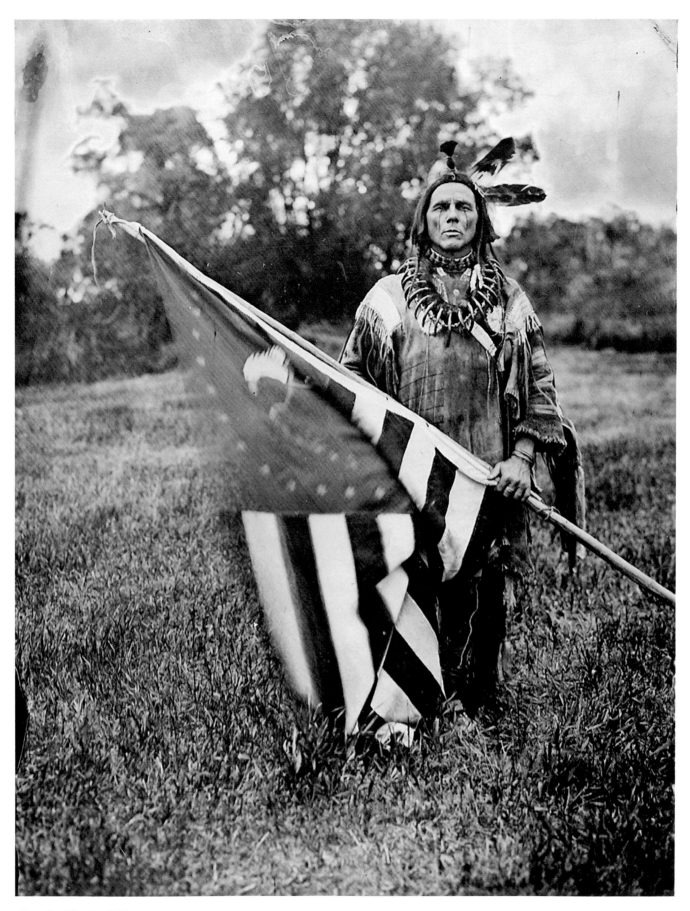

Arrowhead Earring, Hidatsa

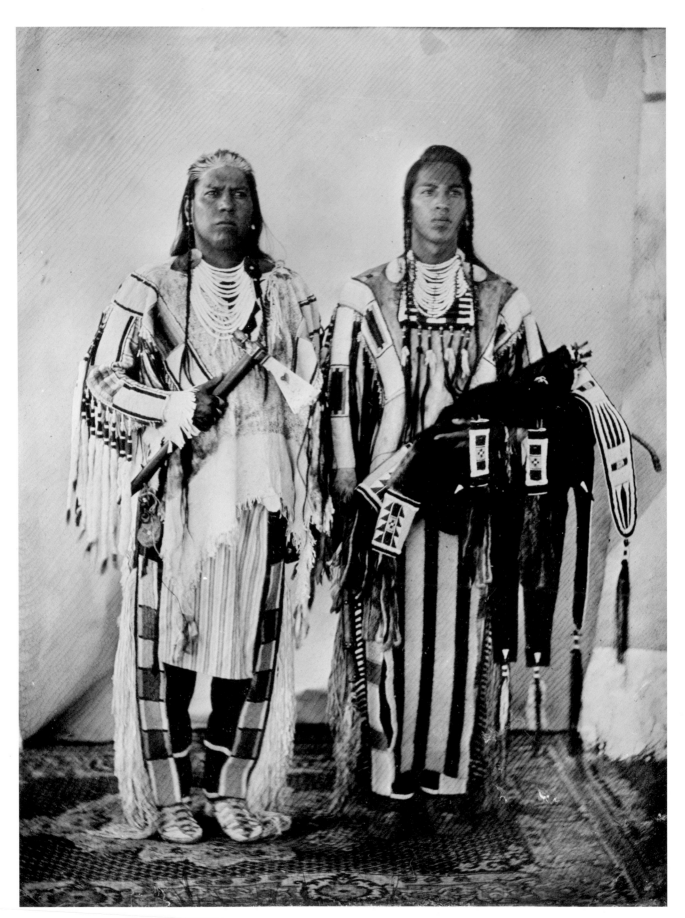

Crow Warriors

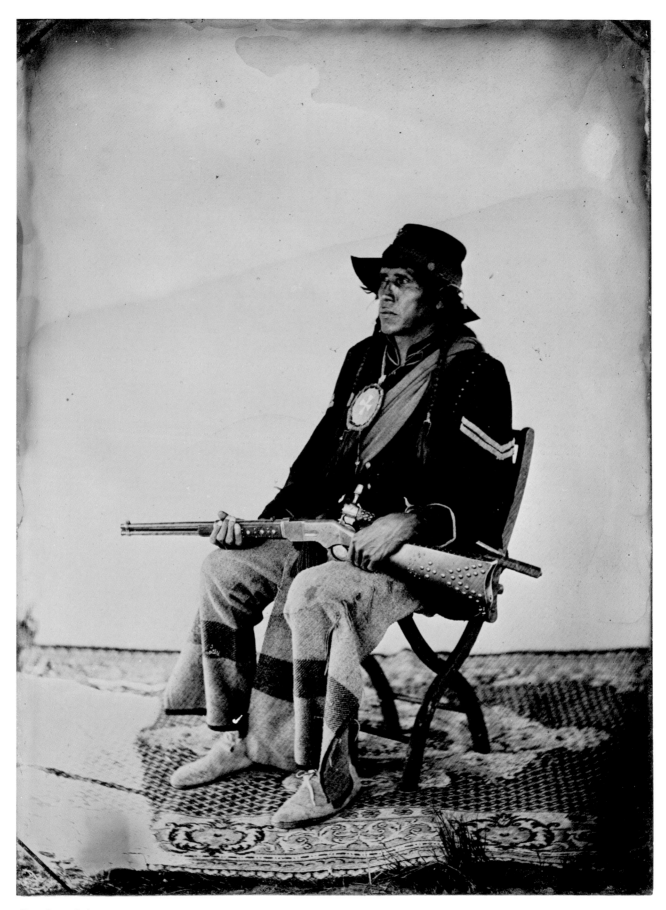

Crow Scout Rides Horse

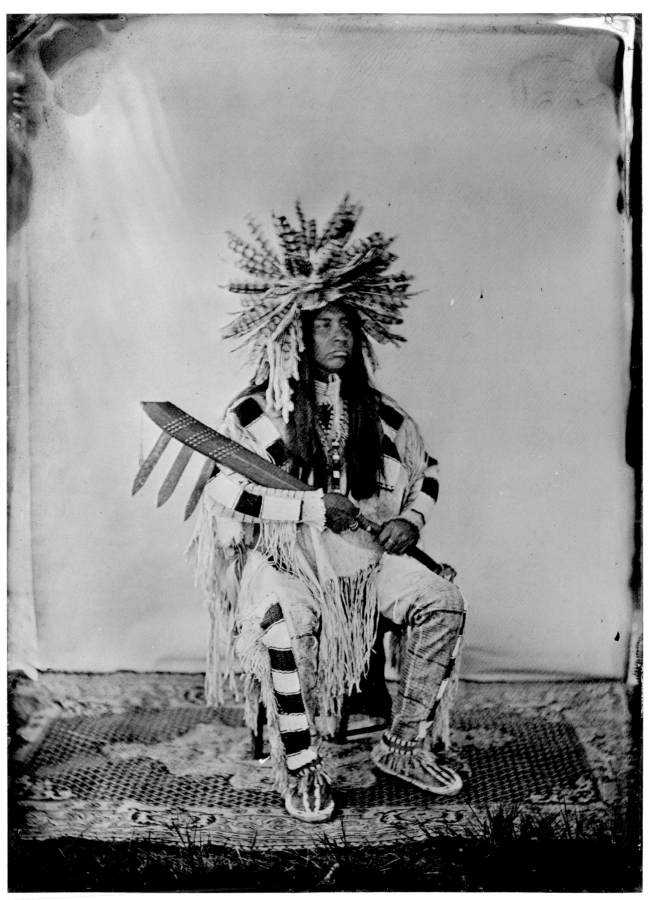

Lakota Miwatanim Old Coyote

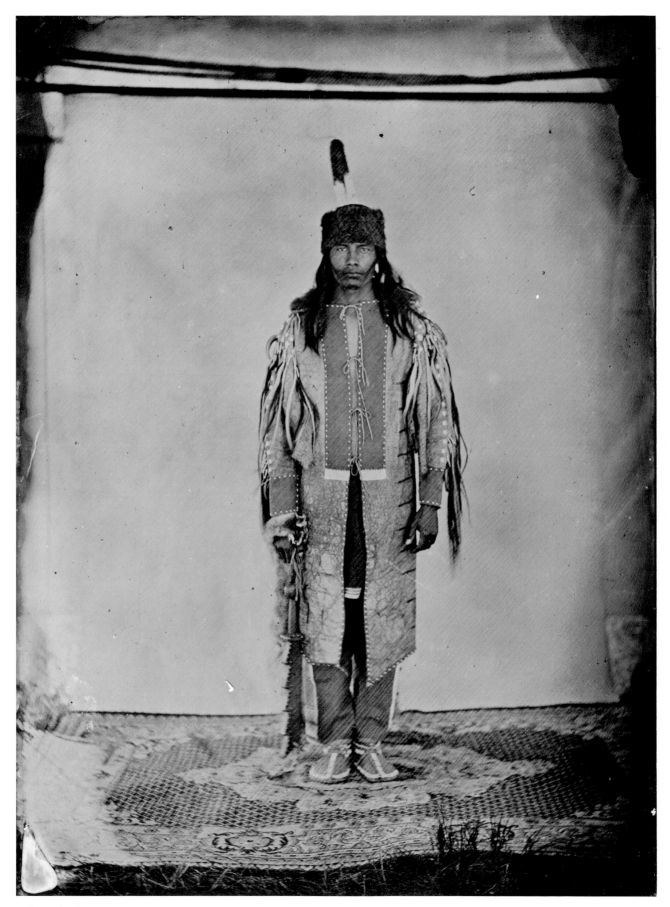

Lakota Chief's Coat

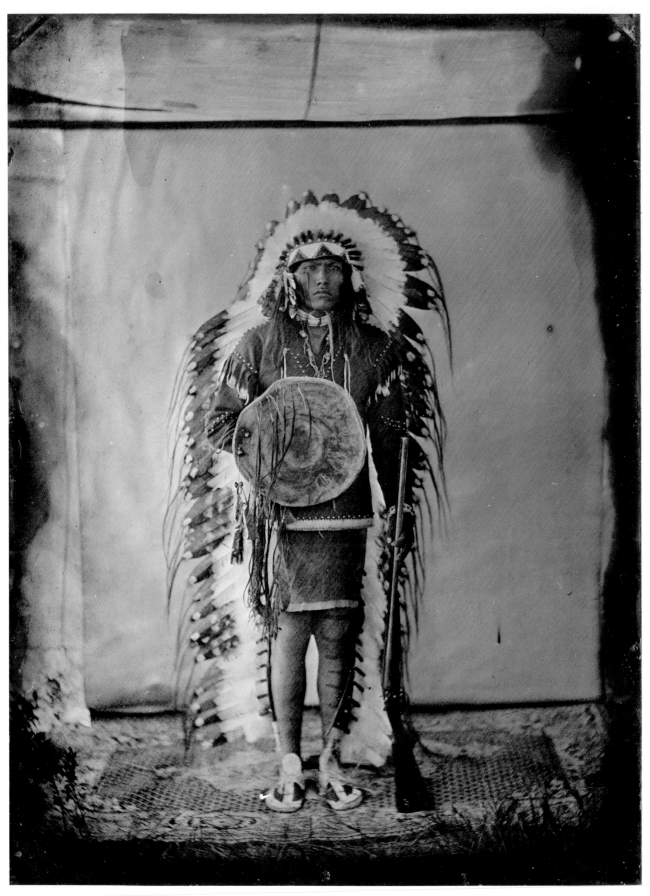

Lakota War Chief

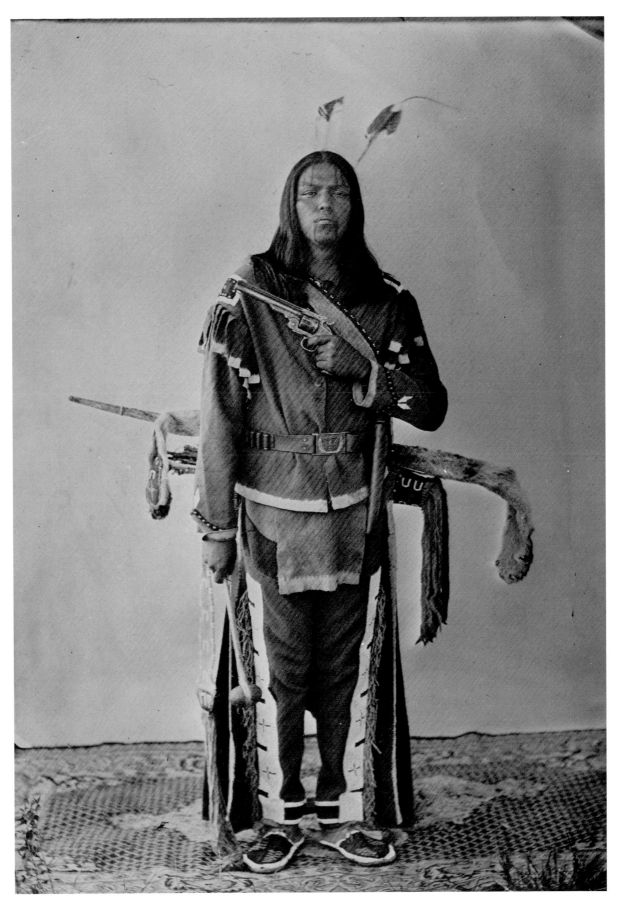

Lakota Warrior

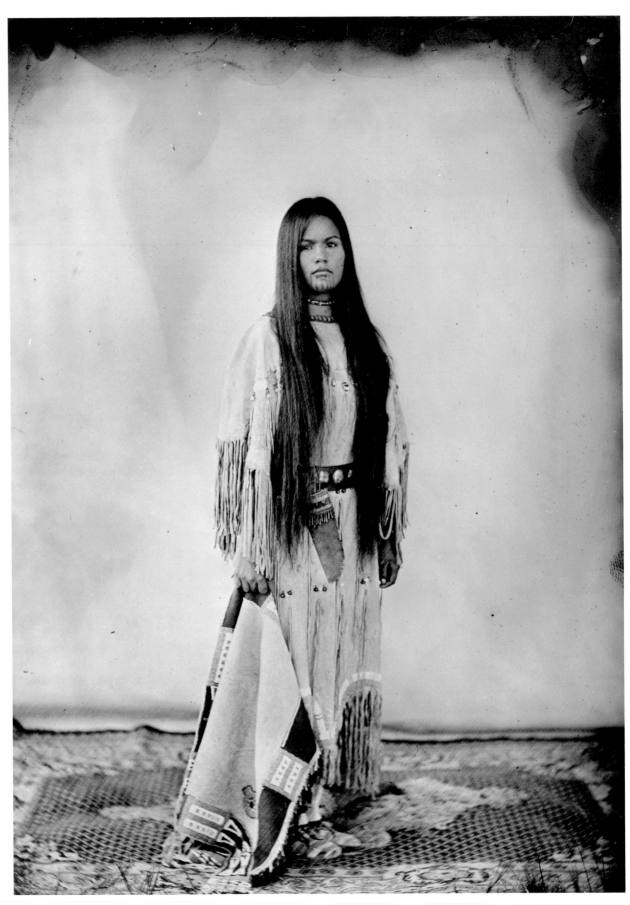

Woman with saddle blanket

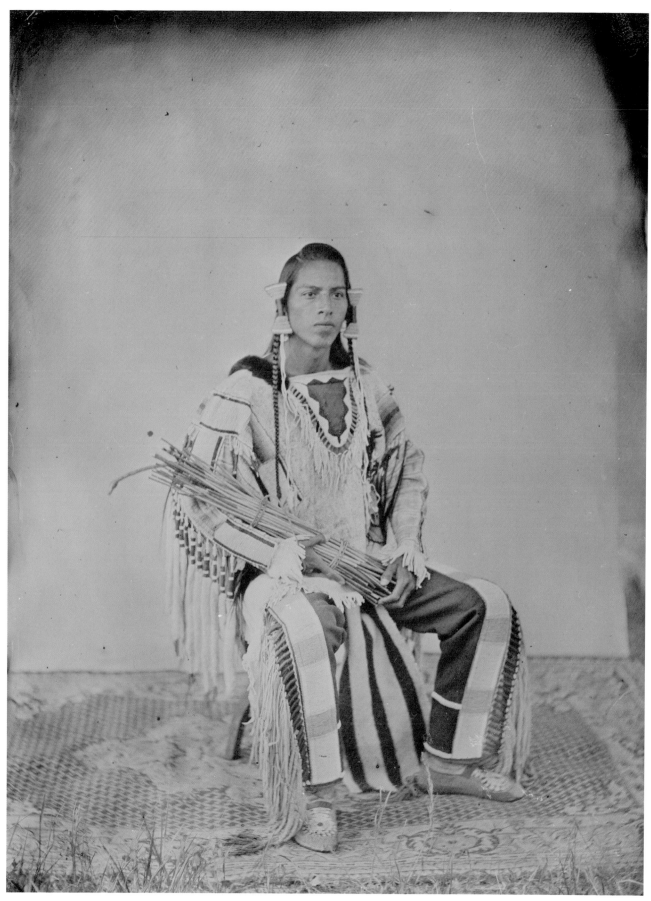

Crow Dandy

Buffalo Dancer Horse

War Horse

Lorbiecke, Marybeth  Painting the Dakota     Afton, MN  2000

Libby, O.E.- Editor     The Arikara Narrative of Custer's Campaign and the _____. *Battle of the Little Bighorn*. Norman, 1973.

Linderman, Frank B. *Plenty-Coup*. Lincoln. 1957.

Lowie, Robert H.     *The Crow Indians*. New York, 1935.

_____. *Social Life of the Crow Indians*. New York, 1912.

Long, James L *Land of Nakoda*. Helena, Montn, 1942.

Long, SH. *S.H. Long's Expedition 1819 -1820*

Lowie, Robert H. *Indians of the Plains*. Lincoln 1954

Mallery, Garrick, *Picture-Writing of the American Indians*. New York,  1972

Maximilian, Paul Wilhelm, Duke of Württemberg, *Travels in North America, 1822-1824*, Norman, 1974.

Mayhall, Mildred P. *The Kiowas*. Norman, Oklahoma, 1971.

McChristian, Douglas C. *The U.S. Army in the West, 1870-1880*     Norman, Oklahoma, 1995.

McWhorter, L.V.  *Yellow Wolf His Own Story* , Caldwell, Idaho,  1995.

McGregor, C. L  –editor. *The Journals of Patrick Gass*. Missoula, Montana, 1997.

McClintock, Walter. *The Old North Trail*, Lincoln, 1968.

Members of the Potomac Corral of the Westerners, *Great Western Indian Fights*. Nebraska, 1960.

Michno, Gregory F.  *Lakota Noon*  Missoula, Montana. 1997.

Miller, D. H.  *Custer's Fall*, Lincoln, 1957.

Morgan, L H.  *The Indian Journals*. Toronto, Canada, 1993.

Nabokov, Peter. *Two Leggings*. Lincoln, 1967.

Neihardt, John G. *Black Elk Speaks*. Lincoln, 1961.

Pferd, William, III. *Dogs of the American Indians*. Fairfax, Virginia, 1987.

Powell, P. J. *Sweet Medicine*. Norman, Oklahoma, 1969.

Prescott,

Reedstrom, Ernest Lisle. *Bugles, Banners and War Bonnets*. Caldwell, Idaho, 1977.

Ronda,  James P.  *Lewis and Clark Among the Indians*. Lincoln, 1984.

Sachsen-Altenburg Dyer  Duke Paul of Wuerttemberg on the Missouri Frontier. MO  1973

Sandoz, Mari  Crazy Horse : The Strange Man of the Oglalas    Lincoln 1971

Schultz, J.W. *William Jackson, Indian Scout*.  San Bernardino, CA 1926.

Smithsonian   Handbook of North American Indians    2001

Standing Bear, Luther    My Indian Childhood  Lincoln     1988

Stands in Timber, John   Cheyenne Memories   Lincoln   1967

Stewart, Ketner, and Miller     Carl Widmar  Chronicler of the Missouri River  Frontier St Louis, MO  1991

Swartz, W.E.    The Last Contrary  Sioux Falls, SD    1988

Tabeaus,

Thomas, David H.   Skull Wars   NY   2000

Thornton, Russell   American Indian Holocaust and Survival   Norman, Ok 1987

Thompson, Scott M   I Will Tell of My War Story   Seattle 2000

Thwaites, R.G.    Early Western Travels 1748-1846  NY  1966

Tyrell, J.B. David Thompsons Narrative of his Explorations in Western America  1812

Turner, C.Frank         Across the Medicine Line  Toronto  1973

Vaughn, J.W.  With Crook at the Rosebud    Lincoln    1988

Vestal, S. *Warpath*.  Lincoln 1984

Wagner, G.D. / Allen, W.A. *Blankets and Moccasins*. Caldwell, Idaho    1987

Walker, James R. *Lakota Belief and Ritual*, Lincoln 1991

West, Elliott , *Contested Plains Indians, Goldseekers, and the Rush to Colorado*, Lawrence, Kansas, 1998.

Wilson,  Gilbert L *Buffalo Bird Woman's Garden*, St. Paul, Minnesota,  1917

_____ Notes to the American Museum of Natural History    1911-1918

_____. *Reprints in Anthropology*, Vol 10. NY  1924

Walker, James R     Lakota Society     Lincoln 1982

Whale,

Wissler, Clark     American Museum of Natural History  N  1912

Wilson, G. L.     Reprints in Anthropology  Lincoln,  NE   1978

Wood, W. Raymond and Thiessen, Thomas D.  *Early Fur Trade on the Northern Plains*. Lincoln, 1985.

White Mountains Village

# Index

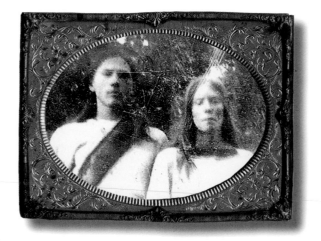

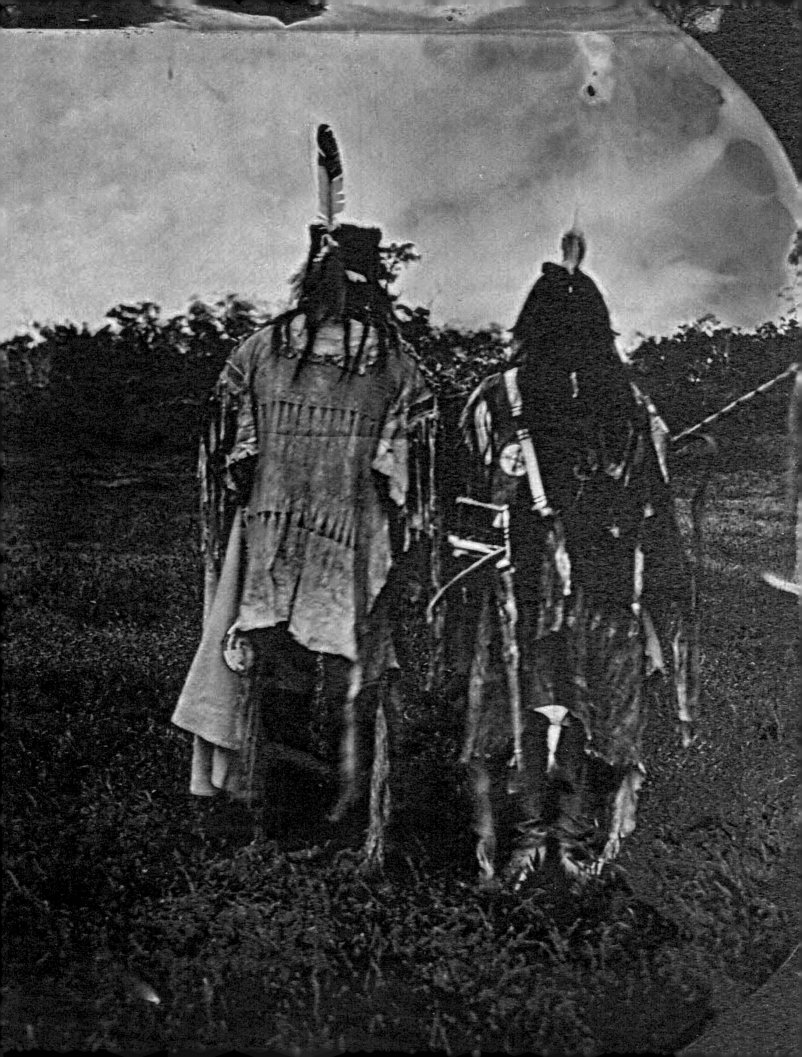